FISH

To my late father Flicky Ford (Sr.), a graceful fly-fisherman, skilled artist and writer who mentored my fishing and all my artistic endeavors. FLICK FORD

To Mary Swain, Louisa, Mariah and Travis. DEAN TRAVIS CLARKE

A GREENWICH WORKSHOP PRESS BOOK
© 2006 The Greenwich Workshop Press
Paintings © 2005 Flick Ford

ISBN–10: 0-86713-095-4
ISBN–13: 978-0-86713-095-9

Published by The Greenwich Workshop, Inc.
151 Main St., Seymour, CT 06483
(203) 881-3336 or (800) 243-4246
www.greenwichworkshop.com

Fish length and weight dimensions are general averages to help readers gauge the relative size of the fish in this book.

To purchase or commission original paintings by Flick Ford, or to inquire about the availability of fine art giclée canvas limited editions of his work, go to www.FlickFord.com.

Library of Congress Cataloging-in-Publication Data is available from the publisher upon request.

Jacket front: Brown Trout
Jacket back: Largemouth Bass, Striped Bass

Photography: Bob Hixon except pp 11, 15, 25, 26, 16, 19, 56 supplied by artist.

Design: Bjorn Akselsen

Manufactured in China by Oceanic Graphic Printing
First Printing 2006
1 2 3 4 09 08 07 06

77 Great Fish *of* North America

Paintings by Flick Ford ～ *Text by Dean Travis Clarke*

FISH

Greenwich Workshop Press, Seymour, Connecticut

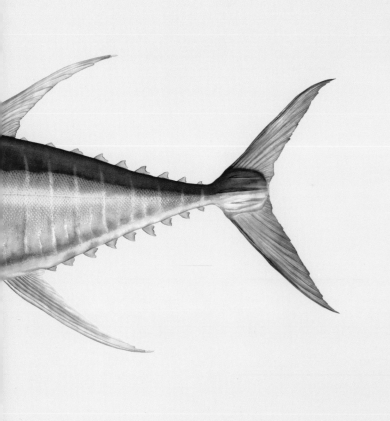
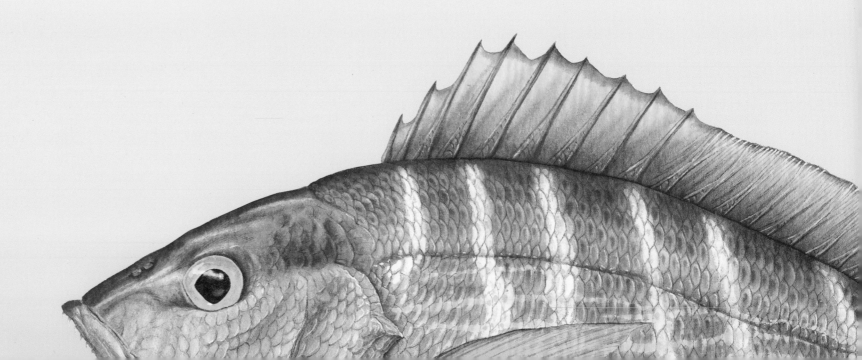

CONTENTS

INTRODUCTION BY PETER KAMINSKY

Among the drawings that our Cro-Magnon ancestors left in the secret recesses of their cave dwellings, there are bison and musk ox, gargantuan tigers, mammoths as big as freight cars…even penguins, but no fish. Although I have always sought to steer clear of the age-old arguments between hunters and fishers (the seventeenth century has many dialogues between Piscator and Venator each seeking to prove the greater saintliness of their sport), I cannot help but think that the prevalence of great land beasts and the absence of finned creatures in those Pleistocene parlors has much to do with the fact that it took a lot more brainpower for humans to figure out how to catch a timorous and perpetually fearful fish than how to chase a buffalo off a cliff.

Fish are special. Consider this: the early Church Fathers often referred to themselves as shepherds and to their congregations as flocks. But the first in stature among those early Christians was Peter, the fisher of men, and the sign of a community of believers, almost as widely used as the cross, was the fish.

My house abounds with pictures of fish, many of them in the same pose as the fish in this book…seen from the side. Among representations of animals the fish is the only one I know where it is possible to see both the profile and the whole view of the body. Correction, it is not the only animal thus portrayed. In Egyptian hieroglyphics the human face is forced into a physically impossible position so that it is seen in profile while the body is turned toward us. The gaze of pharaoh, like that of the fish, fixes us with one eye. It is irresistible. I don't know why it took me fifty years (my first visit to the Metropolitan Museum of Art) to became aware of this similarity. Maybe it took the paintings of Flick Ford to drive the point home.

His pictures, though realistic, have a certain spiritual quality. By spiritual I am not referring to the souls of the halibut, grayling, striper, or salmon. I mean his drawings are informed by the spirit of the angler…and even non-angling fish fanciers. His are pictures of fish as I have dreamed them, more colorful, and somehow more real, than reality itself.

Because every man or woman has a different personality I think we endow wild creatures with similar qualities. Whether or not the trout is haughty, the bass down-to-earth, and the pike a back-alley thug is not the issue. What Flick has captured so clearly, yet so subtly is that we experience these creatures as if they had personalities. Not cutesy and treacly as in a children's book or a cartoon, but more like the run of people we all know and the heroes and princesses we would like to know.

Take for example the hook-jawed brown trout, with his fearsome kype and his steady gaze. His look is one of unconcern. He can handle anything, he seems to say. In like manner it is easy to imagine the lake trout with his ample belly and pudgy face passing the afternoon in the trout version of a La-Z-Boy recliner, stirring from it only if it does not take too much effort to gobble up any stray alewife herring that comes within range. The rainbow trout is Audrey Hepburn dressed by Christian Dior: ravishing yet refined. And the jewel among salmonids, the golden trout, looks understandably anxious, as well he should, since he is diminutive and is found in just one river system in his native range.

I could go on forever about trout because they are the apex of angling or at least I find them so, but there are a number of other fish whose subtly nuanced characters have been caught by Flick. A tasteful blush on the belly of the demure bluegill is that of a just-coming-into-womanhood teenager at her first high school dance and the black crappie is the lunkheaded football player who pines for her but doesn't stand a chance. The largemouth bass is clear of eye and calm of mien, a true son of the Middle Border, which indeed he is because between the Great Divide and the Alleghenies, he and his cousin the smallmouth rule the river. Curiously, though, the smallmouth looks startled,

even wary, which come to think of it, is the way most fish appear to me when I have a rod and reel in hand. Among the saltwater fishes, the goliath grouper looks like no one so much as the odious Jabba the Hutt from Star Wars. And the porgy puts me in mind of the Russian ladies, all in late middle age and well-rounded from a lifetime of blintzes and pierogi, that I remember from Van Cortlandt Park in the Bronx circa 1961, when Mickey Mantle and Roger Maris were chasing Babe Ruth's record and Dion and The Belmonts blared from every transistor radio.

I could go on, but instead, I urge you to. Every painting in this book has a story that each reader can tease out of it. Or you can simply marvel at the beauty of form and color of these citizens of The Republic of Water, each one an evolutionary marvel expressed through the artistry of a man who may one day lay claim to the title of fishdom's Audubon.

Fishing is more popular than tennis and golf combined. I can't tell you why, but

I am always amazed at the diversity of expression the passion for fishing takes.

Imagine blazing across the water at seventy mph in a gleaming, metal-flake and

fiberglass rocket to get to what you think is a fish hiding

FRESHWATER FISH

place. You catch the biggest fish you can find and put them in a special

compartment in the floor to keep them. Your pick-up truck pulls the boat out of

the water. Then, wearing a colorful outfit with sponsor badges, you drive to a

nearby stadium where tens of thousands of devoted fishing fans cheer and stomp

every time a larger fish comes to the scales on the stage.

On the other extreme, a quiet man trudges through the winter woods, the only sound being the crunch of snow under his chest-high rubber boots and the increasing volume of burbling water. He carefully steps into the icy water, balancing himself with his walking stick against the push of the stream. He pulls fly line off the reel and moves the rod tip repeatedly from ten to two o'clock, feeling the weight of the line as it straightens out at the end of each pass, finally letting go of it and watching as Newton's law guides it to the soft calm behind a log on the other side. Feeling his quarry playing tug-of-war with him, he gently pulls the fish toward his net. Wetting his hand before touching the fragile gift, he gently removes the hook from the corner of the trout's mouth then slides it back into the water.

It's all fishing.

(Salvelinus fontinalis)

BROOK TROUT

I had gone up to Maine expressly to catch a decent-sized brook trout four days earlier and I had yet to put a fly over one. The window of opportunity for catching a fourteen-inch or bigger "brookie" from any lake within striking distance of where I stayed in Solon, Maine was slim.

DISTRIBUTION

Eastern North America from Newfoundland down to North Georgia, west to the western side of Hudson Bay and Manitoba, the Great Lake states, and through the Mississippi River basin. Brookies have been introduced to many western states including Alaska.

I arrived right after the worst of black fly season, hoping to take advantage of the famous Hexagenia mayfly hatch in the region's fertile, high-elevation glacial ponds. Historically, this happens in late June and early July. But the wind posed a serious problem.

The hatch, a dusk-to-dark affair each day, lasts a scant thirty-five to forty-five minutes tops and is an amazing sight. The emerging flies float to the surface and the trout go into a splashy frenzy over these giant mayflies in a scene that makes every trout fisherman's heart skip beats. If the wind cooperates, you can see the rises everywhere. Unfortunately, stiff winds not only prevent an eye-popping hatch, but also make it really tough to cast a fly over a feeding fish or even keep the canoe where you want it.

When John Kenealy, maker of bamboo fly-rods, guide, and owner of Mountain Valley Flies, finally told me we were headed for brookies, I was at once cocky and ecstatic. So much so, I almost blew it completely. I managed to make Kenealy — one of the most mellow fellows I've ever met — almost cranky.

First he had to tolerate my aggressive river-wading casting technique (more persistence than style or substance) that rocked the canoe and spooked the fish. Then he saw that my accuracy and timing were off. I couldn't drift my fly like I might on a river. This kind of fishing required every bit of my casting skill. Get a fly near that rise NOW!

I got the hang of it after a fashion, putting the fly right on top of a riser's head within seconds of seeing it. No matter whether the fish was ten feet away or fifty,

FIND ONE!

Brookies like cool, clear water and are sensitive to poorly oxygenated habitats. In many areas where brook trout were once native, they have been pushed out by the introduction of other species, particularly perch and pike. They eat frogs, insects, crustaceans, smaller fish and even small aquatic mammals.

I could finally do it. Unfortunately, it took me until near total darkness to master it.

From the depths I saw a tremendous snout appear under my fly. The open mouth displayed white mottled with black, as it is with very large, male brook trout. Had I not known better, I would have believed it to be the maw of a largemouth bass. In a micro-second, I recognized one of the very rare and precious five-plus-pound brook trout left in the lower forty-eight states and, being one of the greatest fly fisherman alive, I stood ready for him. I yanked the fly right out granddad's mouth.

Kenealy quietly muttered "It's over," meaning the fishing, and to me, that my life as a fisherman had just ended, and finally, that I had a chance at one of the largest brook trout he'd ever seen and that maybe I should jump over the side and drown myself. The very next cast I caught a nice fish. It took Kenealy's floating Hex Emerger pattern on a size six hook that I had tied myself for the trip. That thick-backed male measured out at fifteen-and-three-quarter inches. **FLICK FORD**

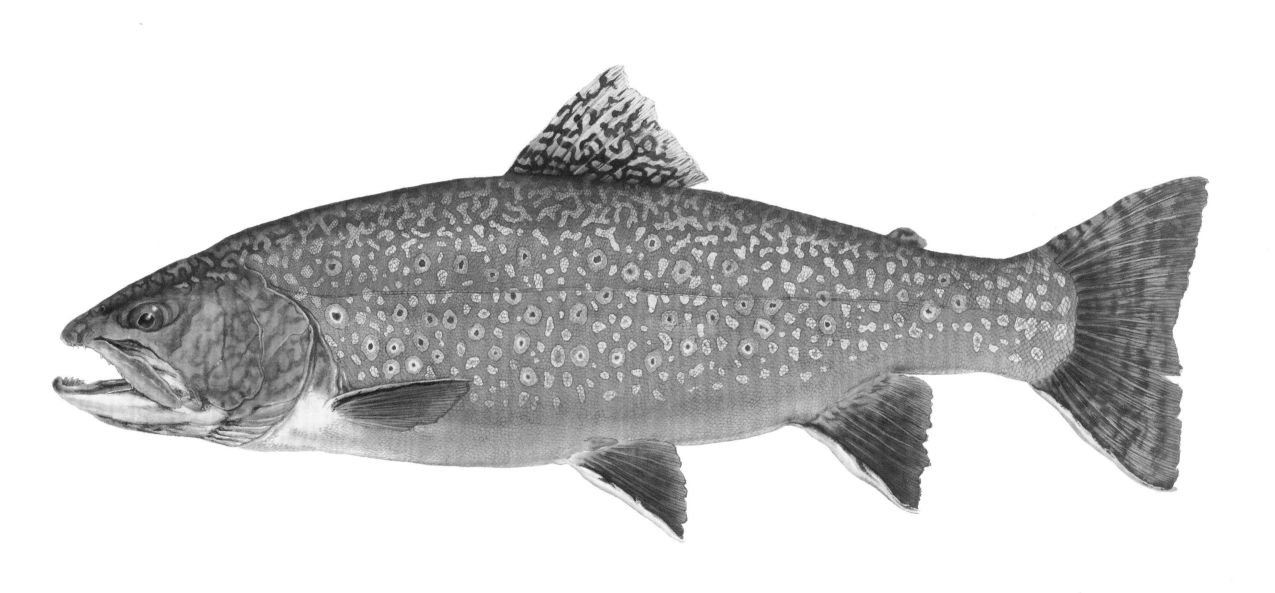

BROOK TROUT

(Salvelinus fontinalis) Size 5–28 inches. Weight 1/4–10 lbs

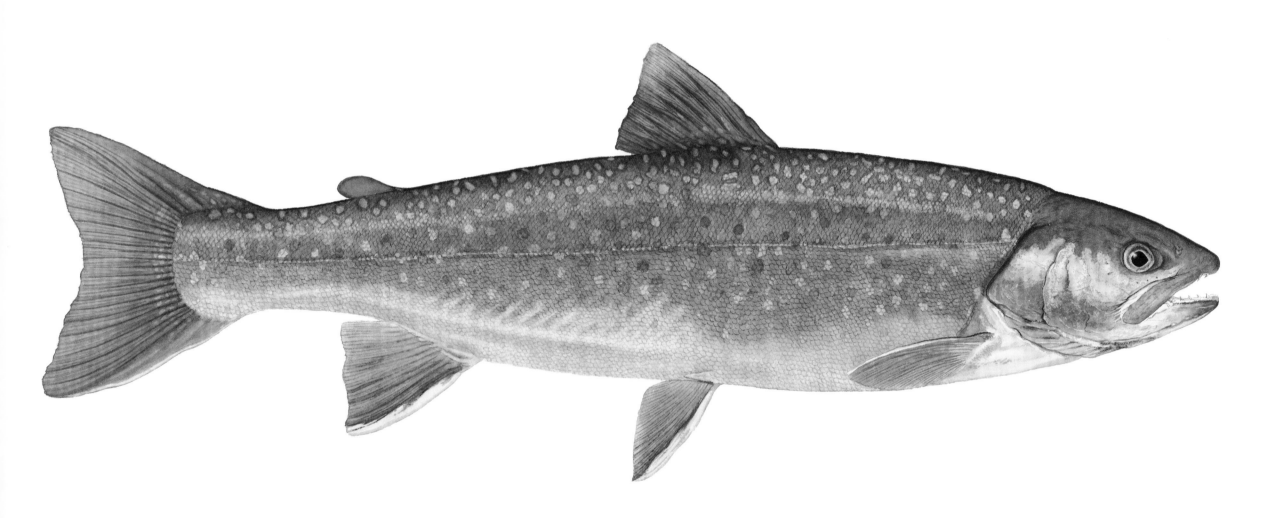

DOLLY VARDEN

(Salvelinus malma) Freshwater 5–18 inches. Anadromous 18–24 inches

(Salvelinus malma)

DOLLY VARDEN

In 1841, Charles Dickens wrote a serialized novel entitled Barnaby Rudge *that was about the 1780 Gordon riots in London and grabbed the attention of Victorian-era Britons. One of the novel's main characters, a locksmith by the name of Gabriel Varden, had a spoiled, flirtatious daughter named Dolly who loved to dress to the nines. Throughout society of that day, Dolly's character inspired songs, dances, paintings, and even spawned a fashion trend called the "Dolly Varden look" which included a specific style of hat and a shiny calico material.*

Her name was also used for a type of horse and a piece of railway equipment. In a daring and inexplicable leap of logic, someone applied the Dickensian trollop's name to a trout. Fortunately for Dolly Varden, she was fictional, because while I imagine she would be flattered by a fashion attribution, few women would ever want their name associated with a horse, railroad equipment, or a fish.

Though remarkably similar-looking to trout, Dolly Varden are Arctic char whose colors appear as the photographic negative to certain trout. Where Dolly Varden have dark-colored bodies with light spots, trout have light-colored bodies with dark spots. Adult Varden males turn a vibrant red over their lower body surface. In addition, like some salmon, male Varden develop an extended, upward-hooking lower jaw.

At age five or six, Dolly Varden return to their streams from the nearshore ocean (near river mouths) to spawn, usually between August and November. Fertilized eggs then slowly develop over the winter and hatch in the early spring. Juveniles start their seaward migration once they reach three or four years old. Because male

WHAT'S IN A NAME?

The Dolly Varden and the bull trout are now considered two separate fish although for years fishermen called them both Dolly Varden. In some areas they are hard to distinguish. Dolly Varden living on ocean shorelines are dark blue with silver sides, and freshwater Vardens tend to be olive green or brown.

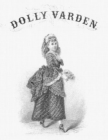

DOLLY VARDEN

Dolly Varden have such difficulty getting along with each other, scientists estimate that less than fifty percent of them survive to spawn more than twice.

In the past, the Dolly Varden's survival hasn't been helped by these same scientists. For a time, anglers considered Dolly Varden a "trash fish" and a threat to the salmon population. Fisheries experts claimed that char ravaged salmon fry and eggs and blamed them for a decline in salmon populations. Consequently, the fisheries scientists offered up a cash bounty for each Dolly Varden tail that fishermen turned in. Eventually, anglers started turning in tails from virtually every fish they caught, depleting the funds and ending the almost twenty-year-long program.

Turns out, char posed absolutely no threat to salmon and in fact, had happily cohabited with them for millennia with no deleterious effect. Today, we can't say as much about man's impact on char. Loss of habitat, pollution and dams have caused Dolly Varden numbers to dwindle.

BULL TROUT

Anglers have chased trout since the Paleolithic era, although they probably didn't wear waders and use flyrods back then. The name trout came from Old English truht *which stems from Low Latin* trocta *or* tructa, *meaning a fish with sharp teeth. Similarly, the Greek word* troktes *means gnawer.*

DISTRIBUTION

Bull trout live in coastal and mountain streams from the southern Yukon to the Missouri River basin. They tend to prefer deep pools in large, cold rivers and lakes.

If someone tells you that bull trout and Dolly Varden are the same thing, just tell them, "Well, bull trout aren't actually trout, they're char. Bull trout (*Salvelinus confluentus*) come from the same genus as Dolly Varden (*Salvelinus malma*) but are quite a different species." (If possible, say this while looking over your glasses perched on the tip of your nose for effect.)

Actually, bull trout are no laughing matter. The U.S. Fish & Wildlife lists them as "threatened" meaning bull trout may become an endangered species in the near future throughout all or a large part of their range.

For millennia, bull trout commonly roamed the entire Pacific Northwest from California to the Bering Sea on one of the longest migration routes of any trout. Today, the species has become officially extinct in California, survives in a single stream in Nevada, and scientists additionally claim the stocks in Washington, Oregon, and Idaho have reached perilous levels. Only two percent of Montana's bull trout stream habitat is considered stable. In fact, Montana's Fish and Game Commission figures its bull trout stock has a strong chance of extinction in a third of its range.

Why the rapid decline? Bull trout need clean, cold water with clean gravel and upwelling groundwater to spawn. They also need places to hide from predators in the form of overhanging banks and natural, in-water structures. They require different types of water, too, for example, deep pools, riffles, and a variety of current velocities. Bull trout travel considerable distance to spawn so barriers like dams, weirs,

EARLY WARNING!

Bull trout's need for high-quality habitat make them ideal bellwethers of environmental health. More ubiquitous species like rainbows and browns can manage in less pristine conditions.

irrigation ditches and the like disrupt their ability to migrate.

Humans have further endangered the delicate balance of many of the bull trout's habitats by our uncontrolled livestock grazing, release of exotic species, and artificial cross-breeding with brook trout. Poorly designed logging access roads raise water temperatures in the bull's habitat as well as dump sediment into the spawning gravel. Overhanging banks have disappeared and agriculture's increasing water demands for irrigation have lowered stream levels to untenable levels. Irrigation ditches and roadside drainage culverts channel bull trout into dead ends where they ultimately expire.

With a prime spot on the list of threatened species, bull trout can't be legally fished. If you end up with one as incidental bycatch, treat it with utmost care. Wet your hands so as to not remove the outer slime coating when you handle it. Then immediately and carefully release it.

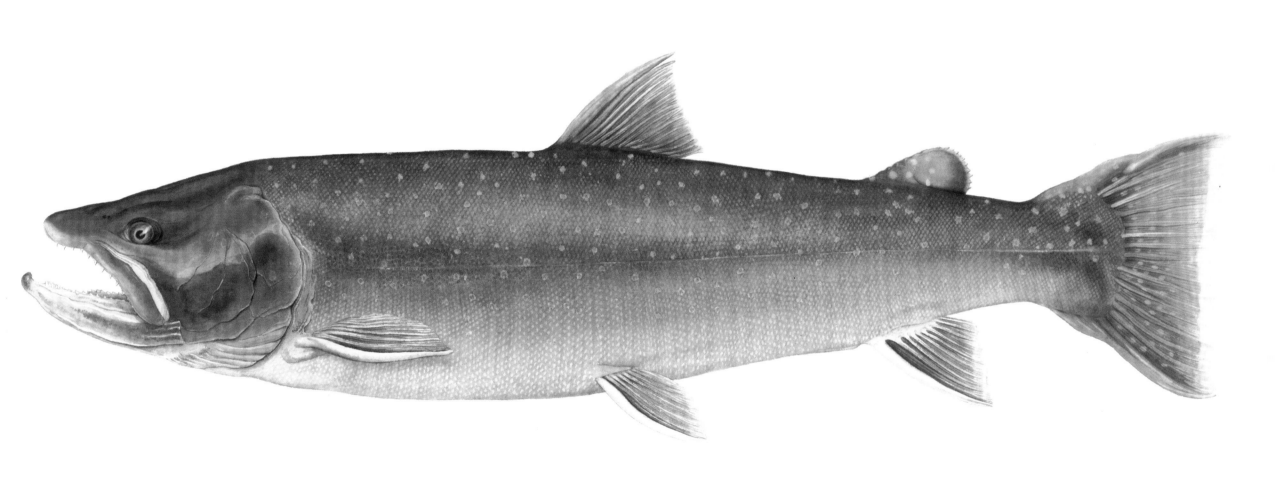

BULL TROUT

(Salvelinus confluentus) Size 1–2 feet. Weight 4–20 lbs

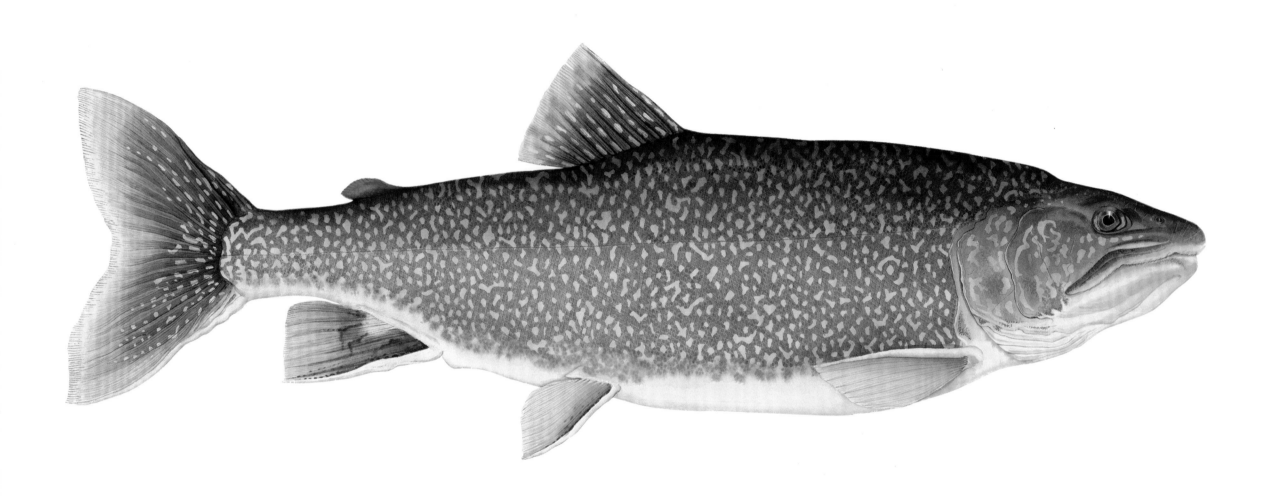

LAKE TROUT

(Salvelinus namaycush) Size 16–40 inches. Weight 5–50 lbs

(Salvelinus namaycush)

LAKE TROUT

…all good things — trout as well as eternal salvation — come by grace and grace comes by art and art does not come easy. – NORMAN MACLEAN

Lake trout are one of the species that truly shares history with Native Americans. Even its Latin moniker, S. namaycush stems from its Algonquin name. The lake trout is actually a char, not a true trout and today it is one of our most important commercial freshwater fish and a popular sport-fishing species.

A beautiful fish, it has characteristic pale spots with darker backgrounds on its head, back, and sides.

From late summer to December, lake trout spawn in shallow, gravel-bottomed water. They make no nest, but males clear the spawning ground of debris. The female lays her eggs on the gravel where they settle in among the stones and remain until they hatch in early spring.

Lake trout can be found in cold, clean, well-oxygenated freshwater. Like so many fish, lake trout have different names in different regions. Throughout its northern

HOW BIG?

Fisheries experts calculate the lake trout's lifespan at around 20 years, during which the slow-growing predator can reach sizes of up to 50 inches and 100 pounds. However, we plebians can expect the ones we catch to be closer to 17 to 27 inches and up to about 10 pounds.

North American range they are referred to as gray trout, mackinaws, lakers, togue, touladi, and salmon trout.

Shaped much like a torpedo with an almost-oversized, deeply-forked tail, the lake trout eats crustaceans, insects, other fish like chubs and sculpins, smelt, and alewives. I've even found small mammals like moles and mice as well as the occasional reptile inside them. Once it clamps down on its prey, a laker rarely loses it thanks to a full and hearty set of teeth on the jaws,

HOW TO TELL WILD FROM FARMED TROUT

Wild trout meat is virtually the same rich pink hue as salmon since trout are, after all, salmonids. The flesh of the wild lake trout varies from pale ivory to deep pink and has an especially delicate, delicious flavor. The flesh of trout raised on Purina Trout Chow, however, is invariably white.

tongue, and the roof of its mouth.

Commercial fishermen, who have the ability to catch fish down deep with gillnets, harvest lake trout winter and summer. Recreational anglers target lake trout with fly and spinning tackle primarily in the very early spring, just after ice-out when the water is coldest. (Lakers like water around 10° C.) As water near the surface warms, lake trout tend to go deep, to colder water. Of course, anyone with a big reel and lots of line can fish deep and catch lakers throughout the summer, too.

From the 1930s to the 1950s, lake trout suffered from overfishing as well as from the rampage of the sea lamprey, an invasive species in the Great Lakes. Thankfully, in one of man's more successful manipulations of nature, the sea lamprey population has declined and through vigorous stocking programs, the lake trout has rebounded.

DISTRIBUTION

Canadians find lakers from the Maritimes and Labrador in the east, to northern British Columbia in the west as well as throughout the Yukon and Northwest Territories. In the United States, lake trout are found in all the northern states.

RAINBOW TROUT

I am particularly fond of wild 'bows. Many times they have saved the day for me on the Delaware, when the big browns ignored all my best presentations with their typical ultra-selective feeding habits.

Legend has it that in the late 1800s, a train carrying fingerling Mcloud River rainbow trout destined for the cold waters of the Catskills broke down in Callicoon, New York. In an effort to save the trout, Dan Cahill, an avid fisherman and brakeman for the Erie Railroad Company, released them into the Delaware River, a warm water fishery at that time. Whether or not this story is a myth, credible evidence exists that the New York Fish Commission was already stocking rainbows in the headwater tributaries and streams of the Upper Delaware River.

In 1878, fish culturist Seth Green released thousands of fry throughout the system. He raised the fry from eggs he'd collected from spawning rainbow trout he called California Mountain Trout from the San Francisco Bay area. In 1875, rainbows of the California McCloud River strain were brought to his hatchery in Caledonia, New York. Reports of the rainbow stockings do not differentiate whether the fry sent from the hatchery to be stocked by the New York Fish Commission were McCloud fry or California Mountain Trout fry. In fact, only DNA testing would determine if there is a mixed strain of rainbow in the Delaware.

Over time, the rainbows in the river were forgotten. But in 1961, the Pepacton Dam, built on the East Branch in Downsville created a cold, tailwater fishery.

In 1967, another dam was completed in Cannonsville on the West Branch. With the Cannonsville Dam just eighteen miles up the West Branch, the cold-water zone extended all the way down to Callicoon on the main stem. Today, anglers and scientists regard the Delaware River system, where this tough transplant managed to survive for nearly one hundred years, to be one of the top wild trout fisheries in the United States.

Look for rainbows in faster water than you would normally find browns. They like to hold in riffles and current seams. Fishing pocket water in steep sections of tumbling freestone rivers and creeks can hold surprisingly good-sized rainbows. Keep moving. If a few casts doesn't raise a rainbow from a likely lie chances are it's not there, they are not very picky. Hook one to witness how their selective breeding in a less than hospitable habitat has highlighted their pulling strength and acrobatics.

FLICK FORD

CATCH ONE ON A FLY

In the East they are very fond of Isonychia mayflies aka the Slate Drake. For fast water and pocket water I like two patterns: Art Flick's Dun Variant and Fran Betters' Ausable Bomber. For flatter water nothing beats Al Caucci's Isonychia Comparadun as a searching pattern from late June on to the closing of the trout season.

DISTRIBUTION

Native west of the Rockies from Alaska to northern Mexico, and inland to central Alberta in Canada, and Idaho in the U.S. Rainbow have been widely introduced around the lower Canadian provinces and Great Lakes region, and in the northeastern U.S., south through the Appalachians and into Georgia and Alabama.

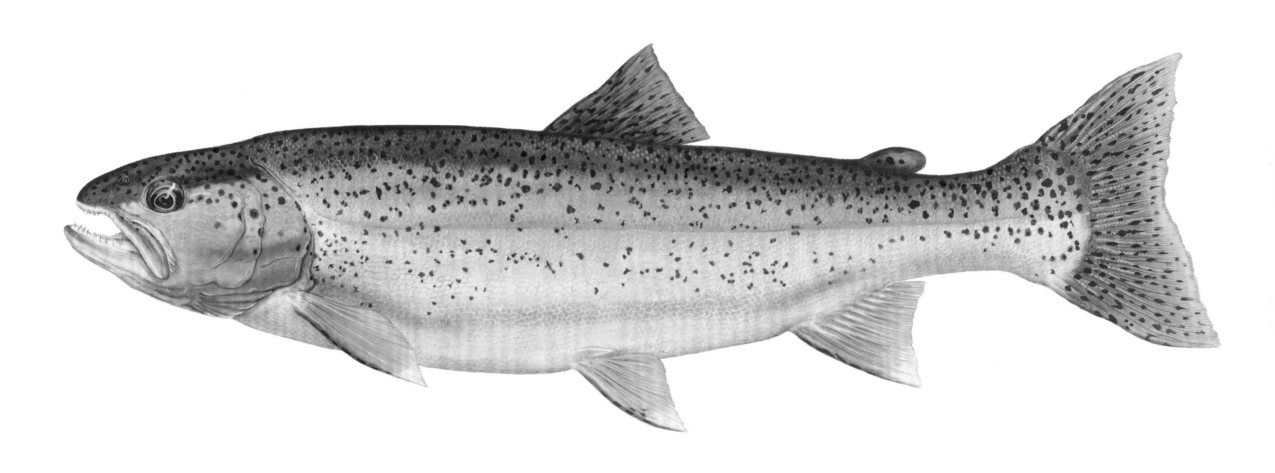

RAINBOW TROUT

(Oncorhynchus mykiss) Size 6–36 inches. Weight 2–20 lbs

FRIENDS OF THE UPPER DELAWARE RIVER

The Upper Delaware trout fishery includes the famous West Branch and Main Stem of the river. In the late 1990s, *Outdoor Life* magazine called the West Branch the "number two wild trout river in America." The prolific insect populations produce big fat browns and rainbows that eat dry flies, and twenty-inch-plus fish are common.

The eighteen mile West Branch tailwater flows out of the Cannonsville Dam and when *sufficient bottom releases* are in effect, it cools the Main Stem to Callicoon, an additional thirty-five miles. The key is sufficient bottom releases. The New York City Department of Environmental Protection (NYCDEP) uses the Cannonsville Dam releases solely to satisfy a Supreme Court decree of 1750 cfs flow at Montague, New Jersey, 100 miles downstream. Releases do not take the fishery's needs into consideration. The release may be 1500 cfs one day (too high and too cold) and the next day it could be 160 cfs (too low and too warm). Erratic and low release practices are detrimental to the fishery and the economy of the area. Erratic releases cause fish kills, reduce aquatic insect populations and rob tens of millions of dollars from the local economy. When the releases are correct, the bug hatches are prolific, the fish are rising, the river is full of fishermen and the local economy thrives. When the releases are too low the water temperature is too high, the bugs don't hatch, the fish are stressed and sometimes die, the fishermen disappear and the area becomes a ghost town.

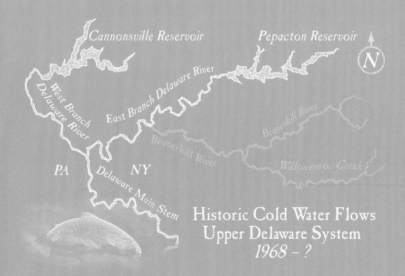

Historic Cold Water Flows
Upper Delaware System
1968 – ?

> *The spirit of conservation and respect for the river prevalent at the Delaware River Club helps make it my home-away-from-home. (That, and they help me "get game.") Al Caucci, Jerry Wolland, and Jeff White work tirelessly on getting out the Friends of the Upper Delaware River's important conservation message.* FLICK FORD

Against this backdrop, in October, 2003, eight fly fishermen formed of an advocacy group called the Friends of the Upper Delaware River (FUDR) that is dedicated to improve the fishery with consistent and proper releases obtained through political and legal action. The message of FUDR is simple — a consistent minimum release of 600 cfs from the Cannonsville Reservoir during the warm weather period (May 15 through September 15), adequate releases for the East Branch and Neversink from their respective reservoirs, wintertime flows sufficient to keep the West Branch wet bank to bank, and proper stewardship of the tributaries where the wild rainbows and browns spawn.

Over the past three years FUDR has grown to hundreds of members and is supported by more than seventy businesses, conservation groups, and legislative representatives in Albany, Harrisburg, and Washington. In 2004–2005, FUDR initiated studies showing that the minimum release regime they support can be accomplished within the parameters of the Supreme Court Decree and without adding material risk to New York City or any of the down-stream users.

The bureaucratic opposition to adequate and constant releases for the fishery is formidable and intimidating: The City of New York, the State of New York, and the Delaware River Basin Commission. Sadly, the tactics of these huge bureaucracies have led some advocacy groups to accept water release minimums, support acknowledged detrimental policies, or turn a blind eye when regulations are ignored, which has too often left FUDR a lone voice in the wilderness.

FUDR cannot succeed without the help and financial assistance of all anglers, businesses, citizen groups and other river users that are concerned about this beautiful and renowned wild trout fishery which was declared a Wild and Scenic River by the National Park Service over a decade ago. It takes money and time to win an important battle like this. Go to www.fudr.org to learn how you can help.

AL CAUCCI, author of *Hatches: A Complete Guide to the Hatches of North American Trout Streams*, and *Hatches II*

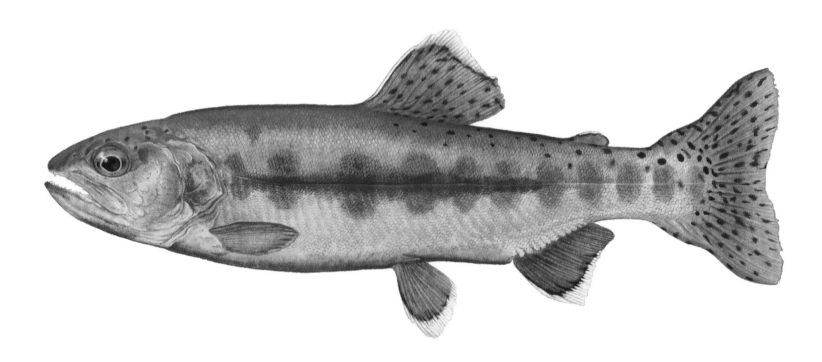

GOLDEN TROUT

(Oncorhynchus aguabonita) Size 6–12 inches. Weight 8 oz–3 lbs

(Oncorhynchus aguabonita)

GOLDEN TROUT

There is no trout more dramatically colored than the golden, which looks like God painted it with a spray can. A dazzling red slash runs down each side punctuated by black spots, all on a bright gold background. In fact, the species — born of fire and ice — could logically look no other way. It takes your breath away.

Approximately 18,000 years ago, the Sierra Nevada was a solid block of glacial ice. Needless to say, no trout lived there. As the ice age ended and the glaciers melted, water ran downhill, ultimately into the sea near the area now known as San Francisco. An ancient version of rainbow trout spent the next several thousand years slowly working their way upstream, but at the top of the Sierra foothills they met insurmountable barriers. Only one river had passable waterfalls: the Kern. Only the persistent trout finally reached the headwaters.

The glaciers continued melting as the environment warmed. What once were raging rivers became shallow streams or dried up riverbeds that effectively prevented later generations of trout from scaling

SAVE THE GOLDEN

The idea of wilderness needs no defense, it only needs defenders.

EDWARD ABBEY

the mountain heights, and the trout already resident in the lakes and ponds were forever trapped. Inbreeding forced these ancestral rainbows to evolve into a precursor to the golden trout. Then the fire came.

Volcanos lifted the Kern plateau until it broke open, spewing forth lava that permanently changed the landscape. Rivers changed direction, washing fish into new downstream areas. These castaways, now separated from their identical genetic stock, began inbreeding with even greater fervor.

If you know anything about evolution and genetics, you know that inbreeding changes things and usually not for the better. Witness an exception to the rule. Over thousands of years, generations of

ancestral rainbow trout evolved into the golden trout. Today, no other trout compares as goldens arguably hold the title of rarest and most unusual trout. Prevalent throughout the southern Sierra Nevada Mountain range for many thousands of years, the state fish of California began to fall on hard times at the turn of the last century. Pollution, over-grazing, and the incursion of non-native species that overpowered the golden, all conspired to squeeze the gorgeous fish out of existence.

We all hope that extinction has been averted with a last-minute reprieve. In an attempt to avoid total extinction, the Federal government established the "Golden Trout Wilderness" in 1978. In this 303,287 acre natural preserve in the Kern River basin (specifically in the Sequoia and Inyo National Forests) at elevations from 4,800 to more than 12,000 feet, the golden trout tries to survive in the face of misguided Fish and Game stocking programs. (Some wildlife conservation groups fear that Fish and Game mistakenly seeded rainbow hatchlings from aircraft into all of the golden trout habitat.)

DISTRIBUTION

Kern River basin in southern Sierra Nevada. Goldens were introduced into remote lakes and rivers in the California high country and the southwest mountains of Alberta, where they are highly prized by adventurous anglers.

(Salmo trutta)

BROWN TROUT

Brown trout was not one of the many foods that Chief Massasoit and his ninety or so Wampanoag Indians contributed to the first Puritan Thanksgiving feast in the 1600s. Enthusiasts brought this "exotic" species to America from Europe and Asia in 1883.

DISTRIBUTION

Found throughout North America in waters of 65– 75° F. Browns thrive in both fresh and salt water. You can find them in many northern lakes and streams as well as in all of the Great Lakes.

As the light around her grew progressively dimmer, she felt drawn — motivated really — to what, she didn't know. But it was time. With the same kind of consciousness that made her heart beat and her gills supply oxygen to her body, she had to move toward that gentle force in her face. She kept to the rocky weeds near shore, where her silvery brown sheen mottled by orange and brown spots let her blend into her surroundings. The slightest movement of her big, square tail provided stealthy thrust, allowing her to move through her environment with none but the most attentive aware of her passage.

Even against the fading light from above, she saw the dark outline of the twisting worm drifting on the barely rippled water,

CATCH ONE!

Anglers most often target this species with fly tackle, employing whatever fly "matches the hatch" at the moment with nymphs of caddis fly, stonefly, or mayflies the most common patterns. Most browns live and feed in one area over the long term. Brown trout seekers should concentrate on fallen trees, root structure, and shore overhangs.

both pushed by the breeze she couldn't feel. With hardly more than a thought, she slowly rose, waiting for the breeze to bring her sustenance. Barely moving a muscle, the act of suddenly opening her huge mouth sucked all the water around her head, and everything in it, into her maw. A dozen sharp, main teeth stood ready to entrap the worm, and her broad tongue and ridge of vomerine teeth along the roof of her mouth helped keep whatever unfortunate prey she inhaled that far from slipping away. Inconspicuous consumption. The water caught in the attack never even slowed down, but passed out the gills. Then, nothing. No disturbance, no cloud of silt… no sign that nature's most violent act had just taken place.

This cycle repeated itself time and again, through a multitude of lights and darks. Like every predator, she preferred to live in the shadows, drawing as little attention as possible. During daylight she rested, finding safe haven tucked into the farthest reaches beneath a rock shelf or tree deadfall. As gray turned to black, she continued her inexorable journey until she finally reached the shallow gravel beds at the headwaters, where she made preparations. Nudging the stony bottom with her nose and fanning it with her tail, she carved a hollow. No sooner had she finished than another brown, this one with a strong hook-shaped lower jaw swam up next to her. Side-by-side, they rushed to expel all that would continue their species into the redd. Then, just as surreptitiously, he left her to cover the fertile pit with sand, gravel, and silt, in the hope against hope that at least some product of this mating would survive.

Sometime in late spring, after the insect larva started bursting forth, some of her young did swim free of their gravelly nursery to feed on forms of life less complex than themselves, and to join the cycle.

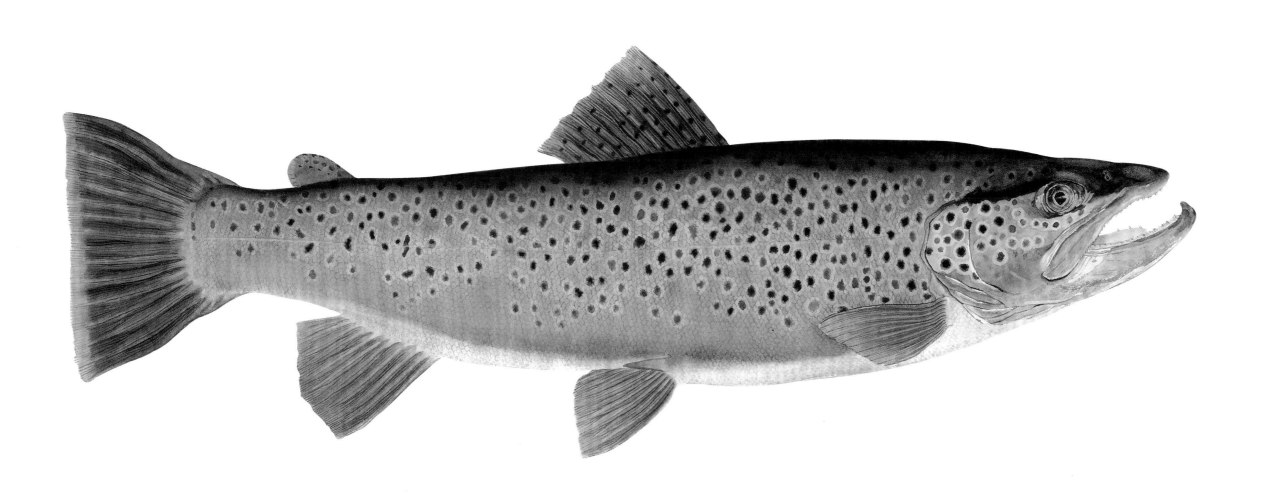

BROWN TROUT

(Salmo trutta) Size 10–30 inches. Weight 2–20 lbs

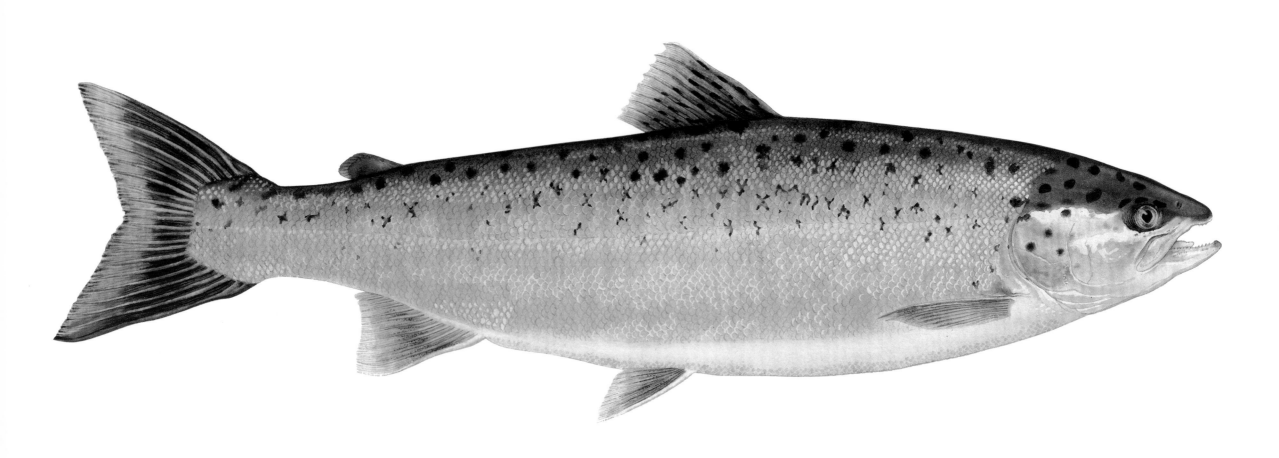

LANDLOCKED SALMON
(Salmo salar) Size 12–24 inches. Weight 2–5 lbs

(Salmo salar)

LANDLOCKED SALMON

As a child, I knew all about how salmon lived in the ocean, and then returned up the same river in which they started life when it came time for them to spawn. I simply accepted that this was nature's way. How did they find their way back to shore? Nature's way. How did they find the very same river where they were born? Nature's way.

But then I went fishing for landlocked salmon, fish identical in every way to Atlantic salmon, except they never leave freshwater.

"Dad, how did they get here?" I asked.

"Nature's way" he replied.

"Pile of crap," I thought. For whatever reason, I just couldn't accept that answer for this one — too much of a stretch. So I tracked down some of the most learned fisheries biologists who specialize in landlocked salmon. Two scientists said that a glacier trapped them inland. Another said that ancient floods carried Atlantic salmon eggs over land and into several lakes in Maine. A fourth replied, "Son, it's just nature's way."

CATCH ONE!

Glacial lakes make good landlocked salmon fishing year round but spring is the easiest time to catch one, even by trolling streamer flies on top of the water. As the surface water warms, use spoons or wobblers on downriggers to get to the cooler water twenty or more feet below.

MAINE US 1

It wasn't until 2006 that I found a theory by D.W. Caldwell of Boston University and Lindley Hanson of the United States Geological Service. They postulated that landlocked salmon first appeared in only four lakes in Maine: Sebago, Sebec, Green, and West Grand, four lakes that abut a "glacial-marine submergence" that geologists call the DeGeer Sea, which dates from about 13,500 years ago. Caldwell and Hanson believe that Atlantic salmon were "spawning in tributaries above the marine submergence, when the relative sea level was lowered by crustal rebound, isolating the salmon." Apparently, the crustal rebound (which I thought was related to children who threw pie against the wall)

caused sea level at that time and in that area to drop by almost 165 feet to its current elevation, leaving some Atlantic salmon trapped. They apparently survived and evolved into freshwater "landlocked" salmon. Of course, other scientists (without better explanations, I might add) disagree.

Obviously old habits are hard to break since the spawning behavior of landlocked salmon involves adults leaving their lake habitat and traveling up streams to lay their eggs during October and November. Eggs hatch the following spring. Juvenile salmon remain in the stream for up to four years before they migrate to the lake.

Today, landlocked salmon represent the most valuable game-fishing resource in the state of Maine, and the outlook for the stock looks excellent. Over the last ten years, the average salmon taken from lakes in the state reached 17.4 inches and 1.7 pounds. That represents the largest average size since Maine Fisheries started keeping such records in the 1950s.

DISTRIBUTION

Landlocked salmon are also called Sebago salmon in New Hampshire, Maine, and New Brunswick; and ouananiche salmon, in Quebec's Lac Saint-Jean and other lakes farther north like Lac Holt.

FLICK FORD ON THE PAINTING PROCESS

The nineteenth-century methods used to make the popular botanical and fauna prints of the time were either hand-colored copperplate engravings or lithographs. They couldn't make photographic prints from original paintings as we can today. As far as the process went, specimens of flora or fauna were pickled, stuffed, smoked, dried, or salted. Then the specimens, along with hasty sketches in journals, were supplied to artists who made detailed renderings, which then went to lithographers or engravers. The purpose of those prints was to bring the wonders of nineteenth-century exploration and discovery into the parlor. While those old plates have a certain charm, unparalleled accuracy is definitely not their hallmark. With a fully modern technique that I've developed on my own, I can get very translucent fins and an iridescent shine on the scales of the fish I paint. My process involves catching the fish, tak-ing digital photos, tracing the catch, and making notes on markings and the exact placement of body parts. I then print out the photos, make a detailed, free-hand ink drawing on vellum, and then transfer that to the watercolor paper with the aid of a light box. Next, I apply a liquid-frisket medium to block subsequent washes, allowing the first frisket layer to hold the white I want to show through. Repeated frisket layers over subsequent washes trap the colors I want to stay. An average painting has between three and five washes before I remove all the frisket, blend the edges by putting on a clear wash of clean water and then, after drying, paint the details in with fine sable hair brushes. I never use any gouache or opaque paints. In contrast, scientific illustrators use sharp, color pencils and a scratch-board technique to get the absolute finest detail. I make detailed illusions within the medium and limitations of fine watercolor painting.

My background as an underground cartoonist also comes into play. I instinctively feel the "personality" of each fish. Certain fish look ferocious to me, others look meek or sad, others proud. I don't hesitate to let this come out in my painting. I figure that if I subtly render its anthropomorphism, the fish will come to life in the mind's eye of the viewer, rather than looking like a dead-fish study. I've never understood why, in our culture, this is viewed as such a horrible thing to do. Native people call all manner of plants and animals "nations" or refer to them as "people" as in the "fish people." I'd like to think I am seeing and recording these connecting threads in creation, as well as the physical aspects of my subjects. It's the spirit of each animal that I try to portray. FLICK FORD

FIGURE 1
First, I trace the specimen on a brown paper bag with a permanent marker—usually on the floor of the boat. I make anatomical notes, do a vertical and lateral scale count, and count fin rays.

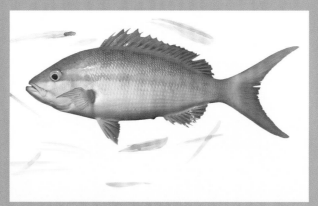

FIGURE 2
I take a digital photo, seconds after the fish is caught, which I later print out to size. The color photo, along with the tracing, will be used to make a detailed freehand rendering on vellum.

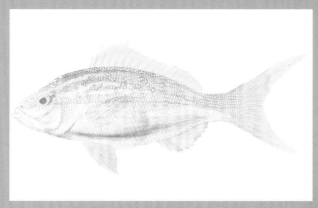

FIGURE 3
The vellum rendering is then traced to the Arches 260 lb. cold press paper. This stage shows the first layer of frisket already applied to the paper, and the first wash completed.

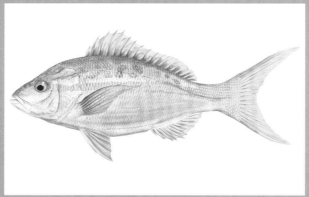

FIGURE 4
Layers of frisket and color washes followed by a blending wash of clean water build up the painting. Details are painted in with fine brushes. Shading adds depth and volume to complete the process.

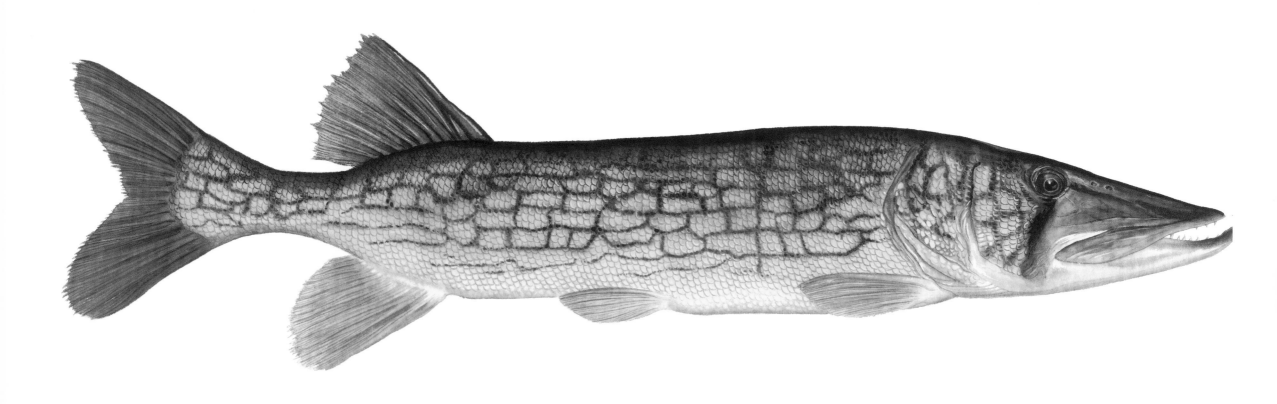

CHAIN PICKEREL

(Esox niger) Size 14–36 inches. Weight 2–9 lbs

(Esox niger)

CHAIN PICKEREL

If you want to introduce your children to "hunting and gathering" without much effort, chain pickerel fits the bill, at least in the eastern half of North America between Nova Scotia and Florida. Virtually every body of fresh water that supports life holds pickerel.

Even small offspring can handle an average-sized pickerel. It takes lightweight tackle and little patience, which makes it an ideal childhood species.

Pickerel eat any type of lure from jigs with tails, to spinner baits, worms, spoons, plugs, and crankbaits, and more. Even if you haven't a clue what any of those are, you could probably catch a pickerel. For most of the summer, pickerel will try to eat anything you quickly reel past it. Children can start with a sub-surface lure like a jig, spoon, or spinnerbait. This way, they can get used to the feel of the strike and fighting the fish without too much surprise involved. Later, once they become more accustomed, you can switch to surface baits like plugs and poppers. Pickerel love to strike on the water's surface and it makes for a dramatic sight. However, the violence of it should be postponed until — as I said — the child becomes accus-

tomed to catching fish. Then the youngster will perceive a surface strike as exciting rather than frightening.

You don't even need a boat to fish for pickerel. In fact, boat-borne anglers looking for chain pickerel cast their wares close to shore. Look for pickerel in weedy areas, where grass beds, logs, and overhanging banks can also be found. Responsible angling can also be taught with pickerel. Releasing the fish and watching it swim away to be caught another day makes for an excellent lesson. Just be sure to keep your fingers away from the flat, duck-billed mouth. Unlike a bass, you can't stick your fingers in its mouth and lift it by its lower jaw.

EAT ONE!
Chain pickerel tend to be fairly boney, but firm and sweet. If you don't want to deal with the bones, grind the cleaned fish in a food processor. Add a little egg and bread crumbs to make fish cakes for frying. Don't leave these fish on a stringer or in a livewell for long. Get them gutted and on ice quickly or they'll turn mushy. Diners claim they often taste "muddy" or "grassy" if you fail to remove the skin prior to cooking.

Those sharp teeth will make one's fingers the pickerel's next meal, which won't endear fishing to children.

Pickerel have a reputation for being a fiercely territorial fish. So fierce that fishery biologists in some southern states introduced chain pickerel into bodies of water where they needed to control the numbers of other species, like sunfish. The pickerel will eat anything that comes near it, including trout and other pickerel of virtually its same size.

The International Game Fish Association world record for the chain pickerel is nine pounds, six ounces, caught in 1961 in Homerville, Georgia by Baxley McQuaig, Jr.

DISTRIBUTION
Pickerel is the name given to three small members of the pike family and they can be found in the eastern half of North America from Nova Scotia to Florida. Members of the Esox genus look a lot alike. You can pick out the chain pickerel most easily by the black lines forming chain-shaped markings on each side.

NORTHERN PIKE

Pike — Great Northern. A fish that packs brass knuckles on his jaws and a blackjack in his tail. — BEN EAST. I headed up to the boundary waters in Minnesota to test a boat and the builder showed up with a local fishing guide. He decided that I could get a better impression of his "baby" if I actually fished it rather than just taking it out for a spin. This little bass boat had an engine that dwarfed the glittered fiberglass hull.

DISTRIBUTION

Northern pike, often called the "alligator of the north," have only two real enemies: lamprey and man. They live around the globe in cold, northern waters, but all attempts at breeding and farming have failed. (Apparently, pike refuse to eat Purina Pike Chow.)

"This is our first foray into building fiberglass, bass-style boats," he volunteered, "but we've got a rich history in aluminum boats. In fact, we're one of the most popular builders in middle America."

The guide wore a shirt with enough writing on it to qualify as a newsletter. I had no idea how good an angler he might be, but I had no doubt that when it came to marketing and getting sponsors, the man was nothing short of brilliant. With the guide driving, we headed across the open lake from the launch ramp — at eighty miles-per-hour. I promise you that when you're running with your head that close to water level, it seems much faster than that. We slowed to a stop and the guide dropped

the electric trolling motor over the bow and broke out a rod for each of us from under the gunwale. Mine sported a rubber wormy thing with a curly tail in an electric chartreuse color. The guide just had a bare hook.

"We'll get serious in a minute but since you don't get much chance to fish freshwater, I'd like to show you something," the guide said as he reached into a tackle bag. Pulling out a lumpy, wet towel, he began to unwrap something that he seemed to have difficulty holding. Once it was half-revealed, I saw that he had a huge bullfrog that he proceeded to hook through the lips.

EAT ONE!

Northern pike make delicious table fare, but be sure to carefully skin the fillets since the outside slime coating will ruin the taste otherwise. Hugely popular eating, they can be baked whole or stuffed, fried, grilled, steamed… but first learn how to remove the y-bones.

"Pike eat a ton of fish. But they have no problem chowing down on frogs, crayfish, birds, rodents, and other small mammals. They like stuff half as big as they are," he boasted. He cast the frog out toward shore into a dark, weedy area under some overhanging tree branches.

"Watch this." Just as he started slowly reeling it back to the boat, the water exploded!

"That's what I'm talking about," he shouted. After a furious battle lasting five or six minutes, he reeled the biggest northern pike to the boat that I had ever seen. A big barracuda does not look fiercer than this duck-billed tooth factory. It had to be thirty-five to forty pounds if it weighed an ounce. Made me rethink taking a dip in the lake to cool off.

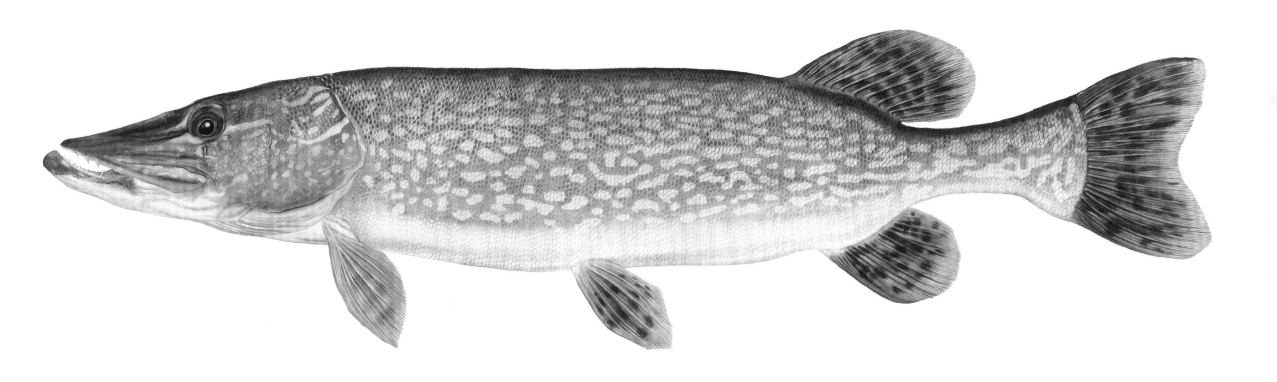

NORTHERN PIKE

(Esox lucius) Size 18–50 inches. Weight 15–40+ lbs

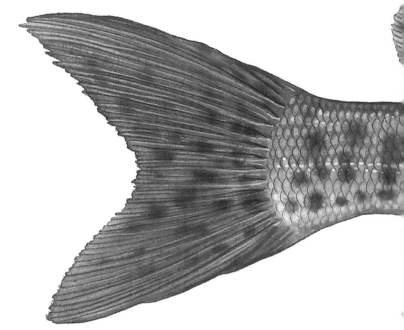

MUSKELLUNGE

My friend, John Ellman, qualifies as an obsessive fisherman. His son, Scott, inherited the onerous malady in a rarer, more virulent form. Being from Minnesota, the bulk of their experience was freshwater. When the family moved to Central Florida, one of the bass-fishing capitals of the universe, the men were thrilled. Mrs. Ellman couldn't care less about fishing, but was always content when her boy was happy. I moved in next door and they discovered what I do for a living. Phew.

DISTRIBUTION

Native to freshwater in eastern North America. In Canada, rivers and lakes from the Saint Jean River system through southern Quebec, the St. Lawrence and its tributaries. Hudson Bay, Great Lakes, Mississippi River basin south to Georgia and west to Iowa. Muskellunge are relatively rare, but restocking has kept up populations.

Actually, I was flattered that they had such a genuine interest in expanding their horizons into saltwater, fly fishing, fishing boats not made out of metal, and so on. We lived on tiny Lake Nan in Orlando and held private fly-casting lessons in our backyards. They quickly discovered that learning to throw a fly only takes an hour or two. (Learning to throw it well takes the rest of your life.)

All the fish they had caught using their baitcasting reels mounted on their flipping sticks (yep — that's what bass fishermen call them) now became fair game for their flyrods. I got loads of questions about different kinds of flies, most of which I referred to the local tackle shop experts since I really had no idea what a chain pickerel

might like to eat. John came over one day in the late spring, wanting some advice.

"I'm going musky fishing in Minnesota next week and I'd like to use a flyrod. But nobody I know has ever used one on a musky so they can't set me up. Any idea what I should use?"

"How big are they?"

"They're kick-ass big! They're the biggest member of the pike family and get up to thirty or forty pounds where I'm going." I went back to my rod rack and pulled out a twelve-weight rod.

"This ought to handle something that size with muscle to spare. I use it on big tarpon and sailfish. Don't spend

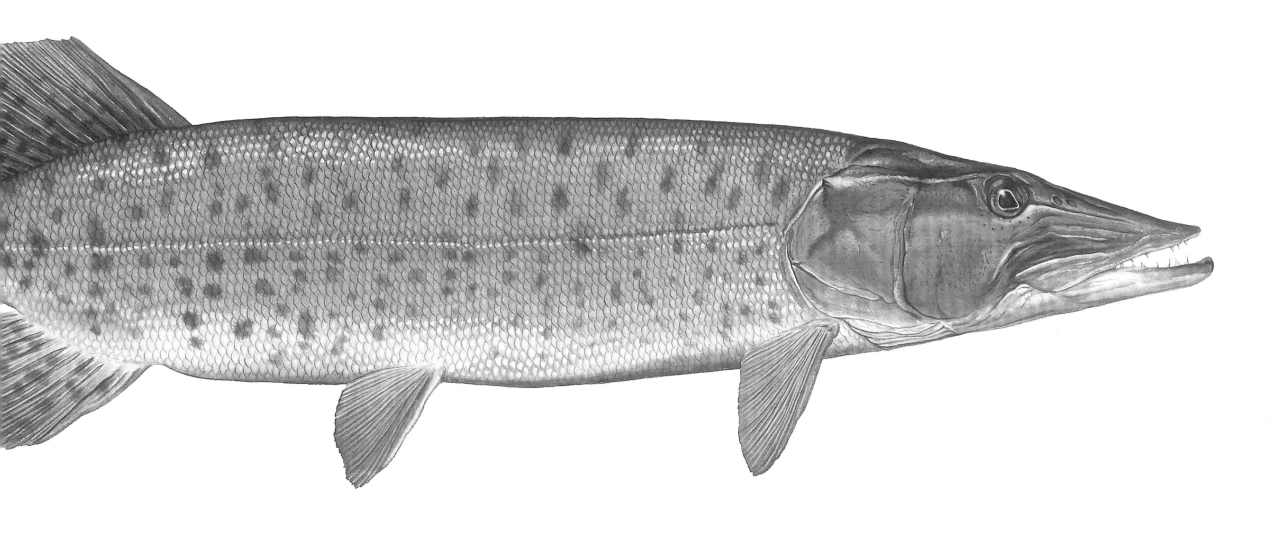

MUSKELLUNGE

(Esox masquinongy) Size 2–5 feet. Weight 15–50+ lbs

much time false casting with it or your arm will fall off," I advised half jokingly. "How deep are these fish?" I asked.

"Usually they hang out really deep at the bottom. But I'm fishing the shallows around the weed beds and lily pads so, probably a couple feet—maybe as much as five or six. But whenever I've caught one, it's always been on the surface with a plug or popper."

I grabbed a spool of twelve-weight floating line, tied up some leader material, attached one of my tarpon shock tippets, put the spool into the reel, and both into the case.

"Okay, then all that's left is the fly. What do they eat?" I asked ignorantly.

"Pretty much anything they want. They're the bullies, the apex predator in the lake. They eat everything that swims as well as rats, mice, frogs, moles, ducks, you name it. If it lives, swims or falls in the water, the musky eats it."

I got a selection of streamer flies that look like a large, thin fish swimming through the water and added a couple with popper heads that make a big splash when you pull them across the water's surface, much like a wounded baitfish would make.

A ROSE BY ANY OTHER NAME

Muskellunge was first named by the Ojibwe Indian, maashkinoozhe, which means "ugly pike." During the French and Indian War, the French changed it (apparently to suit themselves) to masque allongé meaning long mask, supposedly due to the fish's long, duck-like snout.

"I have no idea if this will work. But, honestly, it's been my experience with saltwater fish that if they're hungry and you put something in front of them that even remotely resembles food, they'll eat it — at least once."

A little more than a week later, I got an e-mail with a snapshot of John holding up a big muskellunge. Later, when the phone rang, he told me about it.

"Awesome, I tell you! My buddy couldn't believe it! I took your flyrod out on Leech Lake and just like I said, I cast a streamer into the lily pads. On my third cast, the streamer landed silently. Normally, when I cast a plug, it smacks the water like you just dropped a brick there. I let it sit, then gave it a few strips and let it sit again, when WHAM! That musky hit it and spray must have flown eight or ten feet in every direction. It was awesome! What a great fight!"

"How big was it?"

"Only about ten pounds, but who cares? And I gotta tell you, my buddy was really impressed. He'd never seen anyone fish for musky on fly before. It was awesome!"

"Yes, so you said."

"But I owe you a new streamer fly. That fish plumb

tore it up. I lost the shock tippet, too."

"No problem. That fish in the photo looked a lot bigger than ten pounds though."

"Oh, I didn't catch that one. We found it floating dead. It had a hole in its lip so I assume someone had caught it and put it on a stringer. It must have broken free."

"So that wasn't your fish?"

"Nah. I had a great fight but my musky bit right through the leader and got off."

Ah... fishermen.

Pike and Pickerel

TAKE YOUR CHILD FISHING

Are today's kids any better or worse than they've ever been? As a general rule, those that get loving attention turn out well and those who get ignored or worse, don't. My father, grandfather, and I were always out on boats, fishing, sailing, or just traveling between two points where a boat was the shortest and fastest route. But what I remember most vividly are the "growing up" discussions, especially with my Dad. Every time we had something important to discuss — sex, drugs, drinking, college, career, behavior, responsibility — we discussed it out on the boat.

The boat was a great equalizer. I learned to run boats at an early age and had more than my share of independence on the water, so when we sailed together, I felt we were having a very private conversation rather than me being at the receiving end of a sermon. I also never had to worry about being interrupted. What is it about sitting at anchor with a fishing rod that allows one to discuss even the most intimate subjects when the same discussion elsewhere would be painfully uncomfortable? Perhaps fishing and boating teach virtues like patience, tolerance for the whims and vagaries of nature (that can then be applied to human nature), appreciation for the simple beauties of creation, self-reliance, and stress management.

I know without a doubt that boating and fishing provide a unique venue for bonding. It's no accident that the fishing tackle industry has programs to encourage fishing instead of drugs, to promote the fun and adventure of angling among youngsters rather than letting them fend for themselves out on the street.

Take your child boating or fishing without everyone else along. You'll be amazed at what you'll gain. It's a long-term investment that can start paying dividends today. DEAN TRAVIS CLARKE

WALLEYE

In my experience, walleyes have always been an incidental catch. I've caught them while nymphing for trout in deep holes on the East Branch of the Croton River in lower New York State. I've caught them while tossing plugs at smallmouth bass and while ice-fishing for lake trout in our local reservoirs. Incidental bycatch or not, I've never been disappointed to find one on the end of my line because for my money they qualify as one of the best eating fish.

Imagine my surprise when I set out to catch a walleye for this book and came up empty. I headed up to the Delaware River and enlisted help. I tried plugs, spoons, spinners, lindy-rigs and all manner of bait in places that had been giving up seven-pound fish for anglers all week. I conscripted a crew of both daybreak and late-night stalkers who used every known method. Nothing doin'.

In mid-October of 2004, I went to Ontario to fish with my buddy Randall Smoke and his two sons, Caleb and Chris, on his reserve, Alderville First Nation. An excellent Anishnabe hunter and fisherman, Randall keeps his freezer full of fish and game. I thought asking Randall to help me catch a "pickerel" as they call them

in English or a "Gawaak" as they call them in their native tongue, would have been a no-brainer, good as done!

A cold front slammed us with howling winds, and snow obliterated a temperate spell. For two days we gamely bounced around in his flat-bottom boat coming up empty on waters where just days before they were hauling them in. Later, I tried my luck at some of the super-productive locks and spillways that always hold good fish near the reserve. *Nada.*

RANDALL SMOKE'S FRIED "PICKEREL"

Fillet several large fish and cut into 4- by 2-inch chunks. Rinse and leave fish damp. Dredge chunks in flour mixed with salt and pepper. Fry until golden brown in butter or dredge in a commercial "fish crisp" and fry in lard until golden brown. Serve immediately.

I interrupted the fishing for several days to attend a ceremony in which my Anishnabe friends had graciously invited me to participate. In fact, the elders advised me to wait to resume fishing until after the ceremony. Surely as the sun rises, after the ceremony, I quickly caught a large specimen walleye on a fire-tiger jointed Rapala plug tossed beneath white water at a spillway.

Meanwhile, Chris had caught the twin to my fish and saved it for me. Randall pointed out a subtle barring pattern most artists miss in their renderings. With plenty of excellent reference photos and tracings for my painting, we proceeded to feast on the two fish that gave me, and Randall's family of four, multiple helpings. Of all the ways I've enjoyed eating "pickerel," Randall's method remains my favorite. FLICK FORD

DISTRIBUTION

Native to a wide swath of central North America from Great Bear Lake in the Northwest Territories down to the Gulf Coast drainages in Mississippi and Alabama, walleye have been widely introduced east and west, and there are now only a few areas where walleye cannot be found.

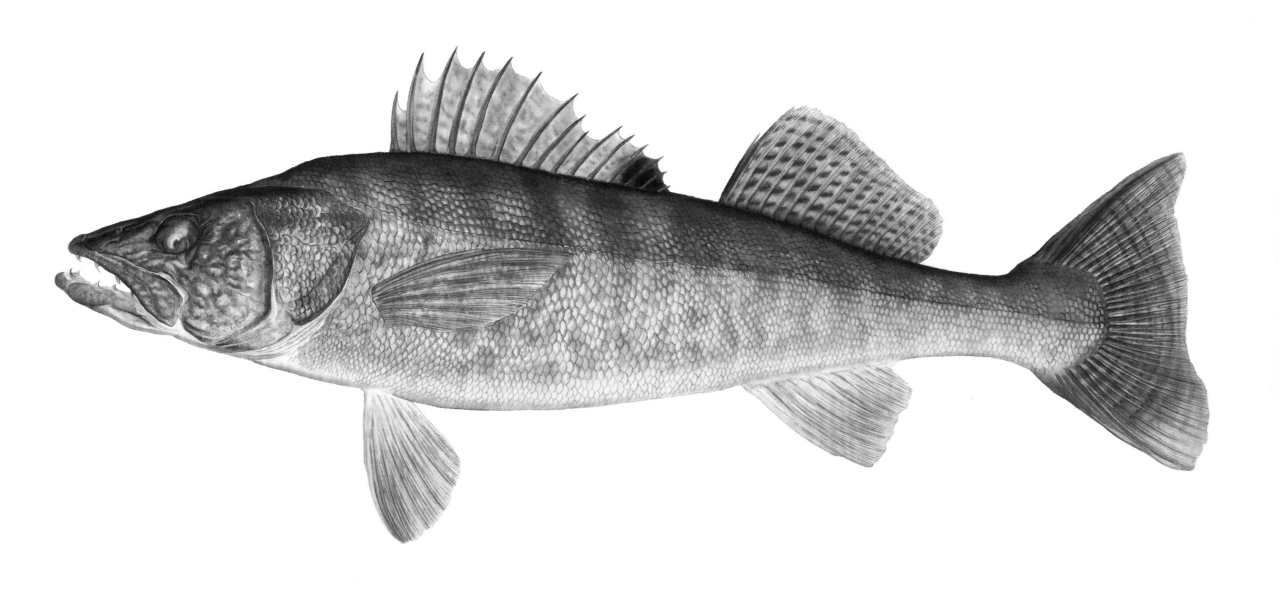

WALLEYE
(Stizostedion vitreum) Size 14–30 inches. Weight 3–15 lbs

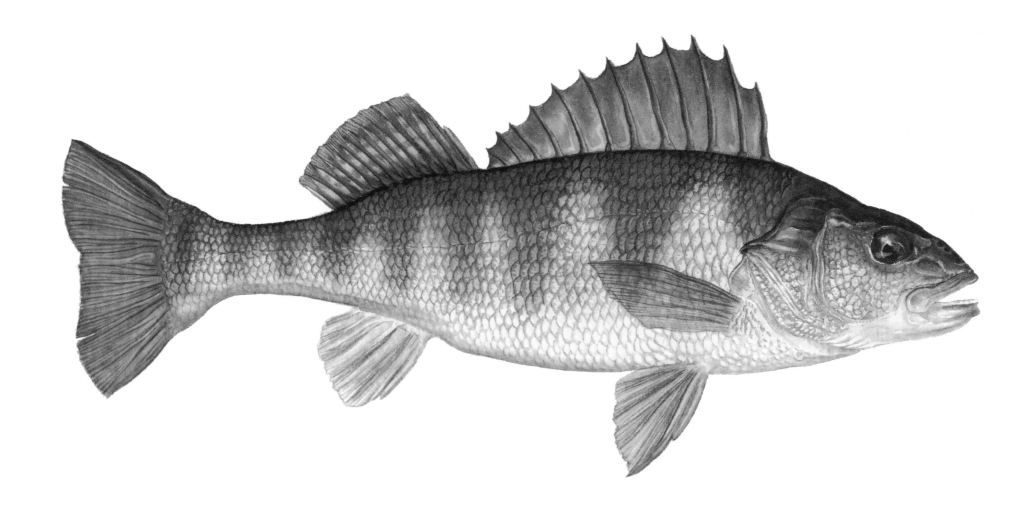

YELLOW PERCH

(Perca flavescens) Size 6–14 inches. Weight 1/4–2 lbs

YELLOW PERCH

Known as lake perch, American perch, ringed perch, striped perch, coon perch, and jack perch, this abundant species is one of America's favorite panfish.

I've spent more years in the tropics than I ever did up north and with good reason. I don't do cold anymore. That's why I couldn't believe that my friend Peter Daubner invited me to go ice fishing while I visited my old haunts in New England.

Peter lives on a relatively large lake that provides winter recreation to skaters, skiers, iceboaters, and hikers when it's frozen. Neither he nor I skate anymore. So when his lovely wife Elaine decided to host a skating party, he deemed it the ideal time to catch some breakfast for the next morning.

In truth, I found it fascinating to watch the process. Unlike the film *Grumpy Old Men*, he had no cabin with furniture. A pair of lawn chairs salvaged from the summer shed had to suffice, along with the biggest damn drill I have ever seen.

"You planning on installing a telephone pole out on the lake?" I asked.

"Gotta make a hole in the ice somehow," he replied with the patience reserved for an idiot-savant brother.

We loaded a toboggan with the drill, the chairs, three gallons of lemon-flavored vodka, a bottle of Cointreau and a gallon of cranberry juice, a stack of paper cups, a portable fireplace, the shortest fishing rods I've ever seen, some funky little rod holders with flags attached, a tackle box, and a box of frozen shiners for bait.

The guests arrived and walked out to the large patch of ice Elaine had shoveled clean. She even slid park benches out there to sit on while exchanging shoes for skates. The fire chimney burned atop a metal garden table.

"Take that drill and start a hole next to the bench," ordered Peter. An odd place to fish, I thought. But I liken Peter to the Borg: resistance is futile. I got about nine inches down into the foot-thick ice when he ordered

CATCH ONE!

Perch like clear ponds and lakes but can be found in rivers as well. They are easy to catch from shore especially where trees and bushes overhang the water. Use minnows, worms, or maggots, or lures will work. Yellow perch are delicious.

me to stop, bring the drill over near the lawn chairs, and drill a hole all the way through the ice where he'd already set up the little flag-ridden rod holders with foot-long fishing rods. He proceeded over to the other nine-inch "bowl" I'd first drilled in the ice and filled it with vodka, the bottle of Cointreau, and the cranberry juice.

He returned and baited a hook on each fishing rod, dropped the lines through the ice hole all the way to the bottom, then reeled up a foot. Finally, he got himself a cupful of that pink stuff in the ice depression by the bench.

"What is that stuff?"

"Cosmopolitans," he answered again as if I had just landed on earth. "Elaine loves them."

I heard a little tinkle and Peter knelt down, picked up the mini rod and reeled up a lovely little yellow perch which he laid on the snow-covered ice under the bench.

"Well, there's my breakfast," he said. "You'd better get busy if you want to eat."

DISTRIBUTION

Thanks to stocking programs, yellow perch inhabit virtually every North American state and Canadian province and can be found as far south as the Santee River in South Carolina. Yellow perch will eat anything.

WHITE BASS

She walked into my office and plopped herself into my guest chair — plopped being the operative word. Her belly protruded far enough so that she couldn't really sit upright, but rather had to leave her hips out at the edge of the seat and lean back in a semi-prone position.

DISTRIBUTION

White bass can be found in large, natural lakes but are more common in large reservoirs and rivers. Can be found in the east and midwest United States, and in lower Canada from Quebec to Manitoba.

I thought she was very pregnant and could deliver in the next few minutes, but I pretended not to notice. Guys learn early in life not to comment on a suspected pregnancy, lest it not be the case.

"Hi. I understand you know lots about fish," went her opening gambit.

"One can never know enough about anything. What can I do for you?"

"My husband just came back from fishing in the Apalachicola River with a mess of white bass. He's planning to cook them up tomorrow for a dinner party, but I'm worried because my friend told me they were full of mercury and I shouldn't eat them because it will hurt my baby," she blurted on a single breath.

"Well, fish can make for a very healthy diet," I responded. "They provide lots of high-quality protein and other essential nutrients, they're low in saturated fat, and contain omega-3 fatty acids that somebody says are really good for you."

"So I can eat it?" she asked for confirmation.

"All fish and shellfish contain some level of mercury, of methylmercury, which is what mercury turns into when it gets into the water. But certainly not enough in your one meal of white bass to even measure," I assured her.

But the question I failed to ask, "How much and what kind of fish do you eat regularly?" could make her white bass more of an issue. Methylmercury builds up over time. Of course, it occurs naturally in the environment and has been around since caveman days, but burning coal is the single greatest source of mercury in the environment, so man now contributes more to the equation than ever before.

You might think that freshwater fish would suffer greater concentrations of mercury than oceanic fish, but you'd be mistaken. The water on our planet moves around. There are a finite number of water molecules: always have been, always will be, the exact same number. It cycles through liquid and vapor states and each time it cycles, it carries more mercury to the earth's surface. Mercury sinks to the bottom of the water where it contaminates the algae, which gets eaten by the minnows, which get eaten by the bass, and, well, you see how it goes. I did a little more research, and then followed her back to her cube.

"I changed my mind," I said. "I don't think you should eat the white bass. It may not have a high mercury content, but why take an unnecessary chance? Tell your husband the fish expert said so. That way, he can't blame you."

HOW BIG?

Mr. Ronald Sprouse caught the current world record white bass in Lake Orange in Orange, Virginia back on July 1, 1989. It tipped the scales at six pounds, thirteen ounces.

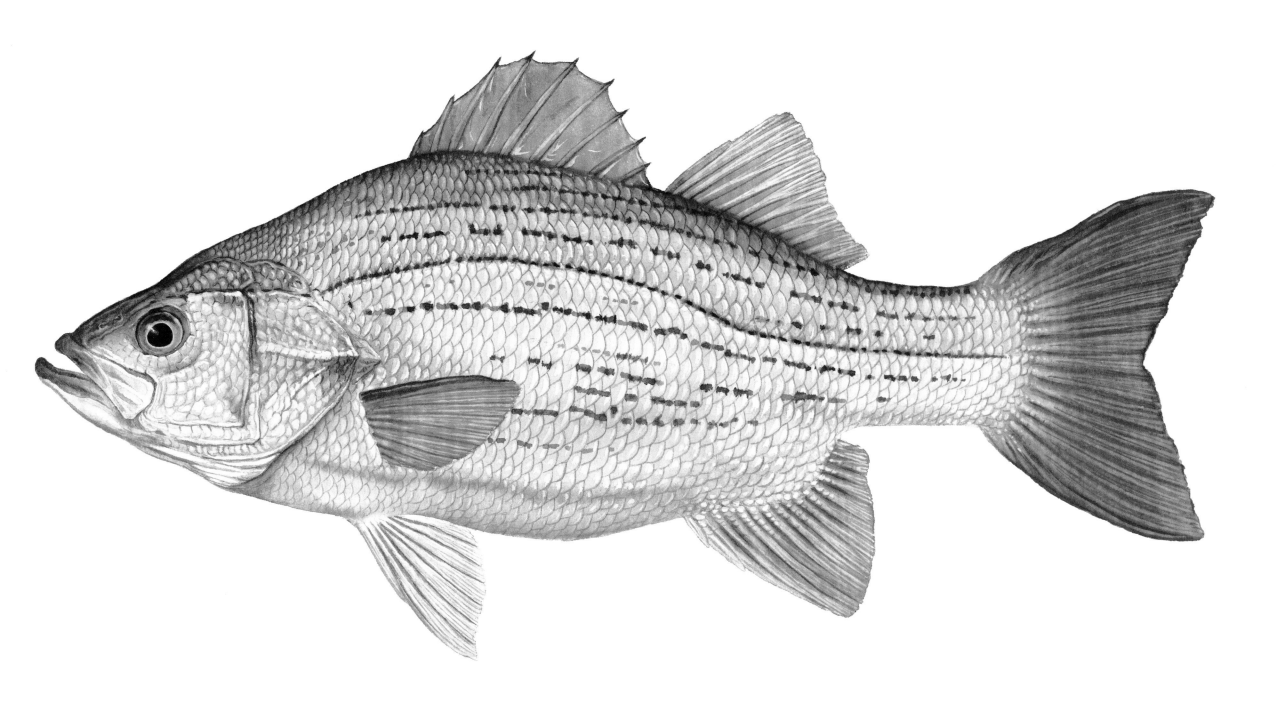

WHITE BASS

(*Morone chrysops*) *Size 10–15 inches. Weight 1–5 lbs*

BLUEGILL

"Dad. Do I really have to go? I just got home and I would really rather see my friends. I haven't seen them all summer!" moaned Jeremy. He'd just spent an entire summer working the cockpit of a forty-three-foot sportfishing charter boat out of Oregon Inlet on North Carolina's Outer Banks.

It was tough work with long hours, but he'd learned more than he did in a year of high school. "This is our first family reunion ever. Your grandparents may not get another chance to see us all together. I will be personally disappointed if you don't go with us," Father replied. The killer blow. You could do most anything and Dad could live with it, except disappointing him. Jeremy had to go.

"Granddad lived on a lake in the North Carolina mountains and he had a little fishing boat. All the aunts and uncles and cousins came.

"Jeremy!" screamed Aunt Lucy. "You have gotten so big and strong! This is your cousin Francie," she said as a little female towhead peaked around her mother's leg. "I told Francie that you spent the entire summer catching huge fish way out in the ocean and that you knew everything about fishing."

"Well, not everything," said Jeremy, responding predictably to flattery.

"I brought my new fishing rod and my own tackle," squeaked Francie. "Would you show me how to fish?"

The next morning, Jeremy awoke to find Francie about two inches from his face, poking him in the side and trying to whisper him awake. "It's time to go fishing, isn't it?" she asked. "Don't you have to go before the sun comes up?" Jeremy drifted back to sleep but Francie would have none of that.

Jeremy couldn't believe he was stuck with this little pain-in-the-butt. How could his weekend get any worse? Babysitting some little girl. Taking her fishing to boot. He just spent two months catching yellowfin tuna and dolphin and marlin with the titans of industry and now here he

was fishing with a ten-year-old girl.

"Grandpa says he has BIG bluegill in here," Francie bubbled. Jeremy picked a leadhead jig out of her tackle box and wove on a rubber wormtail so it would stream out behind.

"Where should I cast it, Captain?" she asked. "I've been practicing in my driveway."

"Try putting it over by that log," he said. "And I'm not a captain." Francie put the jig right where Jeremy pointed. "Now reel fast and slow, fast and slow, fast and …".

Wham! "Yes!" Francie screamed. "I've got him. I've got him!"

Francie reeled a beautiful bluegill up to the boat and Jeremy lifted it up and took the hook out. After admiring it just about until it died, they put it back in the water where it high-tailed it back to its log home.

"Thank you, thank you, thank you!" Francie hugged him. "You really do know all about fishing. You're the best Jeremy."

As much as he didn't want to admit it, she was pretty cool after all — for a little girl cousin. Maybe being captain wasn't all bad.

DISTRIBUTION

Bluegill (also called "bream") is among the most popular freshwater gamefish in North America. They can be found in nearly every contiguous state and parts of Canada.

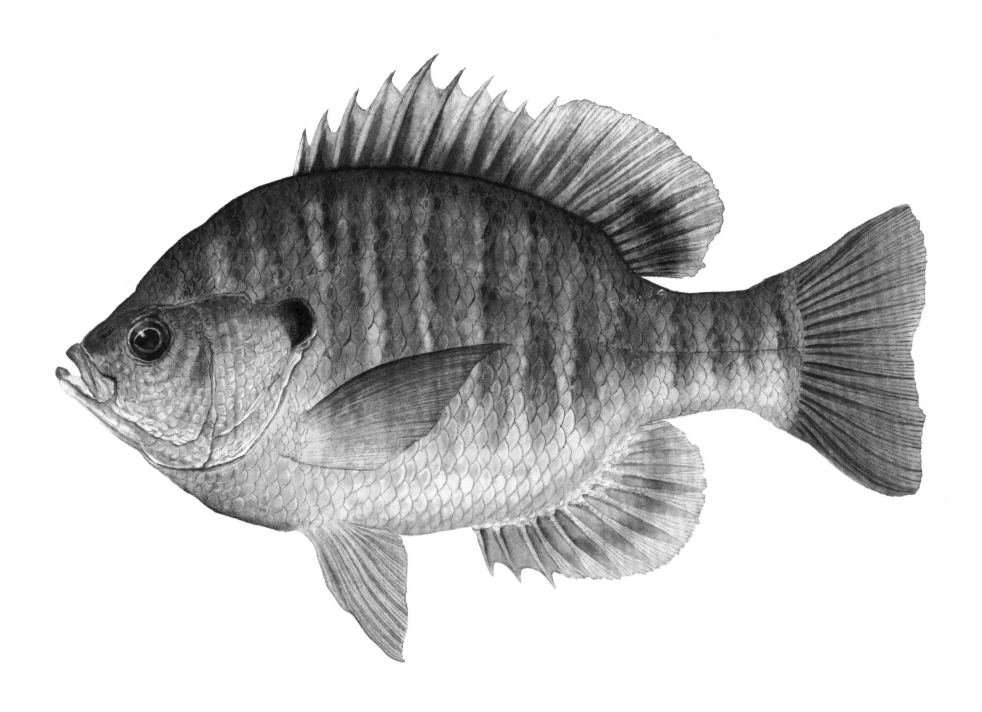

BLUEGILL

(Lepomis macrochirus) Size 6–15 inches. Weight 1/2–4 lbs

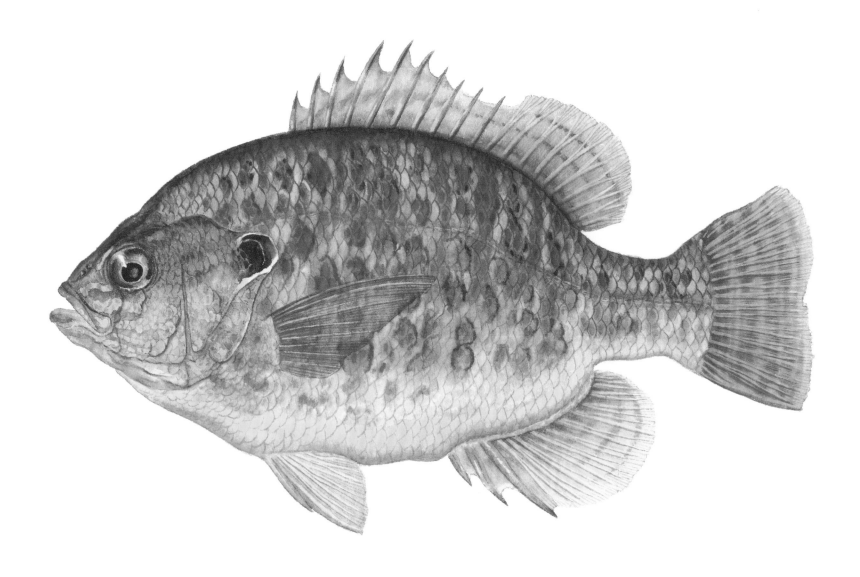

PUMPKINSEED

(Lepomis gibbosus) Size 4–9 inches. Weight 1/4–1 1/2 lbs

(Lepomis gibbosus)

PUMPKINSEED

Pumpkinseed cross-breed with other sunfish and bluegill, often making identification difficult. They spawn from May to July in small communities, often in the midst of bluegills.

The male pumpkinseed uses its mouth and caudal fins to make a depression in the bottom, carrying pebbles away in its mouth and dropping them elsewhere and blowing away silt until their nest is several inches deep and up to fifteen inches across. Next, the males defend their nests against other species and especially against other sunfish and bluegills. They spread their opercula (gillplates) in an effort to make themselves look larger. They charge trespassers, biting and chasing them.

Once the water warms and the males complete their nests, the females arise from deeper water. Initially, the males defend their nests against the females, chasing them away. When they both tire of this game, the female enters the nest where the pair swims in a circle, side-by-side with

CATCH ONE!
Pumpkinseed sunfish prefer temperate waters with lots of vegetation for protection. They may be easy to catch and popular with the youngest anglers, but pumpkinseeds are often sought by adults as well. The fish do put up an aggressive fight on line, and they have an excellent flavor and are low in fat and high in protein. (Careful, pumpkinseeds have sharp spines.)

their bellies touching. This action stimulates the male to release sperm and the female, her eggs. Females may spawn with different males in more than one nest, or several females may lay eggs in the same nest. Progressive pumpkinseeds may venture into a *ménage à trois*, with several females spawning with one male at the same time. An average female will lay 1,500 to 1,700 eggs per season.

As soon as a female finishes spawning, she dumps the male, leaving him to raise the kids. And he does a fine job of it, protecting them for up to two weeks, sucking any that stray from the nest into his mouth and gently spitting them back out into the nest. Baby pumpkinseeds only grow about two inches in their first year and reach spawning age in two years. Fisheries biolo-

gists contend that some pumpkinseeds have lived to be twelve years old in aquariums, lifespan in the wild stretches only to about six to eight years.

Despite the aggressive defense of their nests, pumpkinseeds sit fairly low on the food chain. They eat mosquito larvae, snails, and the occasional really small fish, but just about everything eats the pumpkinseed. Since they spend the bulk of their time in shallow waters near shore, they fall prey to anhingas, cormorants, mergansers, egrets, herons, storks, ospreys, eagles, raccoons, bears and virtually every other fish. Fortunately for the stocks, pumpkinseeds reproduce rather prolifically and therefore suffer no threat of endangerment.

Human activities also have an impact on pumpkinseed populations. Shoreline development can destroy spawning grounds, and increased silt from shoreline erosion can cover spawning sites with sand, disrupting spawning activities. Heavy lake use can also stir up water and disrupt spawning.

DISTRIBUTION
Native to the midwest, across the Great Lakes and southeastern Canada, down to South Carolina, the pumpkinseed was widely introduced in the west and can now be found from southern Ontario to the Pacific Coast, and the Rocky Mountains.

BLACK CRAPPIE

Black crappie have been transplanted successfully across much of North America. Since they are so prolific, you'd think you could catch them like apples in a barrel. Not quite. They're skittish and very wily but you can improve your odds by knowing where they live and what they like to eat.

DISTRIBUTION

Black crappie are one of North America's most transplanted fish so it's difficult to determine their native range. Scientists suspect it was initially the Atlantic slope from Virginia to Florida, and the St. Lawrence-Great Lakes and Mississippi River basins from Quebec to Manitoba, Canada, south to the Gulf of Mexico. Now black crappies can be found in almost every contiguous state in the United States and across much of Canada.

Like most fish, crappie like shelter. In natural lakes without much human incursion, look for fallen trees in the water, shady spots under overhanging branches, and places where deeper-water channels enter the lake. Unlike white crappie that prefer shallow, dirtier water, black crappie would rather spend their time in a deeper, cleaner environment. Try to find places where it's at least six feet deep or more.

Crappie love bodies of water with lots of docks, pilings, and brush piles. Each of these provides structure for security, have algae growth, which attracts grass shrimp, crustaceans and minnows, and, finally, shade. Again, deep water is key. Also, avoid new docks: the waterproof treatment prevents algae growth and fish don't like it either.

On a sunny day, cast up underneath the docks. If you have difficulty getting your bait or lure way under, into the deep shade, try "slingshotting" it. That is where you use a short, five-foot (or so) rod, ready it to spill line and hold the line with the fingers on your rod hand. Hold the line or leader right by the hook with the fingers on your other hand. Pull the rod tip back so the rod bends sharply. Let the hook fly while letting the line go at the same time. This catapults the bait in a fairly straight line quite nicely. Cloudy days don't present quite the challenge, as the fish won't be hiding as much. Keep trying different docks and water depths at each one until you find the fish.

Crappie bite very delicately. My freshwater guide friends tell me that keeping your bait or lure moving just a little bit is critical. If your bait is sitting still, they'll just play with it and never actually take it. The pros also use bright or even fluorescent, neon colors in bright light and dark colors for dirty water or cloudy days. Fishing at night? Counter-intuitive, I know, but use a black lure.

The black crappie represents one of the largest sunfish, growing up to sixteen inches long and sometimes weighing as much as five pounds. (However, they average much smaller.) Since black crappie live in schools, if you find one, chances are good you'll find others nearby.

IT'S A TIE!

Unlike most fishing tournaments where the first fish caught wins in a tie, the IGFA lists two world records for black crappie. One, caught in 1981 in Kerr Lake, Virginia by an L. Herring, Jr. weighed four pounds, eight ounces. Another, caught in Otoe County, Nebraska in 2003 by Allen Paap, Jr. weighed — well, you know. It was a tie.

Sunfish, Crappies and Bass

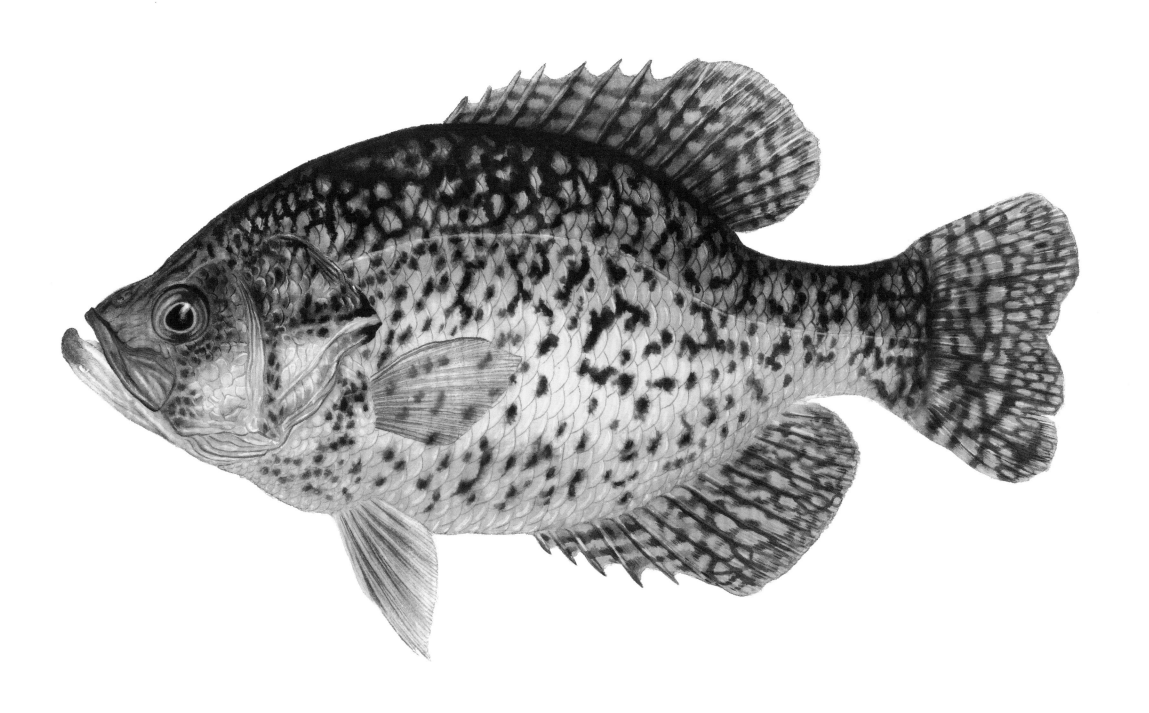

BLACK CRAPPIE

(Pomoxis nigromaculatus) Size 12–20 inches. Weight 1–5 lbs

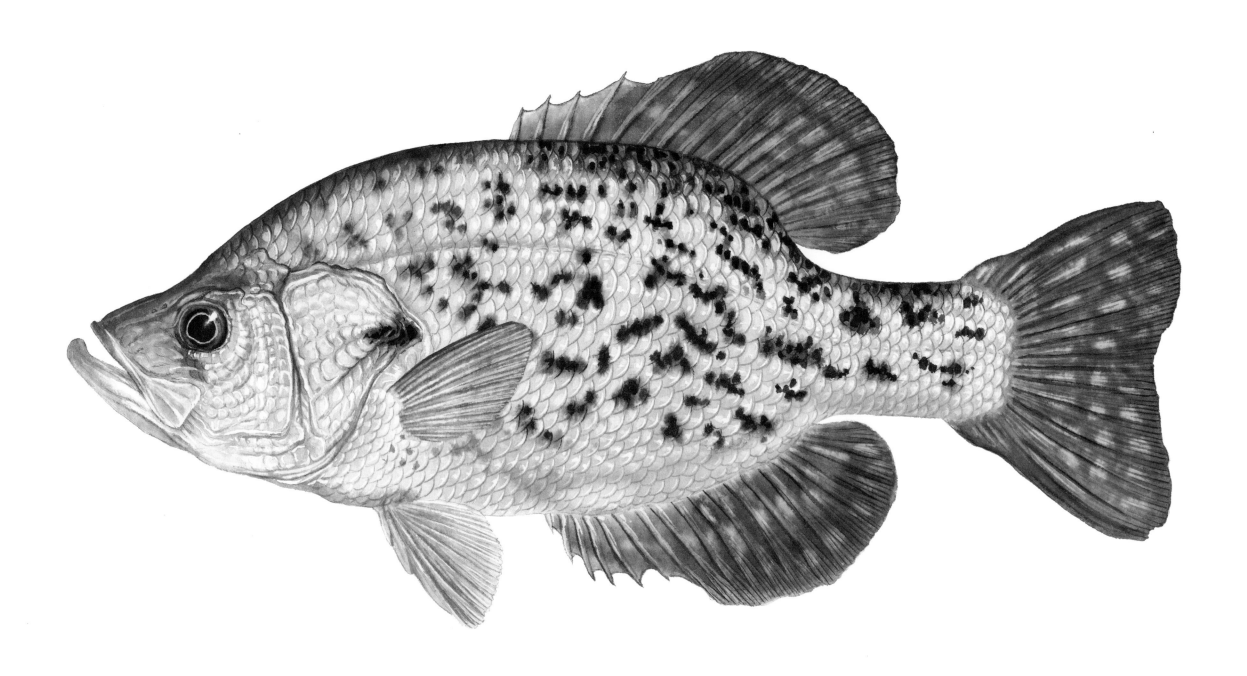

WHITE CRAPPIE

(Pomoxis annularis) Size 6–20 inches. Weight 3/4–3 lbs

(Pomoxis annularis)

WHITE CRAPPIE

As the cult-movie hero Napoleon Dynamite said, "I have skills." Boat driving skills, fishing skills, writing skills, but I especially pride myself on my fish-cleaning skills. I thought I was good until I visited Roland Martin's Marina and Resort in beautiful Clewiston, Florida.

Right on the banks of Lake Okeechobee, bass fishermen from all over make pilgrimage to Martin's in hopes of catching a "lunker" or even a "hawg." Roland Martin qualifies as one of the best and most successful bass fishermen ever. His guides have such a great reputation that Martin offers a guarantee: If you don't catch fish, you don't pay.

I stayed at Roland's marina while taking a boat across the state of Florida through the canals and rivers. As all the guides returned to the dock, they first broke out the cold beer, then they each fired up an electric carving knife. Apparently bass weren't running that day, so everybody had a mess of white crappie, another species that built Lake Okeechobee's fishing reputation. These guides cleaned about one crappie every twenty seconds. I'd never seen anything like this before, so I stood alongside the cleaning table and watched.

First I noticed that unlike my electric knife at home with a trigger button on the top, all these guides used bottom-trigger models. When I asked, they said it was easier on their wrists and that they also didn't like battery operated knives because they were too heavy. They laid the fish on its side and without scaling it, cut down into the flesh diagonally just behind the gill plate and pectoral fin with the long side of the diagonal at the top of the fish and the short side near the belly.

Crappie have tiny, delicate bones, so be gentle. As soon as you feel the knife hit the backbone, turn the blade flat, parallel with

CATCH ONE!

You can fly fish for white crappie in the spring. Later, use poles in shallow water or spinning tackle at depths of twelve to fifteen feet. The current world record of five pounds, three ounces came from right by the dam in Enid, Mississippi. Fred Bright caught it back in 1957.

the table. Slice toward the tail with the blade against the backbone. Stop before you cut the fillet free. Flip the fillet off the fish so it lies skin down on the table, overlaying the tail. Next, cut down into the flesh toward the skin near where the fillet meets the tail. With the knife almost flat but not quite, slice all the way down the fillet toward the unattached end. Now you have a skinless fillet. Cut the little rib cage and other bits of unpalatable stuff off the fillet. Then turn the fish over and repeat the process.

The guides had it down to where one skinned fillet came off in virtually one smooth motion. This technique can certainly be applied to many other fish, but saltwater anglers had better have a really long table to accommodate twice the length of the fish they're cleaning.

DISTRIBUTION

Southern Canada and the Great Lakes region south to Texas and the Gulf States, as well as scattered waters in the West due to transplanting. White crappies were introduced to California in the 1870s.

(Micropterus salmoides)

LARGEMOUTH BASS

They call them bubbas, lunkers, hawgs and other less-printable names. But largemouth bass inspire more passion than most other fish. The Holy Grail of bass fishing is the search for one bigger than George Perry caught at Montgomery Lake in Georgia on June 2, 1932.

Aficionados swear that a fish bigger than his twenty-two pound, four ounce leviathan exists and one angler swears he caught (and weighed) one larger out in California, but hadn't the heart to kill it and so released it unharmed.

Sammy Lee stands about seven feet tall and has the sweetest disposition of just about any good-ole-boy you'll ever meet. We met on a fishing outing off the coast of Los Angeles. Turns out, Sammy's job as a radio broadcaster allowed him to indulge his passion for largemouth bass fishing.

"So Sammy," I inquired, "Just what is a lunker?"

"Son!" he replied. (Southern bass fishermen address other gentlemen as "son" when they're excited.) "Why that's a largemouth bass running ten pounds or more!"

"That's all?" I replied. "Gee, Sammy…I drag baits bigger than that."

So much for his sweet disposition.

"Y'all ever caught a big bass?" he asked.

I hadn't. But, I wondered, how hard can it be to wrestle a ten-pound fish to the boat on thirty-pound test line? I really liked Sammy and despite my Northeastern arrogance, he remained friendly. So I made him a deal. I'd hook him into a tarpon — basically a 150-pound largemouth bass — and he'd get me out bass fishing.

He cursed me for spoiling him after he spent an hour fighting a huge tarpon one night off Miami Beach. And I finally went bass fishing in Eufaula, Alabama. Surely this private lake, liberally stocked with bass and bream, would gird my lunker loins.

Silently coasting around the lake with an electric trolling motor and Humminbird's side-scanning sonar, I cast time and again, snagging my crankbait on every stump and overhang within a mile. Everyone else around me caught bass. What was I doing wrong? Same boat,

DISTRIBUTION

Native to the eastern half of North America from southern Ontario and Quebec down to the Gulf states, the largemouth has been introduced to parts of nearly every state in the U.S. and southern Canada.

Sunfish, Crappies and Bass

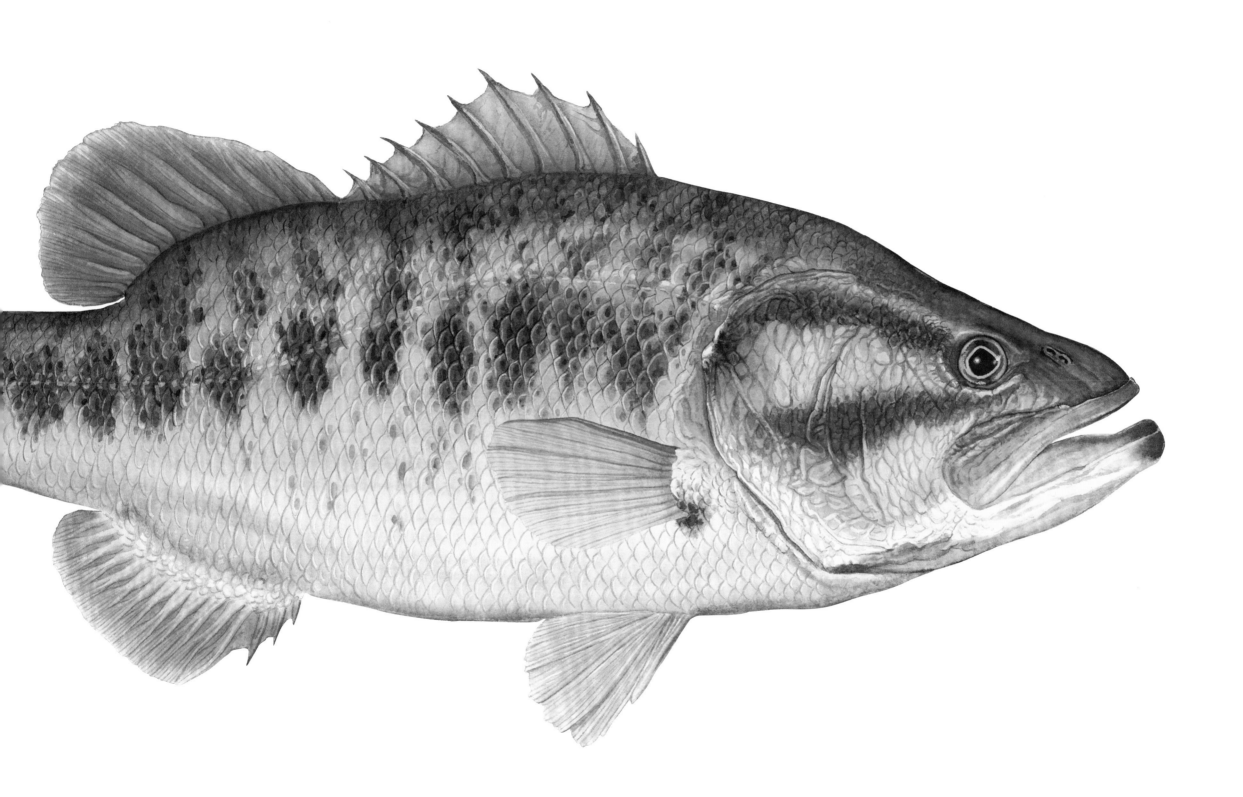

LARGEMOUTH BASS

(Micropterus salmoides) Size 10–30 inches. Weight 3–20+ lbs

bait, rod, line technique. Yet the locals said nothing as they smiled that snarky, knowing smile.

"Yes sir, fish on!" I finally shouted as a nine-pound hawg ran for a few feet before I started winching it in.

Admittedly, it looked beautiful with glistening colors and fat belly. I gently let it go, knowing that I had at last figured out what it took to catch a largemouth bass: sheer luck. Perhaps catching much larger fish has spoiled me. But I must admit that these fish generate more excitement than any fish that swims in a sea.

I guarantee that you've never seen anything like a big-time bass tournament. The brightly colored pickups and SUVs line up outside the football stadium, boats and trailers color-coordinated with the truck and sponsor labels stuck to everything just like NASCAR. The angler pulls into the stadium up to the stage where the emcee has been working the crowd of 10,000 men, women and children into a frenzy. When a fisherman pulls his lunker out of his aerated livewell and holds it up, you'd think it was another home run. The crowd goes wild.

CATCH ONE!

Largemouth bass prefer water temperatures between 65 and 85 F. While they can be found in warmer waters, and in frozen lakes, their digestion slows at more extreme temperatures so they feed less frequently (not good for fishermen). Largemouth can be caught with a wide variety of bait and lures. Use crayfish, night crawlers or minnows for live bait.

TYING THE MESSY CRAW FLY

1. Tie in medium lead eyes one eye-length behind eye of an Aberdeen hook size 2.

2. Tie in one blue flake rubber leg and one pumpkinseed rubber leg at the bend of hook. Fold over and cover with thread.

3. Tie in one dun and one olive-brown marabou plume and palmer together at the bend of the hook.

4. Cross-wrap two blue flake rubber legs and two pumpkinseed rubber legs one-third back from the hook eye.

5. Tie in olive sparkle yarn at the hook bend and wrap forward to hook eye.

6. Tie in one dun and one olive brown marabou plume at the hook eye and palmer tightly.

7. Tie in five strands of blue flashabou at eye and extending to the end of the marabou tail. Tie off thread and secure with a drop of cement.

Sunfish, Crappies and Bass

(Micropterus dolomieui)

SMALLMOUTH BASS

On their days off, the guides at the Delaware River Club (DRC) occasionally fancy a break from trout fishing by going after smallies and, as a Delaware River rat, I try to weasel my way onto these trips whenever possible.

So it was on one beautiful day in July, 2003, that I found myself with DRC's manager Jeff White and his wife Kristin floating the East Branch of the Delaware. The water ran high but clear and the temperature — just starting to warm up — favored bass more than trout on the stretch we were on. Though I spend most of my time on the Delaware trout-fishing, the bass, though not as common, are large and healthy, and amazing fighters.

Jeff and I had started a streamer-fly company, X-Streamer Flies, in the fall of 2002 and we had developed two crawdad and one baitfish pattern. The baitfish pattern, Flick's Phenom, was more or less developed by me and finessed by Jeff. It has produced big trout on the Delaware and is found now in fly-boxes of guides as far away as Montana. Jeff developed one of the craw patterns, The Crawdiddy, and we collaborated on the third pattern called "The Messy Craw."

Armed with several streamers of our own design, we anxiously waited to see if they worked as well with bass as they did with large trout. Fish immediately started moving in on the "Phenom," but we couldn't get them to strike. Nor did topwater popper patterns produce any interest whatsoever from the bass, so we decided to fish deep. The Messy Craw, tied to represent a crayfish foraging in the debris with "messy" trails of marabou surrounding the pattern, ruled the day. With it, we caught both the most, and the biggest, fish including the smallmouth I painted for this book. I landed it after a savage battle in which the bass put a radical and scary bend in my five-weight, stripped my reel down into the backing and made five

incredible jumps. Both orange and blue/gray colorations work best for smallmouth bass with this fly. I switched over to my eight-weight rod for the remainder of the day, since it was easier than the five-weight rod for casting the heavy flies and for fighting energetic smallies.

To catch a smallmouth on the Messy Craw, use a six- to eight-weight fly rod with deep sinking line and dead-drift the pattern slowly. At the end of the swing retrieve the fly with sharp strips. I caught a couple on the drift this way, but the big guy shown here hit the fly close to the boat between strips.

FLICK FORD

CATCH ONE!
These amazing fighters are often found gathered around fallen logs, boulders, and in the shale drop-offs into deep water along the banks of fast-flowing rivers and rock-strewn lakes. Smallmouths often share water with largemouth bass. The mouth of the largemouth extends past the back of the eye.

DISTRIBUTION
Native to southern Quebec and the Great Lakes to the mid-south, smallies are now found across southern Canada and in all but three U.S. states. They prefer cooler water than the largemouth bass.

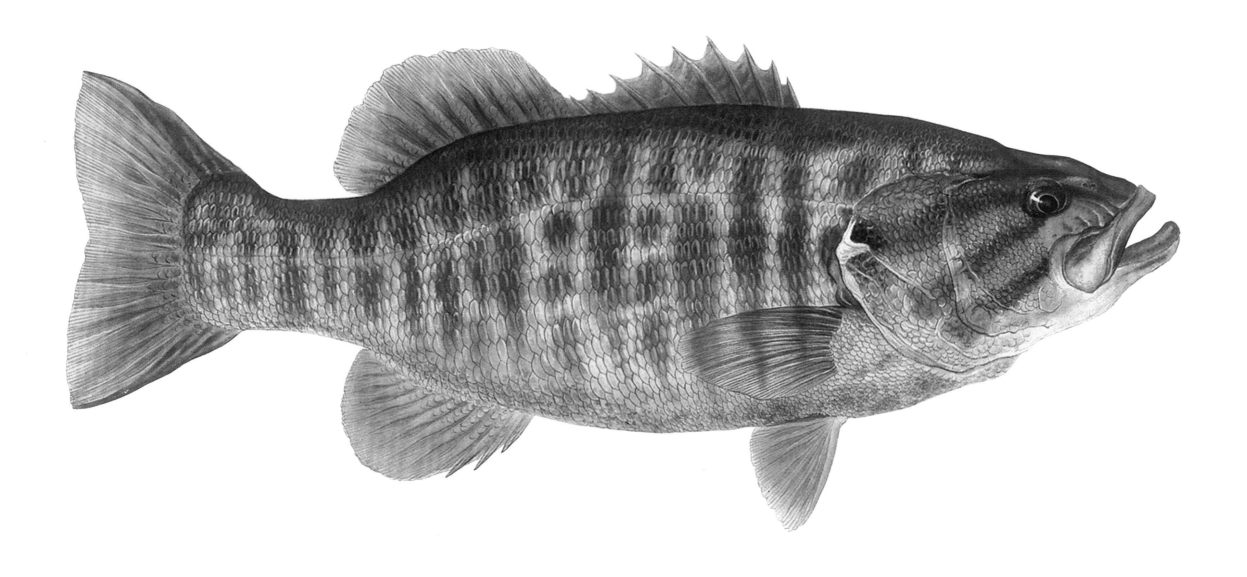

SMALLMOUTH BASS

(Micropterus dolomieui) Size 9–25 inches. Weight 3–10 lbs

FRESHWATER BAITFISH

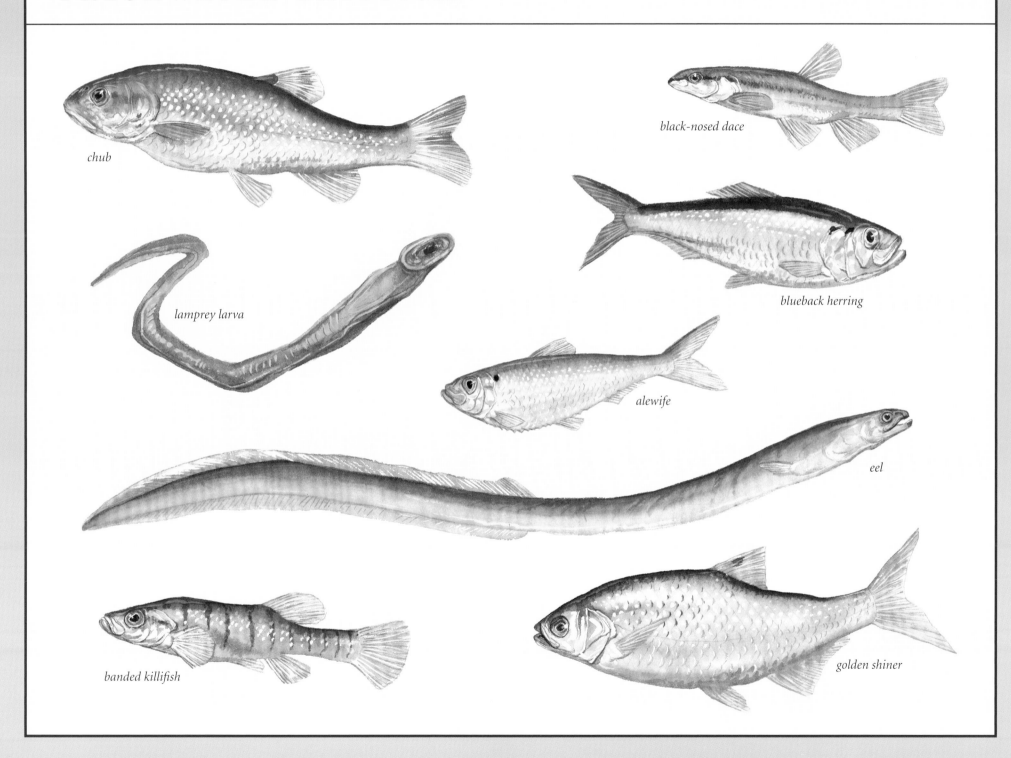

chub

black-nosed dace

lamprey larva

blueback herring

alewife

eel

banded killifish

golden shiner

BROWN BULLHEAD

Eco-conscious detractors of freshwater fish farming rail against its effluence and rotting-food pollution, as well as the demands aquaculture puts on water resources. Historically, fish farming operations that raise a single species — like catfish — consume more resources than they produce.

DISTRIBUTION

In the wild, brown bullhead catfish qualify as "native" Americans, ranging throughout the eastern United States and southern Canada. The current world record holder, Ray Lawrence, caught a six-pound, five-ouncer in Lake Mahopac, New York in September of 2002.

Despite the fact that these operations can't sell their "crop" for more than it costs to produce it (that's capitalism) Americans' demand for fish means that such enterprises are here to stay. Bullhead catfish have become one of the most popular fish to raise.

Most of the country's aquaculture is centered around Mississippi, but one of the most successful operations belongs to Dan Butterfield in Alabama. Butterfield does it quite differently and ecology-minded scientists point to his system as the benchmark of wise use. Most farmers realize that producing a single crop exclusively will deplete the land. Ergo, smart farmers rotate crops to make use of the benefits of different species. Butterfield fits the "smart farmer" mold. He does just about everything differently. For example, ponds containing fish grow algae (phyto-plankton) like wildfire. Any time an algal bloom occurs, the oxygen level in the water drops precipitously. Unchecked, the fish suffocate. Adding toxic herbicides to the water pollutes surrounding rivers and streams when pond water discharges into them. Power aerators, to add oxygen back into water, run on electricity that costs real dollars to purchase.

On Butterfield's catfish farm, he uses the algae blooms to feed species that thrive on it such as tilapia and carp — both "money crops" that keep the algae under control for free. Additionally, Butterfield raises bluegill, crappie, and bass, for food and stocking purposes. These species control other aspects of the aquaculture process that all benefit the catfish operation.

CATCH ONE!

Toothy and dangerous, a brown bullhead should be handled with care. It has slime-covered "teeth" on its pectoral fins. If they stick you, it hurts and the wound usually gets infected.

Without man's interference, nature maintains a miraculous balance among all her flora and fauna. Butterfield approximates this natural balance as closely as possible, creating a profitable and far more ecologically friendly business.

Anytime you have fish gathered in one spot in shallow water, predators will come from far and wide for a free meal. Seagulls, cormorants, anhingas, weasels, bears, ospreys, eagles, hawks and the list goes on, all like fish for dinner. Most fish farmers exterminate birds or animals found "raiding" their ponds. Butterfield has a far much more *laissez faire* attitude than most.

"In the interest of living in harmony with nature, I do not begrudge sharing a portion of my crop," he says. And yet, he still makes a profit when others cannot.

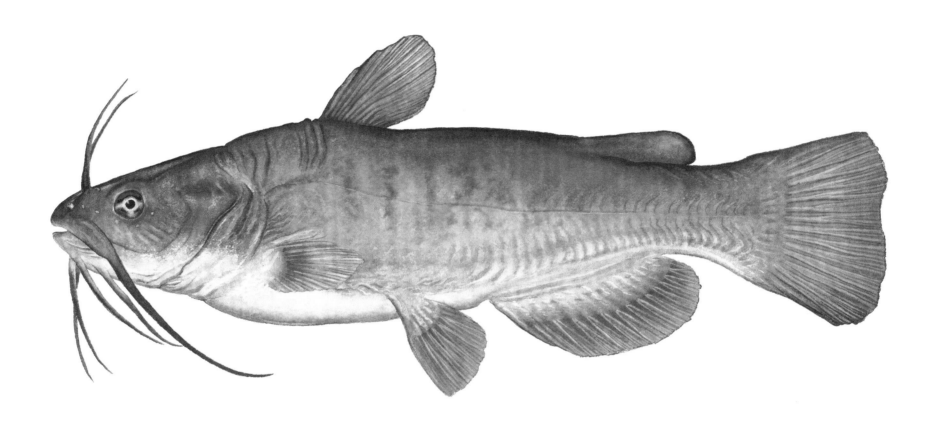

BROWN BULLHEAD

(Ameiurus nebulosus) Size 8–14 inches. Weight 1–3+ lbs

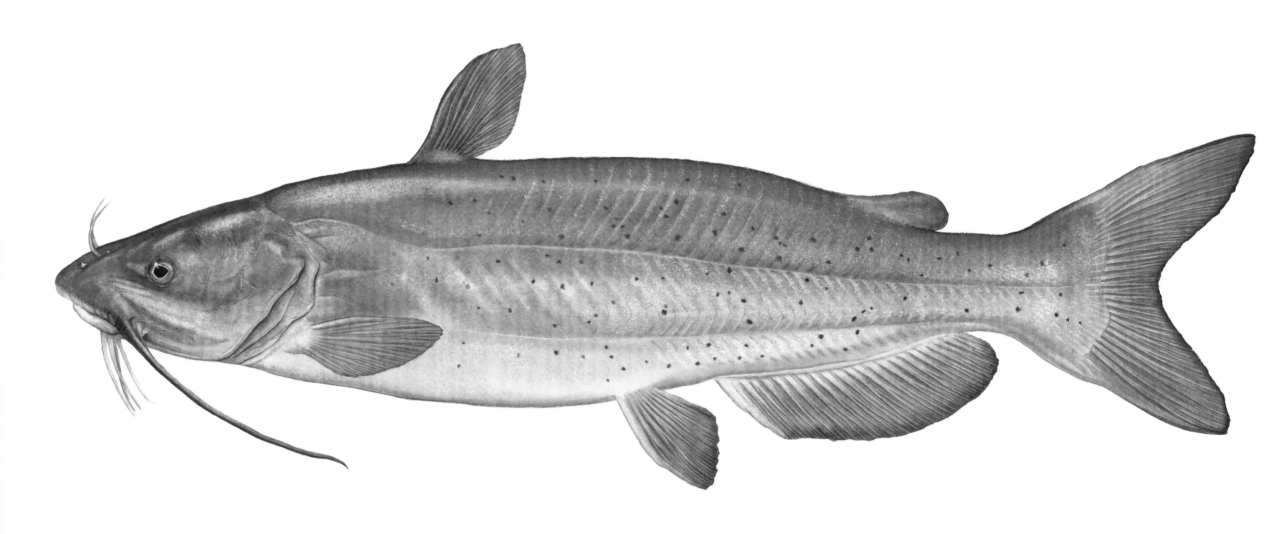

CHANNEL CATFISH

(Ictalurus punctatus) Size 11–30 inches. Weight 4–45 lbs

(Ictalurus punctatus)

CHANNEL CATFISH

According to U.S. Fish and Wildlife Service, catfish rank among the most popular fish to catch in America and consequently they may have inspired some of the most bizarre fishing methods. There are people who wade out in the water and stick their hands into holes in submerged logs, or up under submerged shelves, and in lots of other hidey-holes where catfish lurk. Then, believe it or not, they hope the catfish bites their hand or arm so they can pull it out. They actually use themselves as bait! Most catfish anglers, however, use the same tackle, more or less, as any other freshwater fisherman.

BIGGEST EVER!
A Mr. Whaley caught the world record channel cat in the Santee-Cooper Reservoir in South Carolina back on July 7, 1964. Since then no one has claimed a bigger channel cat than Whaley's fifty-eight-pounder.

There was a time when largemouth bass had a bad rap. Then tournaments started putting the fish in a better light. The same thing is happening to catfish and anglers have started to dispel some of the myths about this misunderstood species. For example, their spines can't inject you with poison. If you get cut, you may get infected from the slime on the outside of the fish. (But this holds true of virtually every fish.) The slime acts as a protective barrier, keeping the catfish healthy and guarding against some parasites and diseases.

Contrary to popular opinion about what bottom-feeders eat, the rottenest, smelliest bait isn't the best for catfish. Though catfish are omnivores — eating everything they come across — they get used to particular foods in their local environment. "Matching the hatch" works equally well for cats. For the best success, offer catfish what they're used to eating. In most cases, this will be minnows, suckers, or other fish.

Some people consider catfish ugly. Others see beauty in their functionality. Either way, after cleaning and skinning, catfish make some of the best, white meat, fish-eating you can imagine. Most of the channel catfish you find in restaurants, fish markets, and grocery stores have been farm raised, eating mostly Purina Catfish Chow. Yet I defy you to discern between the flavor of farm-raised and wild-caught catfish.

Cats breed like wildfire and eat voraciously. Consider that a nasty combination from a wildlife management perspective. To help prevent any natural imbalance and protect future generations of other catfish, sunfish, rock bass, smallmouth bass, and other species, spool your reel with 50-pound test braided line. Tie a piece of 150-pound mono to that with a dropper loop holding a 2/0 baitholder hook. Then tie a piece of heavy floss to the end of that as a breakaway rig with a six-ounce weight. Bait up and have at it. And whatever you do, don't let the fish have its way with you or it will beat you up. Don't give it an inch.

DISTRIBUTION
Slow moving rivers, streams, lakes, ponds, and deep holes are catfish haunts. They like flowing and preferably warmer water. Native to most of the United States east of the Rockies and west of the Appalachians, they've been stocked nearly everywhere including Hawaii.

(Cichla ocellaris)

BUTTERFLY PEACOCK BASS

I'd seen them hundreds of times. The beat-up pickup trucks stopped by some drainage ditch or retention pond next to a turnpike exit and a couple of guys at water's edge fishing. I always thought (in my effete, Northeastern sort of way) that seemed a little, well…redneck.

A guide-friend of mine suggested that I might like to try fishing for peacock bass. I knew this species as a big-money game fish from the Amazon, one that I had neither the time nor financial wherewithal to chase down in the South American wilds.

"No, no. I've got the next best thing," he insisted. "I'll pick you up tomorrow morning at six. I'll even bring the café con leche and guava empanadas." Ah, the real way to a man's heart…

We headed west to where — for the briefest moment — the development ends and the Everglades begin. Each year this edge moves farther west. On Krome Avenue, we headed north. At the first water management drainage ditch, my guide pulled off into the scrub. Grabbing a pair of Orvis five-weights out of the bed, he led me down a little embankment to the water. "Hard to believe I'm only a mile north of Manuel Noriega's jail cell," I offered.

"First try casting that glass-minnow fly up under the bridge," he suggested, handing me one of the rods. As I stripped line off the reel preparing to roll cast into the shadows, he filled me in on his "secret spot."

"There's really no secret," he admitted. "Peacock bass are the first non-native species ever bred and legally introduced into Florida waters specifically for fishing. Actually, anglers released the first specimens. But because peacocks have such specific needs when it comes to water temperature and salinity, they didn't fare well. Then scientists brought a bunch up from Brazil and Venezuela, cross-bred them with some other native species and when they had what they wanted, released more than 20,000 of them into canals. The ones in South Florida canals survived quite well. Those in the wilder areas like the Everglades, or farther north, couldn't handle the cooler water temperatures."

I threw the pile of line out onto the water, slowly raised my rod tip, then waved it downward quickly, causing the line to follow the tip and roll out onto the water under the bridge without stretching out into the bushes behind me the way people normally cast a fly. In fact, it took three tries to different spots under the bridge before I jumped in surprise as a peacock bass inhaled my lure. Now I understand the peacock's allure, if you'll excuse the expression.

DISTRIBUTION

You can find peacock bass in many canals and lakes south of Fort Lauderdale, Florida. They'll eat anything that remotely resembles a small fish or amphibian.

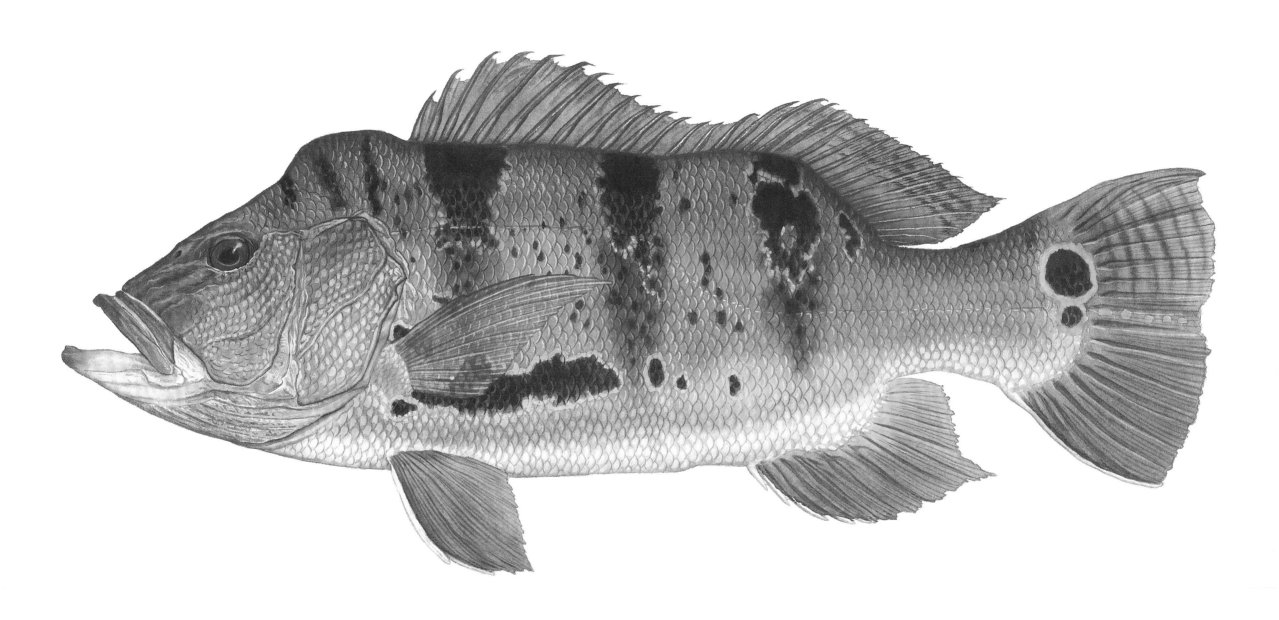

BUTTERFLY PEACOCK BASS

(Cichla ocellaris) Size 10–20 inches. Weight 1–5 lbs

A JOB MANY WOULD KILL FOR...

I've long ago lost count of the number of times someone has offered to carry my bags or even be my slave (all guys, by the way). But it didn't happen overnight. In fact, you could probably say I've spent fifty-three years getting to the point where somebody pays me to travel around the world to go boating and fishing. On the other hand, I've spent forty of those years getting paid to go boating and fishing, so I suppose the chicken versus egg scenario doesn't apply in the case of my particular life experience.

I grew up in several wealthy towns, each wealthier than the next, culminating in Greenwich, Connecticut. No, my family wasn't in investment banking. In fact, my mother was a nurse and my father a fireman who held numerous second jobs. (Don't all firemen?) My grandfather was a retired boat builder. We lived happy lives. As a small child, I spent my summers on a tiny island in Long Island Sound called Hen Island. We had no power. We cooked and lit and refrigerated with propane. I have no idea how my family afforded to live as we did, but I never remember ever wanting for anything.

At age ten, a youngster could drive a motorboat in New York State without adult supervision if they passed a Conservation Department Safe Boating Course. In my area, a wonderful man named Jerry Robinson at the Mamaroneck Beach, Cabana and Yacht Club dedicated a bunch of Saturdays to teaching this class — and to buying us burgers in the club after each session. I passed with flying colors and in the process, discovered I loved being around boats. The yacht-club lifestyle wasn't bad either. When I was a junior at Mamaroneck High School, my father came home and informed the family that he was selling the house and most of its furnishings and moving us all onto a fifty-seven-foot Chris Craft Constellation.

When I hit fourteen, a man named Jack Brewer — the owner of one of the largest marina companies in the world — suggested to

one of his marina clients that he needed a professional captain as his boat skills made him a danger to other living things. The client didn't want to spend a lot of money to hire a professional, so Jack suggested me since he knew I could run the man's thirty-eight-foot Hatteras with no problem. And I'd probably work for much less than a professional adult. I spent the next two summers traveling around Long Island Sound driving a beautiful yacht.

This lifestyle generated a very interesting dichotomy. As a good boat handler and sailor, I quickly found my services could be in demand by people who lacked the skill or the time to deal with their own boats. So I constantly received invitations to participate in all the wonderful sports and pastimes of the rich and famous — without having either of these two qualifications. But even better, I was making money doing what other people paid extraordinary sums to do. To this day, there is (without exaggeration) nothing on earth I'd rather do than drive a boat.

I now travel about fifty percent of the calendar year — mostly to luxury resorts in the world's best fishing and yachting locations. I go at the best times of year for each spot. I fish with whoever happens to be the best at that location and with that species. I learn something every day. I don't make as much money as my friends in the reinsurance business, but I promise you that my lifestyle makes theirs look tame. That's why people of all stripes wish they had my job. To them I say, sorry, I'm not retiring yet. After all, what would I have to look forward to? Robert Louis Stevenson said, "Find what you're passionate about and make it your job. You'll never work another day in your life."

DEAN TRAVIS CLARKE

LIVING ON A BOAT

1) *Tighter quarters than a house. It helps to get along with your family.*

2) *Can't own as much "stuff."*

3) *Never have to pack for a vacation. Take your whole bedroom with you.*

4) *Parties tend to be historic in your friends' minds. A moveable feast.*

5) *At least as much home maintenance, often more.*

6) *Many women will find you… intriguing.*

Since man first walked upright, he's taken fish from the sea. Until the Industrial

Revolution, fishing was strictly a subsistence function. We ate everything we caught,

and our activities did not significantly impact the fish populations.

Once we reached the point where our farms and commercial fishing fleets

SALTWATER FISH

could supply enough food, and technology allowed us to keep it fresh longer, fishing

entered the arena of sport.

Why do so many North Americans fish? You'll get as many answers as there are

anglers. Some retain the innate hunter/gatherer mentality. Others enjoy exercising

their intellect and ability to reason over lesser species. Some like the challenge of

pitting themselves against the sea, knowing that at any moment, something can go

wrong. Still others find the serenity of fishing — the hours of quietude punctuated

by intense moments of absolute chaos — soothing and rejuvenating.

What all saltwater fishermen have in common is the need to fish. Problems at

home or work? Go fishing. Economic downturn? Go

fishing. War, disease, chaos? Go fishing. A fisherman cannot

be turned away from his passion yet when it comes to lobbying for fish-

eries and the environment, most anglers are reticent. They honor

their own relationship with the environment, but beyond that,

statistics show they'd rather go fishing.

FLUKE

How odd a creature the fluke. It starts life swimming upright with eyes on both sides of its head. As it matures, one eye moves to the other side of the head to join the other eye and the fish starts swimming flat along the bottom.

DISTRIBUTION

Fluke range from Nova Scotia to Florida, but are most abundant in waters from Massachusetts to North Carolina. They often flutter their fins to semi-bury themselves in the bottom in order to be further concealed.

Fluke go by numerous names depending on the region. Often called "summer flounder," fluke have the ability to change color like a chameleon, matching their upper body to the surrounding bottom environment. In fact, if you dive where fluke live, and pay very close attention to the sea floor, you might see their eyes sticking up. That's all. Scientists refer to fluke as a "left-sided" flatfish because ultimately, both of its eyes end up on the left side of its head.

Fluke feed on fish and shrimp and despite being bottom dwellers, they'll swim up to the surface to savagely attack prey. The International Game Fish Association all-tackle world record was set by Charles Nappi in Montauk, New York back in 1975, and tipped the scales at twenty-two pounds, seven ounces.

Fluke are terrific first fish for any child because they can be found near shore in bays, harbors, rivers, canals, creeks, and around bridge pilings and docks. They give enough "tug" to make things exciting and yet won't overwhelm an already apprehensive new angler.

Fluke were the very first fish I caught by myself. My best friend Peter Karp and I biked our way to Nichols marina where we carefully cut up our sandworms and wove them onto our hooks. I remember thinking how brave we were since a sandworm has ugly, sharp pincers that hide in its head and come out when handled. Let one get a grip on you and it'll draw blood. We stood there fishing until we each had enough for dinner and then returned home triumphant.

We even cleaned them ourselves. Our mothers particularly appreciated that. If I remember correctly, Peter's mother very lightly sautéed the fillets in garlic, butter, and white wine. Seems like it took about twenty seconds on each side. Then she laid each fillet onto a bed of creamed spinach, covered it with cheese and stuck them under the broiler until the cheese melted.

Since then, I've learned that flounder fillets can be rolled up around things like crab stuffing or scallops and then baked. They can also be deep fried in peanut oil after dredging them lightly in an egg wash and coating. Just don't manhandle fluke. It's very delicate and will fall apart easily.

CATCH ONE!

In summer, they like the sandy bottoms near shore in bays and where estuaries flow out. Fluke can change color to match their surroundings. They can be caught with live bait or jigs, small spoons, and spinners. You can troll, or cast for fluke, or still-fish off docks. The most popular method is to drift bait along the bottom.

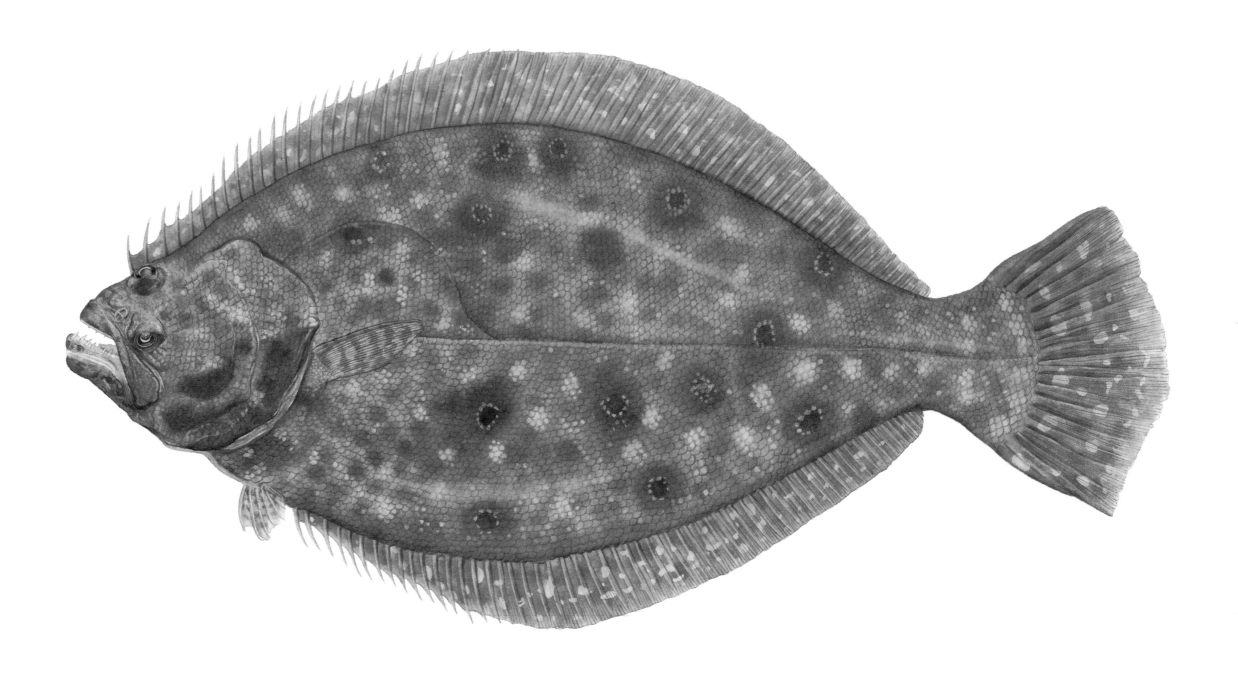

FLUKE

(Paralichthys dentatus) ♂ *12–18 in; 3–5 lbs.* ♀ *18–30 in; 4–20 lbs*

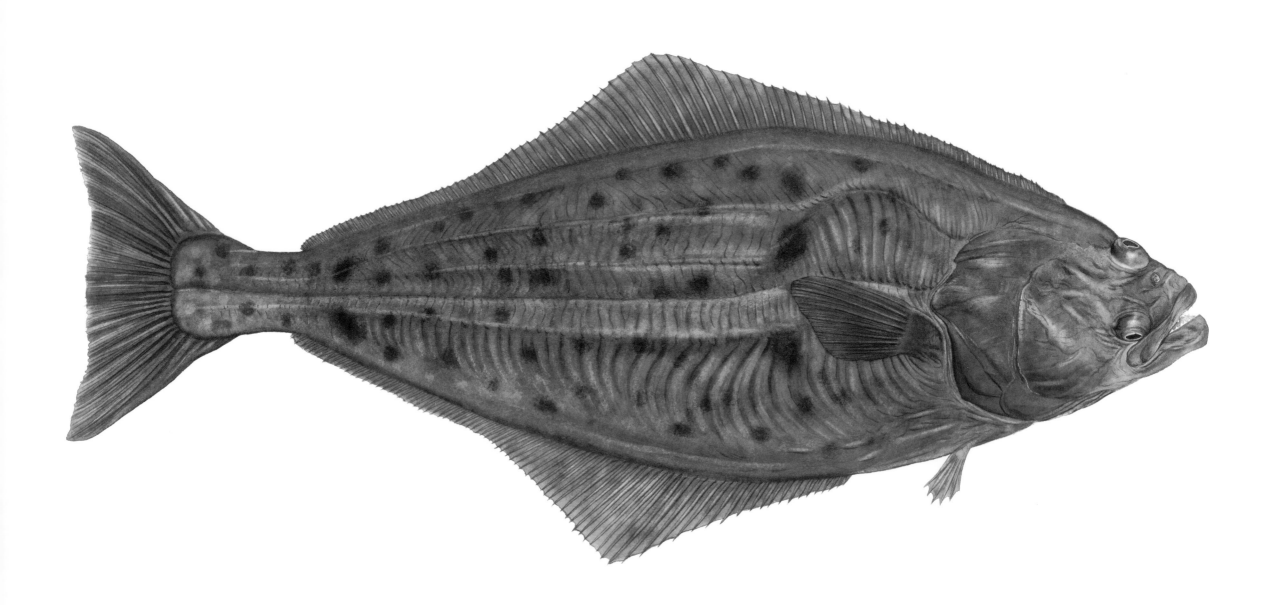

PACIFIC HALIBUT

(Hippoglossus stenolepis) Size 5–9 feet. Weight 100–400 lbs

(Hippoglossus stenolepis)

PACIFIC HALIBUT

Henry couldn't remember ever sitting down to fish. Still, he loved the brand-new fighting chair he'd just finished bolting to the deck in the small cockpit. That varnished mahogany seat, gleaming rod holders, and the über-cool footrest with the name of his boat in gold leaf under the perfect varnish puffed him up. Sure, it smacked of being outré for a thirty-one-foot outboard boat in the Pacific Northwest. But damn, it sure set him apart. Nobody in his marina had a fighting chair — not even bigger boats.

Henry and his usual fishing partner, Rolf, headed out at dawn one Saturday in hopes of scoring some halibut. They went to a deep hole that sat just inshore of a large seamount. Once there, Henry drove a criss-cross pattern with his eyes glued to the depth sounder. First he saw the deep depression, followed by a line on the sounder that ran virtually straight up to the top of the screen. "Right on the money," Henry said. "Drop it."

Rolf tossed a bright orange float over the side and watched as it unrolled the parachute-cord tied to a pound of lead weight. When the weight reached the bottom, Henry had a visible point of reference to the hole to which he could easily return.

Henry shoved the throttles into neutral and watched his chart plotter, a moving electronic map that showed him naviga-tion information such as position, speed, and direction. He wanted to know which way the current would push him and how fast. Once determined, he idled his way up-current just past the far side of the hole where they dropped the big chunks of bait on circle hooks over the side and down to the bottom. They drifted over the hole, repeatedly letting out line until the weight touched bottom and the line went slack,

OLDER WOMEN

Pacific halibut are the largest flatfish on the Pacific Coast. Females spawn in deepwater in the winter, and in spring the juveniles move to more shallow water where they stay along the sandy bottoms for sev-eral years. Females grow faster, get bigger, and live longer than males.

then reeling up a few feet to keep it from snagging on anything.

It didn't take long. Henry's rod bowed until it looked like it would snap. "Whoa, feels like a good one," he said over his shoulder to Rolf. An hour later, a 200-pounder finally rose to the surface. It seemed exhausted and just gently fluttered there alongside. "Get the heavy gaff, Rolf! I don't want to lose this one. It's a personal best for me!"

Rolf carefully gaffed the fish through the open jaw and after Henry put his rod in the holder, they both dragged the docile fish through the transom door and into the cockpit. The fish decided it didn't really like that after all and crashed and thrashed to the point where both anglers ran to the bow to get out of the way. One angry fish splintered the leaning post, the helm console and — oh, the humiliation — the fighting chair, into toothpicks before finally expiring.

Score: Fish 1 – Henry 0

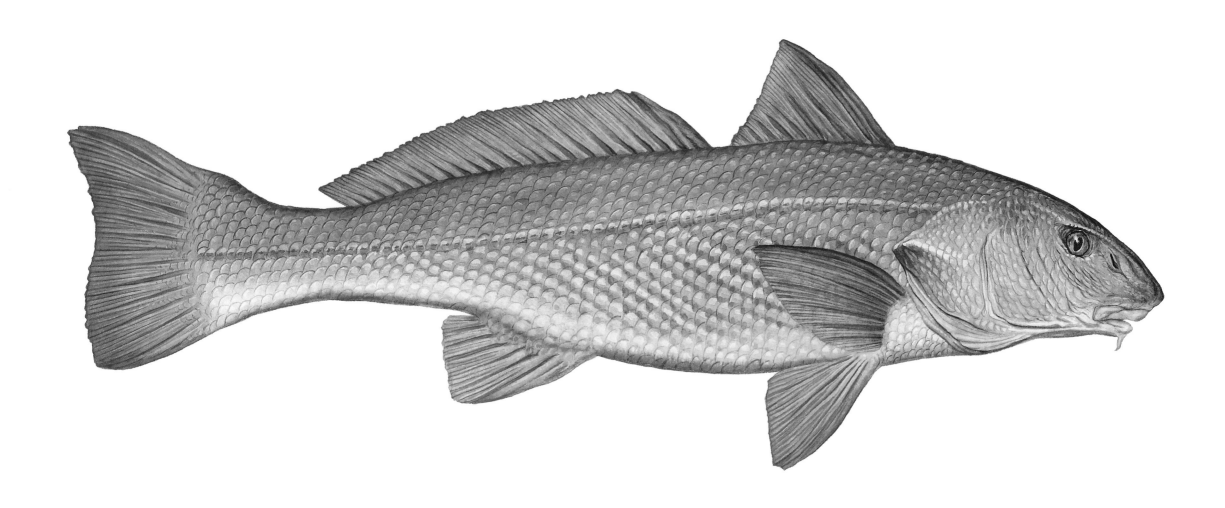

CALIFORNIA CORBINA

(*Menticirrhus undulatus*) *Size 15–24 inches. Weight 4–8 lbs*

(Menticirrhus undulatus)

CALIFORNIA CORBINA

California corbina possess some of the best eyesight imaginable. Believe it or not, you'll do well to wear clothing that matches the color of the sky on the day that you go corbina fishing.

Back in 1982, while my family and I lived on Balboa Island in Southern California, El Niño threw some particularly brutal storms at Newport Beach. One late afternoon after the gale subsided, a friend who lived on the harbor called me for some fishing expertise.

I walked into his backyard, passed his pool and heard a racket from next door. I peered over the fence into his neighbor's yard and saw some wildlife personnel trying to capture a sea lion that had washed over the beach, across the main highway, down the road, through the neighbor's yard and into his swimming pool.

"I need to catch these fish and move them back into the harbor" said my friend.

I looked into his pool and there, scribing a circle, swam a sizable school of California corbina. Corbina, perhaps the fish most commonly caught by surfcasters and pier fishermen in Southern California, get to be about seven or eight pounds maximum. These all seemed to be about four-pounders.

I got a pair of rods and some rubber crabs out of my car and one by one, we started to catch the corbina.

"Can I eat these?" he asked hopefully.

"People do, but sometimes they have worms or high levels of toxins from feeding so near shore, so I wouldn't."

After a half-dozen easy, "fish-in-a-barrel catches," the bite shut down. I tried other supposedly tasty fish attractants to no avail.

"What happened? Why aren't they biting anymore?"

"I don't suppose you want to drain your pool?" I responded. He gave me one of those looks. "Corbina like feeding at night, in the dark, and maybe this water's too deep."

CATCH ONE!

Corbina fishing hits its peak between July and September in Southern California. If you don't have sand crabs, cover the hook completely with a bloodworm, clam, shrimp, or mussel. Use the lightest leader you can.

"You want to come back and try again tonight?" he asked.

"Nope. I'm here now." Back at my car, I exchanged our rods and tackle for the five-gallon pail holding my cast net. I draped the eight-foot circular net over my arms and shoulder. With a foot-planted twist and a throw, the net — uncharacteristically for me — opened perfectly the first time and covered most of the deep end. After it settled to the bottom, I pulled it up and carried about a third of the school over to the sea wall where I dumped them into the harbor. Several more throws and my friend had his pool to himself again.

"Too bad we couldn't have just moved the sea lion one house over," I said. "He would've made short work of the corbina."

"So that's what they mean by catch and release, eh?" he smiled with relief.

"Just don't tell the rangers next door," I whispered. "It's illegal to catch corbina with a net."

DISTRIBUTION

A Pacific species of the kingfish family, the California corbina is also called a California kingcroaker. Found along sandy bottom shores, between the Gulf of California and Point Conception, California, it's a popular pier fishing catch but has a reputation for being temperamental and hard to catch. A good fighter, corbina make good eating.

ORANGEMOUTH CORVINA

West Coast anglers head south to Mexico in search of the biggest orangemouth. Up to fifty-pounders can be found along the Central and South American coasts as far south as Peru as well as throughout the Sea of Cortez. They can be caught up the coast of California, too, but they get smaller as you head north, unless you go to the oddest place you can imagine to find such a fish, the Salton Sea. Suffering delusions of grandeur, the Salton Sea is actually a lake with unusually high salinity.

DISTRIBUTION

Along the West Coast from California down to Central America, and in California's Salton Sea.

Between 1905 and 1907, water managers accidentally diverted enough flood water from the Colorado River to form the Salton Sea, a body of water approximately thirty-five miles long by fifteen miles at its widest point. Located about fifty miles southeast of Palm Springs, California, the Salton covers a little more than 350 square miles.

Back in the 1950s, the California Department of Fish and Game dumped dozens of species of fish into the Salton Sea in an effort to bring sport fishermen into the area. Unfortunately, only three of the introduced species survived: bairdiella, sargo, and orangemouth corvina. In the 1970s, California Fish and Game determined that the Mozambique tilapia would survive there, too. Ergo, in

they went and now, those not eaten by the orangemouth corvina, thrive. In fact, in the Salton Sea, orangemouth corvina qualify as the apex predator, eating everyone else at one time or another.

Unlike open water stocks, corvina in the Salton Sea average five to ten pounds, with the occasional lunker. Another difference between the two stocks is that in the open water ocean, orangemouth corvina travel in schools and most anglers catch them in the upper seventy-five feet of the water column. In the Salton Sea, more single fish are found.

Orangemouth corvina taste considerably better than their better-known cousin, the redfish or red drum. But both are croakers, so named for both the thrumming noise they make with their air bladders when they are lifted the out of the water, and for the same noise they make in the water to attract females. That's right–drummers are always male.

In Central America, orangemouth corvina are a popular choice for ceviche, a raw (but marinated) fish dish. Combine oil, salt and pepper, chopped onions, red pepper, garlic, and lime juice in a bowl. Add hot sauce if you're so inclined. Cut corvina fillets into bite-size cubes and stir into marinade. Let stand in refrigerator for at least an hour. Serve on crackers or with toothpicks. If orangemouth corvina can't be found at your fishmonger, any other non-oily fish can be used for ceviche.

BIGGEST CATCH

Señor Felipe Estrada holds the world record for the orangemouth corvina he caught at Sabana Grande in Guayaquil, Ecuador on July 29, 1992. It weighed an impressive 54 pounds, 3 ounces.

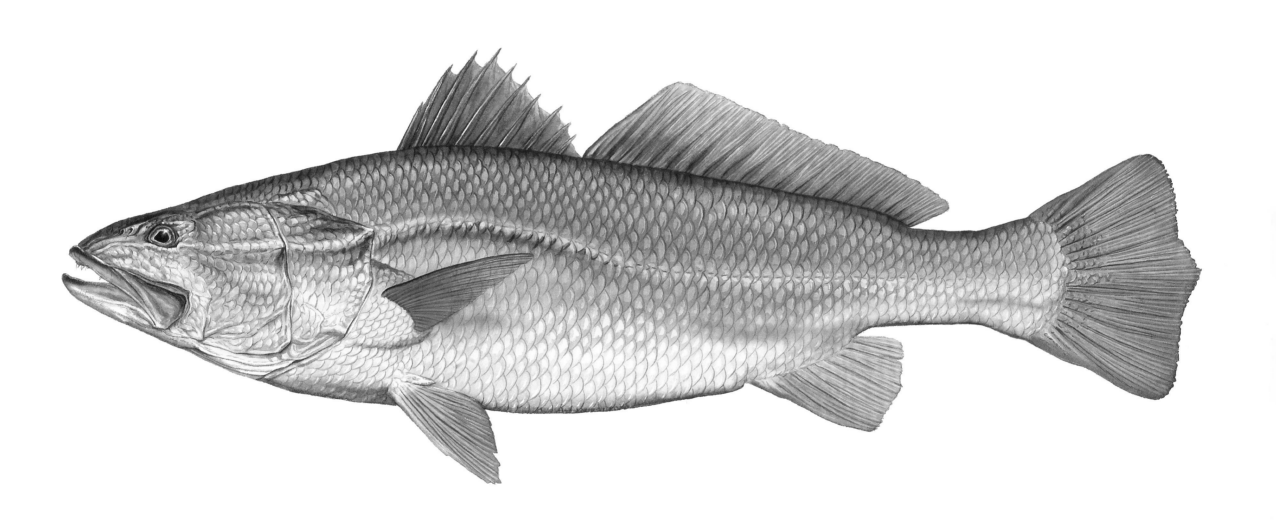

ORANGEMOUTH CORVINA

(Cynoscion xanthulus) Size 24–45 inches. Weight 15–50 lbs

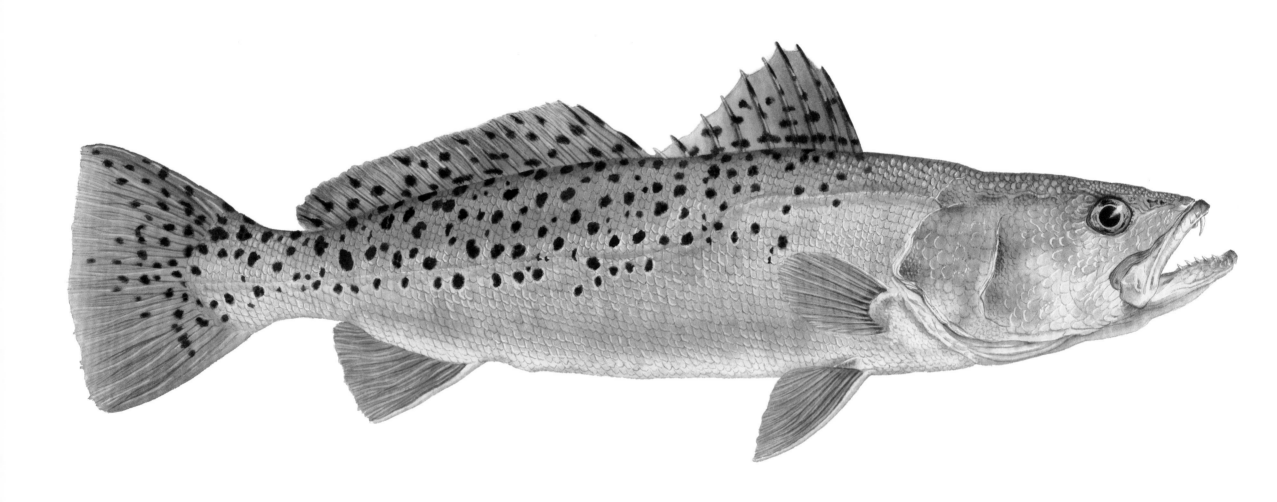

SPOTTED SEATROUT

(Cynoscion nebulosus) Size 19–25 inches. Weight 1–4 lbs

(Cynoscion nebulosus)

SPOTTED SEATROUT

I freely admit to having a terrible memory for dates and names. But I can remember where and what I was doing during particular historic occasions. When President Kennedy died, I sat home with the flu and watched every minute of the proceedings on television.

When man first landed on the moon, I listened to the account of it on the car radio while driving to Woodstock. Spotted seatrout hold a special place in my memory, too. My friend Nick Miller and I had traveled to the wilds of southwest Florida to fish for trout and redfish. And fishing turned out to be great. We'd been fishing some nice weed beds for about an hour, hooking up to a fish on just about every cast. It felt great to be so remote — so far removed from civilization — except for Nick's technology shackles, of course. He goes nowhere without his cell phone, Blackberry or whatever new gadget-of-the-month.

Just as I hooked into what we call a Gator trout (for its exceptionally large size) the gadget

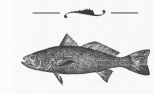

CATCH ONE!
A very popular inshore gamefish, the spotted seatrout is caught with live shrimp, small fish or crabs, or with jigs, spoons, poppers (for shallow water) and other lures that resemble finger mullets.

on Nick's waist started buzzing. Surprised he even had reception there, he popped the cell phone off his belt and read the message.

"I get news headlines sent to me as urgent e-mails," he crowed.

"Gee, that's fabulous," I thought to myself, being as anti-communication technology as Nick is pro. I knelt down to carefully remove the hook from the bright yellow mouth of a huge trout and let it slide off my hand back into the shallow water.

"A plane just crashed into the World Trade Center," he said totally deadpan, as if he didn't really believe it.

For the next hour, his belt buzzed often. The second plane crashed into the other tower. The towers collapsed. The third plane hit the Pentagon. A fourth plane crashed in Pennsylvania.

How bizarre to get such devastating news and yet be so physically detached from the civilized world. We discussed what our reaction should be. We couldn't have felt safer ourselves. Terrorists couldn't possibly find the two of us down there. Heck, we could hardly find where we were ourselves. Should we head home or keep fishing?

In the end, we kept fishing, though with notably diminished cheer. We had no one to comfort nor could we make any difference by returning home. But like the rest of the country, we took it very personally. And we still do. After all, it wasn't an attack on the World Trade Center. It was an attack against our entire philosophy of life. It just doesn't get more personal than that.

FIND ONE!
Spotted seatrout tolerate a wide variety of water from open ocean to coastal rivers. Warmer weather generally finds them closer to shore, in grassy areas until colder weather moves them into deeper waters.

DISTRIBUTION
Known as sea trout, spots, spotted weakfish, squeteague, speckled trout, Gator trout, winter trout, salmon trout, and black trout, these fish inhabit most of the western Atlantic coast and Gulf of Mexico. They mostly eat shrimp when available.

(Sciaenops ocellatus)

REDFISH

When the red snapper fishery collapsed in the Gulf of Mexico, commercial fishing interests proceeded to target redfish in its place. Nowhere near as tasty as snapper, redfish had trouble gaining popularity with consumers until Chef Paul Prudhomme invented his famous Cajun blackening seasoning. It effectively covered up the taste of the redfish, growing its popularity dramatically, right up until the time when that fishery collapsed from overfishing, too.

DISTRIBUTION

Most populous between Long Island and southern Florida to the Gulf Coast, redfish can be found as far north as Massachusetts. The larger redfish stay offshore in deeper water often in large schools. Smaller redfish can be caught in coastal rivers and shallow grassy areas.

Captain Joe Roberts backed the trailer down the ramp while I swatted no-see-ums on every exposed bit of skin. Turns out they love Skin-So-Soft.™ Fortunately, a boat that only weighs five hundred pounds doesn't take much effort to launch. Within minutes, we quietly idled out the Haulover Canal and onto a flat in the world famous (and aptly named) Mosquito Lagoon. Anglers travel to this section of the Cape Canaveral National Wildlife Refuge to try their luck with speckled trout, triple tail, snook, and other species. But armed with my trusty seven-weight flyrod, I wanted redfish and Captain Joe could put me on them if anyone could.

As with golf and several other pastimes, one can learn the basics of casting in a few minutes, then spend the rest of your life trying to get good at it. I have had the great fortune of receiving personal instruction (usually right after I've done something really stupid) from the best flycasters in the world. No lesser instructors than Lefty Kreh, Stu Apte, Flip Pallot, Rick Ruoff, and Chico Fernandez, not to mention myriad flats guides, have shrugged their shoulders in frustration after I've repeatedly flubbed what should have been an easy presentation.

Personally I think the zen of flyfishing is what appeals to me most. My competitive spirit hates to admit that when I'm flyfishing, actually catching a fish is of secondary importance — subjugated by the quest for the perfect cast. Combine this frame of mind with countless forms of wildlife, in a pristine environment, virtually total silence as the guide pushes our boat along with a pole rather than a motor, and the sun rising over the Atlantic; flyfishing becomes a meditative endeavor.

Just as the sun generates enough light to see the water's surface, Captain Joe "psssts" me and points in the opposite direction from where I was looking. There, barely visible, the slightest disturbance of the water moves in the shape of a vee across the flat. Something beneath the surface is pushing the water up above the surrounding surface by maybe a half inch. Unless you knew to look for that specific phenomenon, the average viewer would notice nothing at all.

"They're coming towards us. Quick, drop your fly in front of them but only about twenty feet out," whispered Joe.

CATCH ONE!

Male redfish, more formally known as red drum, make a throaty drumming noise with their swim bladder to attract female redfish during mating season — hence the name drum.

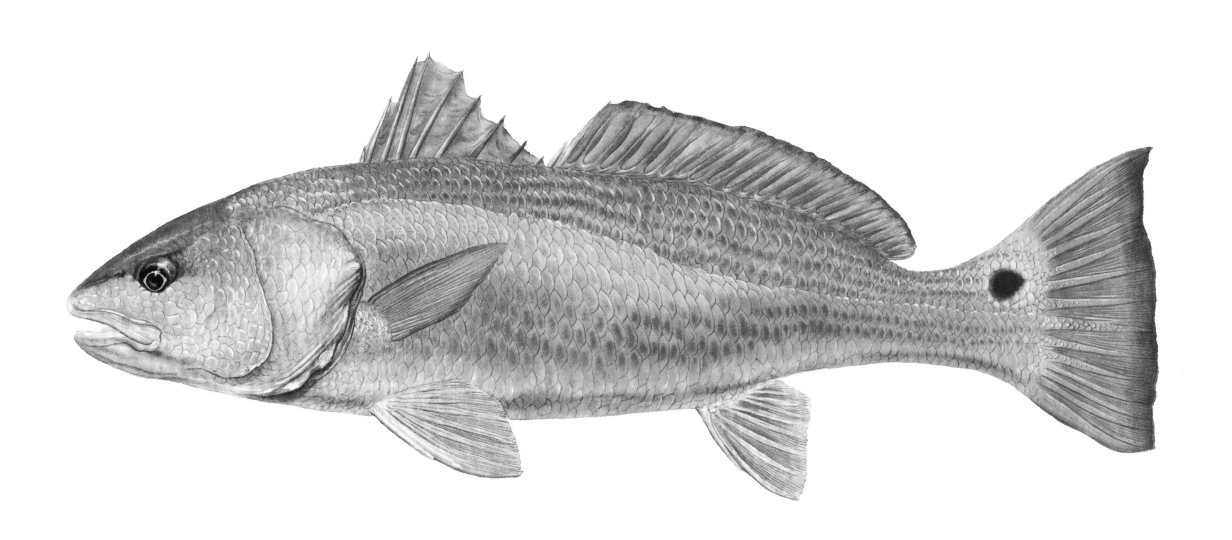

REDFISH

(Sciaenops ocellatus) Size 11–30+ inches. Weight 5–30+ lbs

I have a problem with that. I can power a fly out almost to the end of my flyline — perhaps one hundred twenty feet — maybe more. Ask me to accurately cast it a boat-length in front of me and odds against success instantly stack up like planes over LaGuardia in a rainstorm. I carefully strip some line and start false-casting to move the line out across the water. When I let it go, it stops way short of my mark. I was standing on the excess line lying in the deck. The fly plops onto the water and the fish immediately change direction.

"Geez, Dean," said Captain Joe in a tone that let me know I had just wasted his time, guiding skills, and vast knowledge.

The school of reds made a big circle that Captain Joe transected so I could try again with them crossing our bow from left to right. He didn't have to say a word. Desperate for his approval, I proceeded to lay out sixty feet of flyline on the water as gently as a man tells his wife her jeans are too tight.

Here they come. My epoxy shrimp lay in amongst the turtle grass right in the middle of their path. Little twitch. Little twitch, twitch, twitch. I feel the line pull

EAT ONE!

Up to about ten pounds, redfish make for excellent eating and can be frozen if the darkest parts are first trimmed off. Redfish are great blackened. Dip fillets in butter, roll in a mixture of black and white pepper and paprika, and then fry in a hot dry cast iron skillet.

tight as the red leader gobbles up what amounts to the plastic sushi in the Japanese restaurant window. I pull back on the line between my fingers then slowly let the fish take the excess line until it stretches taut between the fish and the reel.

In my book, the best part of fishing has just finished. Certainly the fish might get away, but from a challenge standpoint, this battle is a fait accompli. But I enjoy reeling a red to the boat and resting it across the palm of my hand upside down. Like an alligator (also present in Mosquito Lagoon) it goes into a trance, allowing you to remove the hook and place it tenderly back in the water.

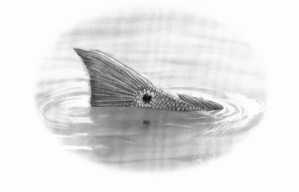

Recent scientific research concluded that our ears once served as gill openings.

The long-held belief that humans developed ears after evolving out of the sea, on to dry land, recently changed following extensive examination of the ear bones of a 370-million-year-old fossil fish called Panderichthys. This fish displays a transition form of ear bone that is believed to be a link between fish and early land animals. In the latter, apparently a small bone called the *hyomandibula* developed a kink, obstructing what was the gill opening in Panderichthys. The bone continued to recede in later animals, creating the cavity now known as the middle ear.

DRUMS AND CROAKERS

Some 275 species in 70 genera comprise this fascinating group of fish known technically as Sciaenids and colloquially as drums or croakers. They all make a remarkable thrumming noise by vibrating their abdominal muscles against their inflated air bladders. Scientists believe this might be a means of attracting mates. (It seems to work for some humans like Ginger Baker, Buddy Rich, Louis Bellson, and Art Blakey, too.) Certainly when removed from the water, these fish drum as a warning or out of fear.

I once saw a guide lay down in the bottom of his boat and put his ear to the aluminum hull to pinpoint the noise from spawning black drum we wanted to catch on flyrods. Talk about being in tune with your quarry!

Dr. R. Grant Gilmore, Jr. studies the noises fish make and these noises certainly don't limit themselves to drums and croakers. An estimated 200 fish species produce mating calls at night on the east Florida continental shelf. Species found in deeper waters such as hake, cod ling, and rattails also produce mating noises.

Most drums mature sexually very early in life. When that happens, they reproduce in prodigious numbers, with a female laying as many as a million or more eggs (depending upon her size) every two or three days over a period of many months. Fisheries biologists believe the average Sciaenid lifespan runs about seventeen years without outside interference.

At one time, scientists used nets to capture drums and croakers in order to study them. Now, they monitor these fish with hydrophones rather than removing them from their environment. Combined with low-light cameras on the ocean bottom or on remote-control submersible vehicles, scientists can glean far more valuable information about these fish in their natural habitat without disturbing them. That's the epitome of a win-win situation.

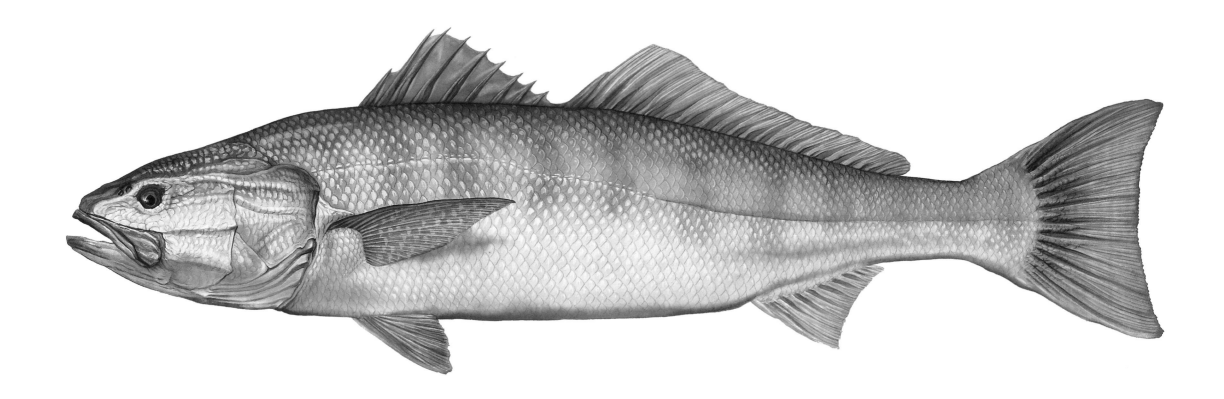

WHITE SEABASS

(Cynoscion nobilis) Size 20–40 inches. Weight 20–60+ lbs

WHITE SEABASS

I met my friend L'okepa in San Diego for a boat show. L'okepa, a native Hawaiian, owns a boat dealership on Oahu. He and I, and several others, took a pair of outboard-powered catamarans from Oahu to Midway Island, about 1,350 miles across the Pacific through the mostly uninhabited northwest chain of Hawaiian Islands.

L'okepa's one of the best free-divers and spearfisherman I know. We finished our business in San Diego and L'okepa suggested we try some diving in the kelp beds off La Jolla. The only thing I knew about kelp beds was that abalone divers sometimes tried to hide in them if a great white shark was around. (That's the rumor that I'd heard anyway.) So off we went to a "place of interest" as he put it.

"You say you like redfishing. Well, there's something here I want you to see," he insisted.

We anchored at the down-current edge of what looked like a huge green mat of wide leaves. As I buckled on my weight belt over my wetsuit, L'okepa suggested I slide my diving knife around the inside of my leg. "That way, the handle of your knife won't snag. Diving in kelp can tangle you up if you aren't careful." He offered several other suggestions like filling my mouth with water when I started down so no bubbles would trickle out of the end of my snorkel, and not to let my fins bang into each other.

"Just what are we stalking here?" I asked.

L'okepa pulled his mask down over his face, gave it his signature quick pull-away adjustments and said "White seabass," as he stuffed the mouthpiece of his snorkel in place and rolled over backwards into the sea. I followed him and after giving the international OKAY sign, he

ANCIENT FISH

Archeologists investigating native American middens believe that approximately 8,300 years ago, early Holocene people along the California coast caught fish with nets. Notable finds included the beautiful otoliths (earbones) of the white seabass, which scientists conjecture were once used as currency. Otoliths grow like the rings of trees and can be used to determine age and growth patterns.

led me down about thirty feet and then upcurrent into the kelp.

Near the far side of the bed, L'okepa stopped me and pointed down at three large fish, two in the forty-pound range, and a third that was much larger. The smaller ones glistened with pure silver while the third had pronounced black, vertical stripes. The two silvers kept rubbing up against, and occasionally bumping into stripey. I could only assume that I was witnessing the mating ritual of the wild white seabass.

Back on the boat, L'okepa commented that the two silvers were, in fact, males and though they looked silver when we saw them, they had the capability to change their colors, like chameleons. Had we come upon them inside the kelp bed, they might have been a much darker color.

Either way, what a treat.

DISTRIBUTION

White seabass is really a drum fish and the males vocalize by contracting muscles to vibrate the swim bladder. Its range in the Pacific is Alaska to Chile but they are most common between San Francisco and the middle of Baja California.

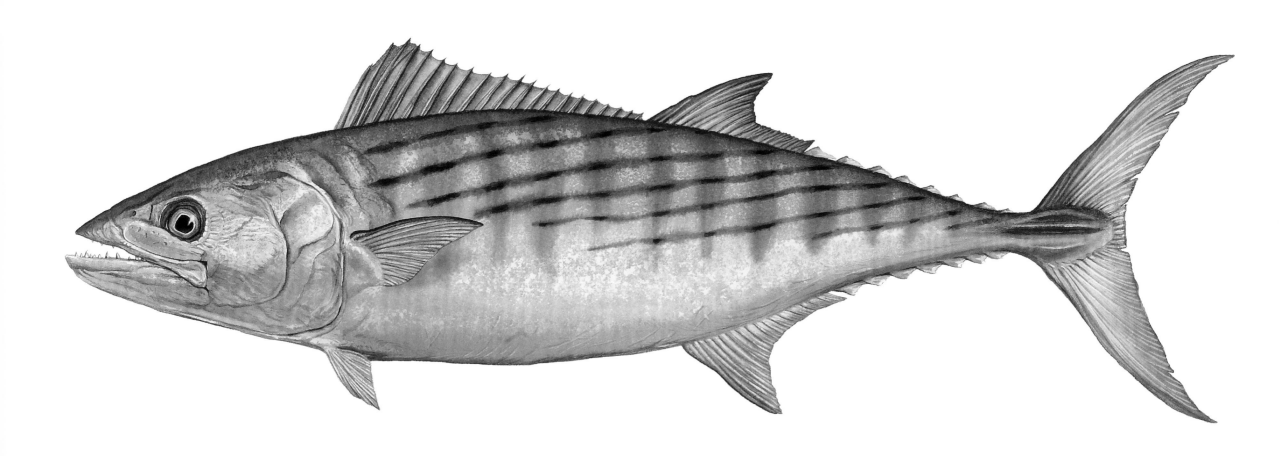

ATLANTIC BONITO

(Sarda sarda) Size 1–3 feet. Weight 4–10 lbs

(Sarda sarda)

ATLANTIC BONITO

I held my new stabilized binoculars to my face and scanned the horizon until the concentration caused a pain in my skull just above the bridge of my nose. Birds. I desperately need to find birds.

That's how you find tuna fish. Find gannets, frigates, common seagulls, or even Mother Carey's chickens swooping and swirling in a cloud above a patch of ocean and you'll find tuna underneath them with ninety-nine percent certainty.

Big, expensive boats with money to burn have radar powerful enough to see flocks of feeding birds from five or even ten miles away. I suffer from being considerably lower-tech. Of course, it's all relative. I have an advantage over those without big binoculars. Not that it seemed to be helping me.

"Look at about ten-o'clock" said my friend and Key West guide, RT Trosset. Playing the glasses in that direction, I rejoiced at the splotch of birds wheeling on the horizon.

"Yep. That's them. Hit it!"

CATCH ONE!

Try ten pound test line. For live bait use mackerel or butterfish, or spin cast with lures. Its firm, dark meat is popular as a fried fish in the Mediterranean.

From our eye level, the sky met the earth about two miles away. The birds' elevation let us see them at about three miles distant. With a pair of 250-hp outboards that pushed us to sixty mph, we reached the birds long before they scattered. Once there, I could plainly see that these weren't the yellowfin or even the blackfin tuna we had hoped for, but the bane of every offshore angler's existence — the bonita. We mostly sacrifice our bait to them and get nothing in return.

I had no marlin aspirations today. I had eight guests coming for dinner and I really wanted some edible tuna for the grill. Bonita absolutely don't qualify as edible in my book. RT broke out the bycatch he'd gotten earlier from a shrimper anchored outside the

EXCITING GAMEFISH

Despite the story on this page, bonito are favored targets of many light tackle and fly fishermen. They are extremely fast swimmers and aggressive feeders who occasionally come near shore but are more often found in open sea.

harbor and started tossing handful after prickly handful of the juvenile fish, sponges, manta shrimp, and crabs over the side. The school of bonita came to the boat like kids responding to the bell on the ice cream truck.

"Watch closely," RT instructed as he pointed down into the water. "There. And there. There's another. See the ones with the black upper body cycling through with the bonita? Those are the blackfin. Now watch," he said as he dangled bait from the tip of his spinning rod. A blackfin come up from the depths and rolled on its side as it inhaled some bycatch near the surface. RT carefully dropped his bait in the water just as the next blackfin neared the surface.

"If you just throw it in and hope for the best, you'll be feeding a lot of bonita. You have to be selective and only feed the…" Pow-ziiiing and RT had his first blackfin on the line. The timing — like so many things in life — didn't come as easily as RT made it look. But ultimately, dinner went well.

DISTRIBUTION

The Atlantic bonito (S. sarda) is only found in the Atlantic Ocean, and the Mediterranean and Black Seas. In North America they range from off Nova Scotia to Florida but are more concentrated between Cape Cod and northern Florida.

Albacores, Bonitos, Mackerels, and Tunas

BLUEFIN TUNA

You may not give it a second thought as you eat your bluefin tuna (toro) sashimi.

Or maybe you've noticed how obscenely expensive bluefin has become.

Bluefin tuna represents the single most valuable fish in the sea and for that very reason it may well become extinct in our lifetimes.

Since 1967, the numbers of bluefin tuna caught by American commercial fishermen has declined by ninety-seven percent. The International Commission for the Conservation of Atlantic Tunas (ICCAT) makes rules for managing what scientists now realize is a single Atlantic stock, rather than two separate (Eastern and Western) stocks. While North American fishermen abide by the rules, few other countries do, so the bluefin tuna species continues to be decimated. When asked why the United States doesn't bring pressure to bear on the scofflaw signatories of the ICCAT, President George H. W. Bush said that the decision-makers in Washington, D.C. establish priorities. Apparently the health of our oceans and fisheries has not been a priority.

I rely on a few trusted experts and guides to help me get fish, both for sport and for painting. For the bluefin, I returned to the waters off Chatham in Cape Cod with Jeff Walthers and his boat the *Tuna Tickler*.

Earlier that season I had gone out several times on my step-father Cliff Hagberg's tuna boat in unfavorable conditions. We came up empty handed. Cliff is one of the rare harpoon fishermen left on the Cape. He considers himself a recreational tuna fisherman, though in the past, he has sold his catch for a few extra bucks. In the early 1990s, Cliff and Dave Zippay harpooned and landed a 1,100-pound bluefin. But today, most of the Cape's tuna fishermen survive on a slim margin of profit and each year bluefin fishing on the Cape has become a riskier way to support oneself and family. Cliff expressed his concern with the numbers and size of the bluefin stocks entering Cape Cod Bay in recent years. Each year he has to go out earlier and stay out longer, covering more water, to find large fish. The past two years have been particularly tough.

Back aboard Walther's *Tuna Tickler*, we started trolling a squid rig twelve miles off the beach, eastward out into the Atlantic from Chatham. Twice we ran into schools of bluefin in the thirty-five to forty-nine pound weight class and landed three for a few hours effort. Since then, Jeff said that in 2005 they had days where they caught forty to fifty smaller bluefins. One can only hope this is an encouraging sign in this era of declining numbers of juvenile fish. FLICK FORD

DISTRIBUTION

From Newfoundland to south Florida. Their summer range is North Carolina to southern Labrador. The fishery is made up of three sizes, each with a separate distribution and migration patterns.

CATCH ONE!

Use 80–130 weight tackle for these hard-fighting fish. You can troll or use live bait such as herring, mackerel, or squid. Most bluefin caught in North America end up in Tokyo. Release large females, especially around spawning time.

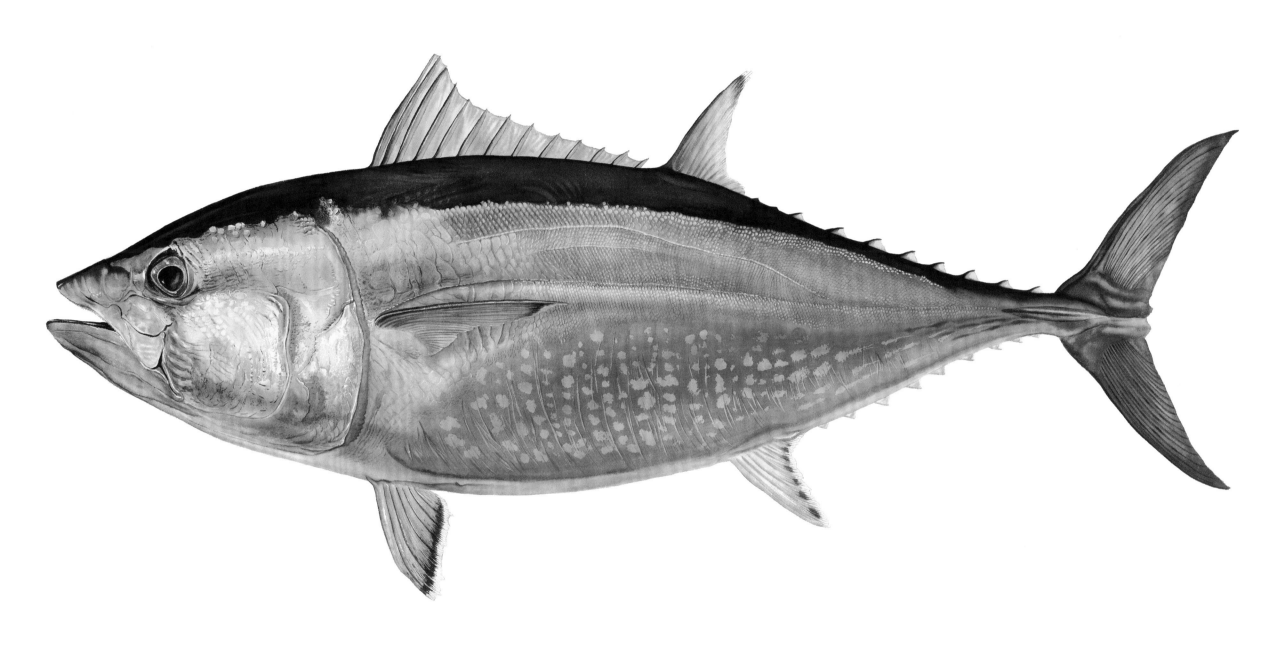

BLUEFIN TUNA

(*Thunnus thynnus*) *Size 3–15 feet. Weight 300–1,200 lbs*

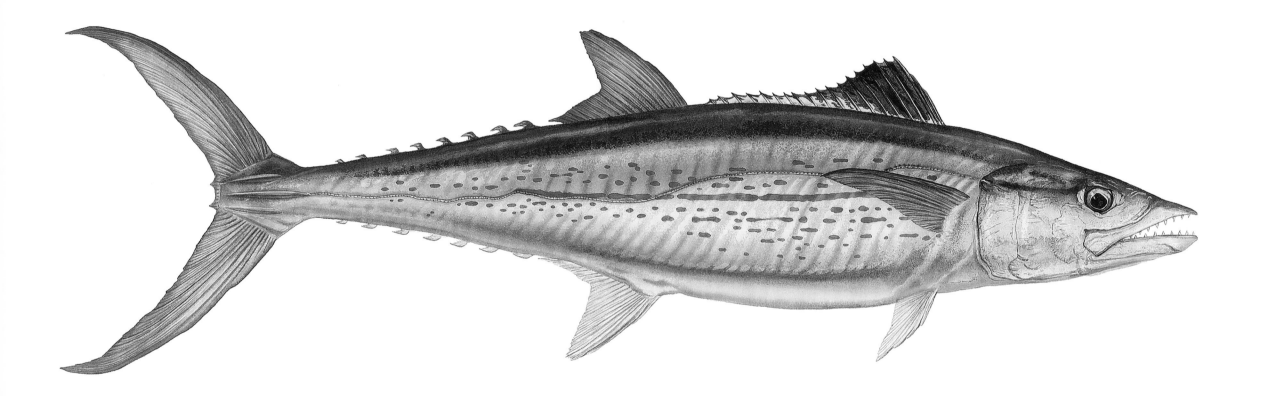

CERO

(Scomberomorus regalis) Weight 5–11 lbs

(Scomberomorus regalis)

CERO

Sometimes called the "painted mackerel" because of its beautiful coloring, the cero is delicious eating whether pan-fried, broiled, baked, or grilled. Cero taste good if cooked when absolutely fresh, but tend to the oily side of the mackerel family. Don't even think about freezing them for eating later. You may as well eat a menhaden.

Not so long ago, cero mackerel suffered some hard times. In waters up and down the East and Gulf coasts, spotter planes searched for schools of the feisty little creatures and when they found them, they directed commercial netters who would vacuum the entire school into their holds.

A 1995 Florida commercial net ban has worked wonders at replenishing the stocks of cero as well as other mackerel, mullet, and a host of other species. The trickle-down effect of the net ban has proven quite miraculous. Many species not targeted by commercial interests depended on a targeted species, like cero, for food. When the food stock returns, so do the predator species including wahoo, sharks,

CERO, KING OR SPANISH?

Fishermen often confuse the cero with the king and Spanish mackerel. The cero has a mid-lateral bronze stripe with several rows of orange-yellow streaks and yellow spots along the lateral stripe.

and dolphins.

Usually solitary, cero will sometimes school over reefs, ledges, and wrecks. Cero seem to be creatures of habit, following the same general routes in their travels. Find one of those routes and you stand an excellent chance of finding cero. As with tuna fishing, cero can be spotted by searching for circling birds and chasing the cero down by boat. Once found, they can be brought right up to the boat with a bag of bloody chum hung over the side.

Cero are aggressive little buggers, striking at anything the glitters or jiggles

CATCH ONE!

Look for ceros on coral reefs and shoals, although they can be found in open water. They are great fighters and jumpers when hooked. Use light tackle, and troll with feathers or live bait.

in front of them. Consequently, surface plugs, jigs, and spoons all work perfectly well. However, you'll be hard-pressed to find a more exciting method than a surface plug. It's always impressive to watch the violence of nature that usually takes place unseen, below the surface. When fishing this way, expect to catch a variety of other species, but you'll know when a cero takes a bait. The reel will sing as the cero embarks on a blistering run for a hundred yards if you're using light tackle. And believe me, there's really no better or more fun way than going light.

Most plugs come with treble hooks: three hooks attached to a single eye. They tangle with every other plug, you'll inevitably get jabbed with a treble hook, and they're harder to remove from the fish if you want to release it. I buy inexpensive single hooks to replace all my treble hooks. Just unscrew the treble hook from the plug and screw in the singlet. Problem solved.

DISTRIBUTION

Like most mackerel, cero migrate with the warm water. Expect to find them as far north as Massachusetts in the summer and, like veritable snowbirds, in South Florida during December, January, and February.

FALSE ALBACORE

What a gorgeous crisp, fall day! The town of Hatteras on North Carolina's Outer Banks still had a seasonally elevated population, but nothing like the height of summer. In the old days, the town all but disappeared from the state's collective consciousness during the winter. But since the winter bluefin tuna fishery took off here, most businesses that used to be seasonal now operate year round.

But we came for flyfishing action. I find the best times along the Outer Banks to be early October through about New Year's. At this time of year, false albacore line the beaches and nearshore areas making for some terrific light tackle sport. Like many other fish, false albacore go by other names such as little tunny, little tuna, and Atlantic little tunny. Closely related to the Pacific kawakawa, they strike aggressively and fight until they die unless you know what you're doing. And unlike many other fish, false albacore aren't hard to find. Just look for areas where the water looks like its boiling. That's them.

I generally use an eight- or nine-weight rod in normal winds or a ten-pound spinning rig if I'm not casting a fly. Of course, the term "fly" might be a misnomer in this case. Where trout fisherman try to tie fluffy little things that look like newborn insects, in saltwater we try to use things that — when wet — look like small fish or other things the bigger fish like to eat. Since saltwater fish generally grow larger than most freshwater species, I also put lots of strong braided backing on the reel so a strong fish that wants to run won't take every bit of line I have. One of the worst things a fisherman planning on releasing fish can do is get spooled (let a fish steal all the line off the reel). Inevitably this kills the fish since all that trailing line gets wrapped around the fish's tail or some structure and that's the end of the story.

False albacore just don't give up. Consequently, an angler must be skilled enough and have stout enough tackle to catch the fish quickly, unhook them and release them unharmed. I used to bend the barbs down on my hooks to make releasing them easier. Now I always use circle hooks and a dehooker that makes very quick work of the release. I rarely even take the fish out of the water anymore.

In case your hunter/gatherer instinct kicks in when you get your tunny close at hand, they taste like the cream you put on a baby's rashy bottom, so don't bother bringing them home.

DISTRIBUTION
False albacore are found in warm and tropical waters from New England to Brazil and Bermuda to Britain as well as the Mediterranean. Look for huge swarms of birds feeding on the scraps left by the false albacores' feeding frenzy.

MR. PRESIDENT
President George H. W. Bush claims that flyfishing for false albacore is one of his favorite pastimes. He specifically ordered his fishing boats without T-tops so as to not obstruct casting.

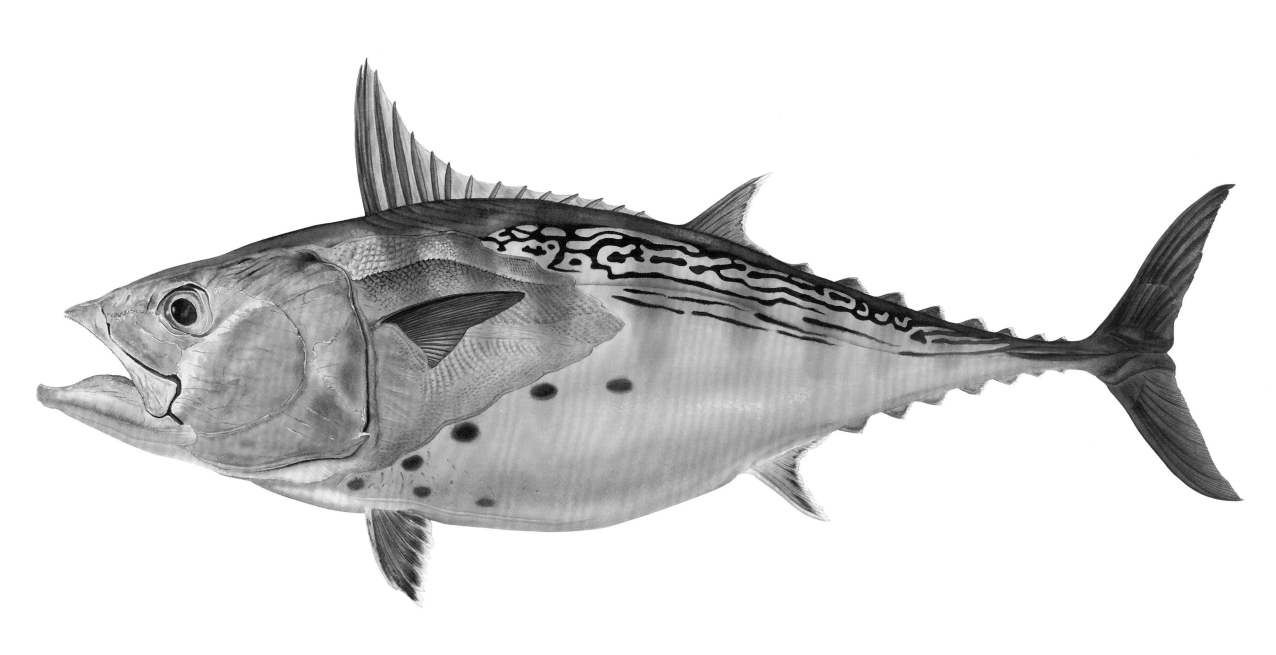

FALSE ALBACORE
(*Euthynnus alletteratus*) Size 1–2 1/2 feet. Weight 10–20 lbs

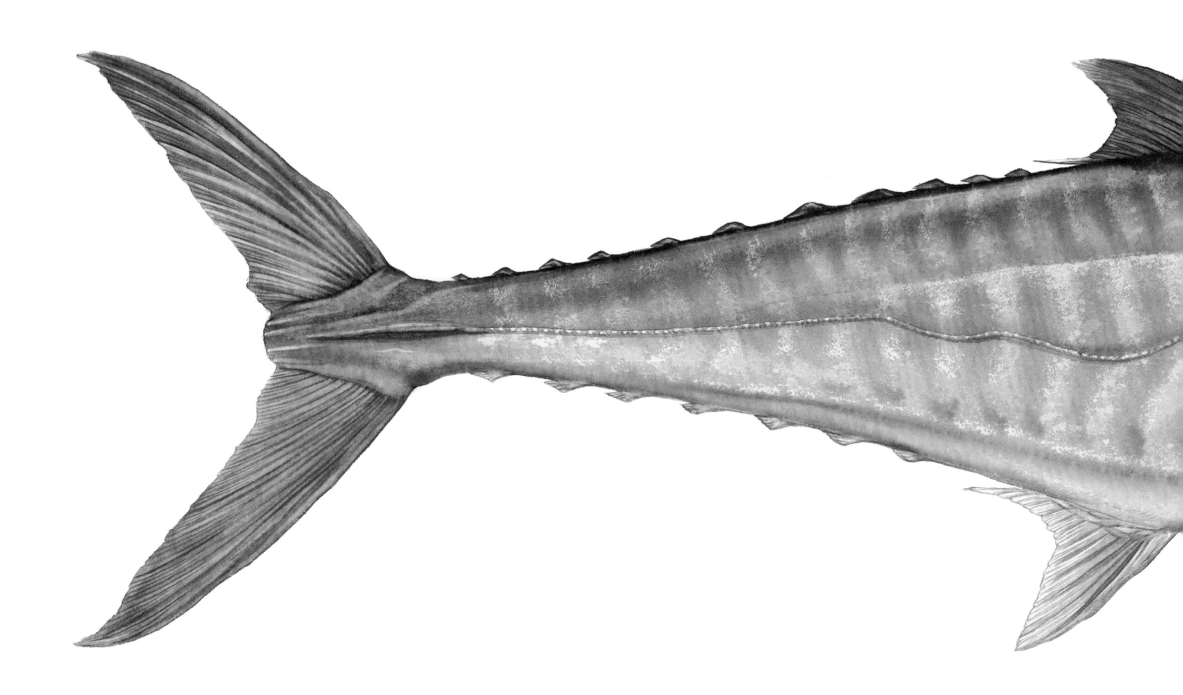

KING MACKEREL

(Scomberomorus cavalla) Weight 2–50 lbs

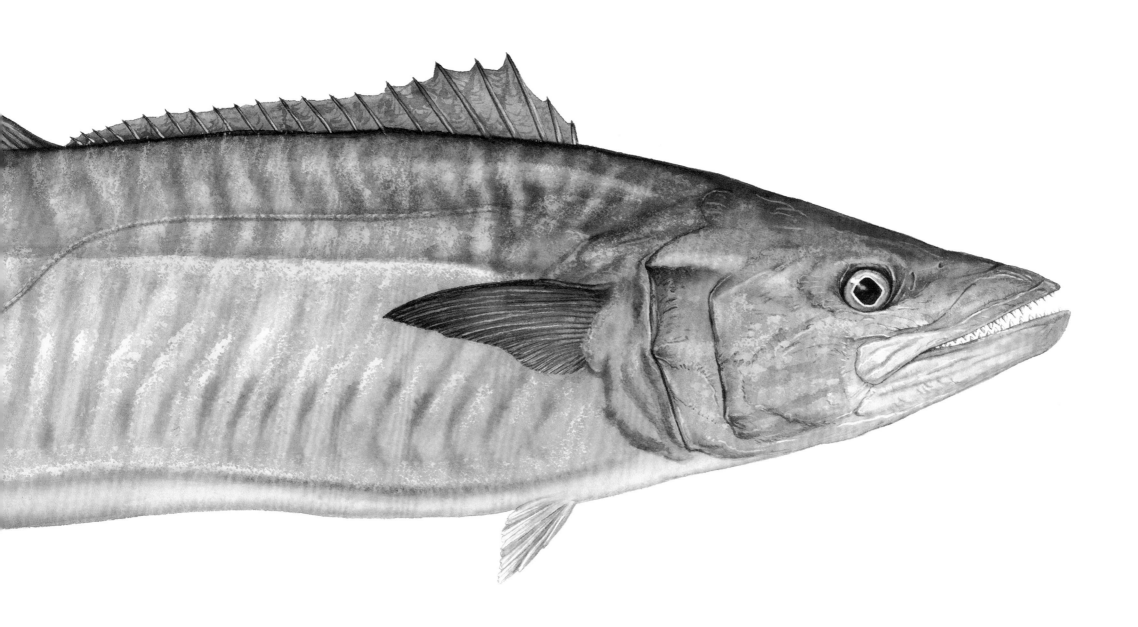

KING MACKEREL

Those Kingfish Tournament circuit anglers are the NASCAR *drivers of fishing.*

— *REGGIE FOUNTAIN, PRESIDENT OF FOUNTAIN POWERBOATS*

The boat trend among almost all offshore fishermen is toward bigger, faster, more expensive. This holds especially true among the elite kingfish tournament circuit participants. Why? Money. These teams want to catch the biggest kingfish each day.

CATCH ONE!
King mackerel can be caught with spinning or baitcasting tackle. Even fly tackle. Use surf tackle for pier and shore casting. On open water, drift with chum or cast lures (use larger diamond-shaped spoons to go after larger kings.) Some anglers prefer titanium wire to avoid sharp teeth biting through the leader.

DISTRIBUTION
King mackerel roam the western Atlantic from Massachusetts to São Paulo, Brazil. They primarily eat fish, shrimp, and squid. Water-temperature-dependent migrations of large schools cover considerable distances along the Atlantic Coast.

Sometimes that means traveling hundreds of miles roundtrip and they must return to a check-in point by a certain time. Sometimes the weather gets rough. To deal with these facts, one must consider the immutable laws of physics. Several factors make a boat go faster and ride smoother: waterline length, weight, hull design and power. It has become commonplace to see a thirty-eight-foot-long boat with three or even four huge outboards on the back. These boats run across the ocean's surface at speeds between sixty and eighty-five mph. Hitting even little waves can get dicey at those speeds. A ride like that will make even the heartiest sailor develop white knuckles. Frequent passenger participants have taken to sitting in oversized bean-bag chairs placed on the deck right by the transom to smooth the ride. Of course, these boats (between twenty-three and forty feet long) are designed specifically for high speeds with deep-vee bottoms for smooth landings when launching off a wave and with sharp bows to cut into oncoming seas. And strong? You could call these boats bullet-proof and be on the money.

Kingfish tournament boats usually go out a few days before the tournament to scope out the lay of the land if you will, meaning they need try to determine where the fish will be when the tournament starts. They know the kind of places kingfish like to frequent, add some local scuttlebutt to the mix, and then they put the throttles to the wall so they can get there before anyone else. Winning a tournament commonly boils down to being in a certain spot and getting your bait into the water as little as a minute or two before someone else in order to get the biggest fish.

On the morning of the tournament, all the go-fast boats line up between two points on the sea about a mile apart. At a predetermined signal from the officials, everyone floors it at the same time. What chaos! What a turbid maelstrom! Seas and wakes going every direction imaginable. And each boat trying to be at the front of the pack.

Most boats lure the fish to the boat with chum, cast a bait out to it, hook it up and then chase it down until the boat comes within ten or twelve feet, at which point someone aboard takes a twelve-foot-long pole with a

large, sharp steel hook on the end (called a gaff) and impales the fish in order to lift it aboard. Small fish don't win anything, so those get cut free before being gaffed. Anglers are allowed to weigh only one fish per day, so conservation is the rule rather than the exception.

Every boat runs to the harbor as fast as possible since the first to the scales of two identical fish will win. Watching these boats go airborne as they launch off seas qualifies as some of the most dramatic boating adventures you'll ever see and never hope to experience. Fortunately, manufacturers of these boats design and build them specifically to withstand the rigors of running at high speeds across open ocean. Unfortunately, God had different design parameters when creating man. This sport puts considerable strain on joints, feet, and spines. It's not uncommon for the boats to handle the abuse better than the passengers.

Back at the dock, the spectators cheer (as if the gladiators just entered the arena) when each boat pulls alongside to weigh their catch. Hundreds of thousands of dollars in cash and prizes can easily be at stake for each tournament not to mention point standings for the annual awards — much like the Winston or Nextel Cups. And don't be surprised at what these ocean cowboys have invested in the game: an outboard engine

alone can cost $20,000. Multiply that times three or four. Add the boat for $200,000 or more, $5,000–$10,000 worth of electronics, another $5,000 of tackle, the matching truck to pull the boat at $55,000, the vinyl "wrap" that places advertising and "ego art" on many of the hulls in lieu of painting that costs another few thousand. And then — oh, the fuel! That might run between $1,000 and $2,000 for a weekend. When you get

right down to it, there has to be a considerable reward for winning these tournaments. Otherwise, think of how much those kingfish fillets would ultimately cost! Without amortizing over an entire season, an average winning kingfish of about fifty-five pounds would run about $6,000 per pound. And it's not even the best eating fish — though I do like it smoked.

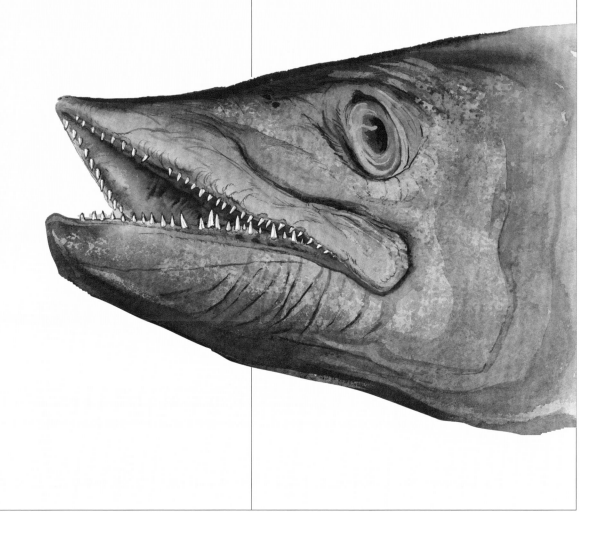

(Scomberomorus maculatus)

SPANISH MACKEREL

Thomas Jefferson Brown quietly stepped out of his bedroom so as to not wake his wife. The Spanish mackerel run was sure to start soon. It came a week earlier last year. Life got so much easier when he could just catch some fresh fish to eat rather than having to spend what little social security money he got from the government on groceries. Then there was Miss Eddie's medicine that kept getting more and more expensive. Yes sir, a month or two of the Spanish run would surely help.

Generally from the Chesapeake Bay south to Florida, in the western Atlantic. Largely coastal, Spanish mackerel will enter bays and rivers. They move north from Florida through the spring and can reach as far as Narragansett Bay by mid-summer.

"TJ" as his few surviving friends called him, quieted the door shut and got his fishing rod, floating live-bait bucket, and backpack with tackle from the shed out back and started his walk to the water. Sure, two miles at his age took a lot out of him, but he sold the car when the insurance got so high. Damned insurance companies. Worse than bankers and lawyers — sometimes, anyway.

He looked around for the guard and when he saw none, he slid through the rails on the fence surrounding the golf course and took the shortcut to the point. Since dawn didn't come for another hour, the guard was probably still asleep in the hut down by the gate.

Getting up so early wasn't so hard. At his age, he had to get up to go to the john anyway, so TJ just didn't go back to bed. Besides, he thought, as he crossed the sandspit, now I got the prime spot. I can reach the tidal rip and both sides of the spit from here. Cover that much more territory.

TJ hauled his ancient cast net out of his backpack. Time was that he could throw a full sixteen-foot diameter net without breaking a sweat. Now, well, the six-footer was plenty for catching the little baitfish he wanted for Spanish mackerel, and it was lighter to carry on his walk anyway.

CATCH ONE!

Spanish mackerel is a schooling fish that migrates north in the spring. Inshore, they are often found above grass beds and reefs. They prefer clear water and will break surface so fish the top if you see it's disturbed. Spanish tend to congregate by size.

He quietly waited for the telltale ripples of a school of fish pushing water, then with a 180-degree twist from the waist up, he opened that net into a perfect circle right where he wanted it and filled his bait bucket with that one toss.

As the sun pinked the sky over his left shoulder, he saw the first school of Spanish terrorizing the water's surface as they tore into a pod of little baitfish. TJ put a hook into a baitfish of his own and sailed it out into the midst of the violent melee. In an instant, his line came taut, he set the hook and started reeling in his mackerel.

Yep. Today has started out better than most, he thought. Miss Eddie will eat well tonight.

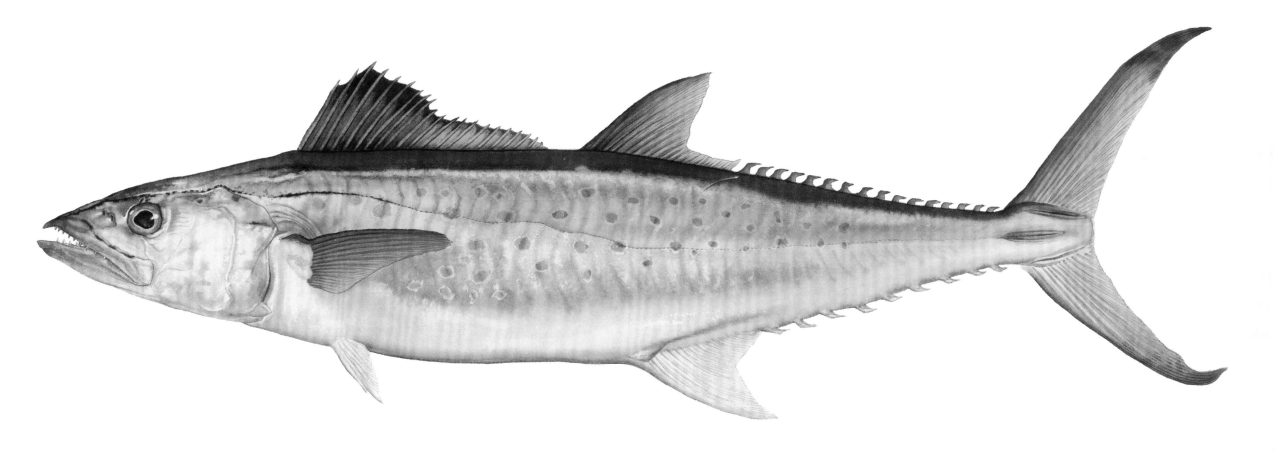

SPANISH MACKEREL

(*Scomberomorus maculatus*) Size 2–4 feet. Weight 2–8 lbs

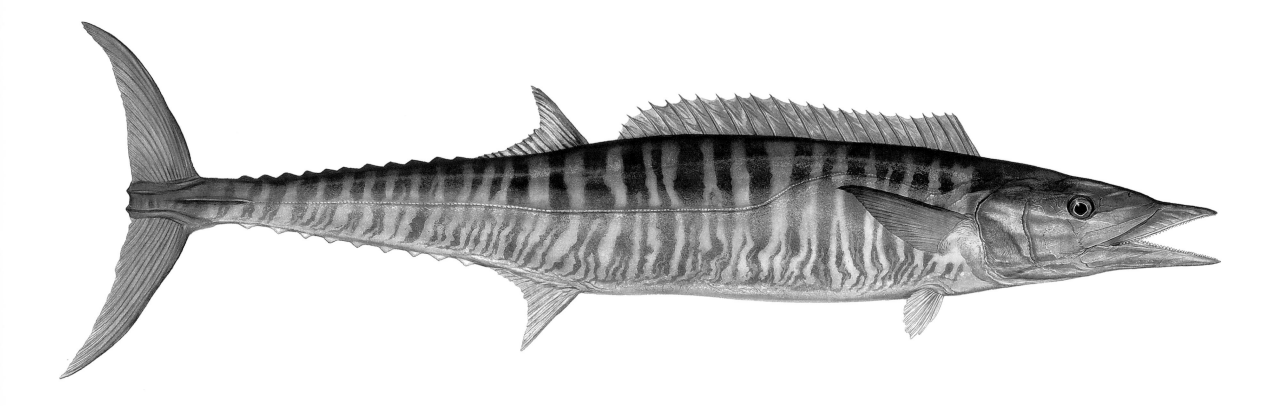

WAHOO
(Acanthocybium solandri) Size 39–66 inches. Weight 20–50 lbs

WAHOO

The charm of fishing is that it is the pursuit of what is elusive but attainable, a perpetual series of occasions for hope. – JOHN BUCHAN, 1915. Captain Ron Schatman taught me everything I know about good wahoo fishing. Schatman spends most of his time in Bimini, regularly sparring with the ghost of Hemingway as he walks along the street past the Compleat Angler Hotel on his way back to the Big Game Resort and Marina.

Sure, Schatman may arguably be the best deepwater bottom-fisherman alive today. He can find you world-records hiding three-quarters of a mile below the surface under some mountainside ledge. In fact, Schatman can probably keep up with the best of them on most any saltwater fish. But nobody — NOBODY — outfishes Schatman on wahoo.

For years, people tried to catch wahoo by trolling baits and artificial lures at sedate speeds, the same way they tried for a dozen other species. Nothing special. And they'd catch the occasional wahoo. Then Captain Schatman put his strange mind on it.

CATCH ONE!

Wahoo eat all types of school baitfish, ballyhoo, jacks, and houndfish. Larger wahoo go for larger prey like tuna and big bonito. The key to catching them is to work at their speed. A lure going 24 mph will be traveling at wahoo speed. Scientists estimate wahoo can top 50 mph in bursts.

"These are some *&%#@#-fast fish," he said in his gravel-toned New York accent, held over from some long ago time when he lived there. "And baitfish don't try to *$&%*# escape at *$&%*# trolling speed!"

And that understanding engendered a now-popular method called high-speed wahoo trolling. It involves using special, heavily weighted, bullet-shaped artificial lures that stay beneath the water's surface at speeds between eighteen and twenty-five knots (multiply by 1.15 for mph). When the wahoo strike at that speed, it's impres-

sive. For those who've only seen wahoo as steaks in the fish market or on a menu, let me explain its caché. This long, torpedo-shaped, silver javelin with dark vertical stripes develops electric-blue stripes when it gets excited — like when it thinks it's about to whack itself another tasty meal.

It strikes; the line pulls out of the trolling clip with a gunshot sound; the rod bends like a direction finder pointing at your quarry, and the reel almost suffers a meltdown so fast does that fish pull line on its initial run. Get it aboard and marvel at the slice-and-dice machinery in its oddly hinged mouth. Its teeth seem remarkably tiny for such a big fish, but a single hair drifting down across them would fall to the deck in two pieces.

Then, too, readers with only culinary experience with the species know, perhaps, all they need to: wahoo make for sublime dining.

DISTRIBUTION

Wahoo (called "ono" in the Pacific) run in very small schools or solo throughout tropical waters of the Atlantic, Indian and Pacific Oceans as well as the Caribbean and Mediterranean seas. Plus, there seem to be seasonal wahoo conventions off the Pacific coasts of Panama, Costa Rica and Mexico's Baja Peninsula in the summer, off the island of Grand Cayman in the Atlantic in the winter and spring, and off the western Bahamas and Bermuda in the spring and fall.

(Thunnus albacares)

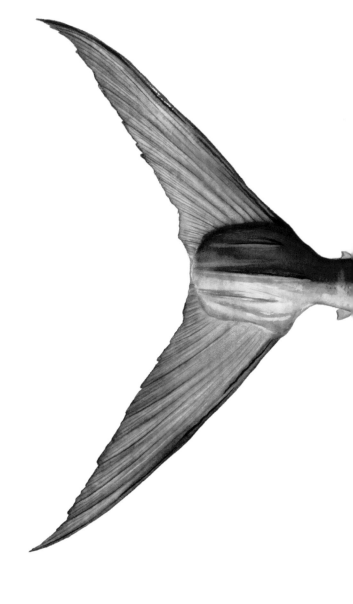

YELLOWFIN TUNA

I've caught yellowfin all over the world, but these were the biggest I had ever seen. Tuna surrounded us, leaping out of the water in an effort to catch the small white squid on which they gorged. Fish easily topping three hundred pounds jumping clean clear of the water. What a sight!

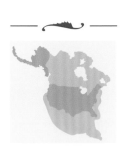

DISTRIBUTION

A highly migratory fish, yellowfin tuna are found in tropical and subtropical waters around the world. Rarely found inshore, they school in like-sized groups in open water. Yellowfin are a mainstay in the commercial tuna fishing industry.

Of course, this doesn't happen anywhere near where crowds of people go fishing. *Au contraire:* I had to travel to Hannibal Bank off the northwest coast of Panama to find these behemoths. We stayed at a scientific outpost on the south end of Coiba Island, which is largely national park except for the remote, high-security prison housing a few of the country's worst felons.

My host, Felix, makes roughing it a stylish pursuit. He arranged for one of his big, converted Chinese fishing trawlers to anchor off the beach with food, fuel, water, and tackle aboard. The crew of the converted trawler spent each night catching live bait for us to use during the day.

CATCH ONE!

Hooking into a big tuna has been described as hanging a steel cable from a manual winch over the side of a turnpike bridge, hooking onto the front of a semi, and then trying to slow it down.

We fished from Felix's Donzi 35, a nice perk considering it took us all of fifteen minutes to make the run to the fishing grounds at sixty miles per hour. His personal chef served the most amazing breakfasts and dinners right there in the middle of the jungle. The numerous boats of his commercial fishing fleet all piped up on the radio with scouting reports, informing us on a constant basis as to the location of fish. It became quickly apparent that I wouldn't have to do a thing but catch. I felt like a rajah on a tiger hunt.

We roared up to an area where giant yellowfin tuna covered several acres and hundreds of boobies and frigate birds

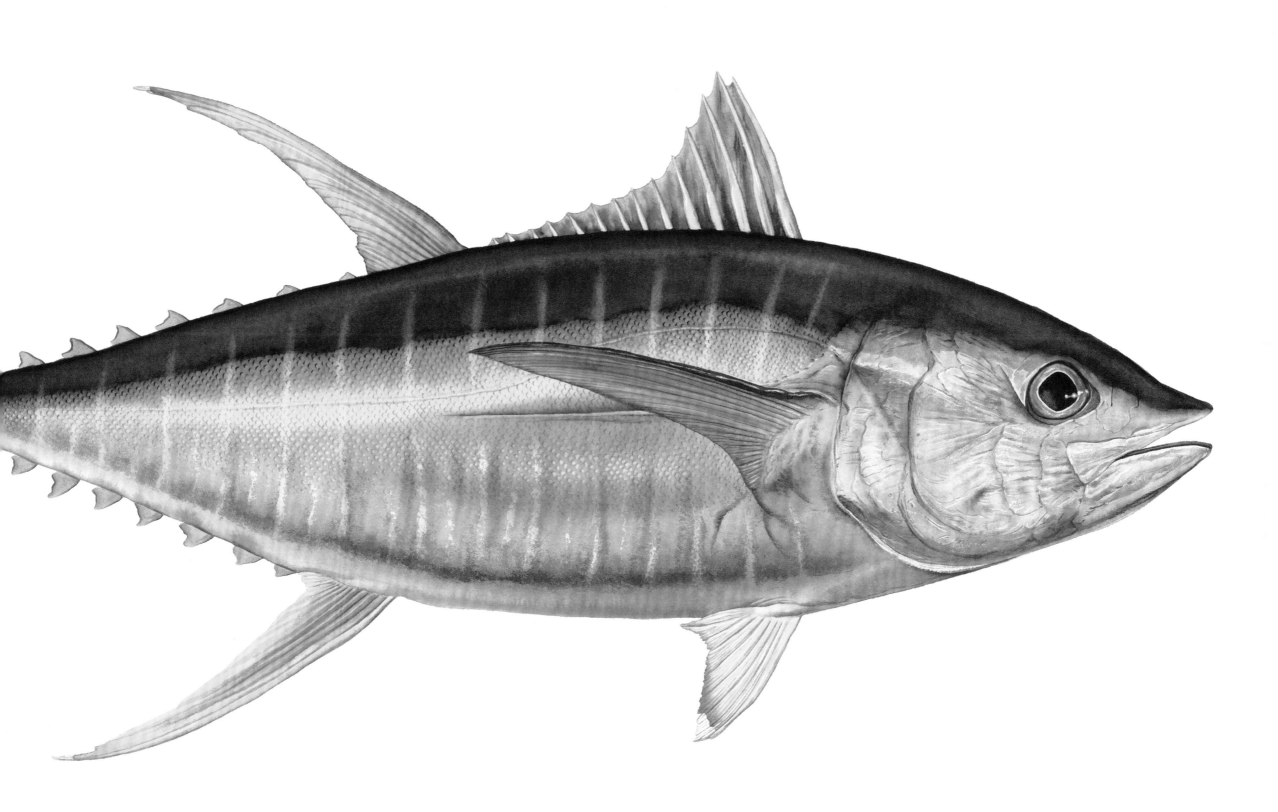

YELLOWFIN TUNA

(Thunnus albacares) Weight 20–300 lbs

swooped down from on high to pick up bits and pieces of savaged squid floating on the ocean's surface. Out went the baits and within a minute, one of the eighty-pound reels began to scream. Being the consummate host, Felix graciously offered me the first strike. A few bouts of give and take later, I pulled a 225-pound yellowfin alongside, where the mates gaffed it and immediately iced it down.

A quick radio call revealed the school had moved about two miles in the time it took us to fight the last fish. In less than five minutes, we pulled back on the throttles and put the baits out into the melee once again. It took a few attempts to position ourselves in front of the rapidly moving school, but on the third try, "SNAP! Zzzzzzing!" went the line as it pulled free of the outrigger clip and tore off the reel.

Felix hooked the rod into his stand-up harness and locked up the drag, whereupon the fish pulled him the remaining four feet from where he stood to the transom, slamming his legs into the padded coaming. He fought that fish for a half-hour in the 90° heat just 7° north of the equator, until "crack!" went the stout, custom tuna rod as it broke off halfway down its length.

The crew erupted screaming a flood of Spanish at each other. They must have decided what to do since they stopped shouting and went to work. Felix let the fish take line with no resistance until it stopped running. After dumping another fifty yards of monofilament into the water, the mate cut the line at the end of the rod and with lightning speed, tied it to the end of the line on a second rod. Felix reeled up the slack, burying the knot in the reel and once again, the tuna knew it had a hook in its mouth.

Another forty minutes passed before the shadow showed itself about thirty feet beneath us. Felix needed to catch this fish soon since the color had left his skin, he had stopped actively sweating, and his limbs had begun to shake. Maybe the fish would actually win this time. Ten feet down, we could see the yellowfin circling. Felix put every remaining ounce of strength he had into lifting the fish to the surface.

"Crack!" The second rod broke. Felix turned the rod slightly to keep the line away from the jagged broken tip and the mates reached down over the side with a pair of gaffs. On the first pass close to the surface, the steel hooks struck, one on each side of the head in a pincer motion. Lifting this fish over the gunwale proved out of the question even for two men. They led it around the

COME AGAIN?

I'd like the yellowfin tuna sashimi, please. But could you cook it for me? I really don't like raw fish.

Twenty-something, date night, Greenwich, Connecticut

outboards to the open transom door and dragged it into the boat.

One of the commercial boats came alongside so we could offload the behemoth onto their hanging scale. Four men winched it up, hung it, and the screams, laughter and high-fives started in earnest. The largest yellowfin I had ever seen tipped the scale at 325 pounds. Felix — with a bottle of water in his hand — smiled from his seat by the helm. He could no longer stand and it would be another half hour before he could raise his arms for high-fives.

Albacores, Bonitos, Mackerels, and Tunas

(Epinephelus itajara)

GOLIATH GROUPER

You say people want to change the name of jewfish to goliath grouper because they don't want to offend any Jews? If that isn't a solution in search of a problem, I don't know what is! — RABBI LESTER MILLMAN

Goliath grouper hold the undisputed title of largest member of the grouper family in the world, hitting lengths of eight feet and weights to six hundred pounds or more. By 1990, numbers of goliaths got low enough to warrant fish and wildlife protection in U.S. waters and, since 1993, in the Caribbean. Although goliaths are slow growing and take years to achieve sexual maturity, their numbers have rebounded enough that certain sectors have petitioned to have protections removed or at least eased.

These fish feed mostly on crustaceans and other smaller fish however they have been known to eat turtles as well. A goliath grouper feeds by opening its huge, gaping maw quickly and anything nearby gets sucked in with the rushing water. Diving provides an excellent insight into the personality of goliaths. But beware, the bigger a goliath grows, the more curious it becomes. I've seen them come out of a hidey-hole to investigate things they consider meal possibilities, including a diver. In fact, numerous reliable reports claim instances of goliath groupers trying to swallow a scuba diver.

Here's the rub from a fishing standpoint. Numbers of goliath grouper have risen high enough, and the fish have gotten large enough again that in many places, it's impossible to fish for snapper or other grouper since the goliaths steal your bait or the fish you've just hooked. These fish have never qualified as sporting fighters. But their nature causes them to swim into their hole and

HOW BIG?

Ms. Lynn Joyner holds the all-tackle world record for the six hundred eighty-pounder she caught in Fernandina Beach, Florida on May 20, 1961. A prohibition on taking these fish artificially protects Ms. Joyner's record. I have personally seen many fish that size but I'm not interested in fighting one.

SEX, ANY OR EITHER?

Many groupers are protogynous hermaphrodites, first maturing as females and later becoming male. Mature females on average are larger than males.

anchor themselves there with their fins. Even if they didn't act so obstinate, their sheer bulk makes them virtually impossible to lift to the boat. An angler has no choice but to find another fishing spot.

Goliath grouper live mostly in shallow, inshore waters — inside the twelve-fathom curve— often around docks, ledges, wrecks and other shadowy places where they can hide. You can find them in warm waters from Florida to Brazil in the Western Atlantic, in the Gulf of Mexico as well as along the eastern Pacific coast throughout the same latitudes. The species carries a zero bag limit in the state of Florida, meaning you cannot have one in your possession at any time. Goliaths are closed to "harvest or possession" in all U.S. and Caribbean coastal waters (out to three miles from shore). They spawn during the summer and can live for fifty years or longer.

DISTRIBUTION

From Florida and the Gulf of Mexico south on the Atlantic side, and from southern California down to Peru on the Pacific side of North America. A shallow water fish, the smaller goliath make better fighters. All sizes taste good.

GOLIATH GROUPER, MAN-HUNTER!

Goliath grouper reach lengths of more than eight feet and can weigh up to 800 pounds. Territorial, a goliath scares off intruders with a quivering body and wide open mouth. They can also make a rumbling sound with their swim bladder, and often do, to protect an area or to locate other goliath's.

Their diet consists mainly of spiny lobsters, shrimps and crabs, smaller fish (including stingrays and parrotfish), octopus, and young sea turtles. These fish qualify as one of the laziest, and as they get larger, they get lazier. But then again, size does matter in this ecosystem.

A goliath's predatory style goes like this: it hides, then ambushes prey by rushing out and sucking them in with a quick opening of its mouth. Its sharp teeth work well for seizing prey and preventing escape, though most small prey simply get swallowed whole.

I have personally witnessed very large goliath grouper stalk scuba divers and try to ambush them (unsuccessfully, thankfully). Since groupers like shallow, often brackish water, near coral reefs, ledges, and wrecks, divers are often in their territory.

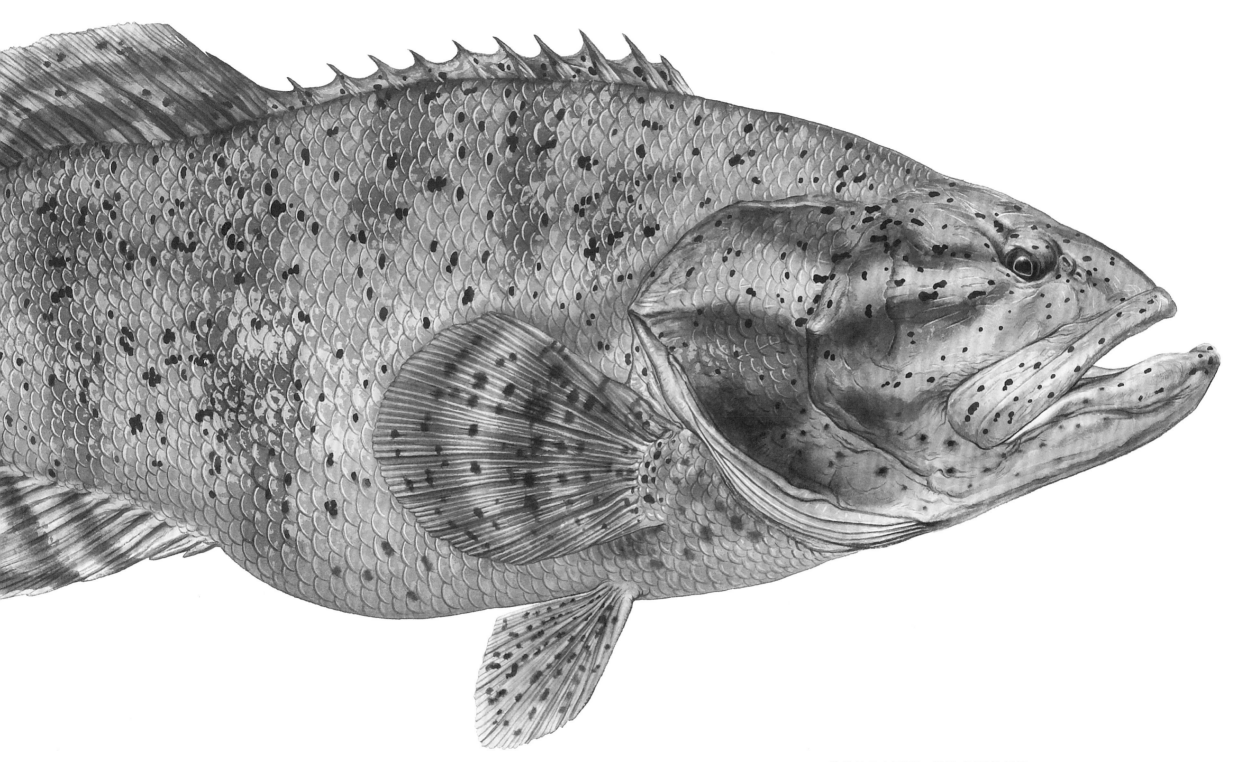

GOLIATH GROUPER

(Epinephelus itajara) Weight 300–700+ lbs

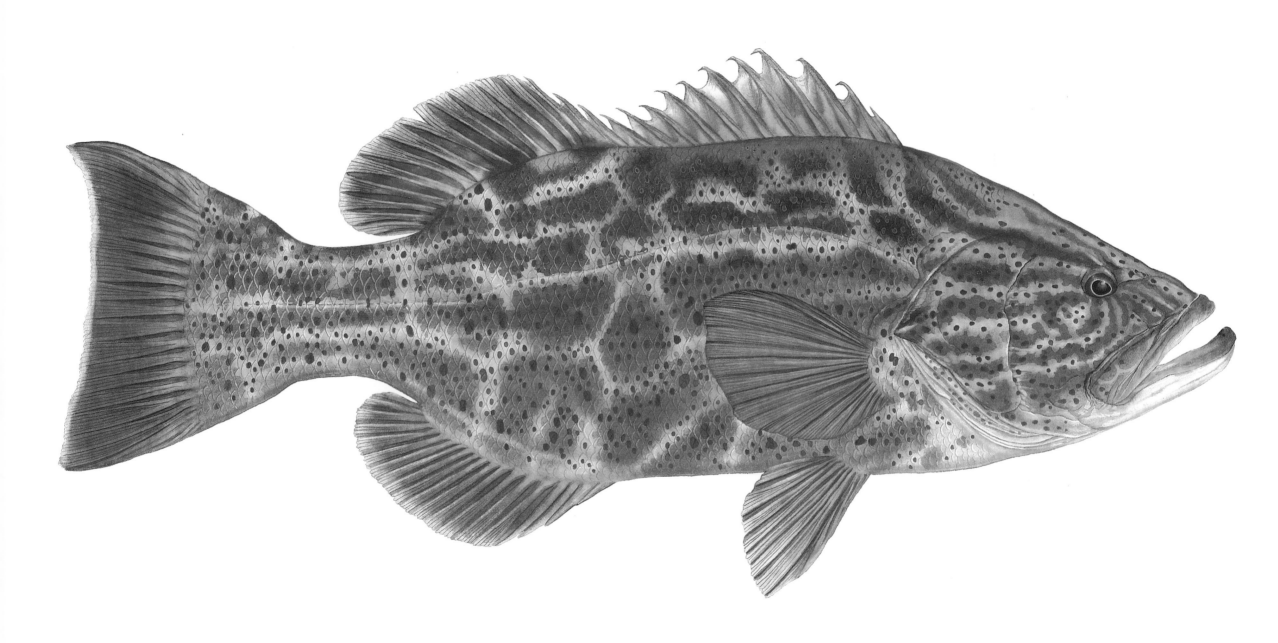

BLACK GROUPER

(Mycteroperca bonaci) Weight 20–100 lbs

(Mycteroperca bonaci)

BLACK GROUPER

Want your kids to eat fish? Make some that they'll really like and problem solved.

I use this recipe for black grouper, but you can use it for almost any firm fish. Panko are Japanese bread crumbs that are slightly coarser than American or Italian bread-crumbs, which can be substituted. Guava juice can be found bottled in most super-markets but you can substitute it with mango, papaya, or soursop juice.

GHOTI'S GROUPER FINGERS

Marinade
3 cups fresh-squeezed orange juice
1 cup soy sauce
4 sprigs thyme
2 tablespoons chopped garlic
4 tablespoons fresh ginger, finely sliced
½ onion, diced

Sauce
16 ounces guava juice
8 ounces coconut milk
3 tablespoons brown sugar
1 healthy pinch of Kosher salt
1 habanero or scotch bonnet pepper (seeded and diced)
(Hold off on pepper for kids' dish)

Panko coating
Kosher salt and ground pepper
2 cups all-purpose flour
2 cups Panko

2 whole eggs, lightly beaten
4 cups peanut or canola oil
fillets from one black grouper

 Combine all marinade ingredients in glass bowl.

 Rinse fish filets and pat dry. Cut fish into finger-size pieces

 Place fish into zip-loc bag with marinade. Squeeze out air, seal and refrigerate for 1–2 hours.

 In a saucepan over medium heat, combine sauce ingredients, stir and reduce by at least half or to whatever consistency you prefer.

 In heavy pan, heat oil to 340° F. Remove fish from marinade, pat dry and season with salt and pepper. In three separate bowls, set out the flour, lightly beaten eggs, and bread crumbs. Dredge fish fingers in flour, then dip in egg, then roll in Panko, to coat completely.

 Carefully place breaded fish fingers in hot oil and cook until light brown. Remove with strainer or spider and drain on a rack over paper towels or newspaper.

 Serve with bowls of the sauce (hot or cold) for dipping.

HOW BIG?

The biggest recorded black grouper catch occurred in Texas in 2003 when Tim Oestreich caught a 124-pounder. Black grouper frequently get mistaken for gag grouper and vice versa. Like other groupers, hermaphroditic black grouper start life as females, and morph into males later in life.

Black grouper feed mainly on fish and squid. Scientists know very little about their average age, growth patterns, and reproduction.

DISTRIBUTION
Black grouper range as far north as Bermuda and North Carolina in the western Atlantic as well as throughout Florida, the Gulf of Mexico, Bahamas, Cuba, Yucatan Strait, Jamaica, Puerto Rico, the Virgin Islands, and the Leeward Islands as far south as Trinidad and Tobago.

BLACK SEA BASS

I happened to eat in a restaurant whose menu touted Chilean sea bass. Usually, what people call Chilean sea bass is actually neither Chilean nor a bass, but rather a Patagonian toothfish. It lives in very deep, cold water down near Antarctica, tastes delicious, and may be the most egregiously and illegally overfished species in the world. Many chefs have removed it from their menus in solidarity with fish conservation organizations around the world.

DISTRIBUTION

Black sea bass habitat extends from Maine to the Florida Keys and into the Gulf of Mexico, though the species more commonly prefers the cooler waters of the central part of the coast from Massachusetts to Georgia. Scientists recently determined that fish north of Cape Hatteras are distinctly different from those found south of the Cape. Fish for them on rocky bottoms near pilings, wrecks and jetties. Squid is a favored bait.

Expecting the toothfish, I asked the waiter if I could see the sea bass before they cooked it. He checked with the chef and a moment later, what to my wondering eyes should appear, but an extra large platter with a fish. The chef proudly showed me the wet, solid eyes and the bright red gills, sure signs of freshness. He then slid the tray closer to my nose offering up a whiff to assure me that nothing but the freshest seafood came from his kitchen.

"That's a beautiful, fresh specimen," I proffered. "I'll take it however you feel it should be cooked. Be creative." The chef beamed.

"But," I said quietly so the next table wouldn't over-hear, "someone, somewhere has made a mistake. While that's certainly a very fine bass and will make a terrific dinner, it's not Chilean sea bass. In fact, there's no such thing as Chilean sea bass."

"I buy from a very reputable supplier who assured me that this was the freshest Chilean sea bass he'd seen in ages," insisted El Jefe Chef.

"Sorry. That's a black sea bass and it probably came from about thirty miles down the Chesapeake. But it could have come from anywhere along the East Coast."

MALE, FEMALE, OR BOTH?

Black sea bass are protogynous hermaphrodites, meaning they start life as females, but some larger fish become males as they grow larger — about five years into their approximate twenty-year lifespan. More than one-third of female mid-Atlantic black sea bass reverse sex after spawning.

Fifteen minutes later, he returned with a bottle of good wine, fresh glasses, and asked to sit down.

"Nobody likes to feel foolish, especially in front of strangers," he said. "But I need to bite the bullet and thank you for a good lesson learned. First, never trust a fishmonger," he laughed. "And second, know what you're looking at yourself rather than depending on someone else to tell you. I called my supplier and he admitted the bass came from near Chincoteague. But he can get more money for something called Chilean sea bass than for a locally caught black sea bass. From now on, I'll take my fish book with me until I learn all the species better."

Buyer beware. Restaurants often call a fish anything they want — truth be damned. But the wine proved excellent— along with the black sea bass.

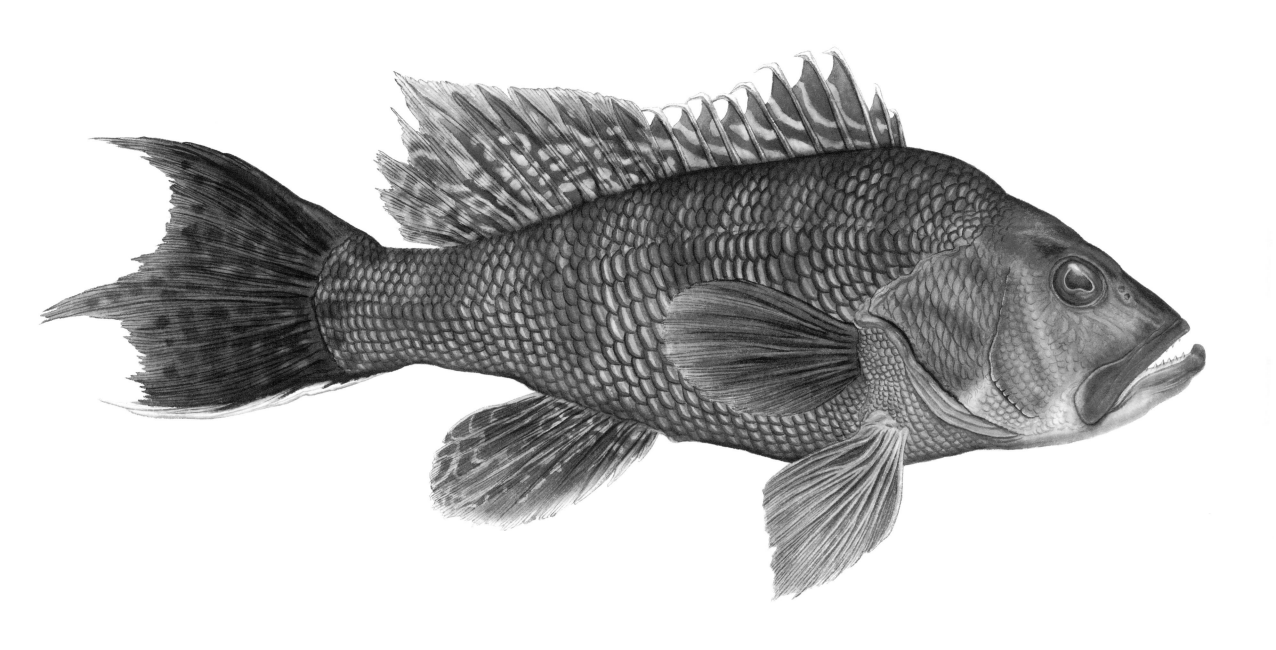

BLACK SEA BASS

(Centropristis striata) Size 4–13 inches. Weight 1–5 lbs

(Paralabrax clathratus)

CALICO KELP BASS

Man is the only predator that consistently targets the biggest, strongest and healthiest prey. All others — more opportunistic feeders — prey upon the weak, sickly, small, slow, and old. Dr. Jim Bohnsack, a research fishery biologist for National Marine Fisheries Service has a theory about reef fish. He figures that during this century, the overall size of the fish man targets for food has shrunk, and he attributes this to genetics. If you remove all the large fish from the gene pool, what you have left are small fish.

CATCH ONE!
Use live anchovies, herring, squid, sardines. Fly line around kelp beds or use a sinker around shallow water reefs, moorings and seawalls. Anything under eleven inches is too small to keep. Fry, sauté, or bake them for excellent eating.

Kelp bass are a perfect subject for a test of Bohnsack's theory. These shallow-water fish rank as one of the top gamefish on the West Coast of North America. No commercial take is allowed, and fishery managers currently consider the kelp bass (also called "calico bass") resource stable. But scientists do question the reason so few large "trophy" kelp bass come to the net. While the world record of fourteen pounds, seven ounces caught in Newport Beach, California by Tom Murphy in 1993 still stands, anglers rarely find kelp bass significantly larger than the twelve-inch minimum size limit. There is one exception, however, which bolsters Bohnsack's theory.

Fisheries biologists and numerous other environmental experts tout Marine Protected Areas (MPAs) as the panacea. These geographic "preserves" bar virtually all human consumptive activity. Some of the pioneer MPAs can be found off California's coast around Catalina and Anacapa Islands as well as at La Jolla. Within the boundaries of these three MPAs, both the size and abundance of kelp bass run higher than outside the MPAs throughout the rest of the kelp bass range. This fact encourages MPA advocates to create more and bigger MPAs.

Of course, many fishermen disagree. MPAs tend to damage everything a fisherman touches, such as resorts, tackle, boat, sporting goods manufacturers, insurance companies, transportation providers, fuel suppliers, and more. Some argue that migration patterns make MPAs futile, especially in the case of kelp bass. The species tends to travel, in some cases up to fifty miles or more. The MPAs aren't that large, meaning that protected kelp bass will likely leave the confines of the protected area. Scientists question the impact this will have on the whole experiment.

According to Bohnsack, if you could protect stocks of larger fish, (who tend to have more offspring than smaller fish) ultimately, the genetic makeup will once again tilt toward larger fish overall. As is the case with several other species, the challenge is to balance the health of the fishery against the economic impact the fishery generates. Manipulation of nature may be man's biggest Gordian knot.

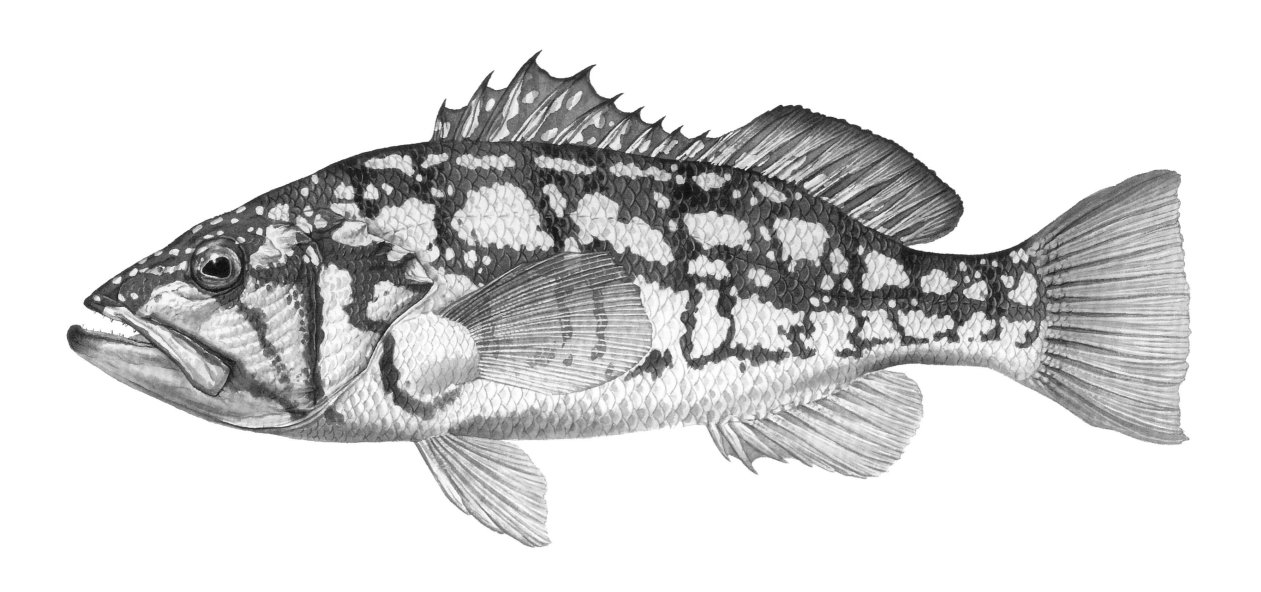

CALICO KELP BASS
(Paralabrax clathratus) Size 10–28 inches. Weight 3–14 lbs

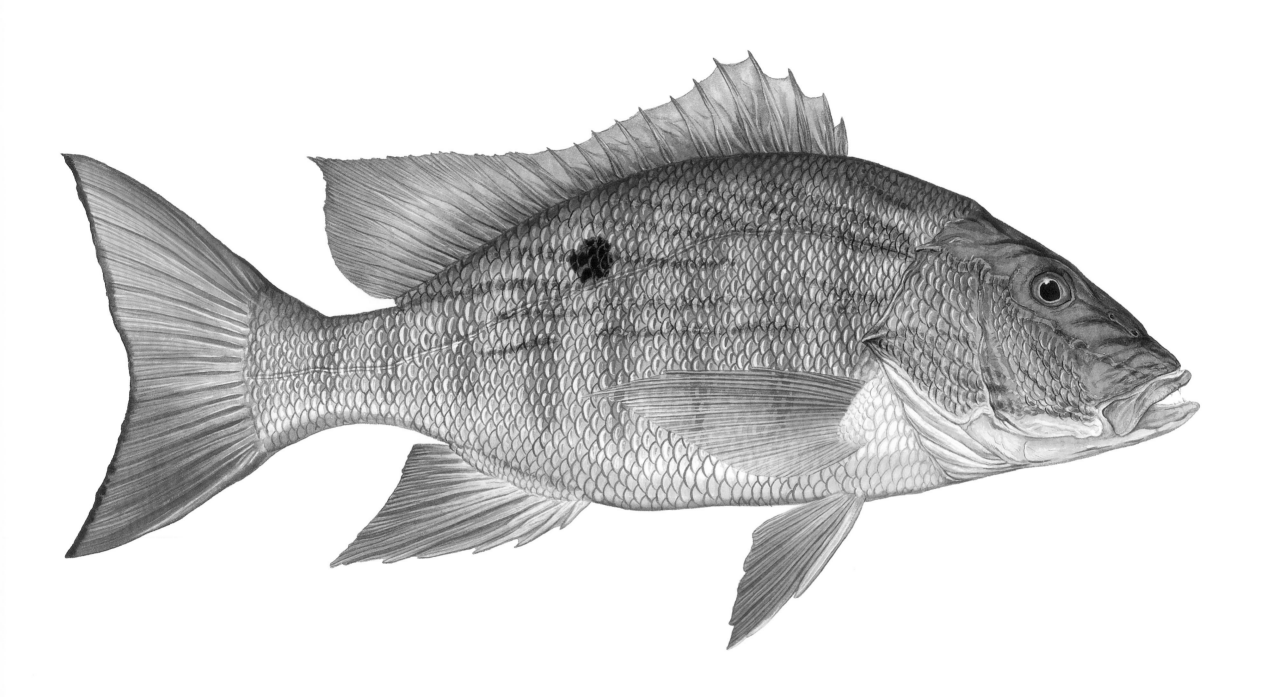

MUTTON SNAPPER

(Lutjanus analis) Size 15–32 inches. Weight 5–15+ lbs

(Lutjanus analis)

MUTTON SNAPPER

Wife: "Hi honey! Welcome home. What'd you catch today?"

Husband: "Mutton, honey."

Unless you regularly bottom fish, you might easily confuse a mutton snapper for several of its relatives. Occasionally, the mutton looks exactly like a lane snapper and other times it can pass for a red snapper. Neither the lane nor the red grow as large as the mutton snapper, which typically run between fifteen and twenty pounds once they reach adulthood.

EAT ONE?

Exceptionally good tasting, mutton snapper is often marketed as "red snapper." Muttons can be baked or even fried whole. Consumption advisories due to high mercury have been recommended for some areas.

sents one of the main oceanic nurseries.)

Once large enough to set out on their own, juvenile mutton snapper prefer shallow depths of less than sixty feet and can even be found on grass-laden flats. As they age, muttons move to deeper waters and live in and around rocky or coral bottoms, shelves, ledges and other hard structure where they eat shrimp, snails, crabs and small fish. Adults are fairly solitary but will form small aggregations during the day.

The barred color on muttons is more visible when the fish are feeding on the bottom, resting, or in encounters with other fish. While swimming through the water, they appear to be plain.

Adults have a small body spot on their upper back below the dorsal fin. In young muttons, this spot is proportionately much larger. Scientists believe this black spot tricks predators from attacking the eyes.

DISTRIBUTION

A popular game fish, mutton snapper territory is North American Atlantic coast (occasionally extends as far north as Massachusetts) out to Bermuda as well as the Caribbean Sea and the Gulf of Mexico, and south to Brazil.

The mutton and lane snappers look identical as juveniles, but the world record for lane maxed out at just over eight pounds. Richard Casey caught a thirty-pound, four-ounce mutton in the Dry Tortugas back in 1998 which still holds the International Game Fish Association world record.

Along the western Atlantic Coast, fishermen look forward to the spawning aggregations each spring when mutton fishing gets really good. Spawning aggregations mean that mutton snapper come from all over to reproduce, so they can be found in prodigious numbers. During the full moon in April and May is the best times to target these groupings. In fact, some anglers suffer such obsessive-compulsive behavior over mutton fishing that they track the lunar cycle at this time of year like a childless couple tracking fertility cycles.

Muttons mostly spawn at night. Females generate up to a million eggs in mid-water depths. Males swim through these clouds of eggs, releasing sperm that mixes with and fertilizes the eggs. The fertile eggs float to the surface where they have a rapid gestation period of a mere twenty-four hours before hatching. Hatchling snapper can often be found among floating sargassum weed, living on floating plankton. (Sargassum repre-

RED SNAPPER

On a humid night in 1996, Maestro Paul Prudhomme sat lost in thought on his stool by the kitchen window at his restaurant, K Pauls, on Chartres Street in New Orleans. His mind mulled a problem he never thought he'd have: One of his famous dishes — red snapper fresh from the Gulf of Mexico — was coming off the menu, maybe forever.

As he looked through the list of fresh fish available from his suppliers, nothing came close to the rich, nutty flavor and white flaky texture of the snapper. Whatever ingredients he used had to be fresh because K Pauls didn't have a freezer. Snapper was only part of the problem. Shrimp, which Chef Prudhomme relied upon for all manner of Cajun dishes, might also become hard to get in the not-too-distant future. Why all the changes?

He just couldn't get the fish. And unlike many stores and restaurants, Prudhomme had a reputation to protect that prevented him from doing what had become commonplace: buying similar fish and calling it (and charging for) red snapper. Sure, between sixty and ninety percent of today's red snapper is mislabeled (and mispriced). But Paul Prudhomme would have none of it.

As hard as it might be to imagine, we got too good at catching fish. And the shrimp? Well, like nature itself, all these ocean resources are interconnected. The shrimpers drag their nets and catch tons of baby red snapper along with hundreds of other oceanic "children." We catch the big snapper to eat and for every pound of shrimp we catch, we also catch, kill, and throw away ten pounds of baby fish. It doesn't take a math whiz to figure out that using a resource faster than it can replenish itself exhausts it fairly quickly. So the government put severe limits on the numbers of snapper that could be caught and to help the species recover faster, limits on shrimp also hit the industry.

MODERATION: THE KEY TO GOOD HEALTH

If everyone — commercial and recreational anglers alike — fished strictly with rods and reels, red snapper wouldn't be in the world of hurt it is today.

—ANTHONY NG, 1999

Prudhomme tried many snapper substitutes and of the lot, redfish or red drum had the best texture, but the flavor couldn't compare to snapper. K Pauls' reputation had been built on an almost magical sense of seasoning. In fact, when good customers asked what went into a particular dish, Prudhomme often gave them a little packet of herbs and spices to take home. He decided that a bit of fire was what the redfish needed to perk it up and he devised a new blend of piquancy to season the redfish. Prudhommes's blackened seafood was an instant success, enough so that he applied the same spices to steak. Everyone who experienced Prudhomme's seasoning agreed on its magical quality, so the chef decided to bottle it, calling it his Magic Seasoning blends.

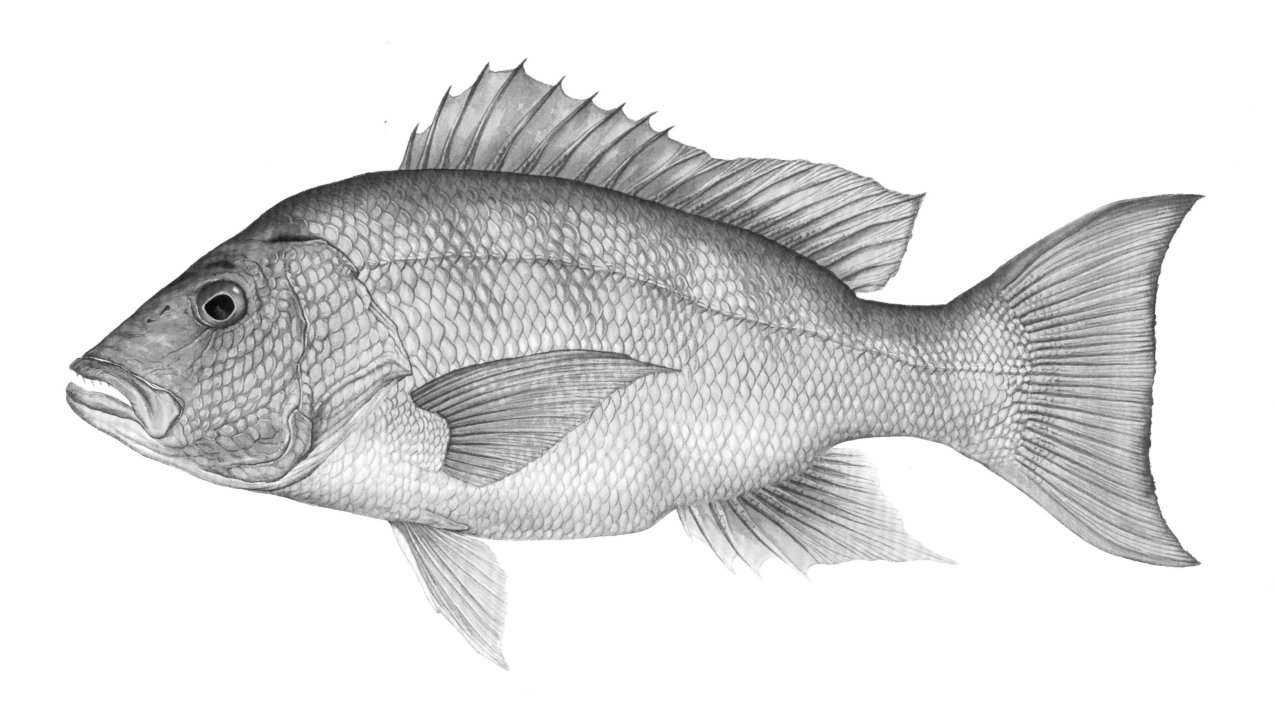

RED SNAPPER

(*Lutjanus campechanus*) *Size 16–30 inches. Weight 4–35 lbs*

SILK SNAPPER

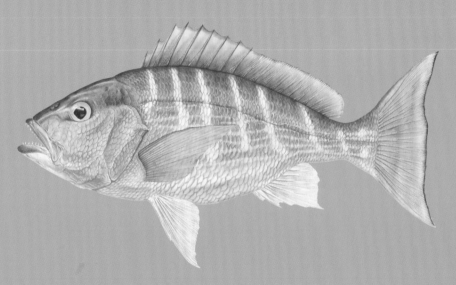

Being new to snapper and reef fish in general, I thought I had found a red snapper to paint when this large silk snapper was landed. The guide and owner of Fat Fish Adventures (and the most skilled hand-liner I know) Peter Jervis, called it a "red silky." The confusion was mine. The bright yellow eyes distinguish the silk snapper from the red-eyed red snapper. There's a lot of deceptive nomenclature surrounding red snappers. A study by the University of North Carolina found that seventeen out of twenty-two fish sold as red snapper were actually some other kind of fish. FLICK FORD

PETER JERVIS' BROWN STEWED SNAPPER

4 lbs. snapper
1 cup vegetable or canola oil
1 large onion, sliced
4 cloves garlic, crushed
½ green bell pepper, sliced
1 Scotch bonnet pepper, sliced
(do not use seeds)
4 whole Pimento seeds, crushed
1 tablespoon margarine

1 tablespoon oyster sauce
4 tablespoons tomato ketchup
1 teaspoon brown sugar
Pinch of salt
Enough water to cover

———❦———

Cut fish to personal preference – sliced no thicker than an inch, or fillet to approximate size of slices
Season with black pepper and salt to taste
Using non-stick frying pan, add fish to hot oil
Fry until golden brown on both sides (do not burn)
Remove and set aside to drain on paper towel

In a deep frying pan, melt margarine and sauté onion, garlic, bell pepper, Scotch bonnet pepper, and pimento seeds
Add oyster sauce and ketchup
Add brown sugar
Add fish and enough water to just cover
Add pinch of salt

Cover and steam for 7–10 minutes over medium flame until liquid thickens (For added thickness, dissolve 1 tablespoon flour in ¼ cup water and add one tablespoon at a time until desired thickness is achieved)

OUR OCEANS MAY KILL US

Sailing along on a sparkling sunny day, water burbling in your quarter-wave, diamonds on the water's surface as far as you can see and the air seemingly fresh and clean, it's exceedingly hard to think of the ocean as critically ill. But solid scientific research shows that man's calamitous attitude of considering the ocean to be an infinite resource, has caught up with us.

Nowhere is this more apparent than in the state of our fisheries. The historically richest fishing grounds off the east coast, George's Bank and Grand Banks, have been vacuumed clean of groundfish (cod, flounder, sole, haddock, etc.). Videos of draggers working for scallops show that after two passes, a bottom that had a living structure of rock, reef, and plant life turns to gelatinous muck. Scientists have no idea how long it will take, if ever, to regenerate.

Shrimpers admittedly kill ten pounds of other fish (called bycatch) for every pound of shrimp taken. Longliners looking for swordfish set out hundreds of miles of lines with baited hooks dangling every few feet. They catch scores of other types of fish including sharks, marlin, sailfish, dolphin (mahi-mahi, not "Flipper") and simply shovel them back over the side, dead, a cost of doing business.

Ten years ago, the average size of a swordfish sold to the fish market was over two hundred pounds. Today that has decreased to about forty pounds. The stock has reached such a perilous level that ninety-five percent of all swordfish caught and sold today have not spawned, even once.

Commercial interests also harvest forage fish from shallow water areas to use in products such as fertilizer. These fish, seemingly less valuable because people don't eat them, represent the main food source for many other species that people do eat. Without food supply, any link in the food chain will be broken.

Agricultural interests flush farm sewage down streams into bays

and rivers causing pfiesteria, an organism that releases toxins usually fatal to fish. In recent years, massive fish kills have been attributed to this problem. Development of wetlands takes away the areas fish use as nurseries. Something as benign as harvesting sargassum weed (a bottom-growing oceanic plant often found floating on the ocean's surface) for fertilizer has had disastrous consequences. Scientists have determined that hundreds of different life forms live and grow in this floating grass. Fishermen know that where there's grass, more often than not there are large fish to be found. Sargasso attracts the entire food chain from single-cell life to apex predators.

Perhaps the single greatest problem with commercial fishing today is how really good at it we've become. We could never have wiped out our richest fishing areas and put such overwhelming pressure on fish resources else-where without today's advanced technology. With mod-ern sonar, GPS, new net materials and designs, and new methods to keep the catch fresh, fishermen have never been more effective — or as deadly. Fishermen used to catch swordfish with a rod and reel or a harpoon thrown by the steady hand of a man standing at the end of a Cyrano-esque bow pulpit. Today, Cyalume light-sticks tied to longline baits attract what broadbills remain like attorneys to a tobacco lawsuit.

To hear the recreational and commercial fishermen go at each other, it appears to be a question of selfishness, each side accusing the other of wanting the lion's share of the resource for themselves. Commercial fishermen claim they've made their living from the sea for generations and it is their God-given right to continue. Sport fishermen claim the commercials are wiping out all the fish and there won't be any left for future generations to enjoy. At the same time, there are still fishing tournaments where hundreds of thou-sands of dollars are awarded the boat that brings the largest dead fish to the dock. Quite honestly, both sides leave a lot

THE GRAND BANKS

A combination of under-water geography and the meeting of the cold Lab-rador Current with the Gulf Stream make the Grand Banks one of the world's perfect fishing grounds. It's also where Sebastian Junger's novel, The Perfect Storm, *takes place. The Treaty of Paris (1783) allows the U.S. to fish the Grand Banks despite Canada's Exclusive Economic Zone (EEZ) boundaries that cover much, but not all, of the area.*

to be desired in the altruism department.

The fish, and the responsibility, belong to everyone: commercial and recreational fishermen, coastal dwellers, and people in the heartland. And the argument commercial fishermen put forth, that to cut back or change gear types will mean a dearth of fish for Americans to eat, is terribly short-sighted. The argument should be that unless we make immediate resource management changes, the fish will be gone — forever.

This is not only a matter of having or not having fish to eat. We have no idea what effect wholesale destruction of large segments of oceanic life will have on the entire planet's eco-system. Humans depend on the saltwater, seven tenths of our world, for our very being. Our own chemical makeup resembles seawater so closely that it defies coincidence. Fish currently living healthy lives in our oceans may not do so for long. We continue to pour garbage, toxins, radiation waste, munitions, petrochemicals,

RECYCLE PLASTIC

Every molecule of plastic that has ever been manufactured still exists. Oceanographers and marine geologists have discovered that the top layers of ocean floor around the world contain an abundance of plastic. Unless we recycle better and become a less disposable society, the health of our planet will almost certainly decline precipitously.

plastic and more into our seas with a cavalier, out-of-sight, out-of-mind attitude. Anecdotal evidence points to the fact that more albatross (magnificent sea birds) die from ingesting plastic than from old age or any other cause. Ghost nets — high-seas drift nets that have been lost or discarded — kill tons of fish and marine mammals as the nets fill with ocean life, then sink to the bottom until the organic matter rots away. Once empty again, the ghost net resurfaces to repeat the deadly cycle. Our thought that we can dump anything and everything into the sea and it will provide infinite dispersal is just plain wrong.

Ultimately, the solution to these problems is political and international. Make your voice heard in Washington. Write, phone, fax, or e-mail your representatives, the National Marine Fisheries Service (NMFS), your state governments and your local leaders and let them know you want change — and soon. Ten years from now may be too late.

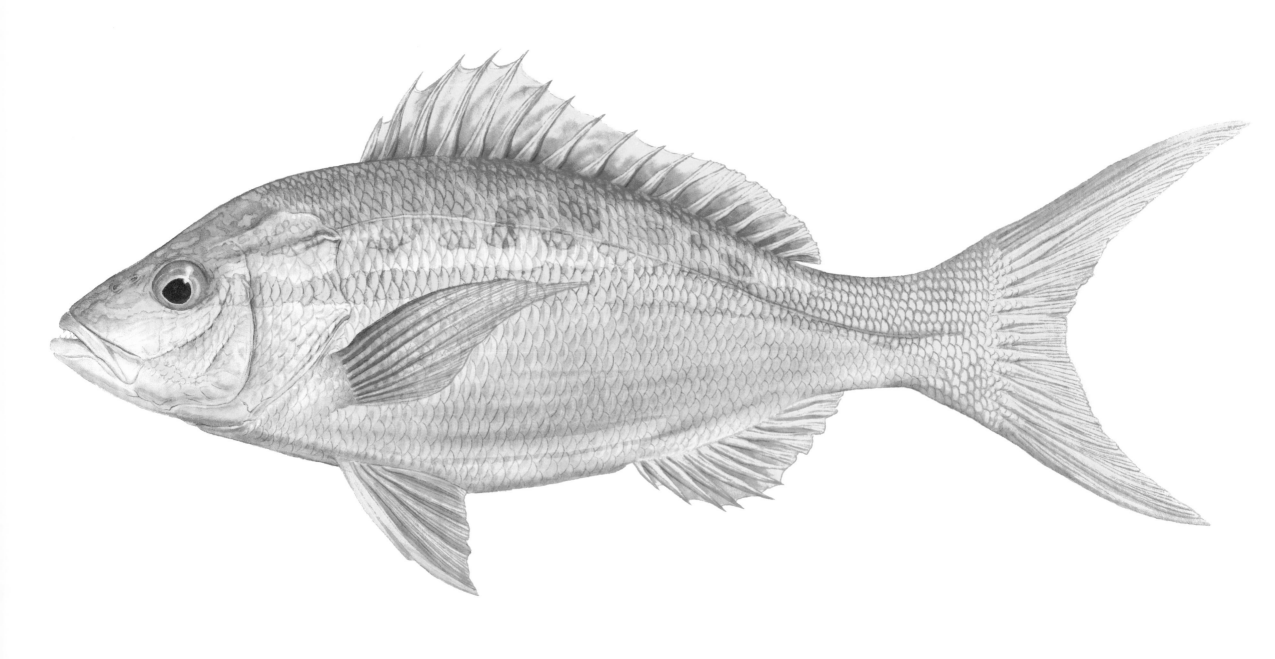

YELLOWTAIL SNAPPER

(Ocyurus chrysurus) Size 10–30 inches. Weight 1–12 lbs

(Ocyurus chrysurus)

YELLOWTAIL SNAPPER

Hey! If you run through my chum slick one more time, I'm gonna shoot your butt! — COMMERCIAL YELLOWTAIL FISHERMAN TO WEEKEND ANGLER. Rarely is a fish more prized as table fare than the yellowtail snapper. In fact, knowledgeable connoisseurs consider it the best of all snapper to eat. A gorgeous creature with both glaring and subtle coloring, the yellowtail excites everyone from jaded commercial fishermen to children.

It's a perfect family outing fish. Not too big, so the small as well as the elderly and infirm can experience the thrill of catching a fish on light, responsive tackle.

Fish for yellowtail while anchored out on a reef or patch of rocks. A very sedate fishing adventure, yellowtail can inspire laughs and finger-pointing if you know how to draw them right up to the transom of your boat. There is a downside to yellowtailing. One person has to be willing to be the host of the "Dirty Jobs" show. At every stage of fishing for yellowtail, somebody has to take "one for the team"

COOK IT!
Yellowtail can be prepared in hundreds of ways. You can fillet it or cook it whole by baking, steaming, or roasting. Or try it Cubano-style. Gut it, scale it, and deep fry the whole fish. ¡Que magnifico!

and handle the bags and buckets of chum, and bait the hooks with tiny, slimy, little dead fish.

The chum contents — like a bread recipe — vary from one person to the next. But the basic recipe remains the same: fish guts and carcasses, cat food, old baitfish, in fact, any old and stinky creature that comes from the sea. Mix in some oatmeal and sand, then stir with one of those paint stirrers that you attach to a strong power drill. It should end up looking like a thick, heavy paste.

Here's how to catch yellowtail. Find a likely place over grassbeds or near reefs (or ask someone who knows) and anchor just up-current from there. Hang a mesh bag of frozen chum over each side of your boat. Wait for at least a half hour, shaking the chum bags every few minutes to get more of it floating down-current, to set up your "slick." Start spooning the contents of your homemade chum bucket over the side a little at a time.

After chumming for about forty-five minutes, put two little silversides or glass minnows on a hook and drop them, along with a spoonful of chum, over the side. The idea is for the hooked bait to drift down and back at the same speed as the chum. When the speed of the line going out increases, wind the reel quickly because you have a fish on the line. Yellowtail snapper have the sharpest spines of anyone in their family. Caveat piscator!

DISTRIBUTION
Yellowtail are found in the western Atlantic, from Massachusetts to southern Florida and are common in the Caribbean. They're called "snappers" because they snap their jaws when hooked.

CALIFORNIA YELLOWTAIL

Early last night, Travis Landreth had paddled his customized kayak out to the bait barge where he bought two scoops of anchovies. He carefully emptied the bait net into the flow-thru baitwell he'd built into his foredeck. With his course programmed into his handheld GPS, he paddled his way out to sea, a set of small navigation lights on his bow and stern. Fishing rods stuck up out of his craft like the antennae on a monstrous bug. Food and water under the deck behind him would have to last for a day or two.

DISTRIBUTION

California yellowtail can be found over much of the California coast, though the farther north, the smaller they grow. The species roams all the way down to Guatemala, up into the Sea of Cortez and out to the numerous islands off Mexico's coast.

He ghosted up to his fishing spot about an hour before dawn. A confluence of currents caused a visible turmoil on the ocean's surface, visible even in the dark as the bioluminescent microorganisms flared a glowing green when the current tossed them about, blackening to invisible once back in the calm. His paddles caused the same explosion with each stroke.

He pulled a battery-powered sonar system that looked like a fishing bobber out of his waterproof bag. He dragged it alongside as he paddled back and forth across the rip, looking, always looking for that perfect piece of bottom that he knew was down there: that ledge beneath which the California yellowtail hid. He carefully balanced his piece of window sash weight with all the nylon string wrapped around it on the deck.

Suddenly there it was, the telltale mark on the sonar screen and reflexively he brushed the weight overboard where it unwound like a yo-yo until the lead hit the bottom. The small inflatable boat fender tied to the upper end of the string now gave him a crucial point of reference on the otherwise barren surface of the sea.

He watched as he drifted away from his marker stretching his muscles after the long paddle. Once he knew the current's direction and speed, he paddled up-current past the buoy for quite a ways. Pinning one of his live anchovies to the end of his line, he dropped it over the side. Current, structure, nobody else around — everything was right. Both rods in their holders, Travis's head began to nod. Dawn always affected him that way. After a brief click-click, the reel began to scream and his Newport Beach sleigh ride resulted in a beautiful flash of yellow stripe glinting just below the surface. Travis led the fish alongside and at the last moment grabbed the tail with his gloved hand and without even removing the hook, flipped his twenty-pound California yellowtail into the dry box behind him.

HOW BIG?

Fishing mate Tom Lambert caught a new world record California yellowtail while bottom fishing on the Qualifier 105 — a long-range boat out of San Diego. His new "best" weighed ninety-one pounds, six ounces.

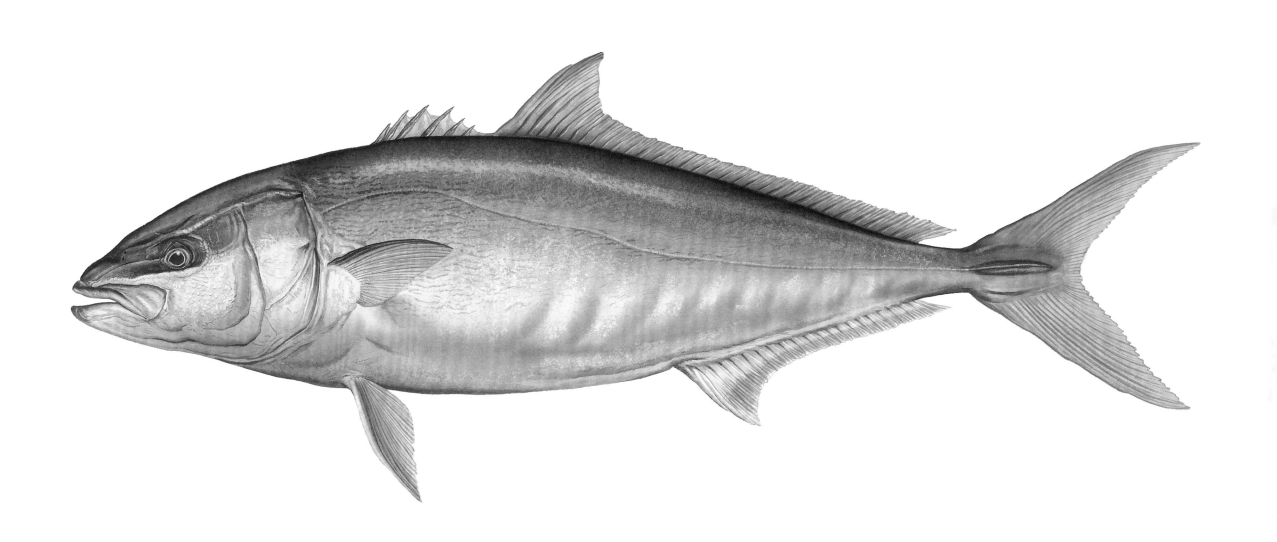

CALIFORNIA YELLOWTAIL
(Seriola dorsalis) Size 12–35 inches. Weight 5–15+ lbs

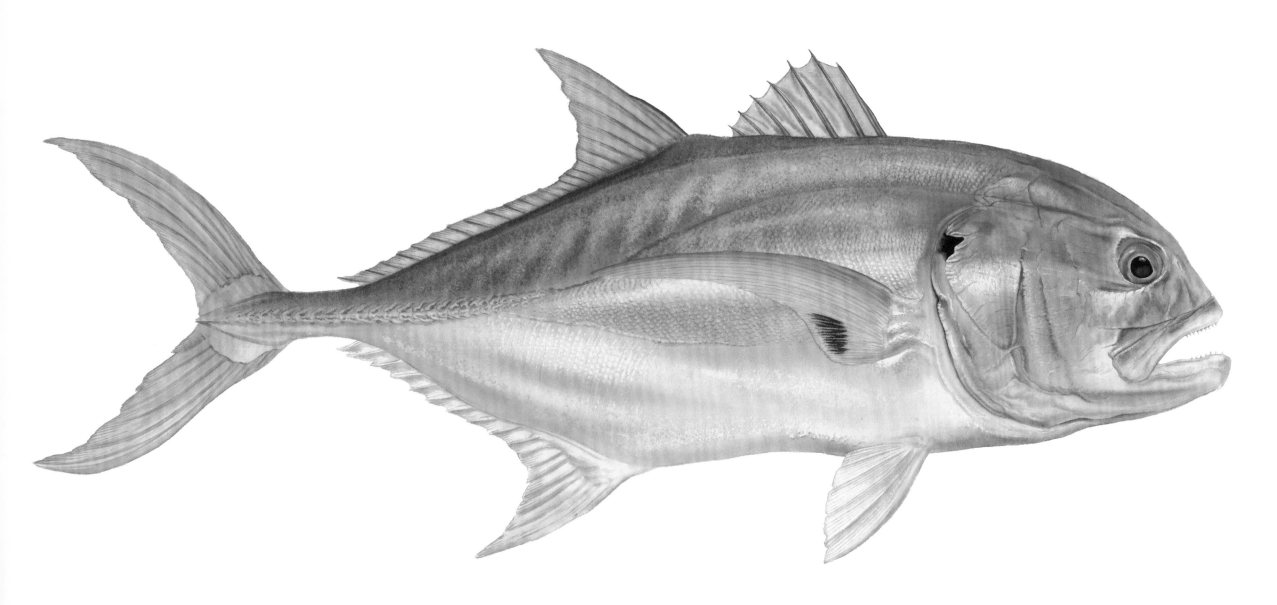

CREVALLE JACK
(Caranx hippos) Size 15–30 inches. Weight 4–40+ lbs

(Caranx hippos)

CREVALLE JACK

The crevalle is also called common jack, cavally, horse crevalle, toro, and most popularly: jack crevalle. Redemption. Salvation. Butt-saver. All terms used by charter operators who can't find more desirable fish for their clients, yet still need something to pull on their lines. Guilt for taking the charter fee and not finding a single fish might otherwise creep into their steely personalities.

Jack crevalle frequently herd small baitfish into tight balls, then take turns slashing through the aggregation, chomping the prey to bits. This all takes place on, or just below, the surface, so the sight (from the boat's cockpit) of a huge, boiling morass with swarms of birds soaring and swooping down to pick up fish orts gets everyone's pulse kicking. Actually, it doesn't take much to get the average charter party excited.

Catching jack crevalle on light tackle constitutes serious fun for the non-jaded angler of any age. They can be caught with virtually any lure from a jig, to a spoon, to a fly, to a popper. The trick is…well…there is no trick. Just cast into the middle of the boil and reel as fast as you can. Jacks feed so voraciously that anything

moving fast — like a small fish running for its life — draws an instant attack. Charters get clients hooked up and fighting hard-pulling fish, as they jump around the deck like ballet dancers in order to keep all the lines untangled, releasing fish and hooking another as fast as they can react, and people go home happy.

No boat? No problem. Crevalle has a reputation for herding shallow-water baitfish up against a beach, seawall or sandbar. Anglers often catch them by surfcasting. They certainly can't be missed. And pound-for-pound there might not be a better fighter in the sea.

DON'T EAT ONE!
Some say you can eat a jack crevalle. But since this species tastes terrible and occasionally carries ciguatera poisoning, why bother? Ciguatera poisoning comes from larger predators eating smaller reef fish that in turn eat smaller fish that in turn eat coral. Ciguatera is an algae that grows on coral and contains a neuro-toxin that if eaten will make ones' life truly miserable for months on end.

Scientists have very recently determined that the virtually identical Pacific jack crevalle genetically qualifies as a totally separate species from the Atlantic jack crevalle. It's difficult to tell the difference between the two by mere visual inspection, which is partly why it took fisheries biologists so long to make the determination. Behavior and feeding patterns of both species remain identical.

Crevalle easily handles vast disparities in salinity, oxygen content, and water temperatures. They often become nuisance fish when plentiful in areas where anglers target other species. And they enjoy a reputation as master bait stealers.

If you're stuck on a deserted tropic island with absolutely, positively nothing to eat but jack crevalle, make a cut across each side of the body just above the tail, then cut each set of gill rakers so the fish bleeds out. That will get rid of at least some of the foul, oily taste.

DISTRIBUTION
Jack crevalle are found on the western side of the Atlantic, though they range widely from Nova Scotia to Uruguay as well as in the Gulf of Mexico and sometimes the eastern Caribbean.

(Trachinotus carolinus)

FLORIDA POMPANO

She was missing again. One parent ran to check the bridges, the other went to the beach. The missing "she" was their ten-year old daughter and the first time she disappeared, her frantic parents called the Palm Beach police, who finally found her with several elderly gentlemen who regularly fished for snook on the Royal Palm Way Bridge.

Barefoot and fascinated, she couldn't understand why all the fuss. She was perfectly safe with her "friends" and the fishing was excellent. Yesterday, she had pocketed the free tide chart from next to the cash register on an errand with her au pair. High tide at the beach at the end of her street would be at 5:04 am. Her "friends" had been talking about pompano and how easily you could catch them during their season. When her alarm rang, she grabbed a Powerbar, took her very own spinning rod and a bucket and padded down to the beach.

The budding debutante stuck the butt of her rod into the sand, walked down to the wet sand with her flashlight, and started searching for the minute holes that showed up between waves. When she found one, she quickly scraped a hole with her fingers until she felt the small, pencil-eraser-sized sand flea squirming between her fingers. No squeamish princess, she quickly impaled the sand flea on her hook and cast it out as far as she could.

Fortunately, the pompano hang out in the surf not too far offshore. In what seemed like no time at all, she felt the telltale tug on the tip of her rod. She reared back on the rod and felt the fish pull away. She patiently played the fish until it came close enough for her to wade into the water, grab the leader and flip it up onto the dry sand. Her first fish caught all by herself. She repeated the process a half dozen times as the sun came up.

"Lilly?" a deep voice shouted from the elevated walkway along Ocean Drive.

Lilly turned, waving, with her heart in her throat. She knew her father's "you're in deep kimchi now" voice: she had heard it a hundred times before. He walked slowly down the stairs to the beach. She hooked up again and started to play the fish. Her father reached her and to her surprise, sat silently in the sand waiting for her to finish. She couldn't have handled the fish better if she had been fishing for fifty years. She quickly removed the hook and slid the pompano into the bucket where it joined five others.

"That's quite a good morning's catch," said her father.

Lilly said nothing as she looked at him, waiting for the other shoe to drop.

"Let's take them home and cook them for breakfast," he said hugging her as strongly as if she'd been lost for weeks. "And in the future," he added," when you want to fish, let us know before you leave the house."

"And that's how I started fishing," said Lilly, addressing her numerous grandchildren gathered around her on her seventieth birthday. "I have never forgotten that morning and never loved your great-granddaddy more. So, go on with y'all now. Out to the beach. Your rods and buckets are there already."

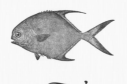

EAT ONE!

Florida pompano are prize catches for their speed and challenge as well as their taste.

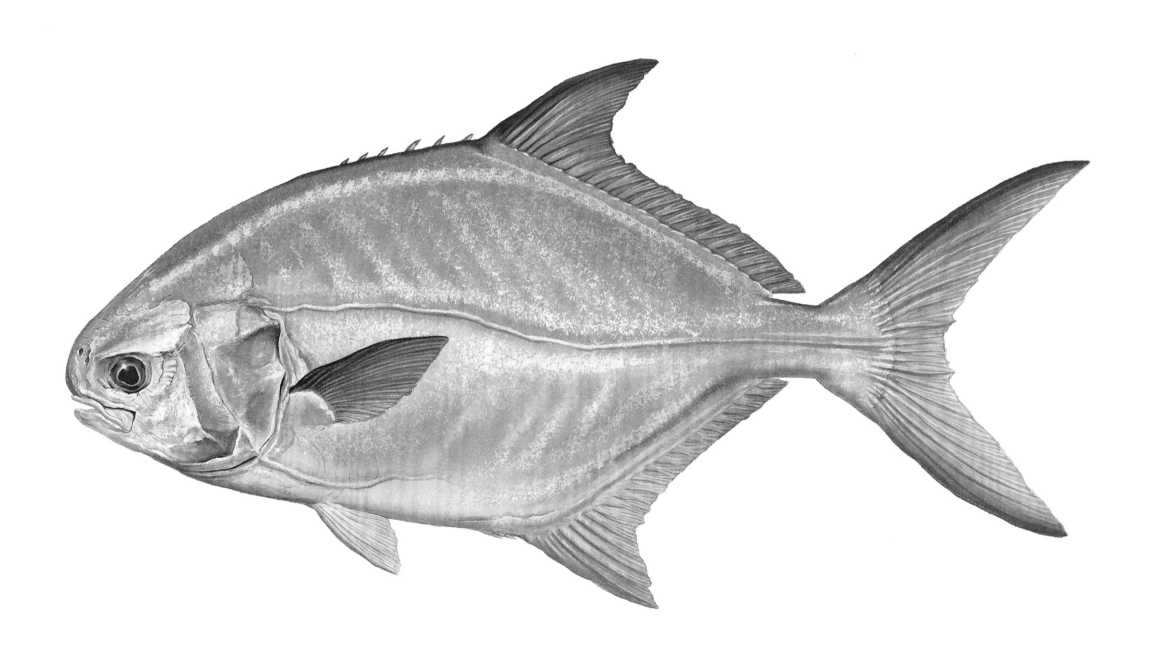

FLORIDA POMPANO

(*Trachinotus carolinus*) Size 10–15 inches. Weight 1–4+ lbs

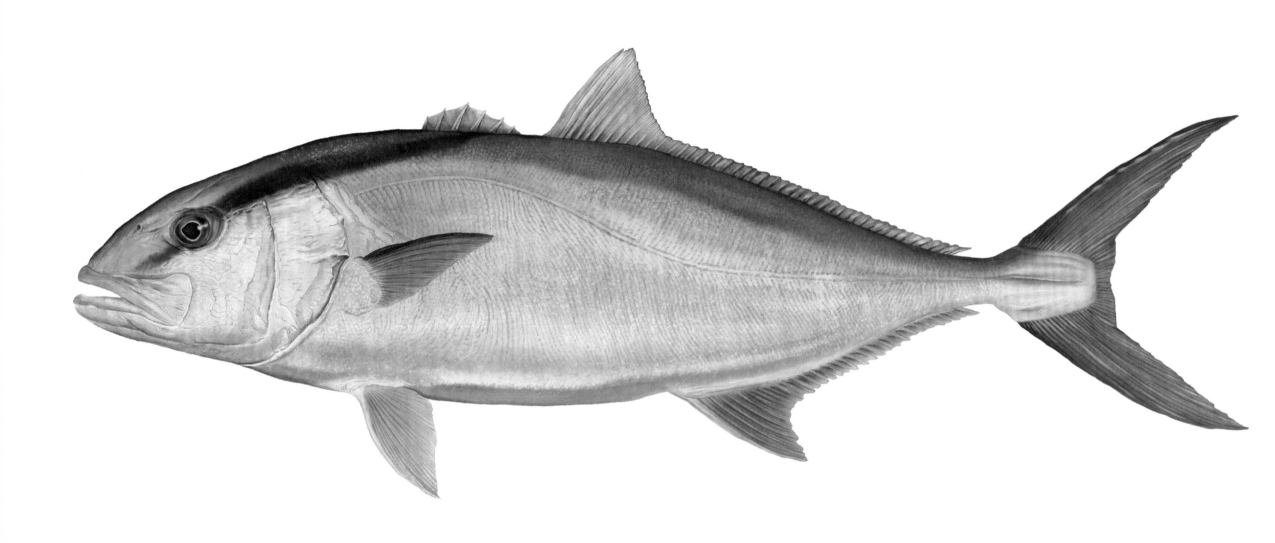

GREATER AMBERJACK

(Seriola dumerili) Weight 20–60 lbs

(Seriola dumerili)

GREATER AMBERJACK

"Don't forget to pay attention." Those were the last words my friend and guide Captain Rob Hammer said to me as we fished near the Dry Tortugas, some seventy miles west of Key West.

I had this terrific idea. Let's get a group of guys together with some camping equipment and head for Fort Jefferson, a National Park out in the middle of nowhere. What started out as just a serious hazard to navigation back in the 1500s when Ponce de Leon discovered this sea turtle-infested group of seven tiny islands seventy miles west of Key West, Florida, became a strategic military outpost in the 1800s. In 1846, the U.S. government under President John Tyler considered this spot crucial to the defense of the Florida Straits and so started to build Fort Jefferson. Rifled cannon shot instantly made the fort obsolete, so they never finished it. But they still imprisoned Dr. Samuel Mudd there after convicting him of complicity in the assassination of President Abraham Lincoln. (He was later pardoned.)

Just before dawn, we pulled up to the transom of a big shrimp boat out of Louisiana where we traded a case of beer for several bags of bycatch. That's the ten pounds of crabs and juvenile finfish that shrimpers catch with every pound of shrimp. Normally it gets shoveled over the side as garbage. Wouldn't you trade your garbage for a case of beer? We use it as an attractant for all sorts of fish.

Our next stop was by an abandoned light tower to catch some pinfish, grunts and cigar minnows to use as live bait. Finally, we moved on to find some permit on a wreck just outside the boundaries of the park.

WHAT'S IN A NAME?

The amberjack gets its name from the stripe that runs along the side of its body. The greater amberjack is the largest and most recognized jack species as it is often found in coastal urban areas in the East.

CATCH ONE!

Frequently found near reefs and structures (like oil rigs in the Gulf) but also in open water as deep as three hundred feet. The larger fish tend to be female since they live up to fifteen years longer than males. Excellent eating although there have been reports of ciguatera toxin in some areas so remove the bloodline from a fillet prior to eating.

"There should be some big grouper and even some goliath grouper on this wreck, too" said "The Hammer" quite confidently. "But pay attention, it also holds some big amberjack."

I should have actually listened to this warning. Pound-for-pound, jacks may be the toughest fighting fish in the sea. I dropped my pinfish down to the bottom, then reeled it up just a few feet.

"Hey Hammer," I said as I turned toward him, still holding the rod over the side. "Can we try for some…" BANG! I saw stars. The amberjack had struck, pulling the rod down so violently that it crushed my hand against the fiberglass gunwale of Hammer's boat, breaking two fingers.

"I told you to pay attention," Hammer laughed as tears streamed down my face. "Aw, don't be such a big sissy! Reel up the damn fish!"

Yes, I got the fish. Yes, I stayed out there camping with my fingers splinted together with the metal shaft of a hook remover. Yes, I kept fishing, but awkwardly.

DISTRIBUTION

More populous from North Carolina south to the Gulf and Bermuda, greater amberjacks roam as far north as Cape Cod. These are schooling fish with impressive stamina that give even experienced anglers plenty of excitement.

PERMIT

Most anglers consider permit a sacred game fish, to be caught on light tackle and released unharmed. Permit, a member of the same family as pompano, make fabulous table fare, too. Don't ask, don't tell.

DISTRIBUTION

Find permit in the western Atlantic south of Cape Cod down through the Caribbean and Gulf of Mexico. Though usually found in shallow water, they also inhabit deeper water structure, travel in schools when young, and become somewhat more solitary as they age.

The anchored shrimp boat looked deserted. We obviously arrived a little late for the culling, when the crew separates all the bycatch from the valuable shrimp. The shrimp go into the freezer and the bycatch — juvenile shrimp, fish, crabs, sponges, and coral — all end up shoveled over the side. They call it trash.

"Here, take the wheel and nose us up to the transom," instructed Captain Rob Hammer. I followed his instructions carefully, since I had never seen him let anyone else drive his boat. While I reveled in his apparent trust in my skills, he knocked on the wooden hull, hailing from Houma, Louisiana.

"Anybody still awake?"

A crewman came out of the wheelhouse and walked back to the stern.

"I guess I got up a little late today," said Hammer. "Y'all still have any bycatch you'd like to trade?"

"Sure. What'd'ya got?" asked the shirtless crewman who still seemed to have all his baby teeth.

"How about some bacon and eggs?" suggested Hammer.

"How 'bout that — and a six-pack?"

"What's that get me?"

"It was a lean night. I got two bags."

"Done deal." Hammer reached into our cooler and pulled out a dozen fresh eggs, two pounds of bacon and grabbed a sixer of Bud out of the console. The shrimper dragged two big fifty-pound potato sacks filled with bycatch to the rail and rolled them down into our boat. Done deal.

Ten minutes later, Hammer had us anchored over the remains of a sunken shrimp boat somewhere just outside the limits of the Dry Tortugas National Park. He slit open the top of one of the bags and dumped it into the engine well on the back of our boat.

"Careful putting your hand in that stuff. Lots of stingy, stabby, spiky stuff. Especially the Mantis shrimp," warned Hammer. We both started shoveling handfuls of the bycatch into the water, saving the small crabs for what we hoped to hook here: permit.

The water under our boat suddenly came to life. Fish of all kinds seemed to come out of nowhere to feast on the manna falling from our boat. Dozens of species from bottom dwellers, to pelagics. The boat's crystalline cushion on which we floated let me see exactly what swam below us and when about ten permit showed up, we were ready. I carefully dropped a baby blue crab on a circle hook down right into the school of permit, hoping they'd stay where they were rather than letting some other non-target steal their lunch.

Bingo! "Hooked up!" I shouted as Hammer just leaned against the gunwale smugly. Nobody ever accused Captain Hammer of having too little self confidence. Fortunately for me, he can back it up — time and time again.

CATCH ONE!

Look inshore on shallow sandy flats and channels. Casting for fast-moving permit is a precise and challenging sport. In deeper water, schools will congregate around reefs, wrecks, and oil rigs.

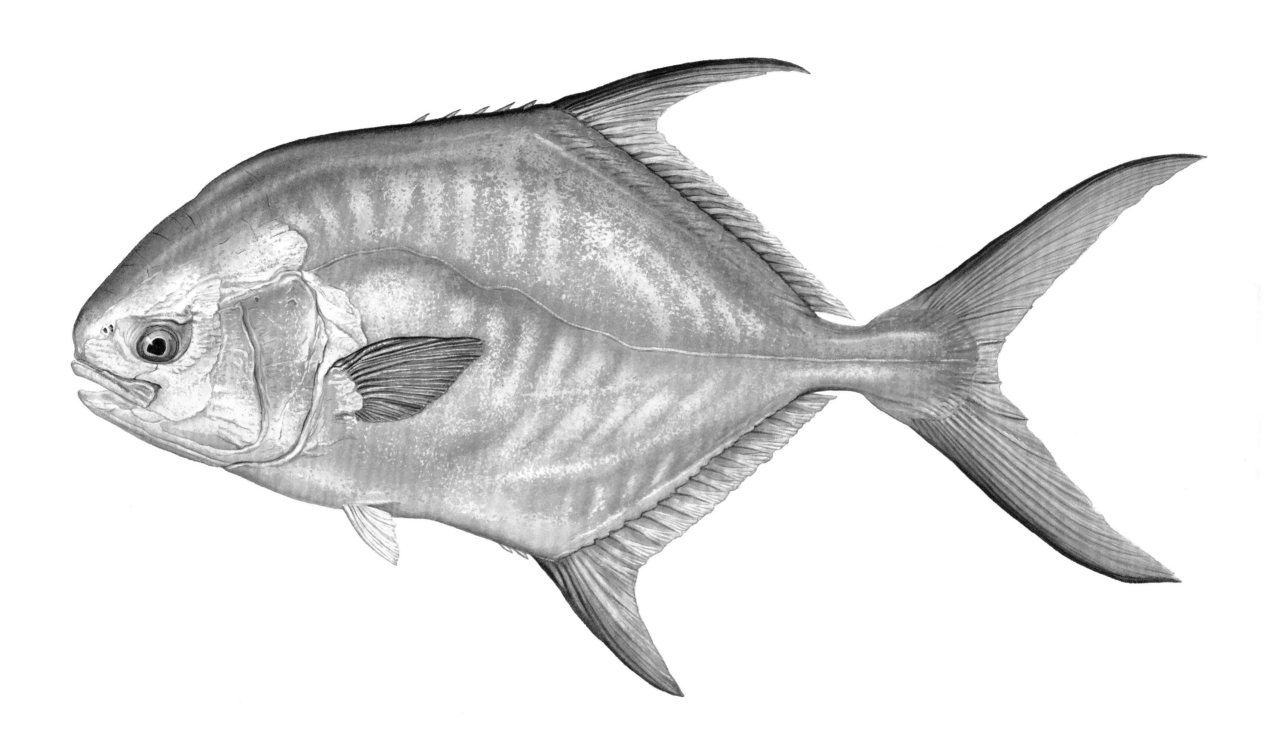

PERMIT

(Trachinotus falcatus) Size 12–25 inches. Weight 10–30 lbs

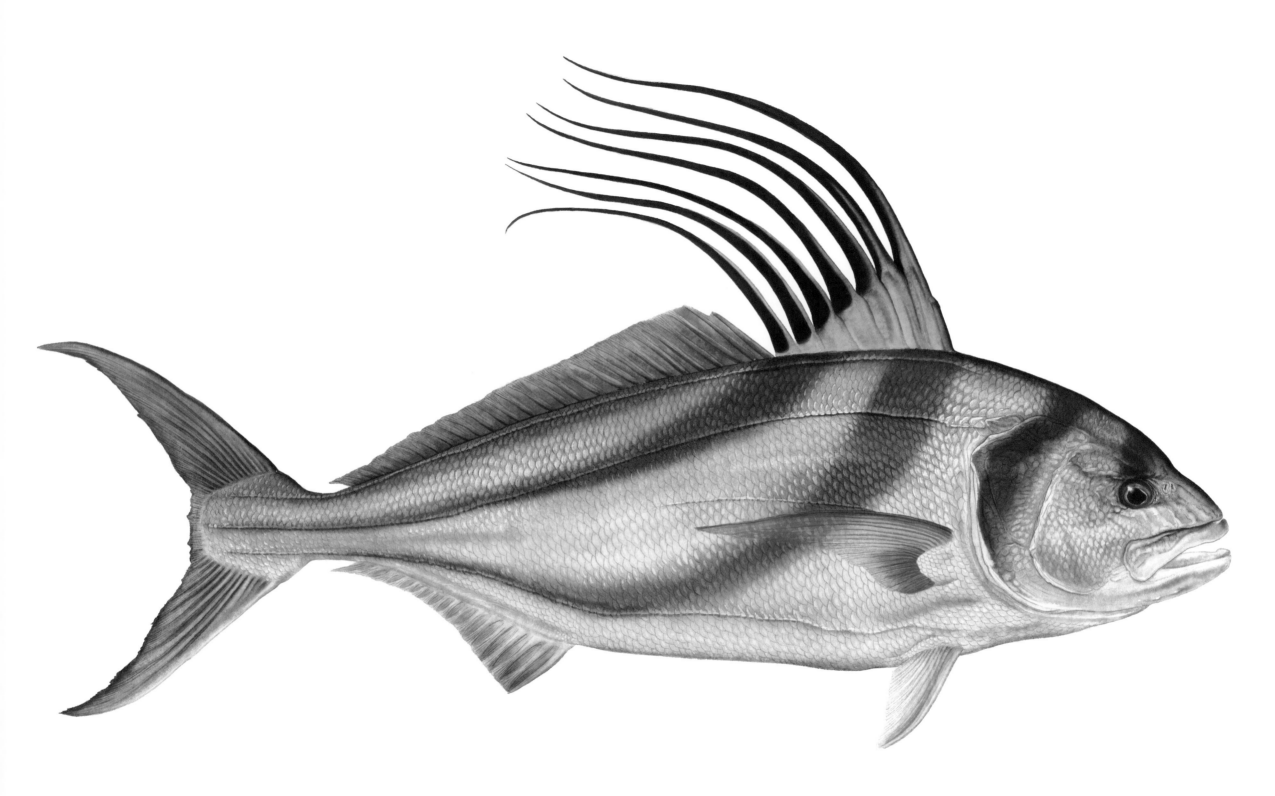

ROOSTERFISH

(Nematistius pectoralis) Size 2–4 feet. Weight 15–40+ lbs

(Nematistius pectoralis)

ROOSTERFISH

Some people are collectors. Of what, it really doesn't matter. Each collector harbors the same inherent need; to fill in a personal list of specific desires. Collectors' lists seem to be completely arbitrary constructs. Why billfish instead of bass or grouper? Or in fact, why fish instead of model trains? I have no clue. My list happens to consist of varieties of fish. For example, around the world you can find seven species of billfish. I have caught five so far and aspire to cross the remaining two (black marlin and spearfish) off my list.

CATCH ONE!

Roosterfish will round up and then tear through bait at the surface creating quite a show and attracting plenty of birds. Check shallow areas close to shore or over reef lines. The current International Game Fish Association world record for roosterfish, at 114 pounds, comes from Mexico.

I spent five years chasing (before catching and releasing) a roosterfish. Found throughout the Pacific Central American coast, this unique fish fights like a jack combined with a tarpon. They grow to a decent size and look unlike any other fish due to the telltale cockscomb of a dorsal fin. Wary, fussy and limited in range and numbers, roosterfish represent a significant achievement in anyone's piscatorial pursuits.

Each year, I traveled to relatively remote places that all laid claim to the best roosterfishing in the world. If it weren't for bad luck, I'd have had no luck at all. I caught all manner of other fish I'd never caught before but never the elusive rooster. I honestly can't count the number of times I heard guides offer up my two most hated and hackneyed phrases in fishing: "You should have been here last week!" and "That's why they call it fishing and not catching." Prepare for a severe lashing should you ever make the mistake of suggesting one of those loser balms to me.

I made two trips for roosters last year. That I almost always have a TV crew at hand to document my failures only adds to my thrill level. At Los Suenos Resort, where I personally know dozens of anglers who regularly catch monster roosterfish, I hooked what might have been, could have been, a rooster. Never saw it before it spit the hook. The last fish of the trip took my baited circle hook and bounded like a deer fleeing a corn field. Beautiful arching jumps and sizzling, reel-dumping runs ruled the cameramen's lenses until a sudden nothing took over. Everything just stopped in its tracks — the fish gone forever. I reeled the empty hook back to the boat.

The second trip, to Crocodile Bay in southern Costa Rica, found my fishing partner hauling a small roosterfish to our transom a scant five minutes after we started fishing. His derisive laughter almost made me forget never to punch anyone out on national television.

Once again, at the end of the last day, a fish struck my line and put on an impressive display of acrobatics and fighting prowess. When I finally got it to the boat, it weighed almost sixty-five pounds — a big roosterfish by any standard and success, at long last.

DISTRIBUTION

You'll find roosterfish along the eastern Pacific coast from the northern Baja Peninsula in Mexico south to Peru, including the Galapagos Islands. Roosters prefer shallow inshore areas, especially sandy shores along surf beaches. Natives eat them, but only when they have nothing else.

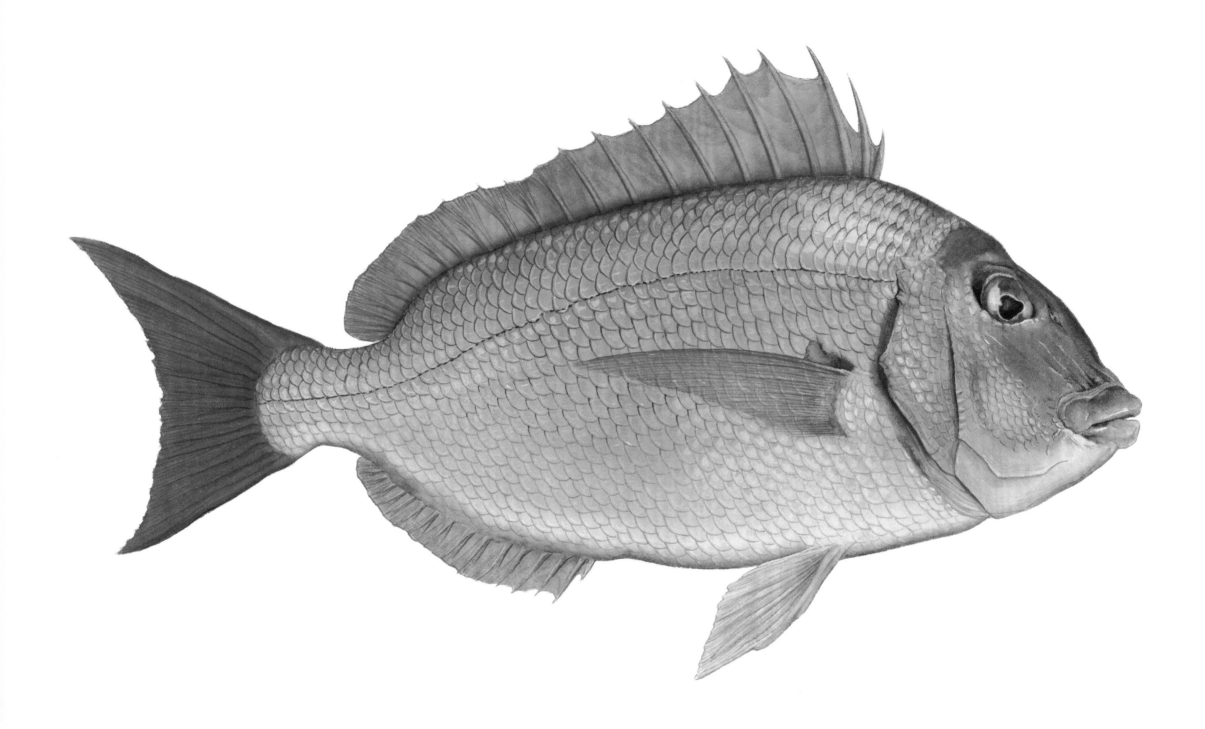

PORGY (SCUP)

(Stenotomus chrysops) Size 8–18 inches. Weight 1–4 lbs

(Stenotomus chrysops)

PORGY (SCUP)

Native Americans gave us the name porgy. To them it translated as "fertilizer," one of this fish's main (among many) uses during colonial times. As with so many species, the porgy has other names, including sea bream. In France porgy is **dorade***, in Germany* **meerbrasse***, in Spain* **esparido***, in Russia* **porgi** *and the Japanese, who take as much porgy as the United States can export, call it* **tai***.*

Used as bait by many anglers in the Northeast, porgy actually represent an important commercial catch, especially the red and yellow porgy. At least a dozen varieties exist around the world and people regularly eat them fresh and frozen, and cook them by pan-frying, broiling and baking. Personally, I like smoked porgy, so here's my incredibly easy smoking recipe that I use for almost any fish.

— ᕙ —

Ingredients

1 cup Kosher salt
1/2 cup white sugar
1/2 cup dark brown sugar
1 tablespoon crushed black peppercorns
Fillets (skin left on) from at least two porgy

In a bowl, mix together salt, sugar, brown sugar and freshly crushed peppercorns. Lay out a sheet of aluminum foil a little longer than the length of the fish and top with an equally long layer of plastic wrap. Sprinkle enough rub on the plastic to coat. Lay one side of the porgy skin down onto the rub. Create a thick coating of rub on the upside. Lay a second slab of porgy atop first, meat-to-meat. Coat the top skin-side of the porgy with rub. Enclose fish in plastic wrap, then in aluminum foil. Repeat the process for all other fish, using one fish per package.

CATCH ONE!

Porgy can be found in protected water or open ocean. Chum with shrimp, crabs, or squid, or fish off piers using the same as bait. Most mid-Atlantic states have size limits to commercial and recreational porgy catches that vary from eight to fourteen inches minimum length.

— ᕙ —

Place all the wrapped fish packages (one layer high) onto a plank, or a sheet, or roasting pan, top them with a heavy weight and refrigerate for at least 12 hours. Flip all the packages over and refrigerate for another 12 hours. (Be prepared for some juice leakage.)

Unwrap the fish and rinse off the rub with cold water. Pat porgy dry with paper towels then place in a cool, dry place (not the refrigerator) until the surface of the fish is dry and hazy looking. This takes between 1 to 5 hours depending on the humidity. Feel free to use a fan to speed the process. Smoke fish over moistened hardwood chips or sawdust, keeping the temperature inside the smoker between 150 and 160° F. until the thickest part of the fish registers 150°. Serve immediately or cool to room temperature, wrap tightly and refrigerate for up to 3 days. Vacuum-bagged, it will last in your fridge or freezer for ages.

DISTRIBUTION

Porgy roam the western Atlantic from Nova Scotia to Florida, though they become scarcer south of the Outer Banks of North Carolina. You'll find sizable schools inshore during the summer months. Porgy tend to winter in deeper offshore waters.

— ᕙ —

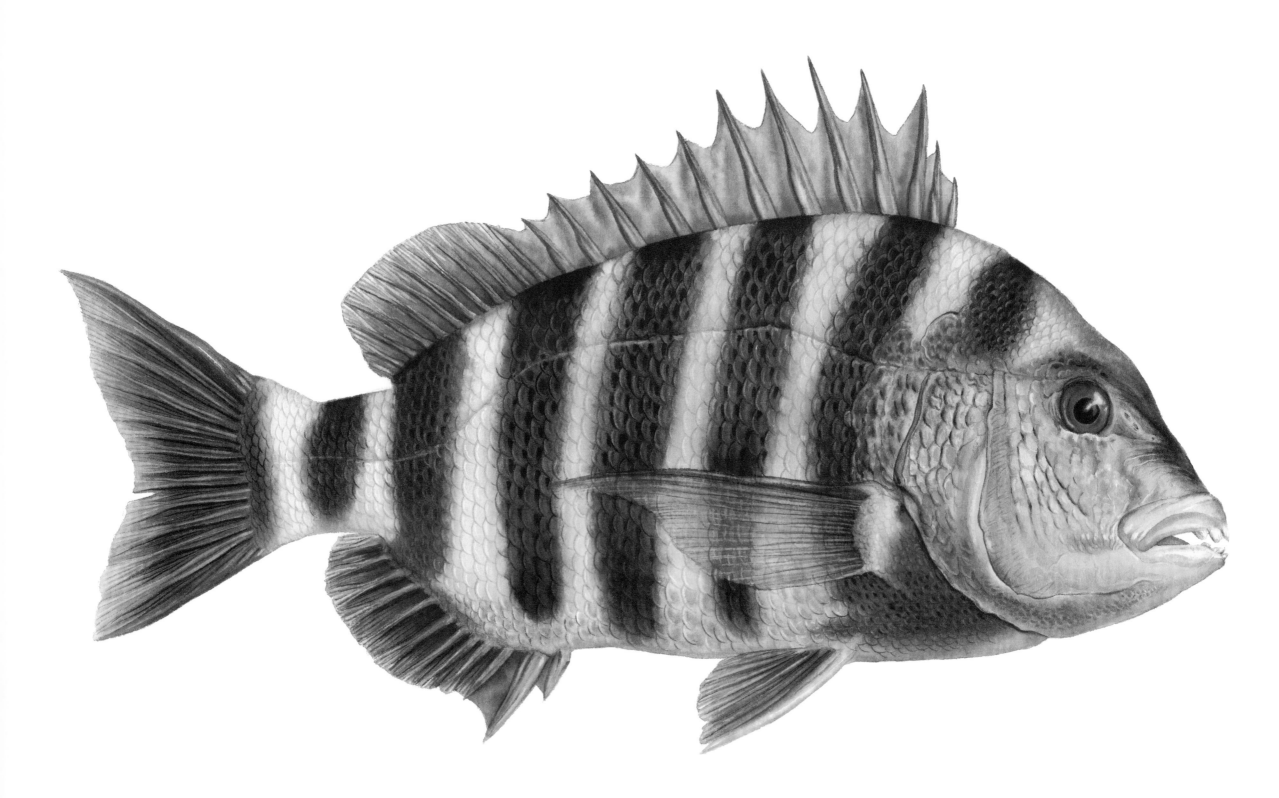

SHEEPSHEAD

(Archosargus probatocephalus) Size 8–20 inches. Weight 1–7 lbs

(Archosargus probatocephalus)

SHEEPSHEAD

We had planned to run a short distance offshore and fish a small reef for whatever we could find. I didn't want to do anything too strenuous or adventurous since my friend Drew brought his small son Andrew with us for his very first grown-up fishing trip with "the men."

Apparently five-year-old Andrew fairly vibrated with excitement the prior evening. He had his own Zebco spin caster and a tiny tackle box that Drew had filled with a few jigs, rubber worms, hooks, and split shot sinkers. Nothing we planned to use today, but it was his and he brought it.

As I nosed the boat around the point of the jetty, I realized that this was not the day to baptize a newbie angler of single-digit age. I offered a *sotto voce* suggestion to Drew that we try some other kind of fishing so Andrew would have a better time of it. I turned the marine radio up loud, listening to the weather forecast.

EAT ONE!

Sheepshead can nibble away your bait with their big buck teeth that look positively human. Their heavy scales and fin spines make them a bit hard to clean and the fillets tend to be small for the size of the fish, but the meat makes an excellent dinner.

"Andrew," I said after shutting the radio off. "I just got the fishing report about the place we were going and it didn't sound good so I'd like to take you to another really great spot." Andrew couldn't have cared less where we went, as long as he could catch fish. Actually a rather adult response when I consider it.

We tied off to a bridge abutment right next to the channel, and I set Andrew up with the rig he needed to catch sheepshead. People call them nibblers. When they strike, you can barely feel it. I pointed to where Andrew should cast and I put my rig right next to his. In moments he reared back with his rod and started reeling.

I felt something and tried to set the hook but came up empty. Andrew pulled up a two-pound sheepshead.

I didn't get it. "Wait until you feel the bite," I suggested.

"I know how to do this," he insisted. His bait would no sooner get down toward the bottom and he'd whip the rod tip back and start reeling — inevitably bringing up another fish. I waited and waited for a sign and got zip. So I finally asked him how he kept catching sheepshead.

"I just hook them when I think they're there."

Ah, blind faith, I thought. So I dropped my fresh bait down next to the piling. I didn't feel anything bite. But when I thought it had been there long enough to attract a fish, I reeled down and set the hook. It worked. Art Linkletter had it right. If you set your adult ego aside and listen — I mean truly listen — a small child can teach you a great deal.

DISTRIBUTION
Sheepshead inhabit the western Atlantic from Nova Scotia to Brazil including the Gulf of Mexico. However, they seem to have passed by Bermuda, the Bahamas and the West Indies. They live around rocks and pilings eating barnacles and crabs. They frequent salt, brackish and occasionally fresh water estuaries.

BARRED SURFPERCH

Abuelo woke eight-year-old Esteban before sunrise. "Mijo," he whispered as he shook the boy's shoulder. Esteban bolted upright as if he'd been jolted with electricity.

"I'm ready, Abuelo," he said as he slid out of his bunk bed — already clothed. Down in the kitchen, Abuelo set two empanadas in front of each of them, one hot beef and the other guava with cheese, along with steaming cups of café con leche with lots of sugar.

"Esteban, take time to chew your food," chided Abuelo, but with this special adventure looming on the horizon, his admonitions fell on deaf ears. Down on the beach, Abuelo gave Esteban the bucket with the hinged lid and lots of tiny holes in it.

"Here's your job," he said as he walked the boy down to the water's edge. "See those crabs running along the hard sand? You need to catch as many of them as you can and put them into this bucket. When you have enough, we'll start fishing."

Esteban ran back and forth, missing the first five or six sand crabs until he figured out how to cut them off. After that, it was only a matter of half an hour before the bucket almost overflowed with sand-colored pincers. The younger and elder shuffled through the soft sand up to the head of the pier and walked out to where the surfline curled into turbulent white foam. In conspiratorial fashion, Abuelo knelt next to Esteban and showed him his secret to catching barred surfperch — the "greatest saltwater panfish in the world," he called them.

"First," he said, picking a crab out of the bucket and slapping the lid closed against the myriad potential escapees, "break off the pincers." He carefully bent each claw over until it separated from the body, then tossed it over the rail into the sea. "Then, do the same thing with the legs. Take your hook, and put it through one of the leg holes in the shell. That way, it won't pull out. Then finally…" Abuelo looked over his shoulder in the dusky morning light, then around behind Esteban. Esteban mimicked his reconnoitering. "Here's the secret. Hold the shell between your fingers and squeeze it just enough to crack the shell. That lets the crab smell into the water and that's what attracts the fish from far away. But make sure that you do it just before you cast it so nobody sees."

Esteban baited his hook and cast out into the surf, right where Abuelo had instructed. In his mind, he could see the crab tumbling along the bottom and surfperch sniffing the trail that would lead them right to it. Bump-bump. Esteban's rod tip bounced and he reared back to set the hook.

"It's not a whale, Mijo. You don't have to pull its lips off," said Abuelo.

Esteban reeled with the energy of a dynamo. Up out of the water came a small fish with vertical copper stripes, wiggling at its sudden change of venue.

"¡Felicitaciónes!" laughed Abuelo. "If you catch one on each cast, we'll be able to cook them up for your mother and father for breakfast. We'll be done before they even wake up."

As Esteban put the fish into the cooler, he whispered to Abuelo, "I promise that I'll never tell anyone our secret, Grandfather."

DISTRIBUTION

Barred surfperch are the most popular pier and beach-fishing species in California. They are more populous in the southern part of the state. Calico surfperch are mostly north of Morro. North of San Franciso, redtail surfperch rule. The species don't seem to intermingle.

CATCH ONE!

If you can't catch barred surfperch with sand crabs (their favorite meal) try clams or mussels instead.

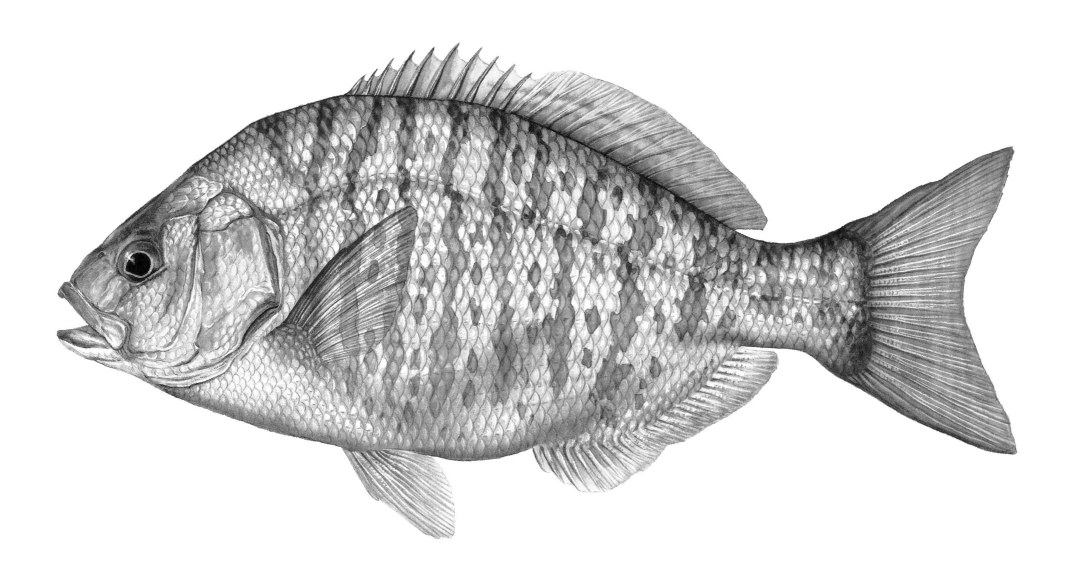

BARRED SURFPERCH
(Amphistichus argenteus) Size 6–16 inches. Weight 1–4 1/2 lbs

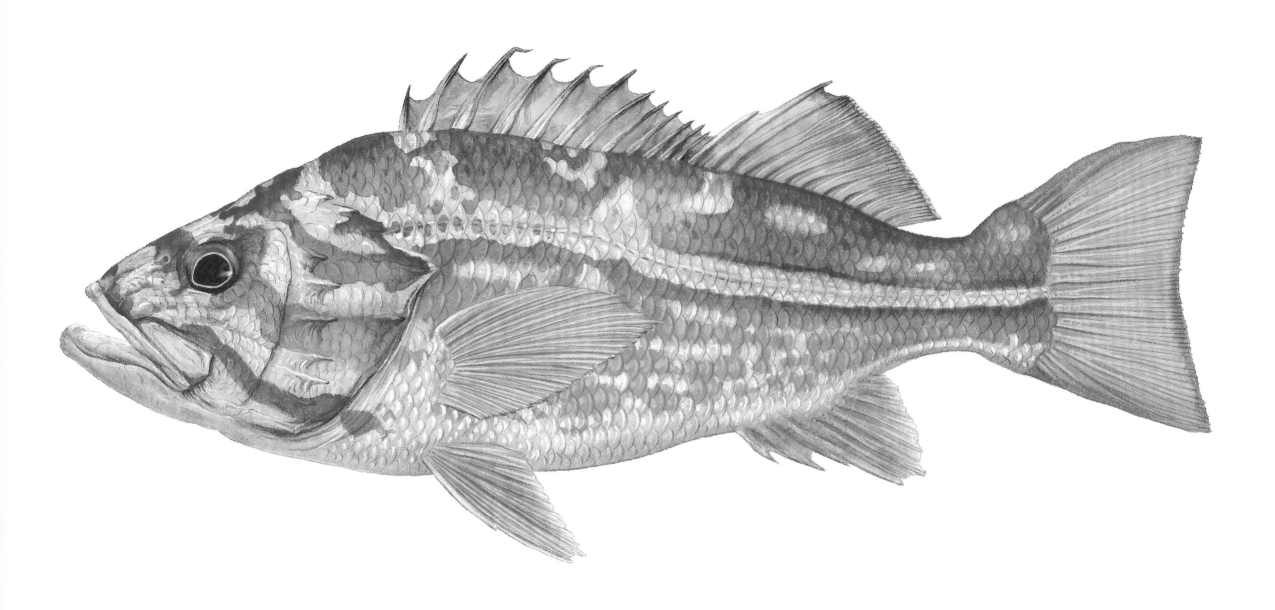

CANARY ROCKFISH

(Sebastes pinniger) Size 12–30 inches. Weight 2–8 lbs

(Sebastes pinniger)

CANARY ROCKFISH

Canary rockfish labor under some of the strictest and most volatile fisheries regulations on the West Coast. With the collapse of the Northeast groundfish resource as a glaring example of mismanagement, California fisheries scientists have instituted bag, seasonal, and size limits in an effort to keep the canary rockfish (and other rockfish species) from disappearing. Canada has Rockfish Conservation Areas (RCAS).

Scientists taking census of canary rockfish populations indicate the fish stock has some problems. Canary rockfish, like all rockfish, grow slowly and live long lives. Scientists believe that canary rockfish, left undisturbed, can live as long as eighty years, however studies are limited and impressions come from declines in historic catch tonnage. The Pacific States Fisheries Management Council lists the following seven rockfish species as currently overfished: bocaccio, canary, cowcod, darkblotched, Pacific Ocean perch, widow, and yelloweye. For some of the species in deeper peril, scientists feel that under optimal circumstances, building stocks back to forty percent of their historic number could take over fifty years.

One significant problem with conservation efforts targeting any deep-water fish is that catch-and-release simply doesn't work. The air bladders (used for vertical equilibrium) in fish caught at depths greater than 100 feet expand as the fish is lifted to the surface. In fact, after a certain point, the angler stops lifting the fish and simply reels in line as the fish floats the remaining distance. At the shallow extremes, these bladders can be vented with a needle and the released fish can return to the depths. In commercial fishing, where hundreds of fish rather than singles are caught, that process lacks practicality. In other words, even if someone doesn't target

canary rockfish, but catches them incidentally, the fish still die.

Characteristics such as late age at maturity, extreme longevity, and tendency to stay in one place make canary rockfish vulnerable to overfishing. Although anglers have caught them at depths greater than 1,000 feet, the bulk of the commercial harvest occurs to only about 500 feet — still too deep for catch-and-release.

When spawning, the female receives sperm from the male, but she just stores it for several months. The eggs remain inside the female until she mixes the stored sperm with the eggs and then the embryos develop inside of her. A month or so later, the female expels live embryos which join the planktonic community and drift away.

The canary's species name *Sebastes pinniger* stems from the Greek words for magnificent and large-finned. I guess what's true for people holds true for rockfish. You can't survive on good looks alone.

BEWARE!

Canary rockfish belong to the same family as scorpionfish and sport slightly venomous spines as well.

DISTRIBUTION

From northern British Columbia down into the Baja Peninsula, the canary rockfish dominated the Californian commercial rockfish industry since the 1880s. Young canaries live in relatively shallow water. Adults move out to deeper water, 260–650 feet.

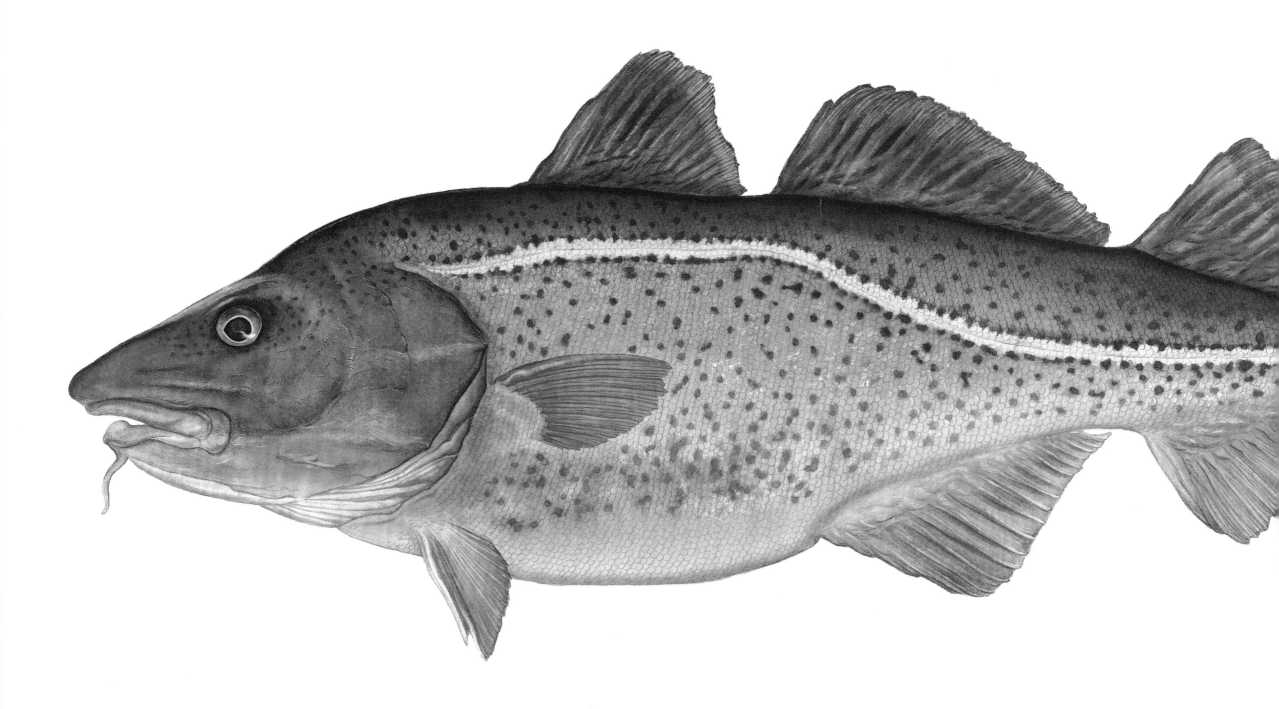

ATLANTIC COD
(Gadus morhua) Size 20–42 inches. Weight 8–50 lbs average

(Gadus morhua)

ATLANTIC COD

There is debate as to whether the Atlantic cod can still be considered a great game fish.

It is well known that the stocks of this fish crashed dramatically in 1992 and have not fully recovered. A decade later, the physical appearance of cod specimens alarmed fisheries scientists. With flat bellies, arched backs, and down-turned heads, cod appeared to be moving towards more of a bottom feeder lifestyle.

An April 2004, Canadian Department of Fisheries and Oceans (DFO) study stated: "Canadian cod are starving because their ocean environment is no longer providing enough food to support them, and an important cause of this food shortage has been centuries of fishing." For years, commercial fishing interests and the DFO alleged that codfish depletion was caused by seals and other predators eating the groundfish upon which cod feed. In 2004, the DFO finally acknowledged that commercial overfishing (cumulative physical removal of groundfish) actually caused the stock to crash.

The DFO study also suggested that increased numbers of small, open-ocean fish such as herring have depleted the amount of nutrients drift to the ocean floor where groundfish feed. Rather than helping the cod stocks, culling of seals would exacerbate the problem since they eat tons of herring, and other small fish, whose populations would grow and then, in turn, eat more nutrients that would otherwise reach the ocean floor. Simple logic says that if you remove the food source of any living creature, that creature will not survive.

In the summer of 2004 I set out with Jeff Walther of Striped Tease Charters out of Chatham, Massachusetts on Cape Cod to catch specimens for this book, including, hopefully, an Atlantic cod. In short order, Jeff got us onto a very large healthy cod. It seemed deceptively easy to catch one for this book, as if the absence of big cod today were not debatable. Using stout poles and three-and-one-half ounce kicker jigs (a West Coast yellowfin lure) the fight wasn't remarkable or memorable. It was a bittersweet fishing experience. **FLICK FORD**

FIND ONE!

The bigger fish stay offshore in deep water, except in the choice cod areas between New-foundland and Long Island where they can occasionally be found with smaller cod. Their delicious flavor has contributed to commercial overfishing. Smaller fish (under five pounds) are called scrod.

DISTRIBUTION

North Atlantic from northern Canada, the Hudson Strait, and south to Cape Hatteras. Spawning occurs from December to late March in the Gulf of Maine.

LINGCOD

Ophiodon elongatus *stems from the Greek words* ophis *meaning snake and* odons *meaning tooth. Other common names for lingcod include ling, cultus, green cod, and buffalo cod.*

DISTRIBUTION
Found mainly in the eastern Pacific from the Baja Peninsula in Mexico up to Kodiak Island, Alaska. They prefer kelp beds and rocky areas.

I had never fished in the Pacific Northwest before. I mainly wanted to catch some salmon, but people told me not to miss out on halibut and lingcod, so I took a day off from salmon fishing and my guide moved just several hundred yards deeper and we started bottom fishing. I caught two small halibut and dropped a fresh bait over the side. I quickly hooked into another small fish, but then surprisingly, my rod suddenly pulled downward harder by an order of magnitude.

"That's the one," said my guide. It always amazes me how skilled charter captains can tell what you've just hooked up to, several hundred feet below the surface, simply by watching your rod tip. I started reeling with renewed fervor, anxious to see what my guide already

BAIT!
It eats just about anything including flounder, hake, herring (what we used as bait) and even other lingcod, to name just a few. Were lingcod human, they would have no friends.

knew. In clear water, when your catch approaches the surface, you can often see color before a distinct outline of your catch. By the time I could actually see a shape, it looked like nothing I'd ever seen before.

"That's one tenacious predator," said my guide as the mystery fish came up from the depths, getting ever closer to the boat. If I didn't know better, I'd say I'd caught two fish on one hook.

"Just keep reeling him up until the leader reaches the rod tip and I'll lift them aboard," said the guide.

MAN POWER
In the far northern range, male lingcod move toward spawning grounds near the shore in October where they establish the nests near strong current areas. Spawning takes place between December and March after which the females leave the nest for the males to protect until the eggs hatch.

"Them?" I thought. The guide grabbed the heavier leader and started hand-over-handing it in until my halibut came up over the rail with a twenty-five pound lingcod holding the whole back half of it in its mouth — like a pit bull that just won't let go.

"Want me to net it?" I asked.

"Nope," he replied. "That fish simply won't let go. It's greedy and aggressive. It thinks it still has a chance of swallowing that halibut." And sure enough, he lifted both fish up and over the gunwale and we didn't lose either.

Absolutely no relation to the cod of fish-and-chips notoriety, a lingcod is easily recognized by its huge mouth that slants down toward the back. In fact, its face looks a lot like a Muppet character. It comes in a variety of colors from grey to blue, brown, black, or green. What impresses me most about lingcod, though, is how voracious it is when feeding.

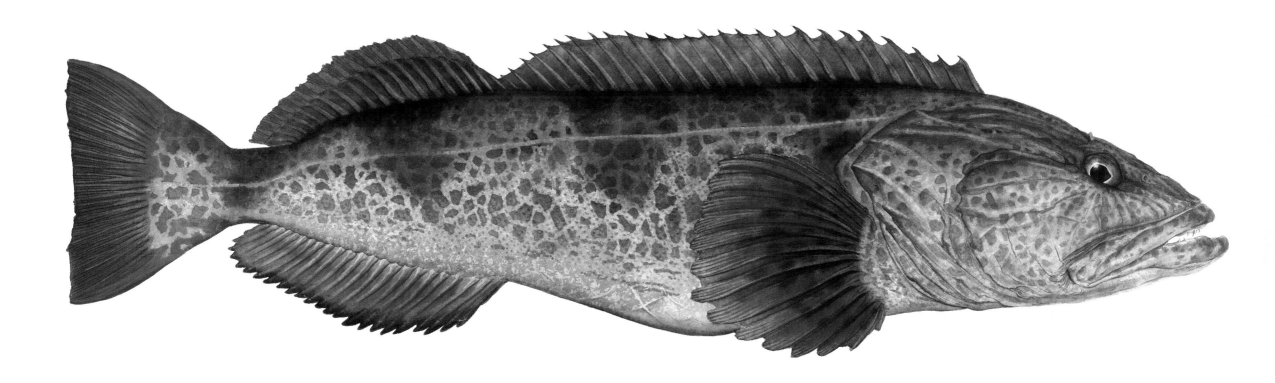

LINGCOD

(Ophiodon elongatus) ♂ *18–36 in; 10–20 lbs.* ♀ *24–45 in; 15–60 lbs*

(Albula vulpes)

BONEFISH

Recognizing a bonefish in its natural environment is akin to chasing a chimera. It blends so well with its background that the fish itself is often never seen, only the shadow it casts on the bottom as it passes. Among light tackle and flyrod anglers, the bonefish represents one of the most sought-after species, and the toughest, to catch.

DISTRIBUTION

A coastal species found in tropical and warm waters on both the Atlantic and Pacific coasts, the bonefish typically school in large groups. Larger fish stay out in deeper water, while the smaller ones come into bays and intertidal flats.

The day in Islamorada in the Florida Keys dawned sunny with winds blowing a solid thirty knots and gusts higher. Islamorada ranks as one of the top places in the world to catch really big bonefish and we were there to tape a sportfishing television show.

"I don't care how well you can throw a fly, it's not going to happen today," said Paul Tejera, a well-known bonefish guide. One of the toughest things about taping a TV show about fishing is that unlike taping in a studio with actors, the director can't stop everything in the middle and shout, "Take two." Fish, weather, and ocean don't cooperate on demand. The TV director, Ken Kavanaugh, and our cameramen, all had on that "this-isn't-starting-out-very-well" look.

We ran about ten minutes to one of the many serpentine channels that connect Florida Bay to the Atlantic Ocean between keys. We stopped and shut down the outboard at the upwind side of a large, shallow flat. With the wind blowing, it was hard to see the bottom even though the normally crystal-clear water was only a foot or two deep. Tejera would need to put all his effort into keeping us from kiting across the flat like a rocket, rather than his usual job of pushing us along with a long pole. He climbed atop the four-foot-high poling platform on the stern to look for fish. I stood on the bow with the ultra-light spinning gear and a live crab on the hook, ready to crush it like a grape just before casting it, which would attract bonefish like a loaf of baking bread attracts people with knives and butter.

OLD-TIMERS

Bonefish are rare members of a family of bony fishes that date back to the Cretaceous period, 125 million years ago. They are indiscriminate eaters, sucking up everything as they speed across the shallow bottoms.

Tarpon and Bonefish

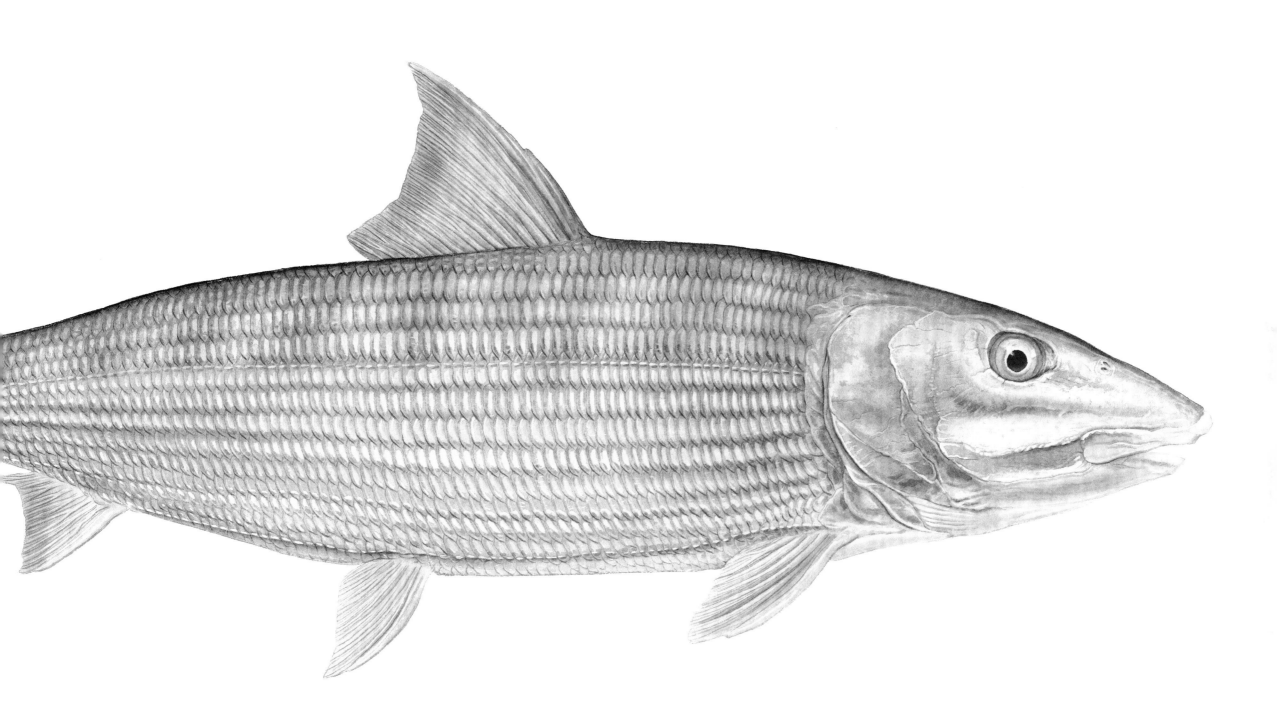

BONEFISH

(Albula vulpes) Size 10–30 inches. Weight 3–14 lbs average

"There's one — look at nine o'clock at about one hundred feet."

I cast from my position standing on the bow out to where he had indicated, and I was instantly reminded of playing golf. The wind caught the lightweight crab and curved my cast about ninety degrees from where I wanted it. The two cameras and a half-dozen people documented my ineptitude.

"Good one, Dean," said Tejera. (Guides often forget that the rest of us don't do this everyday.) "Get another bait. I'll move us down toward the other side of the flat a bit." Tejera pulled the pole out of the sandy mud where it had been staking us in position and we took off. When we reached where he wanted to try again, he jammed the pointed end of the pole back into the bottom to act as an anchor. The momentum of the boat in the wind just about pulled him overboard. The crew laughed at our rendition of fishing Keystone Kops.

"There's a bonefish mudding dead ahead. It's straight downwind at about one hundred fifty feet. See it?" asked Tejera.

For a change, I could see the tail sticking up out of the water as the bonefish nosed down into the soft bottom rooting through the turtle grass in search of crabs

and shrimp.

"He's moving right to left. Cast about twenty feet to the left of it," Tejera said in a stage whisper.

"Please let me not screw this cast up," said the thought balloon over my head. Plop. Right where I wanted it. Even a blind pig finds an acorn once in awhile.

"Okay, just let it sit. Don't move it. Wait. Wait. Give it a tiny twitch. Good, let it sit. The bone is right on top of it. Does it have it?" he asked.

With the bail open on the spinning reel, the line started to move out through the rod guides, ever so slowly at first, and then faster. Then faster still until, more-or-less confident that the fish had the crab in its mouth, I flipped the bail closed and started reeling. A circle hook pulls out of a fish until it catches right in the corner of the mouth — the least damaging place for it. When the line came tight, the bonefish suddenly realized the price of that last crab it ate and took off, burning line off the reel and I felt like I had just hooked a teenager on a Japanese motorcycle. Next problem. The wind wouldn't let Tejera pole the boat upwind. Honestly, if we didn't have so much invested in the crew and travel expenses, we would never have fished that day.

"I have to let the boat drift into the channel on the other side of the flat and start the engine if you ever want to catch this one," yelled my agile captain as he vaulted off the platform. Five minutes later, I had my bonefish alongside the boat. I waited while the camera boat repositioned itself, all the while hoping that something terrible wouldn't suddenly rob me of my fish. It looked pretty big.

Tejera staked us to a stop again and quickly got out his big net. As the footage later showed, the fish wouldn't fit in the net. Tejera lifted it out of the water with the net and his hand on its tail. He was more excited than I've ever seen him.

"Holy Bleep! This is huge!"

I pulled the hand scale out of his tackle box and handed it over. He attached the pincer grip to the fish's lower lip and lifted it into the air. There in front of God and the viewing masses, Tejera called out: "Fourteen pounds, four ounces!"

Doesn't sound like much. I mean we buy Thanksgiving turkeys bigger than that. But in the world of bonefish, that ranks as not far from a world record and certainly the largest bonefish ever caught on television. We measured it, inserted a scientific tag just by the dorsal fin, and gently released it.

TARPON

It boggles the mind how much sportsmen spend in an effort to catch a fish that you can't even eat. Of course, that very fact alone probably keeps the tarpon resource healthy.

"Fortunately, my job pays me to do what others spend a fortune on."

"Mine, too, in a way," said my guide, *Islamorada's* Captain Gary Ellis. "Now quit gloating and bring that leader over here so I can let this fish go before something eats it."

Ellis gently pulled on the fluorocarbon leader until he could grab the lower lip of the tarpon's square, bucket-sized mouth with his gloved hand. (Something you want to do carefully to avoid your fingers meeting the crusher plates the tarpon uses to purée hard-shell crabs deeper in its mouth.)

"Why don't you twist that circle hook out with your pliers while I hold it," said Ellis.

Even in the water, a 150-pound tarpon takes some muscle to control, frequently requiring two hands.

"I'm glad it doesn't have wahoo teeth," I said.

"Go and head us back toward our anchor ball while I swim this baby for a minute," he said. I put the outboard into forward and idled it in a circle back toward the Seven Mile Bridge while Ellis forced water over the tarpon's gills. Up ahead floated a big, inflatable fender tied to the end of our anchor line for quick release purposes.

"See ya next time," said Ellis as he let the tarpon go. With one powerful tail flick, it headed down to cooler water near the bottom to rejuvenate. "No worse for the wear…"

Anchored again, we both manned our stations. Ellis used the increased height atop the poling platform at the stern of his flat's skiff to see deeper into the water while I stood on the bow with a twenty-pound spinning rod.

"One o'clock at thirty yards," Ellis whispered.

I hadn't seen anything but put the painted jig right where he wanted it and started the erratic motion I hoped would convince this prehistoric beast that a piece of lead with a hook was something it ate all the time.

DISTRIBUTION

You can find tarpon in tropical and sub-tropical waters all over the world. Megalops atlanticus is strictly the Atlantic species.

Tension. Line slowly moving away. Reel down fast and "Whiz-Z-Z-Z-Z-Z-Z-Z-Z…" Line peeled off the reel so fast I feared something might catch fire.

"You want me to drop off the anchor ball and chase it down?" asked Ellis.

"Let's give it a minute. I think I've slowed it."

"You may want to rethink this," he replied. "We've picked up some company."

I scanned the water near the boat and had no trouble finding our guest. A shark fin loafing along right beside our boat reached fully as high as my knee as I stood on the deck. I've frequently seen hammerheads and bull sharks (the nastiest) cut a hooked or tired tarpon in half. You only see half because the other half disappears in a single bite. They grow them big in the Florida Keys.

"Think it's seen my tarpon?" I inquired, already knowing the answer as the hammerhead picked up speed — heading straight toward the end of my line.

I quickly reeled down as tight as I could, palmed the reel spool and pulled the rod straight back. The tarpon objected to the added strain and with a mighty

CATCH ONE!

Few fish provide the excitement and power of a tarpon running and jumping clear of the water. Hardy fish, tarpon can live in foul, oxygen-poor water thanks to their ability to breathe air (from their swim bladders) as well as use gills normally. Consider it a largemouth bass on steroids.

leap, cleared the water's surface by a good five feet, breaking my line right by the hook in the process. The shark came back to sniff around our boat, even bumped it in hopes that I'd fall in, I guess. He needed to find lunch somewhere, after all.

If you want a really exciting fishing experience, try planning a visit to the Florida Keys around the full moon in May and June. That's when the Palolo worm hatch happens and tarpon become whacked-out drug addicts during the hatch, making for some of the finest tarpon fishing on the planet. Palolos — segmented worms that live in shallow coral reefs — send out egg-sperm packages spurred on by the lunar cycle.

Samoans build festivals around their Palolo hatches, collecting them and eating them in bread, fried, or on toast. Americans who have tried it claim it's like eating scratchy mucus. Oh, those wacky Samoans.

Tarpon and Bonefish

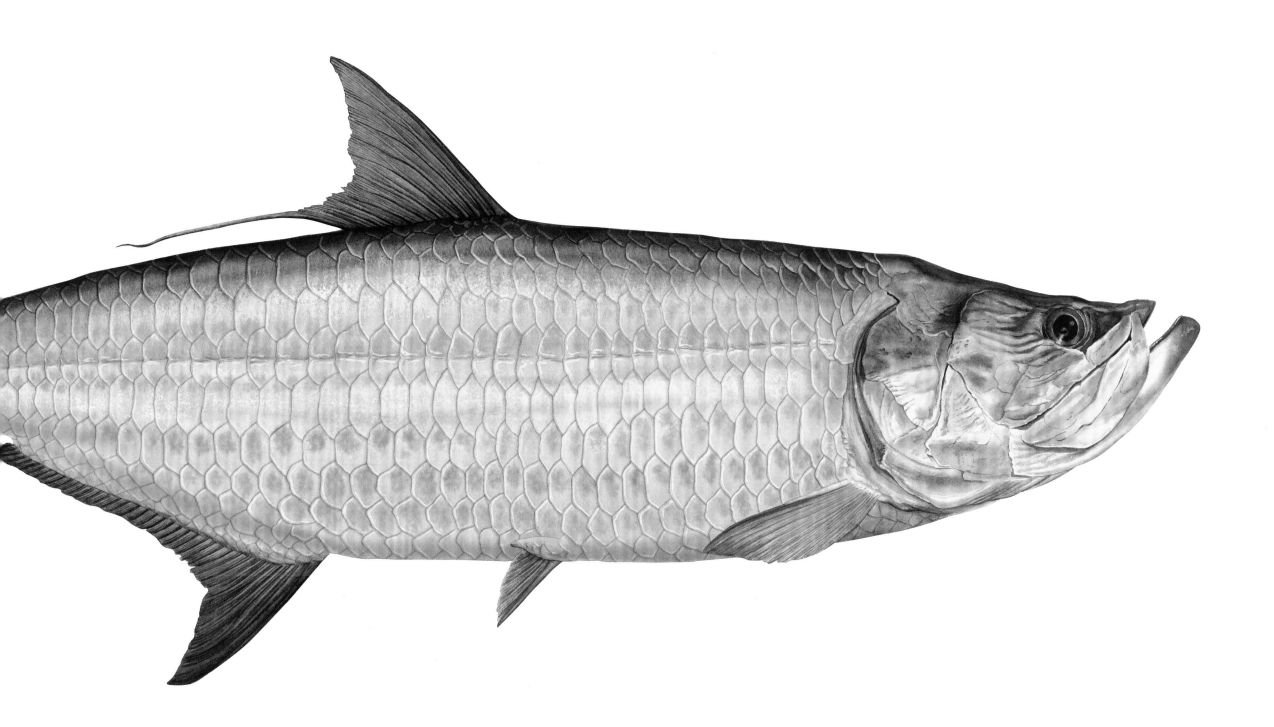

TARPON

(Megalops atlanticus) Size 4–8 feet. Weight 75–300 lbs

(Makaira nigricans)

BLUE MARLIN

I know that he would rather keep a ship clean, and paint and varnish than he would fish. But I know too that he would rather fish than eat or sleep. — ERNEST HEMINGWAY, WRITING ABOUT PILAR'S CAPTAIN, GREGORIO FUENTES. Hemingway wrote The Old Man and the Sea in 1951, the year I was born. It's a novella about an old man's epic battle against the sea, his self doubt and mortality, and a huge marlin. I've read most of the learned commentary about the story and I wonder about these people who read so much into a fabulous fish story. They postulate from the comfort of land rather than going to sea to determine for themselves what the story was really all about. As Freud said, "Sometimes, a cigar is just a cigar."

DISTRIBUTION

Found as far north as Nova Scotia in the Atlantic, it is more common from Cape Hatteras south to Florida. There is some debate in the scientific community as to whether or not the blue marlin found in tropical and temperate waters of the Pacific Ocean is a distinct species, Makaira mazara.

Most people think Hemingway based the character of Santiago on Gregorio Fuentes, captain of Hemingway's boat, *Pilar*, for more than twenty years, until the writer left Cuba in 1960. I met Captain Fuentes while marlin fishing in Cuba in the early 1990s when he joined us as the guest of honor at the Hemingway Marlin Tournament. When I asked him to fish with me, he responded, "Gracias, pero no. Yo no e pescado desde Señor Ernesto murió. No tengo deseo. Perdí mi compañero de pescar. No hay para pescar." (No, thank you. I haven't fished even once since Sr. Ernesto died. I lost the desire. I lost the will. I lost my fishing partner. There's nothing left to fish for.)

Hemingway describes Santiago as "… a well-worn man. His face and body show the signs of aging, but inside he is young and alive: Everything about him was old except his eyes and they were the same color as the sea and were cheerful and undefeated." But when Fuentes worked for Hemingway catching marlin and tuna, he was young and vital. Either way, it's safe to say that for those twenty years in Cuba no one spent more time with Ernest Hemingway than Gregorio Fuentes, who became Hemingway's closest friend. Fuentes died in 2002 in Cojimar, Cuba at the ripe old age of 104. He said he had never read *The Old Man and the Sea.*

What was it about catching marlin that consumed a man such as Ernest Hemingway? Why do people refer to it as the sport of kings (along with horse racing and yachting, of course)? You need to get attached to a marlin by a barely visible plastic string in order to understand.

Imagine traveling across an alien environment, one in which you could not survive. In this environment, there are beasts much bigger and stronger than you, behemoths that could kill you in an instant should you make a mistake. Not only could such an animal be dangerous, it

CATCH ONE!

Japanese longliners claim that blue marlin represent the largest istiophorid billfish. Males don't grow larger than 300 pounds. Females grow much larger.

Marlin, Sailfish and Swordfish

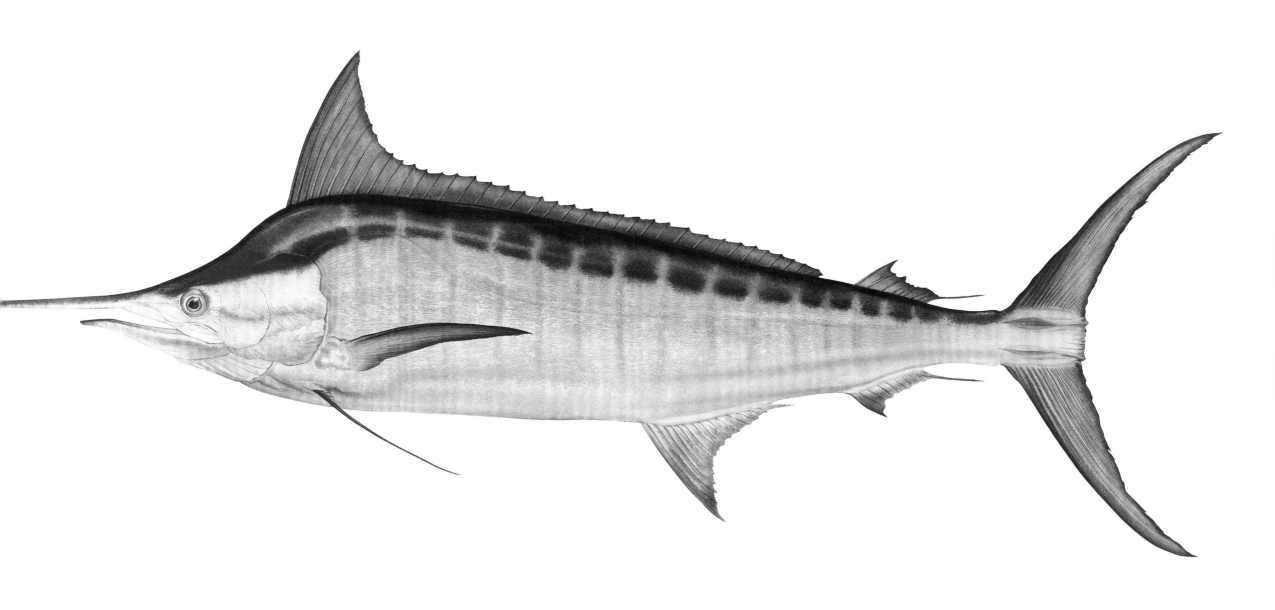

BLUE MARLIN

(Makaira nigricans) ♂ *up to 300 lbs* ♀ *1,000+ lbs*

also looks completely unfamiliar, bizarre, and menacing. This mysterious fish comes from places we don't know much about. The challenge for man is to prove his superior ability to reason, to use tools, and to prevail.

As you cruise along on the open sea, something unseen starts trying to take your boat. Perhaps for a moment you imagine you are in a horror movie and some unseen monster is trying to catch you. Then you remember that small bit of security — you're aboard a boat. Hopefully the fish won't come aboard after you (although this has happened with some tragic results).

You strap yourself into a large chair bolted to the floor. The tight line pulling against the brake drum in the fishing reel lifts you out of the seat as if to catapult you over the stern and into the sea. You lean back against the strain and the laws of physics take effect. You are locked into a secure fulcrum with almost infinite drag. The fish, however, must push against a fluid medium with nowhere near your efficiency.

ON THE MOVE

We know through tagging programs that blue marlin are highly mobile, following warm ocean currents. Generally solitary, they do school in small groups while younger. Spawning is thought to occur in tropical bands north and south of the equator.

HEMINGWAY

THE OLD MAN AND THE SEA

Slowly but surely you gain that thin thread back onto the reel as the fish tires and comes closer. Its skin turns a lustrous gold color as the lactic acid builds up in its muscle tissue. You, on the other hand, turn red with exertion, then white with fatigue and dehydration. Superior brawn pitted against superior brain. With luck, the marlin comes alongside the boat, you remove the hook and the marlin swims away freely. You and your comrades slap each other on the back and rejoice in your manhood. But what real value is there? You have just been intimately connected to one of the greatest apex predators on earth. You came within touching distance and enjoyed its majesty. And you let it go free.

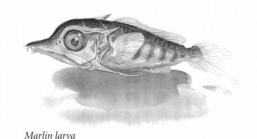

Marlin larva

SCIENCE SPOT

AMPHIDROMOUS

Fish that move between fresh and salt water during some part of life cycle, but not for breeding. (sawfish, grayling, gobies)

ANADROMOUS

Fish that live in the sea mostly, breed in fresh water. (alewife, striped bass, salmon, sturgeon, shad)

CATADROMOUS

Fish that live in fresh water, breed in sea. (American eel)

DIADROMOUS

Fish that travel between salt and fresh water. (salmon, smelt, gasperau, American eel)

OCEANODROMOUS

Fish that migrate within salt water only. (tuna, marlin and most other saltwater species)

POTAMODROMOUS

Fish that migrate within fresh water only. (sturgeon, giant catfish, lamprey)

(Istiophorus platypterus)

SAILFISH

No real commercial market exists for sailfish. The recreational community has supported catch-and-release of this species with reformed-smoker fervor. While out sailfishing once, I had one come up and not survive. It happens occasionally. Since smoked sailfish happens to be delicious, I took it home to smoke rather than let it sink to the bottom. I was impressed at the vitriol hurled my way by people on the dock as I walked to my car with the sailfish over my shoulder.

Sailfish can be found in temperate to tropical waters all over the world. Generally, Pacific sails grow bigger than those in the Atlantic. Anglers in most places around the globe simply troll for sailfish. But in the southeast U.S. a relatively new method has blossomed like kudzu. There, anglers consider fishing with kites the most effective method and judging by the numbers of fish released, it's hard to argue.

These anglers attach special kites to the end of a Dacron fishing line spooled onto electric reels. The line has several quick-release clips. The kites fly off the stern of the boat. Fishing line from regular rods goes through the kite's quick release clips and gets carried up and away from the boat. Live baitfish hooked to the end of the fishing rod line then dangle just below the surface, suspended from the vertical fishing line. From underwater, only the baitfish can be seen — no line, no leader. When a sailfish sees what it considers an easy meal, it swallows the baitfish, pulling the line from the quick-release clip on the kite line and the fight is on.

Today, most anglers use circle hooks. These prehistoric designs, made out of bone, obsidian, and other stone have been found in caves once inhabited by Neander-

thals. The point of a circle hook turns in towards the shaft rather than forming a "J." The main beneficiary of this type of terminal tackle is the fish. Where "J" hooks can easily get caught in the gullet or stomach of a fish after it swallows it, a circle hook will, in most instances, pull back out and catch in the extreme corner of a fish's mouth, causing it the least amount of injury or discomfort.

That may sound like so much claptrap to those inclined to PETA-esque philosophies. But sportsmen represent some of the most fervent conservationists. Any fish that won't be going home to grace someone's dinner table needs to be released unharmed and circle hooks make a significant and fundamental contribution toward this end. The bottom line? Sailfish are far too valuable to catch only once.

EXCITING COLOR!

People marvel at how a sailfish (among other fish) "lights up" when it gets excited. This happens because of deep skin cells called chromatophores. These cells change when the fish gets excited, allowing light to strike bright pigmentations. When the excitement abates, the cell changes back, hiding the coloration.

DISTRIBUTION

Sailfish migrate extensively. Their range in the Atlantic is from Maine to Venezuela. There is some debate in the scientific community as to whether or not the sailfish found in Pacific tropical and temperate waters—from southern California down to Peru—is a distinct species.

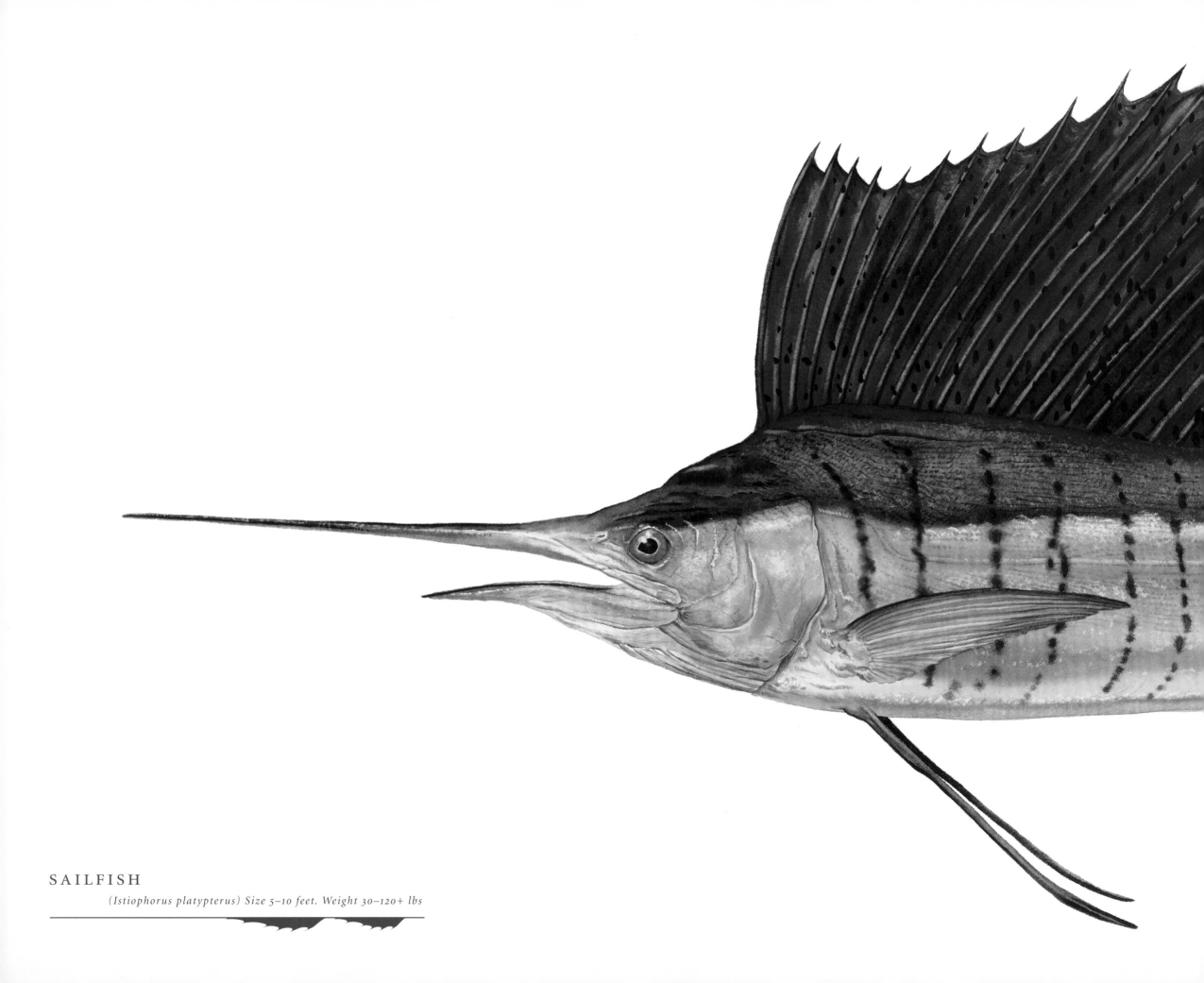

SAILFISH

(Istiophorus platypterus) Size 5–10 feet. Weight 30–120+ lbs

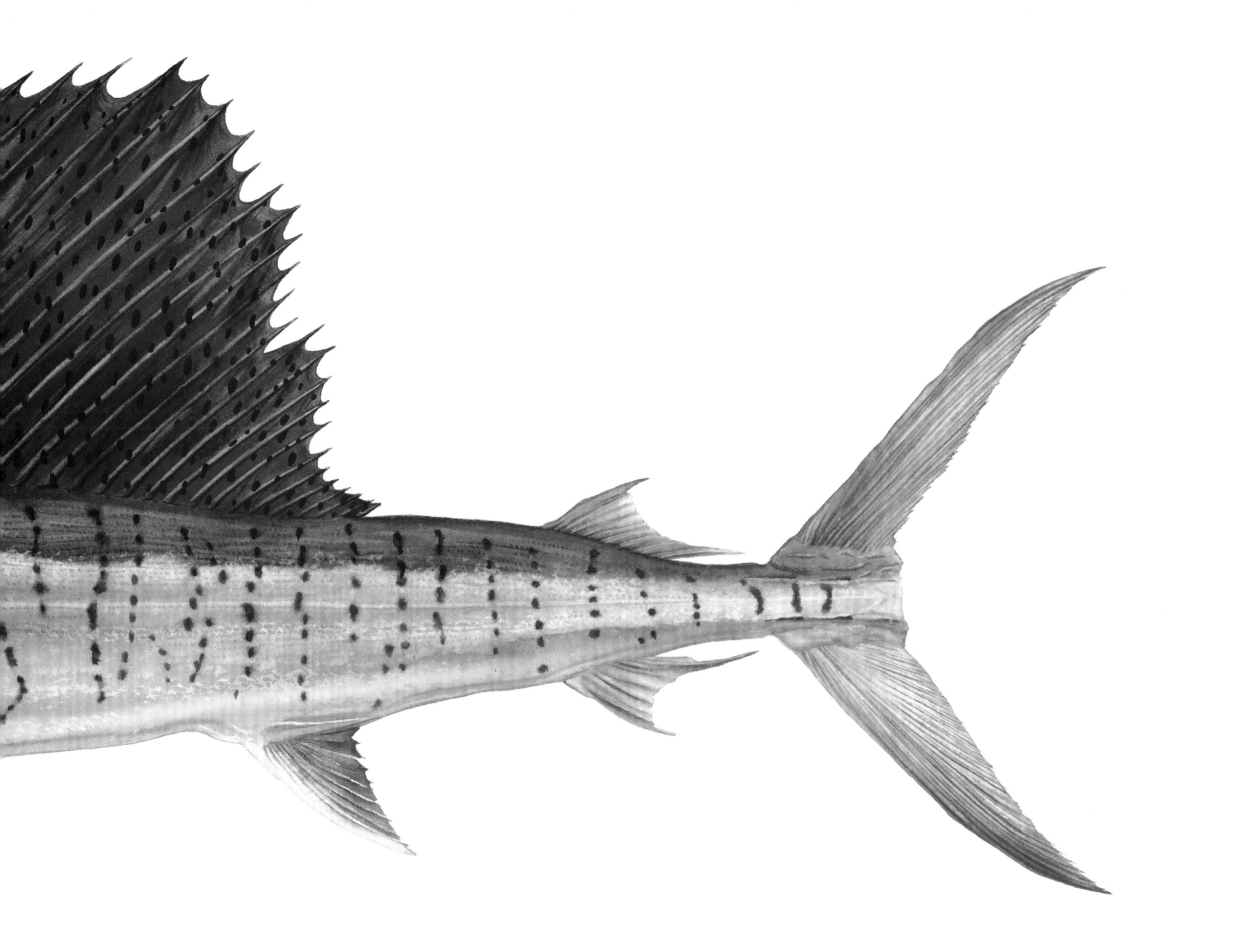

SWORDFISH

Swordfish qualifies as just about the most aggressive, stubborn fish in the sea! Unlike other gamefish that will fight for a while, then pretty much give up and come alongside the boat, a sword never quits. And it will plumb try to take you out if it gets the chance. It'll attack you, your boat, other fish… damn, they're nasty. — CAPT. PETER B. WRIGHT

DISTRIBUTION

Swordfish are found throughout the world, in both cold and temperate waters. Swordfish fisheries are active in tropical and temperate waters worldwide.

Swordfish represent an interesting study in that in the space of one human generation, this species has gone from plentiful to bordering on endangered, and has started back to healthy levels again. When I was young, I went out on "swordfish boats," vessels with the most outrageously long catwalks extending thirty or forty feet out from the bow in a nautical version of Cyrano de Bergerac's face. These boats ran around the waters offshore of Montauk, Block Island, Martha's Vineyard, Nantucket, and Cape Cod searching for swordfish "sunning," or basking sleepily on the surface. Their dorsal fins and tails could be seen protruding above the waves.

At the outset, lookouts aboard the boats used powerful binoculars to spot these fish from a distance.

Later, commercial operations hired spotter planes which covered much more territory and would direct the boats to the fish. Ultimately swordfish boats graduated to longlining. Heavy fishing lines with baited hooks every few feet stretch for thirty miles at a clip. Obviously, longlines are one of the least selective types of fishing gear and kill all sorts of other sea life besides the target species. Unfortunately, this spelled the beginning of the end for the swordfish industry.

Back in the day, the swordfish boats with the long noses would quietly pull up to a sunning sword and one of the crew standing on the catwalk (called a pulpit)

SAVE ONE!

Eight years into a ten-year recovery program, Atlantic swordfish populations have rebounded thanks to strict catch quotas. In U.S. waters, swordfish nurseries are closed to fishing. Migratory fish that swim long distances, swordfish have recently been protected by commercial and recreational fishing interests on both sides of the North Atlantic.

would sink a bronze-tipped harpoon into the swordfish. The swordfish resource was once treated much more kindly than with today's methods. The fish stock thrived and the meat from harpooned fish proved arguably much better than that from hooked fish. (Thrashing around fighting against the hook builds up lactic acid in the muscle tissue in a way that doesn't happen with quick harpooning.)

Swordfish came so perilously close to disappearing that many of the world's great chefs signed onto a "No Swordfish on the Menu" campaign some years ago. At that time, the average commercially caught swordfish weighed 90 pounds and many were taken as small as 30 to 40 pounds.

Harpooned swords on the commercial market used to average 300 to 400 pounds. Those small fish never got the chance to spawn, even once. Once the breeders are taken out of a species, it takes very little time for the stock to collapse.

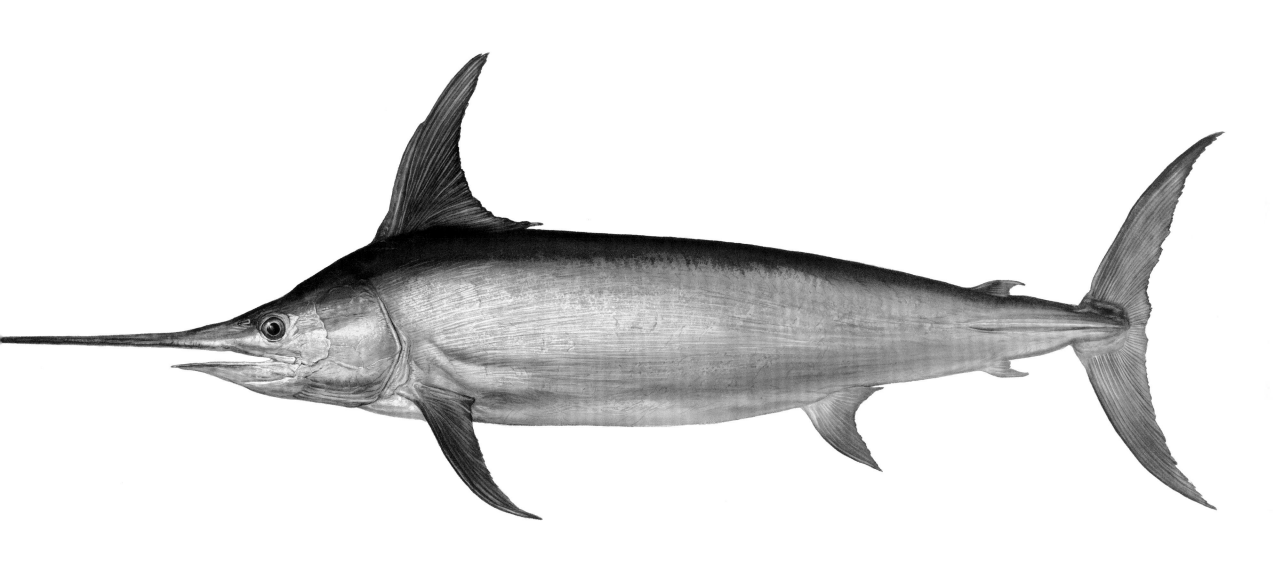

SWORDFISH

(Xiphias gladius) Size 4–14 feet. Weight 50–700 lbs

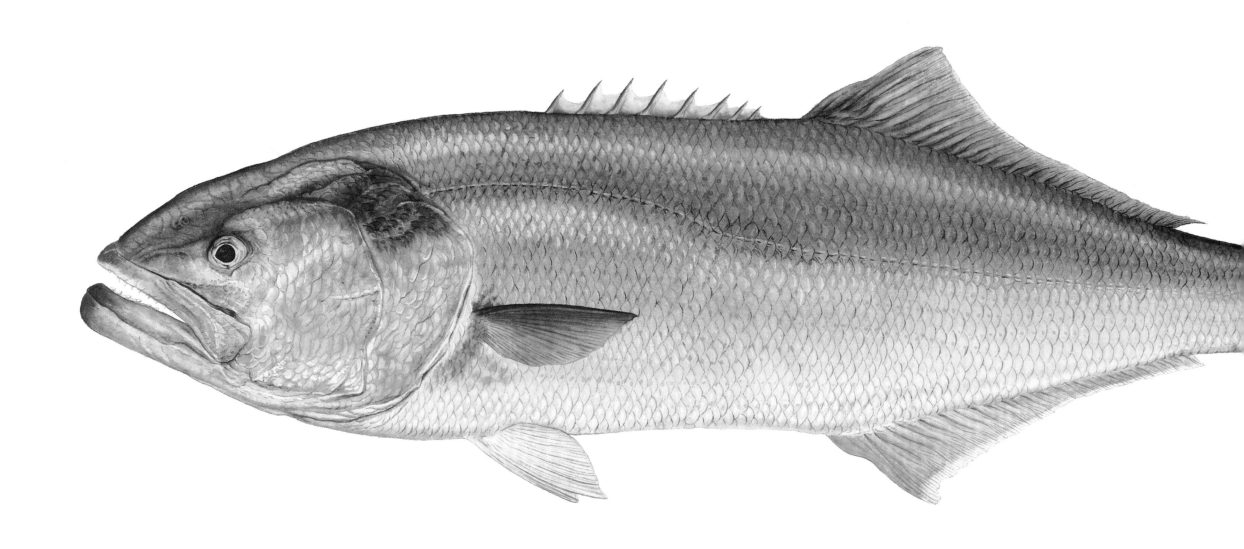

BLUEFISH

(Pomatomus saltatrix) Size 14–30 inches. Weight 2–20 lbs

BLUEFISH

In 1973 the South Street Seaport Museum republished a curious little paperback entitled A Fisherman's Breeze: The Log of the "Ruth M. Martin" by A. Graham Miles. First published in 1923, this 102-page account of Mr. Miles' September, 1904 fishing trip (he calls it his "vacation") out of the historic Fulton Fish Market in New York, includes a chronicle of the storm of September 15th, during which thirteen vessels sank in New York Harbor.

DISTRIBUTION

Like so many snowbirds, bluefish winter off the southeastern Florida coast, heading back north come spring, pulling off the oceanic highway for rest and spawning stops in various bays and sounds along the way. Also like snowbird migrators, young and old fish seem to take different routes.

CATCH ONE!

Small bluefish can be caught casting along bays and shorelines. Larger fish prefer colder, deeper water but they will follow bait close to shore. The world record, sport-caught bluefish was caught at Cape Hatteras, North Carolina and weighed in at thirty-one pounds, twelve ounces.

I found this unadorned journal impossible to put down! What made this somewhat dry account all the more fascinating was its utterly frank, almost detached description of a working fishing boat of that era, and the author's role as a hired hand. (He had asked that they not grant him special privileges.) The work aboard was, of course, brutal. Miles reveals the slender profit margins of a typical fishing-schooner owner and the wages earned by the captain and crew, which were tied to how much fish they caught. This was truly a hard-earned living for all involved. The forty photo illustrations provide a truly remarkable glimpse into a vanished era.

I was surprised that Miles' story focused on commercial bluefishing, since today bluefish are more of an incidental commercial catch. I rarely see it in fish markets anymore. Thanks to air freight, we now consume fresh, exotic fish from far-flung waters. Back when Mr. Miles wrote his book, they ate the local catch, and what was caught and fed to New Yorkers by the ton was bluefish. Contrary to today, diners back then held it in very high esteem as table fare.

Reflecting on Mr. Miles account from 1904, I felt saddened by some of our modern attitudes toward blues. While bluefish still has its aficionados, most

contemporary anglers consider it a trash fish, barely edible, and often caught, gaffed, and tossed aside. Some anglers despise its fearsome disposition (or perhaps secretly envy it) as they seem to take special pleasure in killing bluefish in a brutal manner and in great numbers. On the other hand, third- and fourth-generation New Yorkers still revere bluefish as a patron saint. Their ancestors ate well, benefiting from its affordable, nutritious abundance.

It's a rare blessing to have a friend you've known since childhood suddenly discover a passion for fishing late in life… even better when he buys a boat. We took off at dawn from the marina on the southern Connecticut shore. It was the third week of October and this was our second shot at schoolie-sized blues — three- to six-pound fish — that are, for my money, the best tasting. We had seen a remarkably curious sight the previous evening. Baitfish were busting on the surface with neither birds above them, nor tell-tale swirls of predator fish below them. Nor could we smell that typical oily-fish odor always

given off by a leaping herd of peanut bunker when they're getting chewed up by bluefish. What was going on?

We stopped at a bait-and-tackle store just before sunrise and discovered the sad circumstances surrounding the mysterious bunker behavior. A hypo-thermal current had hugged the Connecticut shore for weeks and the water was suffering severe oxygen depletion. The menhaden were suffocating and trying to breathe by forcing oxygen into their gills with their frantic jumps. The big blues, normally there this late in the season, had stayed away because their food — the larger bunker — had avoided the hypo-thermal current.

We made the best of it by crossing to currents of colder water on the Long Island side of the Sound. We found small, very fast pods of schoolies busting on peanut bunker and brought home three fish each for the table. While thankful for the bounty nature had provided us, I had to wonder about that hypo-thermal current. Was it natural, or was it influenced by human activity?

FLICK FORD

FEED A FAMILY OF ONE

The bluefish is the only living species in the family Pomatomidae, *whose closest relatives are the jacks and pompanos, family* Carangidae. *They are voracious, indiscriminate predators who feed primarily on shrimp, crabs, squid, alewives, and other small fish, but whose stomach contents has also included sand dollars, sea lampreys, and rays.*

Bluefish — one of the truly effective cannibals — roam from Nova Scotia to South Florida in season. They travel in large schools, following schools of baitfish. At the height of the species' cyclical movements, bluefish can cover dozens of square miles offshore. Shoreline residents of the East Coast witness the carnage wrought by bluefish every summer and fall as schools of "choppers" pen baitfish such as menhaden (bunker) against a beach or seawall and chow down. A more voracious predator is rarely found and their razor-sharp teeth perfectly suit the bluefish to this job. Though bluefish have few natural enemies, they are a favorite food of giant bluefin tuna.

Bluefish aren't terribly prized as table fare except in the Northeast. Cooked properly, they qualify as haute cuisine. Unfortunately, that has worked against the species over the years. Between the sporting fight and the food value, bluefish caught by recreational anglers constitute between eighty and ninety percent of the total catch. In Chesapeake Bay, bluefish ranked highest in both number and weight harvested each year between 1970 and 1990. Consequently, the majority of sport fishermen have strong conservation attitudes regarding blues. Anglers still occasionally waste barrels of bluefish but this practice is on the wane. DTC

FLICK FORD'S BLUEFISH RECIPE

The key to enjoying fresh-caught blues is getting them on ice immediately — right off the hook — and to clean and cook them the same day they're caught. Remove the strip of red flesh that runs down the lateral line of the fish before cooking. I like to use whole hardwood charcoal chunks for the smoky taste. If they're not available, I add a small amount of soaked wood chips to the regular briquettes or the hot rocks of a gas barbeque range right before closing the lid. This simple no-name recipe reminds me of a Greek outdoor wood barbeque and it has never failed to please.

3 schoolie blues, filleted (6 pieces total)
2–3 tablespoons light olive oil
2 sweet onions chopped into rings
1 large red bell pepper chopped
2 cloves garlic minced
1/2 stick butter
2 teaspoons fresh chopped thymea
2 lemons, with peel, sliced thin, seeds removed
Fresh ground pepper and sea salt to taste

Let the briquettes get a uniform gray or set your gas barbeque range to medium heat. In a large foil boat put a layer of the onion rings over the olive oil. Cover the onions with one layer of bluefish fillets and sprinkle the garlic and red pepper on top. Season with black pepper and thyme. Dot fillets with small dabs of butter and cover with lemon slices.

Put the barbeque lid down. Bluefish does not have flaky flesh. It gives up a lot of juice and still stays moist so it can cook a little longer than most fish, but it does get mushy after a certain point so check on it after four to five minutes. The onions will be cooked translucent in the melted butter mixed with the fish and lemon juice. The flesh will be soft yet firm. Remove lemon slices, sprinkle with sea salt and serve immediately. Use crusty peasant bread toasted on the grill or serve on rice to soak up the juices. You'll never think of blues as trash fish again. Serves 4–6.

GREAT BARRACUDA

DISTRIBUTION

The great barracuda can be found anywhere from Florida to Brazil in warm waters, in estuaries, along the shoreline and out in deep ocean. In deep waters they run from ten to twenty pounds but larger ones are not uncommon.

Young thirteen-year-old Jamie loved to run his little Whaler skiff under the Ocean Highway bridges with his engine tilted up until the prop was almost out of the water. He'd gun it just as he passed out from under the bridge, creating as big a roostertail of water as he could in an effort to wash cars up on the highway.

You could always tell Jamie's little thirteen-footer even though perhaps three hundred similar boats resided in the Florida Keys. Jamie's had his boat's name emblazoned in big block letters down each side: TRUANT. Plus, even at age thirteen, Jamie was recognized as one of the best boat handlers in the Keys.

Jamie knew one particular little hole on the bayside not far south of Snake Creek where a really big barracuda lived. He'd spent the last month trying to catch that 'cuda with no success. He stopped by on his way home one day, checking the glass-clear water for a sign of his quarry. There it was, hovering over by a clump of turtle grass. Jamie picked up his ten-pound spinner from alongside the console, unhooked the chartreuse lead head jig from the line guide, and cast over toward a school of small snapper. With just a few flicks of the rod

tip, one snapper peeled out of the pack and unknowingly committed suicide by getting hooked on the jig.

Jamie opened the bail on the reel, letting the snapper swim free, and waited, knowing full-well how this scenario would play out. The barracuda twitched. Seemingly without any motion at all, it had changed direction and now faced the snapper head on. Jamie closed the bail, quickly pulled off some line to check the drag tension and started reeling the snapper toward his boat. The barracuda started to move toward the snapper. Jamie reeled faster. The 'cuda hit afterburner and became a blur.

EAT IT?

Despite having a truly foul smelling coating, barracuda taste delicious, but they can carry ciguatera—a dinoflagellate toxin that grows on reef algae. Since ciguatera toxin is cumulative, the older and larger the fish, the higher the level of toxin. Only barracuda caught far offshore in deep ocean waters should be considered safe eating. Even better, depend on local knowledge of ciguatera-prone areas before you decide to eat barracuda.

Even practiced predators make mistakes. The barracuda streaked right by the snapper and launched itself clear of the water, something 'cudas often do when chasing prey. It flew through the air straight at Jamie with its mouthful of three-inch-long teeth wide open. Jamie froze and all color drained from his upper body. "Wham! ZZZ-z-z-z-z-z." The fish bounced off the top of the outboard engine about a foot from Jamie's midsection, then landed back in the water behind him to the left and proceeded to disappear over the horizon, taking every inch of Jamie's fishing line with it.

Jamie's momentary glimpse of mortality kept him away from that barracuda for two whole weeks.

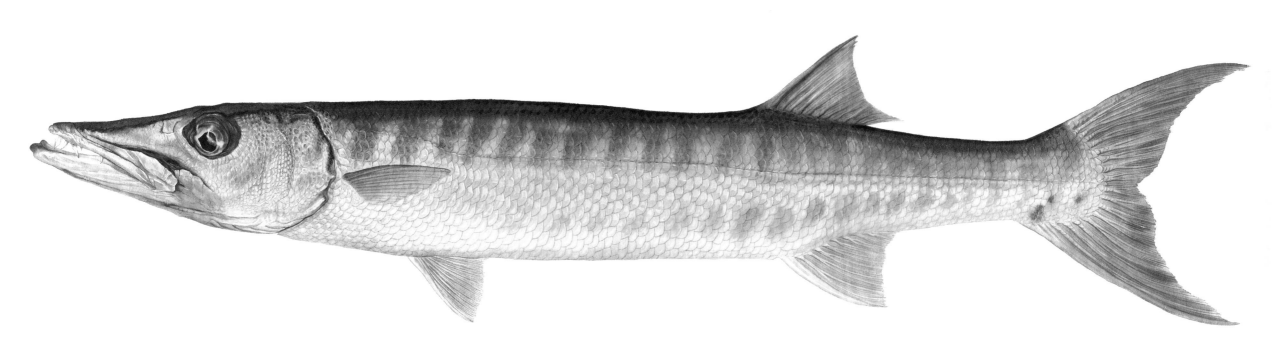

GREAT BARRACUDA

(Sphyraena barracuda) Size 2–6 feet. Weight 20–100 lbs

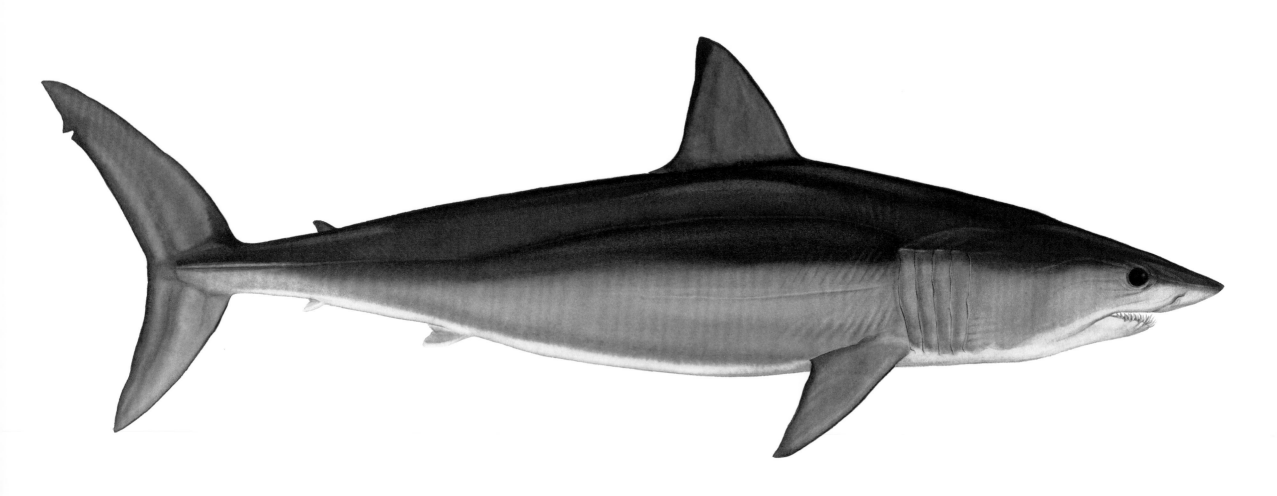

SHORTFIN MAKO

(Isurus oxyrinchus) Size 8–12 feet. Weight 100–1400 lbs

(Isurus oxyrinchus)

SHORTFIN MAKO

I did a terrible disservice to sharks… PETER BENCHLEY. *Cruising lazily through blue with quivering rays of light creating ethereal diagonal bars all around. No stimulus there. Before long though, I feel a tingling on my right side, like the pins and needles you get when your hand falls asleep. Very mild sensation but I turn to the right to investigate. Not close enough to hurry yet. Have to save energy. I can feel the sensation all across my nose now and getting stronger. I think I'll go a little deeper.*

Above and ahead of me, a school of amberjack circle, excited by baits hanging down from a dark hull. Everything is dark from down here, silhouetted by the sun. One of them eats one of the baitfish and goes wild. Swimming erratically. Injured. Frightened. Vulnerable. Food. I'll circle around and come back for the other half. I don't feel it there, though. The electricity — it's gone. Other than the dark shadow on the surface, everything has gone. Faint pulses growing weaker. Time to move on…

Benchley was right. He did a tremendous disservice to sharks by creating an "us or them" mentality. He instilled in humans a fear so visceral that even the average person on the street has no problem with killing sharks. In truth, sharks perform a critical role in the ecology of the sea. They help to keep everything healthy. While a few sharks occasionally prey upon healthy fish and mammals, most target the old, the lame, the injured and the small. This effectively keeps the stock of that species healthy and strong.

SAVE ONE!

The practice of killing sharks in tournaments and finning them for Asian soup delicacies must stop. Finning—an all-too-common commercial fishing process—means caught sharks have their fins removed and the shark is dumped back into the sea alive where, no longer able to swim, they slowly starve to death. It's entirely too easy to kill sharks faster than they can regenerate, which will cause extinction.

As Canadian author and biologist Farley Mowat discovered when he lived in the northern tundra studying the grievous effect wolves had on the caribou herds, we had it all wrong. As Mowat explained in his book *Never Cry Wolf,* the caribou herds that were not culled by wolves, sickened and died at a much higher rate.

Most sharks bear only a few live young at a time and the gestation period can be as long as two years. Though makos generally spawn ten to twelve pups at a time, mako babies are cannibals in the womb so they don't all make it out in one piece.

Mako sharks can swim faster than all other sharks and have been seen leaping twenty to thirty feet or more out of the water. Scientists estimate that makos can top out at sixty mph. Makos can reach twelve-foot lengths and weights up to one thousand pounds.

DISTRIBUTION

The mako is a true pelagic (open sea) species found in temperate and tropical waters around the world. Makos follow warm water within a specific geographic area. They are solitary.

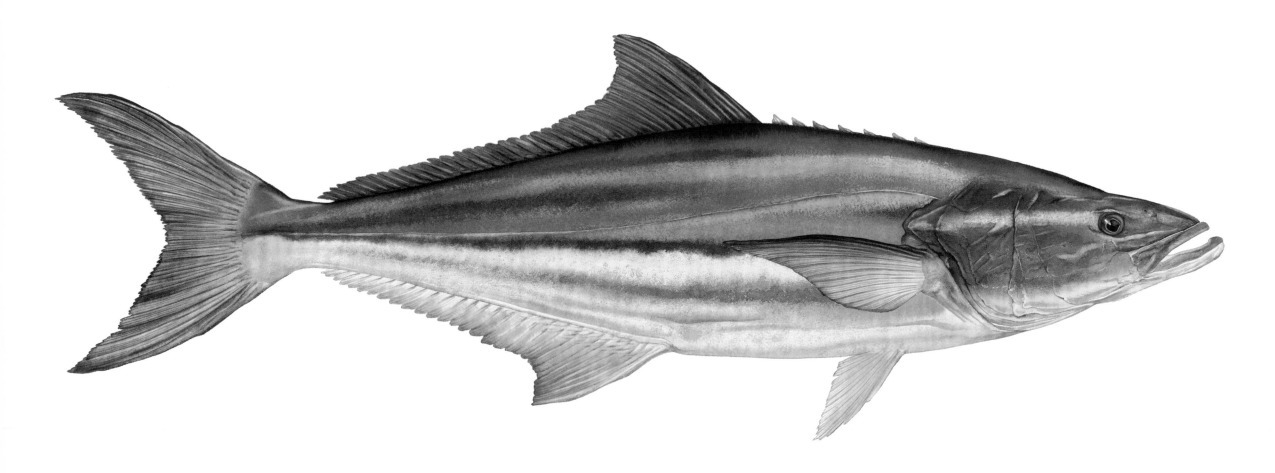

COBIA

(Rachycentron canadum) Size 20–55 inches. Weight 20–50+ lbs

COBIA

I couldn't believe it. There was a twenty-six-foot open boat slowly cruising along the shoreline in the Gulf of Mexico up by Panama City. One guy was driving while his passenger was standing atop an eight-foot-tall step ladder that was tied into the boat. He had a fishing rod in hand and every once in a while, they stopped and the guy on the ladder would cast a jig at something.

ETIENNE "DEE" GELE, TV CAMERAMAN

GOOD EATING?

Although the commercial catch is small due the cobia's solitary existence, they make very good eating. The unique flavor lends itself to baking or smoking.

CATCH ONE!

While migrating in the open ocean, cobia often hang out with larger fish like sharks and rays. Cobia will wrap your lines around the structures where you find them so use saltwater gear with thirty pound or heavier test line. Best to tire a cobia out in the water before landing one inside your boat.

Whether you call it cobia, ling, lemonfish, black salmon, black kingfish, sergeant fish, crab-eater, runner, or cobbeo, this remains one of the odder-looking game fish. In fact, it looks for all the world like a remora, one of those fish with a suction pad on its head that you so often see attached to larger fish like sharks and marlin, so it can feed on the little scraps that the big fish leaves behind. Except the cobia has no suction pad.

Fishermen catch cobia only incidentally throughout most of the year. However, in the spring, cobia embark on one of those mammoth migrations for which nature is so famous. Then, anglers get entirely too creative in their quest for this brown torpedo. During the migration, cobia swim lazily along just below the surface of the water, often within swimming distance of the beach. This proximity allows every boat, from a mega-sportfishing yacht to a kayak, to try their luck at catching a fantastically delicious tasting fish that also happens to put up one heck of a fight.

A fish just below the surface can be very difficult to see from the deck of a boat. Hence the efforts to elevate oneself. Larger boats, especially those offshore boats with tuna towers (a tall metal platform) have a distinct advantage. When targeting cobia, there will often be two or three more bodies up in that "crow's nest" than its design called for. Buckets of bait and rod holders tied to the support pipes with duct tape provide equipment flexibility. When someone sees a cobia, they cast to it from up there, some forty feet or so in the air. With three or four guys trying, hopefully one of them will hook up. Then the fun begins.

You can cast, but you can't fight a fish from up in the tower. So you have to climb down an awkward, slippery, wet latticework of aluminum piping to the middle deck, then down another ladder to the cockpit where you can fight, and with luck, boat the fish. As you might surmise, doing this while holding a fishing rod (with fish attached) in one hand could result in a serious fall, so these boats devised a pulley arrangement from the tower to the cockpit. The angler attaches the rod to the pulley line with a clip. Then one of his mates sends it down the "clothesline" while the angler climbs down and meets it below. Honestly, it's a wonder anyone ever catches a single fish with all this Rube Goldberg action going on.

DISTRIBUTION

Cobia prefer to live around structure such as platforms, rigs, pilings, and offshore reefs. The young can be found in bays but larger cobia prefer the open water. In the summer, cobia migrate north as far as Nova Scotia.

COMMON SNOOK

*How apropos! The snook (*robalo en Español*), with its protruding lower jaw and slight upturn of nose, appears to have a perpetual smile. That smile reminds me of a serial killer — all sweetness and light until your back is turned and he gobbles you up.*

DISTRIBUTION

Although mainly found along the Atlantic coast of south Florida, common snook are also found in the rivers, landlocked lakes, and ponds of south Florida and southeastern Texas.

Many people consider fish stupid, unable to reason, because of their tiny brains. A recent scientific study determined that common goldfish have a memory span of three seconds. Conversely, a respected trout guide swears by his empirical research that a single brook trout can be caught up to three times. After that, the trout remembers the experience, making it almost impossible to catch them again. Admittedly, some fish qualify as dumb as a brick. But others?

I waded along the edge of a blindingly bright sand flat in Exuma in the Bahamas. The sun's glare off the sandy bottom turned the very air white. I cast my fly into the mangrove roots along the shore, hoping to find a snook. Shuffling my feet to stir up any stingrays, I walked hundreds of yards, renewing my enthusiasm with each cast.

A darker spot than its surrounding area implied a deeper hole with deep shadows and a steel maze of man-grove roots. It was a perfect snook hideout. I carefully laid my fly at the edge of the shadow and gave it the tiniest twitch. An explosion lifted water all the way to the top of the tree as the snook mistook my lure for something edible.

I yanked on the line with my fingers to set the hook, then started to reel to take up the sudden slack that appeared. Slack — the bane of any fisherman's existence. No better way exists to lose a fish than to let the line go slack.

Against the glowing white bottom, I could see the darker back of the snook racing straight at me. "My God, this thing is coming after me!" I thought. But it raced right past me on its way out to the middle of the acres of shallow water behind me. About

CLEAN FISH!

Among numerous other names, snook have also earned the name "soapfish." If you cook one without first removing the skin, the flesh tastes like that time your mother washed out your mouth for swearing. They are excellent eating, fried or grilled and don't forget the fresh mango chutney.

halfway across the flat, the snook stopped, generously allowing me to catch up and tighten the line. Oddly though, it made a hard left turn and took off again for about two hundred feet, then executed a 180° about-face and ran back again. What extraordinary behavior. Two more about-faces later, my line went slack.

I didn't stop muttering all the way out to the spot where the snook won its freedom. "I can't believe it! It didn't jump, it didn't snag on anything. How did that fish get off?" And there it was: a bleached-out cinder block with tiny sponges and coral and algae all over it. The only thing within a thousand square yards that was not absolutely flat. Now you tell me, did that fish know the cinder block was there? Did it remember it? And does cutting me off on that block constitute both the ability to reason *and* the ability to use tools? Maybe we humans should rethink the term "schools of fish."

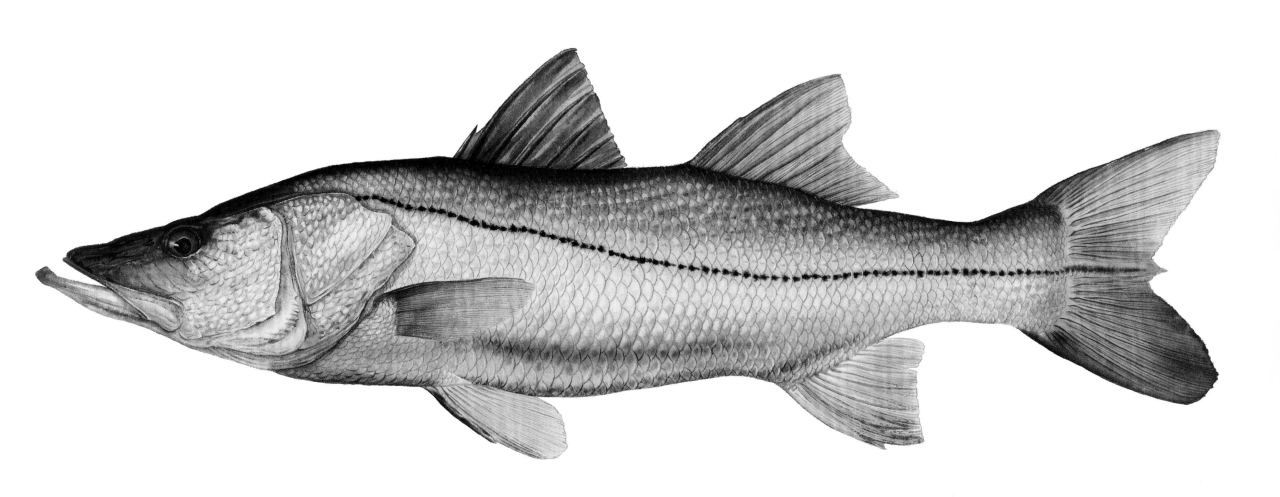

COMMON SNOOK

(Centropomus undecimalis) Size 1–4 feet. Weight 5–40 lbs

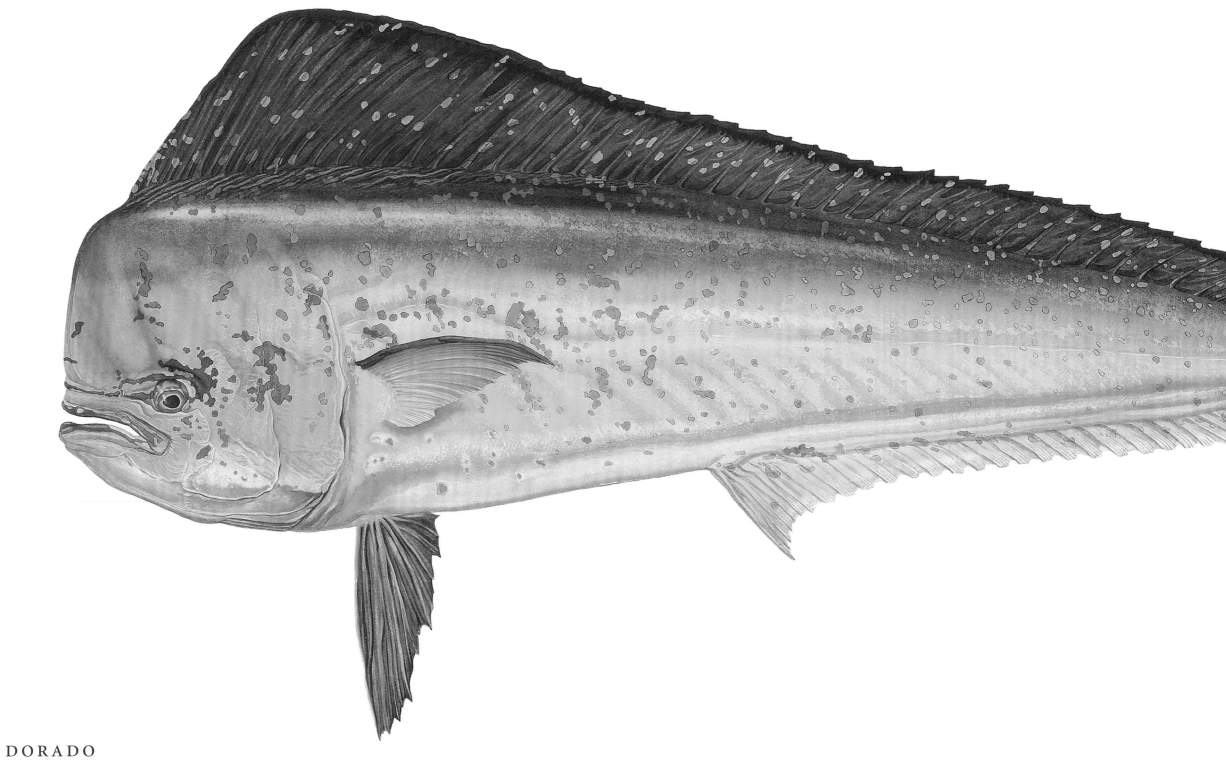

DORADO

(Coryphaena hippurus) Size 16–50 inches. Weight 5–50+ lbs

(Coryphaena hippurus)

DORADO

Dorado, Mahi-mahi, dolphin: no matter what you call it, this must be one of the most beautiful fish in the sea.

Dolphin (not to be confused with the mammal dolphin also known as a porpoise) are also among the more social, some might say gang-oriented, fish. As juveniles, they run in packs and fishermen refer to dolphin of that size and company as "schoolies." Later in life, dolphin seem to travel in pairs — a male and female. Males can be distinguished from females at a glance: the male has a high-blunt forehead while the female's curves gently back right from the snout. When they first come after your bait, both can take your breath away with the brilliance of their natural colors.

Like so many creatures that change colors, dolphin have skin cells called chromatophores that "switch" on and off to hide or display brilliant colors. Some fish use this function for camouflage. Dolphin have chromatophores that change to indicate excitement.

Recreational anglers who consistently find dolphin, search the skies for birds. Avians such as frigate birds (Man O' War), boobies and gannets, among others, often soar high above cruising dolphin. The fish feed so much and so often that the birds don't wait long for a meal. As the dolphin tear into their next meal, scraps of their prey float to the surface for the birds.

A good recreational angler keeps track of what the currents in the area are doing. For example, in the Atlantic off the coast of Florida and the Florida Keys, fish beneath birds heading south or west (the Keys run east/west, not north/south) will usually be larger than those headed in the opposite direction because the big fish can more easily swim against the current, while the smaller fish ride with the current. Another way to find dolphin is to look for flotsam and jetsam as well as sargassum weed floating on the surface. Dolphin love shade and will hide under just about anything that provides it. Dolphin are so popular because they qualify as one of the finest eating fish, reproduce early and often, grow fast, have healthy stocks and oh, yes...did I say what great table fare they make?

DISTRIBUTION

This rainbow-hued fish roams every sea with temperate and tropical waters. Voracious eaters, they qualify as one of the fastest-growing fish. They reach breeding maturity in just a few months and their average lifespan is under five years.

Extraordinary Table Fare

Imagine being three years old. You wander away from the only home you've ever known. Nobody looks for you or even misses you. You travel along with other children for a short while, but ultimately, find yourself out in a vast empty wasteland. Sure, there's a little food

ANADROMOUS FISH

on the ground here and there, enough to just get by, but you have no idea where you are, where you're going or even where you've been. For several years you wander the barrenness avoiding larger beasts seeking to harm or eat you. Then one day, you change direction and head back. There are no street signs or landmarks to guide you as you move along with unconscious inevitability.

Finally, you feel your surroundings change, the world shrinking to a more personal size, the very medium in which you live changing dramatically. Fighting yet more stumbling blocks in your journey's path, you finally make it back home, even though, you had little or no idea that was your goal.

Anadromous fish return to the streams where they were born on a cyclical basis, often from hundreds of miles away. They negotiate and survive such a journey without the ability to reason, and culminate it in a return to their spawning homeland, a particular stream known as "the one," only to procreate and (in most cases) die. Nature is at once both awe-inspiring and cruel. It certainly makes one glad to be human.

(Morone saxatilis)

STRIPED BASS

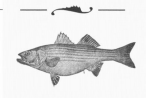

Summer 1965 — Todd's Pt., Greenwich, Connecticut. During the summer and early fall, I'd watch the gray-haired Japanese man walk down to the dock at the end of our street every night just before dusk. He'd drop his "Cuban yo-yo" filled with monofilament fishing line, a weight, and a hook into his little rowboat, then push it off the beach and start the almost two-mile row out the harbor and around the point.

CATCH ONE!

If you want to find stripers study tidal flows, current and surf breaks, and any place else where forage fish and other food gets stirred up. Fishing at dawn and dusk proves most productive. Use a jig, top-water plug or live bait. Feel free to cook this delicious fish in any way that you can imagine. It's all good.

He was the U.S. president of a large, Japanese company but weekdays during fishing season, his limo would drop him off at home in the late afternoon and he would emerge a half hour later in jeans, a t-shirt, and ratty old flip-flops. Down to his boat he'd go, yo-yo in hand to fish the best striper rocks the coast of Connecticut had to offer. Those fish loved what that elongated, mostly demolished old jetty did to the tidal flow. The eddies and still waters stirred up food while providing lazy fish with a perfect place to lie in ambush.

My Japanese friend would take stock of the tide and currents, row up-current for a ways, then ship his oars, bait his hook, and wing the weighted line out to a current edge. I could be imagining it after all these years, but I'd swear that he never came home empty-handed. I once asked him why he chose to row his little boat so far every day when he could readily afford a nice boat with an engine.

"Ah, Mistuh Crock," he replied. "Fish no rike engine."

Back then, striped bass represented an incredibly healthy fish stock. Today, it once again thrives. For a time in between, however, striped bass faced dire peril. For breeding stocks of striped bass, the four most important bodies of water include Chesapeake Bay, Massachusetts Bay/Cape Cod, and the Hudson and

DISTRIBUTION

Find stripers in temperate waters from coast to coast in both fresh water lakes and rivers as well as saltwater. In midsummer, they range as far north as the Bay of Fundy on the East Coast and Oregon on the West Coast.

Temperate Bass

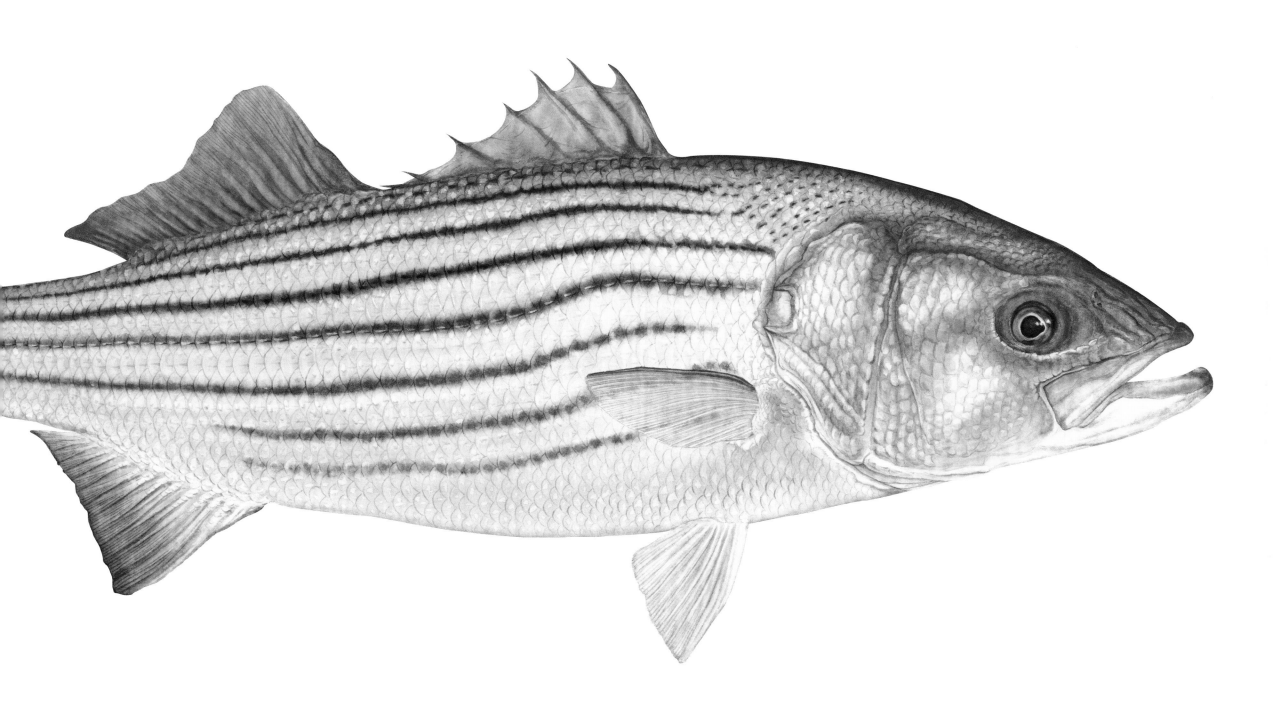

STRIPED BASS

(Morone saxatilis) Size 1–4 feet. Weight 10–40+ lbs

Delaware Rivers. Certainly greedy fishing took its toll on the resource over a period of many years, but pollution was surely even more responsible.

The Chesapeake Bay, probably the most important striped bass breeding ground, along with three major rivers, has numerous dead zones — large areas almost completely devoid of life-sustaining oxygen. The main culprits? Farming and sewage plants. It's called non-point source pollution since you can rarely put your finger on one specific source. It's all the little sources contributing to the whole that kills the Chesapeake and other vital bodies of water.

The Chesapeake Bay Program reports that the flow of major pollutants from rivers into North America's largest estuary has declined nearly forty percent since 1985. But U.S. Geological Survey water-monitoring data from the mid-1980s through 2003 (requested by the *Washington Post*), indicate that observed concentrations of the two main causative pollutants — nitrogen and phosphorus — showed no decline at all in most of the major rivers spilling into the bay.

The 3M company's recent efforts to cut toxic wastes in half as reported by "green" business advocates have to a large degree been public relations hype and disinformation campaigns. (General Electric set that corporate precedent with its campaigns to "green" up its image while it delays cleaning up all the PCBs it dumped into the Hudson River.)

Clearly we can trace the rejuvenation of the striped bass resource at least in some measure to a grassroots effort by organizations pressuring these two companies into some type of compliance with the Clean Water Act. But it is also thanks to commercial and recreational anglers pressuring the government to regulate the fishery that this incredibly popular species qualifies as the single, greatest success story of fisheries management in America's history. Of course, when the draconian measures of a zero bag limit first came out, anglers didn't greet the regulations with enthusiasm. Now, recreational anglers can enjoy a very limited harvest while stripers continue to be off the commercial market. Still, no one can rest on their laurels. Since the stock rebuilt to its current state, scientists have studied few fish as thoroughly.

STRIPED BASS

Striped bass have been one of our country's most important fish since the earliest colonies in the 1600s. In the late 1800s, entrepreneurs introduced stripers in California and thirty-one other states along the way. Everywhere they've been introduced, stripers have thrived, in both fresh and salt water. Across the United States and southern Canada, striped bass generate massive revenues from recreational and commercial fisheries. Though stripers spawn in the Chesapeake, Roanoke River/Albemarle Sound area and New York's Hudson River, scientists believe that the health of all striper resources hinge on the Chesapeake breeding waters, which must be protected.

SALTWATER BAITFISH

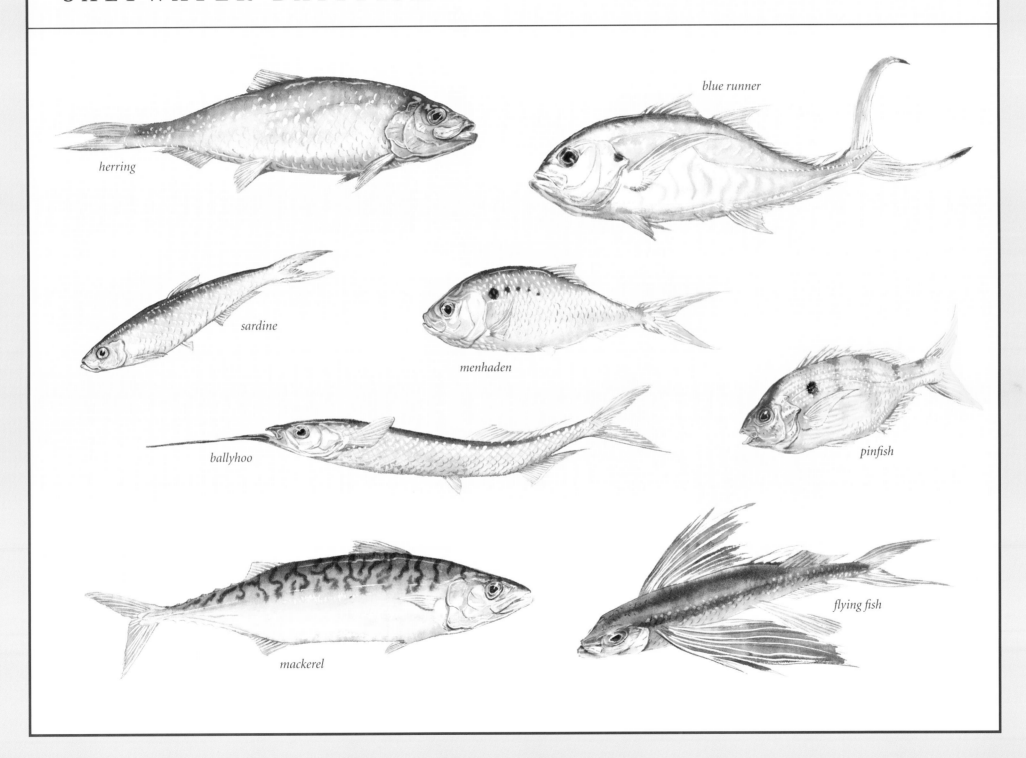

herring

blue runner

sardine

menhaden

ballyhoo

pinfish

mackerel

flying fish

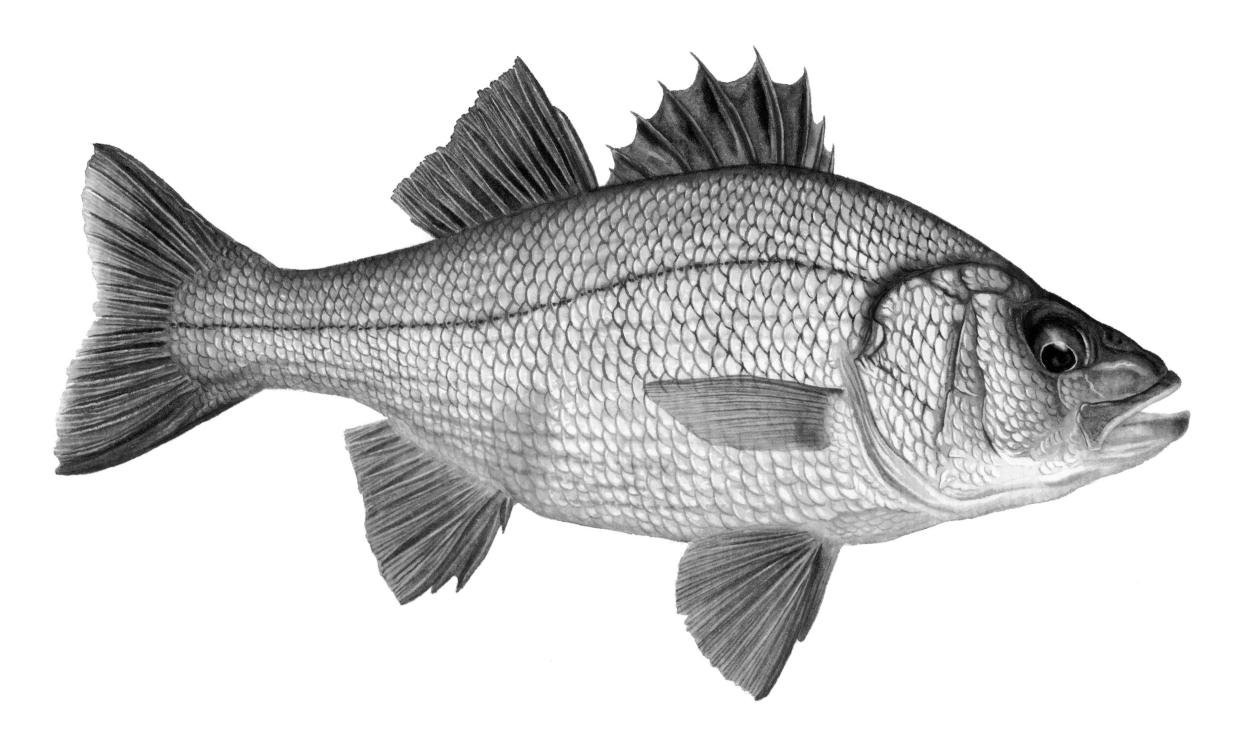

WHITE PERCH

(*Morone americana*) Size 6-12 inches. Weight 8-16 oz

(Morone americana)

WHITE PERCH

White perch live along the Atlantic Coast from South Carolina all the way up through the Canadian Maritimes and into the St. Lawrence River. They prefer brackish or salt water. So how did they become one of the more popular gamefish in all five Great Lakes?

The secret to their invasive nature has to do with the fact that this fish, masquerading as a perch, actually belongs to the bass family. It's related to the striped bass — perhaps the most successful transplant from salt to fresh water. But unlike the happy-go-lucky striped bass that everyone loves, white perch qualify as troublemakers.

In the 1950s, masses of white perch traveled from their coastal and estuarine habitats up through the Erie and Welland Canal into the Great Lakes. These non-native fish immediately developed a taste for walleye eggs as well as minnows. According to fisheries scientists, as much as one hundred percent of a white perch's spring diet consists of the eggs of other spawning fish. And apparently, these whites have very hefty appetites. Experts fear this has caused a significant decline of walleye, one of the most valuable fisheries resources in

the Great Lakes. They point to the complete collapse of the walleye fishery in Lake Ontario's Bay of Quinte, which coincided with the introduction of white perch into the ecosystem.

The University of Wisconsin Sea Grant Institute further states that white perch have interbred with the native white bass in Lake Erie, resulting in a hybrid bass. Experts seriously fear dilution of the gene pool of white bass. Speculation follows that the same hybridization now occurs in all of the Great Lakes.

A question that begs an answer: man (for a change) had nothing to do with the introduction of white perch into the Great Lakes, nor

CATCH ONE!

White perch can be found in both fresh and brackish water, and even in the open sea (often called sea perch). A popular and spirited game fish, they feed both during the day and night. In tidal areas, check out the small feeder creeks that dump into larger rivers. White perch are schooling fish so if you find them, the action can be furious. Lightweight tackle is fine.

with the problems and changes that stem from it. Does this constitute simple evolution? Should the process be left to run its course naturally? If man had the knowledge to prevent such changes back in Darwin's day, how dramatically different would our biosphere be today? (Man has interfered with this species somewhat by artificially introducing it into bodies of water in Kentucky, Massachusetts, Nebraska, and New Hampshire.)

Caught in its original habitat, white perch has the reputation of being an excellent panfish. Elsewhere in its freshwater habitat, anglers don't hold it in as high regard, perhaps because in areas where it lacks sufficient forage, they remain fairly small.

DISTRIBUTION
White perch live along the Atlantic Coast from South Carolina all the way up through the Canadian Maritimes and into the St. Lawrence River and the lower Great Lakes and Lake Ontario.

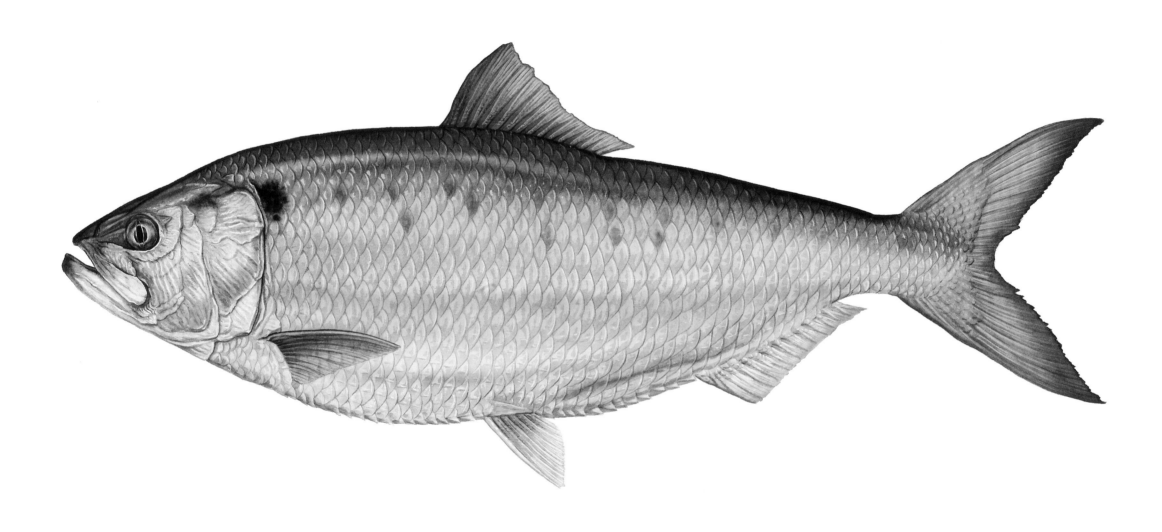

AMERICAN SHAD

(Alosa sapidissima) Weight 3–6 lbs

(Alosa sapidissima)

AMERICAN SHAD

I stood below the spillway of the Canonsville Reservoir on the West Branch of the Delaware River, futilely casting streamer flies for brown trout. I looked over at my buddy, Gary Inzana, who was casting spoons and spinners for the same quarry. He had a terrific bend in his rod.

Fishing for browns with streamers on this stretch of river always holds the promise of hooking a lunker, but I had also noticed huge pods of shad swirling around everywhere. Either Gary had a lunker brown on, or one of those silvery streaked mating shad.

Why a shad would hit a small spoon is anyone's guess, but this one had gotten hold of Gary's. After a lengthy battle complete with aerial acrobatics Gary landed it. What a beautiful, iridescent fish — with hues of pink, blue, and violet on its mint-silver sides. This female looked healthy and deep bodied and obviously full of roe. I beseeched Gary to keep it, but he let her go. He has regretted it ever since.

I tried to figure out how I could get one to eat a fly, but I didn't even know where to begin, so we left the shad alone and went elsewhere. I have never forgotten our encounter with that gorgeous, spirited fish, and have since learned how esteemed they are with anglers downriver from where I usually fish, and how skillful and specialized fishing for shad has become.

Pound-for-pound shad are considered unparalleled on light tackle and fly rod. John McPhee describes the physiology of the American shad in his excellent book *The Founding Fish*. "It has the high aspect ratio (span versus width) associated with extreme high speed." He goes on to describe the streamlined shape of the body— laterally compressed with pectoral fins that fair into the body when not in use as stabilizers or brakes. The scales are loose fitting and the body is extremely flexible with twenty-five percent

CATCH ONE!

Most fishermen use trolling or casting, but as this story shows, fly fishing for shad has some unique game qualities. Shad darts or small spoons and jigs work for bait. Shad spend most of their lives in salt water, returning to fresh only for spawning runs. Their Latin name means "most delicious" and it's no lie. Shad roe, too, are a delicacy.

more vertebrae than a trout. Shad fishermen on the Delaware River, who hook rainbows twice the weight of a three-pound shad, describe the trout as feeling "weak." Fights with four- to six-pound shad on six-pound-test line commonly last forty-five minutes or longer for with their paper-thin, delicate mouths, you cannot horse them in. Experienced shad anglers describe the fish as being the ones in control of a fight, "knowing" and using your panic against you, while they jump, roll and use their flat flanks to plane in the current against you. Reel drags scream. As an angler, your job is to simply wear them out, which thankfully represents a considerable challenge. **FLICK FORD**

DISTRIBUTION

Mainly from Nova Scotia to North Florida, but found as far north as Newfoundland and has been transplanted to most of the West Coast. American shad have complicated migration patterns and impressive ability to navigate their way back to their home for spawning.

FOUNDING FISH: AMERICAN SHAD

Biologists successfully introduced the American shad, the State Fish of Connecticut, into big West Coast rivers, like the American in California, where they have become very popular with anglers. Sadly, here in their native range on the East Coast, shad have suffered from centuries of overfishing for both their roe and flesh. Commercial records show that Atlantic Coast landings exceeded 22,000 metric tons in 1896. In contrast, commercial landings averaged less than 1,350 metric tons annually since 1980, and reached 900 metric tons only once since 1993.

Recreational angling for shad is still very popular, but we have no statistics on the impact it has on the fishery. While excessive fishing bears the considerable blame for shad's population decline from Labrador to north Florida, how can we overlook pollution in our eastern rivers, like the lower Delaware that has had an oxygen-depleted dead zone at Philadelphia for decades? Without exception every major natal river in New England has dams restricting access to shad spawning sites. It can be argued that this species was key to the survival and prosperity of early settlers in North America. We owe the American shad a secure future in its native range.

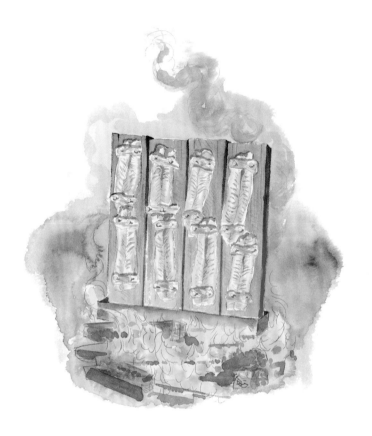

PLANKED SHAD

This colonial method of cooking shad was learned from the Native Americans and is still practiced in Atlantic states during annual shad bakes. Fish fillets are nailed to planks of wood using roofing nails, and salt pork as ties. The planks are then set upright at a slight angle in front of long, narrow fire pits. In Wakefield, Virginia, what began as a cookout tribute to the annual run of the James River shad, has become a major political function for candidates of all parties, and it's called, appropriately, the Shad Plank.

(Salmo salar)

ATLANTIC SALMON

On the face of it, fish farming seems like a no-brainer. Proponents claim it helps take the pressure off wild stocks and answers North America's ever-increasing demand for fresh fish protein. But as with so many nature-dependent businesses, reality isn't quite so cut-and-dried.

Eastern North America has enjoyed Atlantic salmon since humans first walked the shore. These fish travel the Atlantic Ocean, returning to their spawning place far up the same river where they started life. The Atlantic salmon's range traditionally covers most of the North Atlantic Ocean and its freshwater tributaries on both North American and Eastern Atlantic (European) coasts. After leaving their respective rivers on both sides of the ocean, the majority of Atlantic salmon gathers in one area of southwestern Greenland where they spend a year or two before returning to their natal rivers.

Environmental changes in both its fresh and salt-water habitats have had a devastating impact on wild Atlantic salmon as has commercial over-fishing. If the demand exceeds the supply, then business must adapt to meet the demand. Hence, offshore aquaculture.

Fish-farming of the species makes perfect sense when faced with the precipitous drop in the numbers of Atlantic salmon. (Just since 1994, scientists estimate that the number of adult fish returning to spawn in North American rivers has dropped from approximately 200,000 to 80,000.) Farming operations can deliver consistently fresh product year-round, whereas commercial salmon fishermen labor under seasonal limitations. Advances in technology, well-capitalized corporate backing, and the rapid growth of the global seafood market all add to aquaculture's attractiveness. Other fish-farming advantages include reliable overnight seafood shipments, consistently homogenous product,

FARM VS. WILD
Farm salmon represents one of the fastest-growing and most lucrative segments of the global aquaculture industry. In 1980, commercial fisheries produced more than ninety-nine percent of salmon consumed worldwide. Today, they catch less than forty percent.

– Josh Eagle, Director, Stanford Fisheries Policy Project

and the ability to control production costs.

Another fact that corporate business just loves about aquaculture is there is precious little regulatory control; nor has much scientific research been undertaken on the impact of fish-farming on the environment and native fish stocks. That's why more than forty environmental and scientific organizations have lobbied Congress to rein in industrial farming of fish until the potential risks of these operations can be evaluated and protective procedures formulated.

What are those risks? Both the U.S. Commission on Ocean Policy, appointed by President George W. Bush, and the Pew Oceans Commission warn of the potential significant dangers associated with offshore aquaculture. Alaska has banned salmon-farming and British Columbia established a total moratorium that ran from 1996 to 2002. (Interestingly, the largest problem with inter-breeding of wild and non-native species salmon in the Pacific Northwest stem from Atlantic salmon which commercial farmers brought there.)

DISTRIBUTION
The Atlantic salmon's range covers the North Atlantic Ocean and its freshwater tributaries from Ungava Bay in the Canadian Arctic to Lake Ontario and southward to Connecticut in the western Atlantic.

Questions raised by these two policy research groups abound regarding location, containment, food, effluence, currents, bottom habitat, parasite infestation, blending of genetics, bio-engineering, disease, and levels of toxicity in farmed fish. That doesn't take into account the impact fish farming has on communities or commercial fishermen, either.

Nevertheless, despite the seeming doom-and-gloom pronouncements regarding offshore aquaculture, scientists firmly believe that with study and careful procedures to counter the risks, fish farming for salmon and other species can, and probably will, supply most of the earth with the fish we eat.

Learn more about the wild stocks of Atlantic salmon from the Atlantic Salmon Federation at www.asf.com.

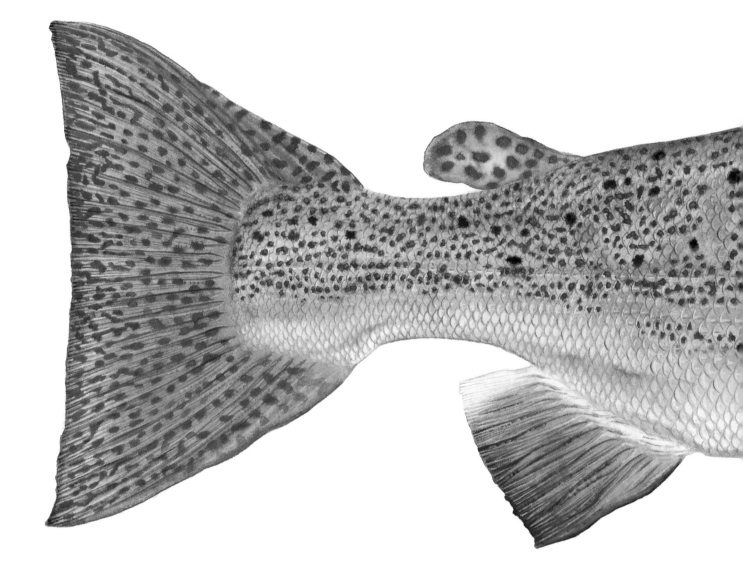

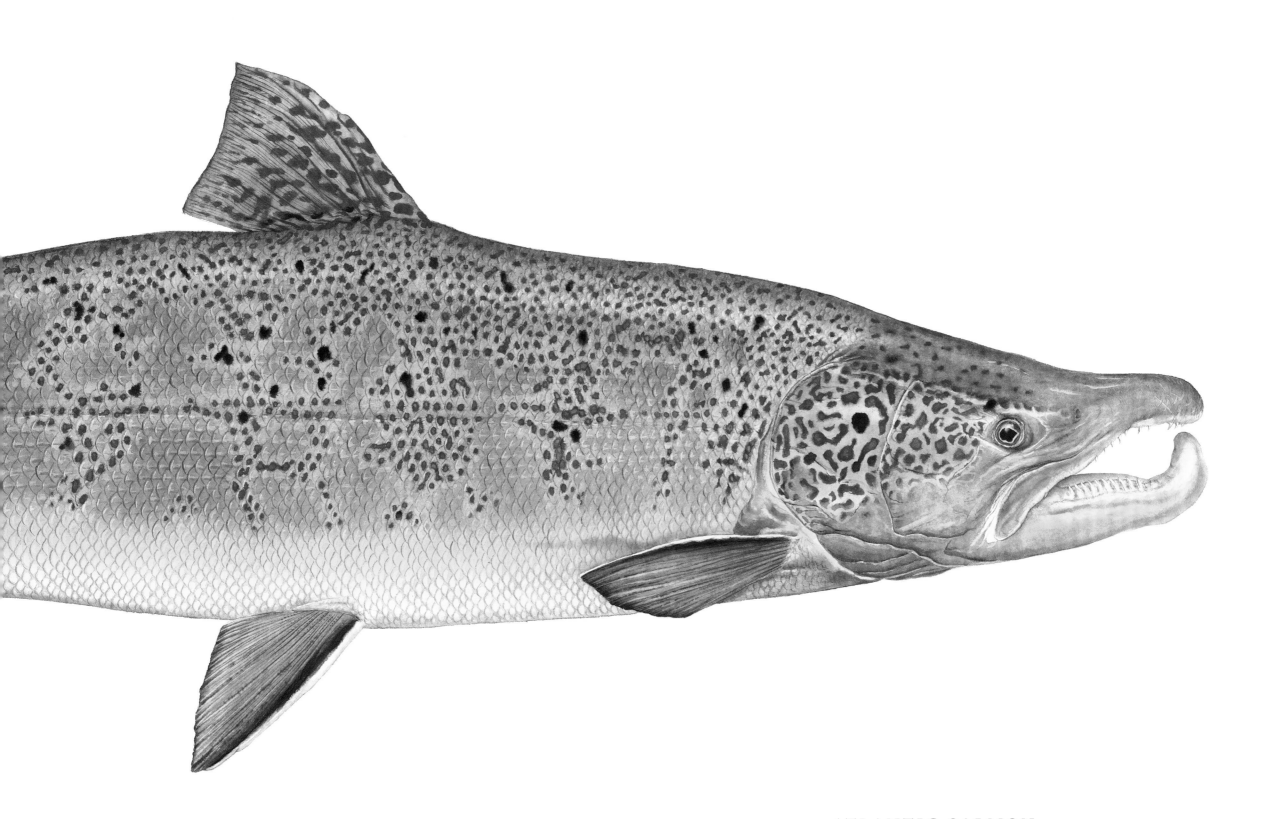

ATLANTIC SALMON

(Salmo salar) Weight 2–30 lbs

ATLANTIC SALMON OFFSHORE AQUACULTURE

LOCATION

Some farms work 200 miles offshore; others as close as 3 miles. The closer to shore, the greater the impact on coastal residents.

CONTAINMENT AND BLENDING OF GENETICS

Fisheries biologists have documented numerous incidents of farmed salmon being released (accidentally or intentionally) into the sea. (Most of the farmed salmon released in the Pacific Northwest turn out to be Atlantic salmon.) The numbers run into the millions. These fish establish themselves in the wild, reproduce, and compete with native salmon populations for food and habitat. In addition, they inter-breed with the various species of native fish, diluting the gene specificity. Scientists have determined that adult farmed salmon have eighty-four percent less success than native fish at reproducing in rivers. However, their male offspring (parr) score four times more successfully than their wild salmon counterparts. The net result would be like having the stray dogs of New York City crash the party and inseminate all the blue-ribbon pups at the Westminster Dog Show.

BIO-ENGINEERING

While not a huge problem yet, capitalism dictates that one must streamline a product to maximize profit and minimize overhead. Salmon, as just another product, are no exception. What happens when genetically altered fish escape into the wild? And they will.

FOOD AND EFFLUENCE

You can bet that farmers aren't chopping up small fish and crustaceans to feed a hundred-thousand fish at once. They use pellets, just like Purina Salmon Chow. These pellets contain all the recommended daily requirement of vitamins and minerals, antibiotics and growth hormones and who knows what else. Of course, not all of the food

gets eaten. Some of it drifts to the bottom where those ingredients enter the ecosystem. Some of it drifts elsewhere on the current with unknown effect.

ANYTHING THAT EATS, POOPS

It's an immutable fact of life. In the wild, fish spread out in large areas so the diluted effluence dissipates without impacting the environment. Tens of thousands of fish in a small, enclosed area concentrates the excrement, altering the ecosystem in the immediate area.

DISEASE AND PARASITES

So many fish in tight quarters become more susceptible to diseases and are easier targets for assorted parasites. Those diseases can get carried to native species if farmed salmon escape or schools of wild salmon swim nearby. Many of the diseases result in high mortality.

TOXICITY

Researchers at Indiana University and five other research centers tested salmon from North America, South America, and Europe and determined that farm-raised salmon contain higher levels of PCBs and other environmental toxins in their flesh than wild salmon.

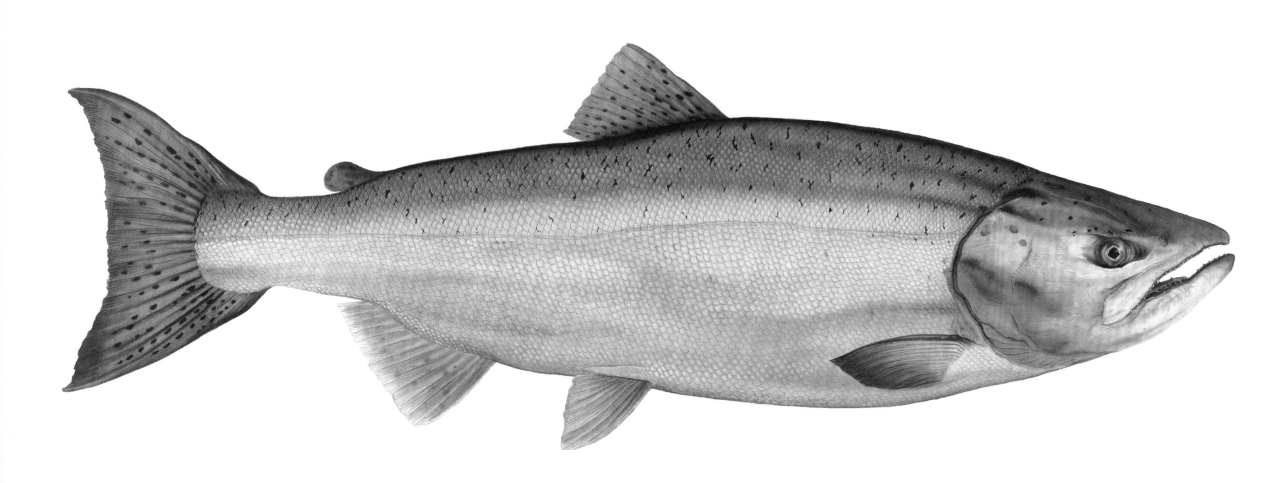

CHINOOK SALMON

(Oncorhynchus tshawytscha) Weight 15–80 lbs

(Oncorhynchus tshawytscha)

CHINOOK SALMON

I couldn't believe our luck. A mother orca and her calf lazily cruised around us as we fished for salmon at the end of a magnificent fjord open to the wild Pacific Ocean. "Man! Could we be any luckier? What a truly rare and beautiful sight!" "Crap!" muttered my guide. "There goes the fishing." One man's inspiration is another man's inconvenience.

Apparently, the moment killer whales show up, the salmon bolt. The Queen Charlotte Islands (Haida Gwaii) in British Columbia have to qualify as one of the most beautiful places on earth. Snow-capped mountains meet the sea, birds of prey soar above the virgin forests, bears line streams in search of trout, and deepwater fjords stretch for miles westward from the Pacific. For a man like me, who saw a mountain on a postcard once, the term breathtaking doesn't even come close. Everything — including the inconveniences — are inspiring.

We stayed on a converted barge that was totally isolated, self-contained, and luxurious. Normally, an hour-long ride to the fishing spot would engender some

CATCH ONE!

The chinook is Alaska's state fish and an important commercial and recreational fish resource for the northern Pacific. Trolling with rigged herring is good in salt water. Lures and salmon eggs are favored by freshwater fishermen.

grumbles but not in this case. The high-speed cruise down and out the fjord brought with it meditative opportunities bordering on zen.

Our young guide helped make even the rain and cold tolerable to an hombre "muy tropical." She was a young woman of the indigenous Haida tribe, possessed of Hollywood starlet beauty that took my breath away and a capable, no-nonsense attitude. That she could fish, run a boat, find her way around the wilderness and look perfect throughout it all pretty much made her the ideal woman in my book. The fact that she didn't need help or advice from the male species didn't hurt either.

We mounted four, incredibly long

and whippy mooching rods in their holders. Two were attached to heavily-weighted downrigger balls that would keep the plug-cut herring baits down deep in the water column. The other two pulled brass spoons spinning just below the surface. I quickly discovered why the barge hid where it did. In three days of fishing, we hadn't failed to hook two big salmon at a time. It always amazes me how, when the fishing is great, I can overlook cold, rain, rough seas, layers of bulky clothing and general discomfort.

A mooching rod's reel spun like a cartoon clock. It took several tries and numerous swollen fingers and knuckles to remember that a direct-drive reel can really hurt if not handled carefully with a fish on. The chinook on my side engaged in a twenty-minute give-and-take before I brought it alongside and my guide swooped the biggest landing net I've ever seen underneath the fish and strained to lift it into the boat.

"I say fifty-three pounds," she estimated with a confidence borne of thousands of similar guesses. Back at the dock, the big hanging scale told the truth: fifty two pounds, five ounces…or what the Haida call a tyee (big salmon).

DISTRIBUTION

The largest and least abundant of salmonids, the chinook, also called king, spring, quinnat, tyee, and blackmouth salmon, range from northern California up to Alaska. They are stocked in the Great Lakes but populations do not reproduce.

(Oncorhynchus clarki clarki)

COASTAL CUTTHROAT TROUT

Cutthroat trout may represent the largest population of trout in western waters, but they still have their share of problems. Hatchery stocks cross-breeding with wild stocks, reduction in habitat because of man's increasing land and water use development, and pollution from logging, mining, and other non-point sources all contribute to the decline of some cutthroat populations.

DISTRIBUTION

The coastal cutthroat normally cannot be found more than one hundred miles inland and is most common from the Eel River in California, north to Prince William Sound, Alaska. Unlike most other salmon species, cutthroat may spawn more than once.

Cutthroat have more living arrangements than the average college campus. Some are resident, meaning they live in one small stream area and never leave. Fluvial cutthroat migrate between small headwater streams and larger down-current rivers. Adfluvial fish migrate between those same small streams and large lakes. Finally, the most popular cutthroat among recreational anglers, the anadromous population, migrates between the ocean and the freshwater streams from whence they came. Scientists have no idea whether or not any of these fish-of-different-habits intermingle. Genetic studies will someday give us the answer.

Anadromous cutthroat trout seem to be suffering the most severe decline. In Oregon alone, catches of wild and hatchery fish combined declined by more than ninety percent in the last ten years. That single statistic elevated the cutthroat to a political hot potato. National Marine Fisheries Service (NMFS, the schizophrenic government agency responsible for both managing the health of our fish resources as well as promoting commercial fishing and providing marketing assistance for same) along with the United States Fish and Wildlife Service took a huge gulp when they saw the decline. Ten percent of historic stocks of anything borders on extinction, so the two agencies arranged for cutthroat

WHAT'S IN A NAME?

The name Oncorhynchus clarki comes from onkos, *Greek for hook,* rynchos, *Greek for nose, and* clarki *after Captain W. Clark of the Lewis and Clark expedition. We call these coastal trout "cutthroat" thanks to the brilliant slash of orange or red that usually highlights their lower jaws.*

trout to be listed as an endangered species in 1999.

In 2002, the Fish and Wildlife Service, without concurrence of NMFS, reversed the decision unilaterally. It appears that the animosity between business interests and the Endangered Species Act (ESA) spurred the reversal. Measures necessary to protect and restore the cutthroat simply cut too deeply into corporate profits. Several environmental groups filed suit against the Fish and Wildlife Service in 2005 hoping to reinstitute the ESA standing, stating that "decisions about how to protect our rivers and fish need to based on science, not politics." There may be some validity to the claim. The Clinton administration listed 394 endangered species. George W.'s father, George Herbert Walker, listed 234. The second Bush administration, however, has denied the safety net of the Endangered Species Act to more species (45) than it has protected (31). That doesn't qualify as responsible stewardship.

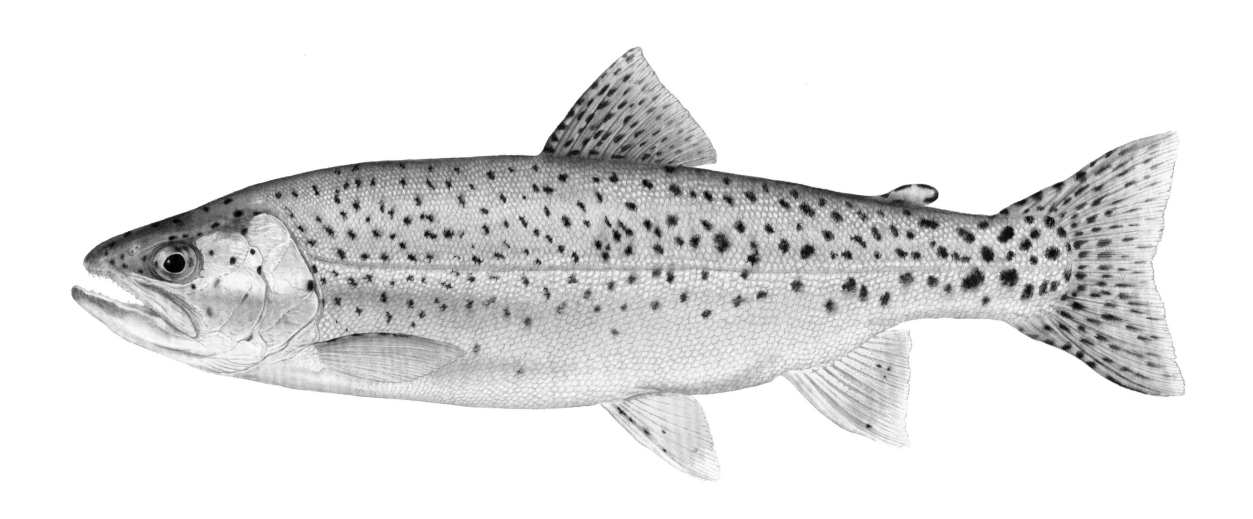

COASTAL CUTTHROAT TROUT
(Oncorhynchus clarki clarki) Size 20 inches. Weight 1–4 lbs

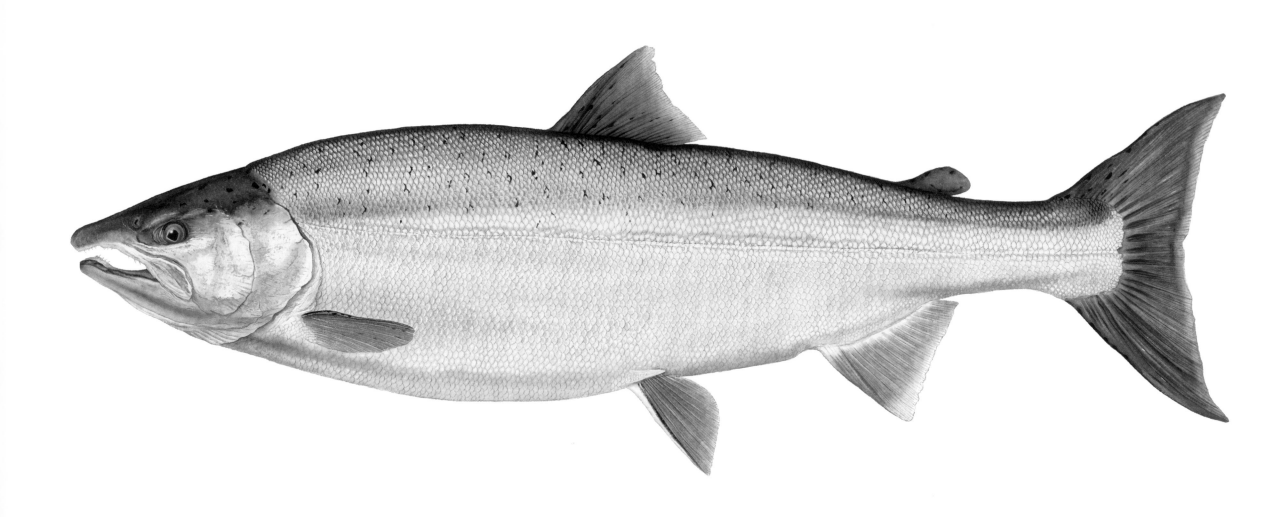

COHO SALMON

(Oncorhynchus kisutch) Size 24–28 inches. Weight 4–25 lbs

(Oncorhynchus kisutch)

COHO SALMON

Five species of salmonids inhabit the Pacific Northwest. Pink salmon have the largest population but physically are the smallest of all the salmon. Sockeye, or "red," have the second highest numbers while chum come in third. Coho rank fourth in size of population and chinook come in last in terms of numbers, but first in physical size.

Records show that throughout the Pacific Northwest, commercial harvest of coho salmon has increased fairly dramatically since the 1960s, reaching some five million fish in 2005 in Alaska alone. Sport fishing interests consider the coho one of the premier game fish as they are often thought to be the most "acrobatic" of the salmonids. The coho season runs from July to September. Anglers targeting coho before they head upstream to spawn have great success by trolling using long, whippy rods baited with plug-cut herring or brass spoons. Anglers at river mouths or upriver can use flies or lures, salmon eggs, spinnerbait, or spoons.

The indigenous people of the Pacific Northwest have always enjoyed a very healthy diet including a variety of fish and game. But historically, they never had much refined white sugar. That's not to say they didn't have sweets. A Haida guide I fished with offered me some native candy while we mooched our way along the coast of the Queen Charlotte Islands. Slightly chewy, very sweet and quite delicious, it tasted like nothing I'd ever had before. I asked her what it was, and her answer took me by surprise: coho. If you have a smoker, you can easily make it yourself.

CATCH ONE!

The coho at left is in the sea-run (not spawning) phase. During spawning both males and females have dark backs and the males have bright red sides, the females more pinkish. Coho are the most acrobatic of the Pacific salmon, and unlike chinook, coho don't pick at the bait but rather snap right on. Fishermen in the Great Lakes get to experience this game fish as coho have adapted remarkably well to a solely freshwater life. Introductions in Maine and Maryland rely on restocking.

Ingredients

1/2 gallon of water
1 cup pickling salt
2 pounds of dark, heavy-molasses type brown sugar
1 cup real maple syrup

Clean and slice fillets of salmon (against the grain) into ½-inch slices.

Mix brine, molasses and maple syrup and soak salmon slices for 1–2 days.

Slow smoke for 8–36 hours using a mixture of cherry and apple wood. Occasionally baste with a mixture of 3/4 cup honey and 1/4 cup water. Smoking time depends on local weather — colder days require longer smoke time. Longer smoking also results in chewier candy. However, smoking for too long turns your candy into jerky — a not altogether bad thing. Have your children taste it before you tell them what it is.

DISTRIBUTION

Their native range is northern California up through Alaska, along the coast and in spawning rivers. The coho has been transplanted into the Great Lakes and several states including Alberta, Canada, Maine and Maryland. Natural spawning in these areas, however, is uncertain and populations are kept up by restocking.

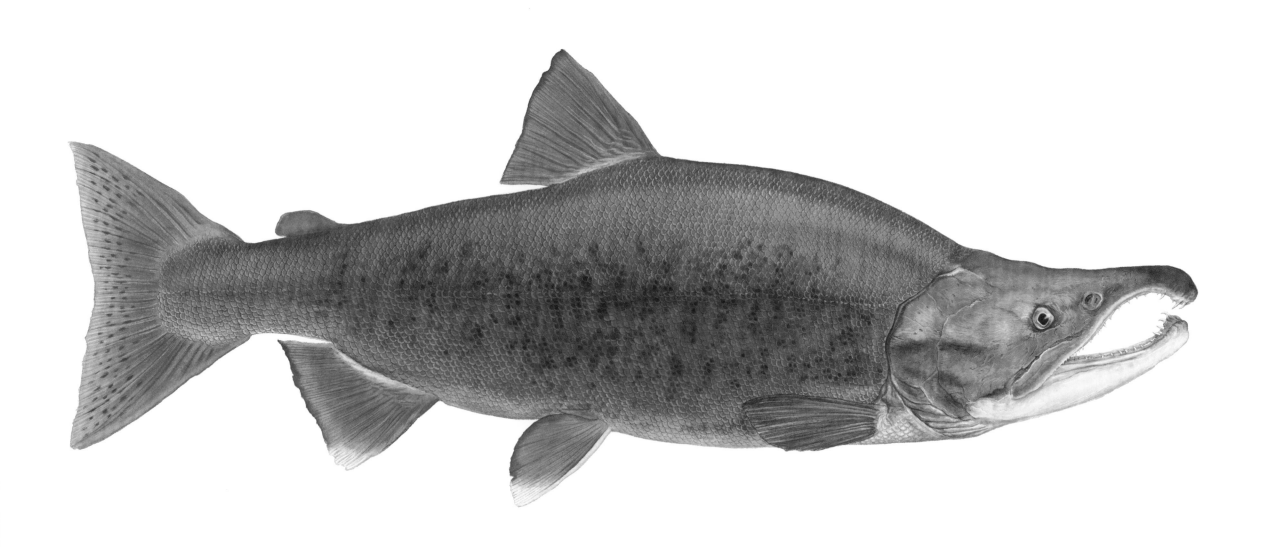

SOCKEYE SALMON

(Oncorhynchus nerka) Weight 5–12 lbs

(Oncorhynchus nerka)

SOCKEYE SALMON

It seems that every year at the opening of sockeye salmon season in Bristol Bay, Alaska (the world's most productive sockeye fishery) National Fisherman, the trade publication for commercial fishing, runs an aerial-view cover shot of the salmon boats on the bay.

Cheek-by-jowl they tow their nets, which make serpentine trails behind each vessel. I understand that collisions abound and nets get tangled and yet, it remains a most productive salmon fishery. The sockeye run lasts roughly six weeks but these salmon "cowboys" catch about seventy-five percent of their annual harvest in about seven days.

In recent years, a good sockeye boat on Bristol Bay might catch 100,000 pounds. Once upon a time, the commercial sockeye fishermen received as much as $2.50 per pound on the dock. By 2005, that had dropped to sixty cents per pound. I use the term cowboys because back in the days of premium prices for sockeye, Bristol Bay turned into the wild west with illegal fishing in off-limits areas, boats ramming other boats, and gunplay.

Situated on the eastern-most arm of the Bering Sea, Bristol Bay covers an area 250 miles by 180 miles. The bulk of the fishing though, takes place near the eight rivers that flow into the bay. The upper end of the bay rivals the Bay of Fundy and other areas with monumental tides, some in excess of thirty feet. The area makes for perilous fishing with its many shoals, sandbars, and shallow spots. In fact, the bay can be so tight and dangerous that the government passed laws limiting sockeye fishing boats to thirty-two feet long.

Unfortunately, the bulk of the sockeye tonnage caught each year gets canned for consumption in the United States. The best

MADAM CAPTAIN

Capt. Fran Kaul is one of the only female captain boat owners in the Bristol Bay fleet and is the founder of Misty Fjord Seafoods. The future of the Bristol Bay sockeye resource looks bright, says Kaul, "because it is based on a sustainable resource and is a well-managed fishery. The Monterey Bay Aquarium Seafood Watch program lists wild salmon caught in Alaska in its "Best Choices" category. Also, our company recently received the highly-coveted seal of approval from the Marine Stewardship Council."

fish, however, are bled and then held in refrigerated holds for a few hours until they can be delivered to a receiver boat where they are cleaned, the pin bones removed, brined to give it a glaze, and then flash frozen for export to Japan where the darker red meat and stronger flavor command top dollar. And contrary to common opinion, flash-frozen fish often has better quality than store-bought fresh fish. With the latter, you never know how long ago the fish left the water. Flash-frozen fish retain the freshness born of instant freezing within several hours of being caught.

The proliferation of farmed salmon caused the market for wild sockeye to plummet. Fishing permits, once a valuable commodity that was handed down generation to generation, could not even be given away. Today, the most successful boats in Bristol Bay all have refrigerated holds and their own down-stream market established.

DISTRIBUTION

Sacramento River drainage north to arctic Alaska. British Columbia is home to the quadrennial (every fourth year, following the sockeye lifespan) Salute to the Sockeye, a mid-October celebration of the return of over two million sockeye to spawning grounds.

(Oncorhynchus mykiss)

STEELHEAD TROUT

Though they look dissimilar, steelhead and rainbow trout are nearly identical except that the former lives mostly in the ocean while the latter remain in fresh water.

If steelhead were human, I'd say they had multiple personalities. By their nature, they are loners, yet biologists have discovered a vast swath of ocean near the Aleutians where steelhead from both sides of the Pacific, plus the full migratory range of North America, all gather. As anadromous fish (returning to streams to spawn) this steelhead behavior has fisheries experts baffled.

Steelhead populations are further split into two distinct migratory groups: winter steelhead head to their home streams starting in November, while summer steelhead start inland in June. Interestingly, both groups spawn during the winter. Perhaps they split to avoid a traffic jam.

Unlike most anadromous trout and salmon, steelhead don't die after spawning. They can spawn twice or in some cases three times in their lifetimes. Also unlike other char and trout, up to twenty percent of the stock will spawn in streams other than the one in which they started life. Fisheries biologists postulate that this may be nature's way of protecting genetic viability by preventing inbreeding. Newborn steelhead live in their birth stream for up to four years before they migrate downstream to the sea.

Steelhead and rainbow trout both enjoy greater adaptability to their environment than other salmonids. Though genetically the same, one heads to sea and the other remains in its natal stream. But if access to the sea suddenly disappears, steelhead apparently have no problem giving up their anadromous ways and living full time in fresh water. In fact, it's not uncommon to have both rainbows and steelhead in the same streams. Studies have also shown that rainbows can have both rainbow and steelhead offspring and vice versa. Some scientists logically speculate that food availability determines if fish head to sea as steelheads or remain in the stream as rainbows. Plenty of food tends to keep the fish around.

DISTRIBUTION

Though man has transported steelhead to New Zealand, Australia, South America, Africa, Japan, southern Asia, Europe, and even Hawaii, this trout's natural range is the Pacific Coast of North America up through Alaska and across to the Kamchatka Peninsula in Russia.

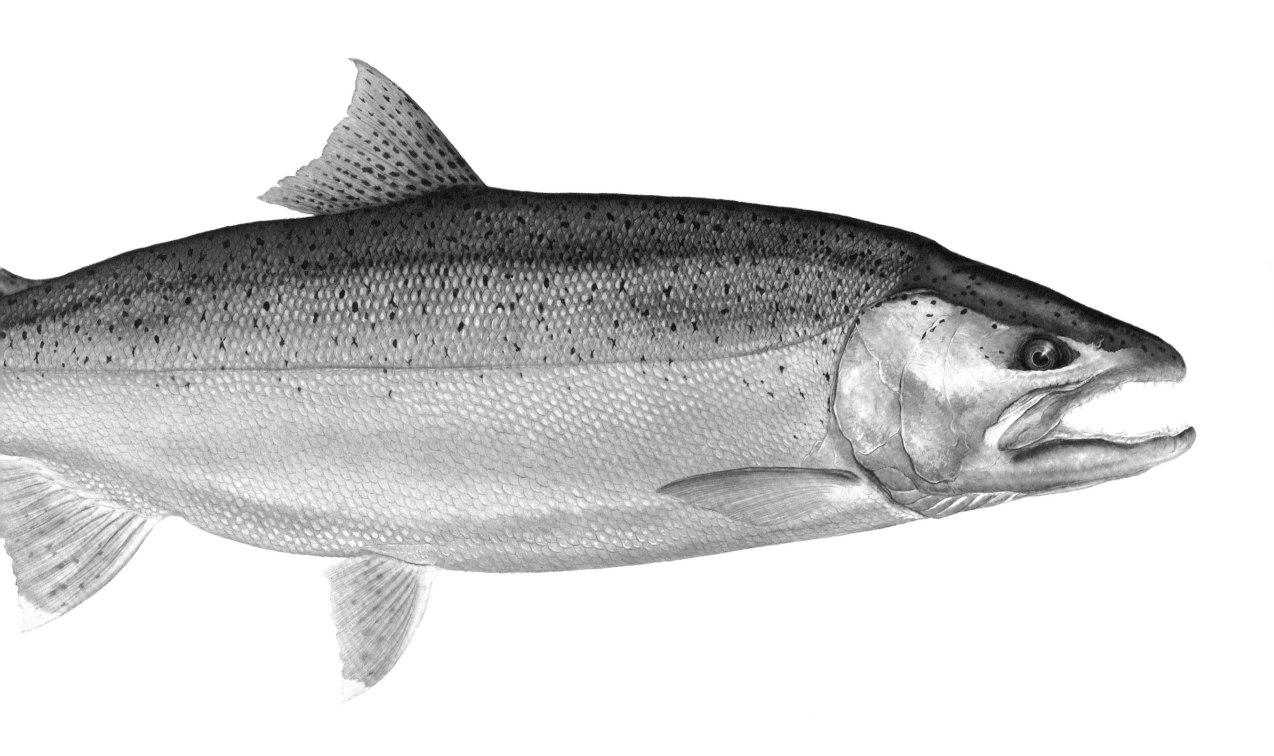

STEELHEAD TROUT

(Oncorhynchus mykiss) Weight 10–25 lbs

The California Department of Fish and Game estimates that the state's steelhead population has halved over the past thirty years, due mainly to upstream barriers to spawning migration, removal of critical habitat requirements such as in-water structure and bank overhangs, the silting over of crucial gravel bottoms where steelhead lay their eggs (smothering the eggs), and diminished oxygen levels in the water due to temperature fluctuations. Salmonids throughout North America suffer from the same threat: land development that destroys or damages critical habitat.

Steelhead are one of the top five sport fish in North America because of their hard fighting ways. For a person to remain upright in a fast-moving, rocky river in the middle of winter is hard enough without even considering hooking, fighting, and landing a beautiful and wily fish like the steelhead. When you plan to release your fish, wet your hand first so you don't remove any of the protective slime coating. Fishing barbless lets you remove the hook more easily.

EAT ONE!

Many people who only buy trout in the local market may not realize that the flesh of a wild steelhead looks identical to salmon—bright red and rich in smaller individuals. Try broiling steelhead with garlic, lemon, and herbs. Or smoke it (using the same ingredients) after soaking it in brine.

STEELHEAD FLIES

Fishermen mix and match flies across territories but generally speaking they can be grouped into Pacific Northwest and Great Lakes. The flies on the left are the western, and on the right are the eastern.

Comet

Bear's Hex

Egg-Sucking Leech

PT Nymph

Green-Butt Skunk

Krystal Bugger

Antron Bug

Spey

ABOUT THE ARTIST

Born in 1954 in Atlanta, Flick Ford was raised in Westchester County, New York. He fell in love with fishing at age five. His father, an accomplished fly-fisherman and talented commercial artist/copywriter, instilled in him a deep respect for nature and nurtured his early creativity. Throughout the 1960s and 1970s Flick fished the Adirondacks, New England, Long Island Sound, Chesapeake Bay, Virginia, and the woodland lakes of Quebec, while pursuing two other passions: music (as lead singer in a garage rock band) and art. He took formal watercolor classes in the 1960s, figure drawing and graphic design classes between 1973 and 1976, and then studied art at Evergreen State College in Washington.

Flick moved to New York City in 1978 and dove into the audio/visual scene of indie film, video, underground publishing, cartooning, illustration, and he reconnected with music. He performed in the East Village with several bands, and continues to write, play harmonica and sing lead vocals for The Crazy Pages, which was formed in 1988.

He left New York in 1993, heading for the Hudson Highlands where he quickly became obsessed with fishing the New York City watershed. The effects of over twenty years of pollution, over-development and acid rain became painfully apparent as he branched out to many of the Adirondack and Vermont brook trout places where he had previously fished.

"I felt I should start to keep a record of the fish I caught. I wanted to catch and paint these fish, and show how they appear to me in all their iridescent beauty." These first paintings formed the core of FISH: 77 *Great Fish of North America*. Today, Ford makes his home in Putnam County, New York. He fishes more than one hundred days a year and ties his own flies.

ARTIST'S ACKNOWLEDGEMENTS

I would not have been able to produce the images for this book without first the vision of Scott Usher, my publisher, who agreed to meet me and view my paintings of fish for what I thought was some friendly advice on how to market them — possibly as prints — and instead offered me a book deal. As an angler his enthusiasm and belief in the need for this book has afforded me a significant lifetime achievement. I would also like to thank both Wendy Wentworth, my editor, and Scott Usher for their patience while I struggled and ultimately made my deadlines. To the entire staff at The Greenwich Workshop I thank you for your support and professionalism. I would like to thank the author of this book, Dean Travis Clarke, for his professionalism and flexibility in shaping the content of this book. Even though we grew up a scant mile from each other and never met until this project was underway — I say better late than never!

In exploring resources for this book many individuals whom I contacted really came through for me with excellent photography from which I could make definitive studies with the other resources I had at hand. I would like to thank: Lance Campbell, a fisheries scientist and artist in Corvalis, Oregon, for his elegantly detailed photos of Dolly Varden trout, chinook salmon, coho salmon, lingcod, pacific halibut, sea-run cutthroat trout and sockeye salmon;

Gilbert van Ryckevorsel, of Subsea Deco Art, Dartmouth, Nova Scotia, a champion of Atlantic salmon and the leading photographer of the species, for his incredible underwater photos of Atlantic salmon; David Finkel, Development Manager of California Trout, San Francisco, California, for the definitive photo study of a California golden trout; Noel M. Burkhead, Research Biologist USGS— Florida Caribbean Science Center, Gainesville, Florida, for his photo-studies of channel and bullhead catfish; Herb Segars of Herb Segars Nature & Wildlife Photography, Brick, New Jersey for his wonderful underwater shots of greater amberjack, striped bass and bluefish; James Prosek, renowned artist/author and fellow angler for his personal snapshots of black crappie and pumpkinseed sunfish; Lee Hartman of Indian Springs Fly Fishing for permission to use information on the Delaware River rainbow trout fishery pulled from his website with research from DEC specialist Ed Van Put; and finally Al Caucci, owner of Al Caucci's Delaware River Club for his personal snapshots of Andros bonefish, and for writing the piece on FUDR.

Along the way I tried to catch as many of the species as I could. However without the anglers and guides who accompanied me, in many cases I would not have had a specimen to paint at the conclusion of each fishing trip. I would like to thank: Jeff White, manager of the Delaware River Club, for guiding me into smallmouth and for catching chain pickerel and his wife Kristin for helping me record specimens in photographs and tracings; Whitten's Marina in Boca Grande, Florida for supplying me with a fresh caught tarpon to photograph; Dave Zippay and Captain Wayne Joiner Captain of Boca Grande, Florida for their efforts at getting me onto snook; Les Hill of Boca Grande, Florida for guiding me into seatrout and jack crevalle; Cliff Hagberg, my step-father, who got me onto spanish mackerel, summer fluke, redfish, and bluefish; Bob Howe and his son Heath of Pine Grove Lodge in Pleasant Ridge, Maine for their tireless efforts at helping me get northern pike and yellow and white perch and his wife Andrea for her delicious home-cooked meals and afternoon pies; John Kenealy formerly of Solon Maine, who is a very talented bamboo fly rod maker who patiently guided me into a nice brook trout and who has apparently disappeared — I hope you are well and fishing and if you read this get in touch with me, will you?; Randall, Nannette, Caleb and Chris Smoke for their hospitality and their efforts at getting me a walleyed pike and muskellunge, megwich!; Jeff Walther of Striped Tease Charters, Chatham, Cape Cod, Massachusetts, for guiding me into false albacore, bluefin tuna and Atlantic cod; Peter Jervis of Fat Fish Adventures in Grand Cayman for hooking me up with too many species of snappers and reef fish too mention as well as barracuda; Phil Bodden of Chip Chip Charters in Grand Cayman for the opportunity to catch a rare white marlin while trolling offshore for blue marlin; Jon Brown of IT-Dept, Cos Cob, Connecticut, for help with managing digital files and scanning transparencies of resource photos, and for inviting me to fish for blues on his boat; Captain Luis Rionda of Cha Cha Charters, Islamorada, Florida Keys, who got me into dorado and gave me a second chance at landing a wahoo; and finally Ben and Cindy Rinkler — who are legends on the Upper Delaware River — for their location promotional video footage that made me look like a real angler while on numerous floats and moveable feasts aboard their drift boat.

My deepest thanks go to my friends and family who have supported this project and are in some ways responsible for my vocation. Thanks to my dear friend Josephine DeMichele who with my father prodded me into painting fish for a living seven years ago. Thanks to my mom Margaret Hagberg and my step-dad Cliff Hagberg who made Cape Cod and Boca Grande available (and affordable) for me to fish for specimens to paint. Thanks to Peter, Nathan, Ruby and Sarah Bernstein for making the Grand Caymans available to me and for helping me eat the dozens of fish I've painted over the years — many of which are in this book. Last but not least thanks to Lori and Odgie the 2-legged and 4-legged ladies in my life whose welcome makes returning home from a fishing trip joyous.

ABOUT THE AUTHOR

Dean Travis Clarke comes from a family of watermen. His grandfather was a boat builder, his father a captain and fireman. Dean got his first professional captain's job at age fourteen running a private Hatteras sport fisherman out of Montauk, New York during the summer. A licensed captain, Dean has hundreds of thousands of sea miles on both power and sailing vessels around the world. He was a member of the crew of *Courageous* in the 1983 America's Cup and has sailed in numerous one-design national and world championships.

For the past eighteen years, Dean has been a marine journalist, holding the position of executive editor at World Publications for the past fifteen years. At World Publications, Dean works with *Sport Fishing*, *Marlin*, *Fly-Fishing in Saltwaters,* and *Boating Life* magazines. He also hosts the popular *Sport Fishing Magazine* television show on the Outdoor Life Network.

Dean served two and one-half terms as president of Boating Writers International and received the prestigious National Marine Manufacturers Association's Directors Award for being the foremost marine journalist in North America. Dean also currently serves on the National Advisory Board of BOAT/US, the fishing committee of National Marine Manufacturers Association, the Board of Directors of the Barta Boys and Girls Club Billfish Tournament and is an active, licensed Judge Referee with the United States Rowing Association.

Dean Travis Clarke is considered by most in the marine industry to be one of the world's most knowledgeable experts on recreational boats and fishing. He has been married to Mary Swain Landreth for more than half his life and has three of the most wonderful children in the universe — Louisa, Mariah, and Travis. He aspires to make them as proud of him as he is of them.

AUTHOR'S ACKNOWLEDGEMENTS

Thanks to my family for their patience. To John Merwin for sharing his extensive collection of famous fishing quotes as well as to all the dedicated fisheries scientists who work so hard to learn about fish and to convince government agencies to listen to them. I thank Al Gore for inventing the internet where I can always find fish facts as well as the sum-total of human knowledge, and to the many scientists who contribute their knowledge to the internet for me to mine. Thanks to William F. Buckley, Jr. for teaching me about the Oxford English Dictionary. Thanks to Doug Olander for making me a better writer. To my father, grandfather and my famous Uncle Bob Clarke, who all instilled in me a passion for the sea. And finally, to Mary Swain, Louisa, Mariah and Travis — thanks for loving me anyway.

LIST OF PAINTINGS

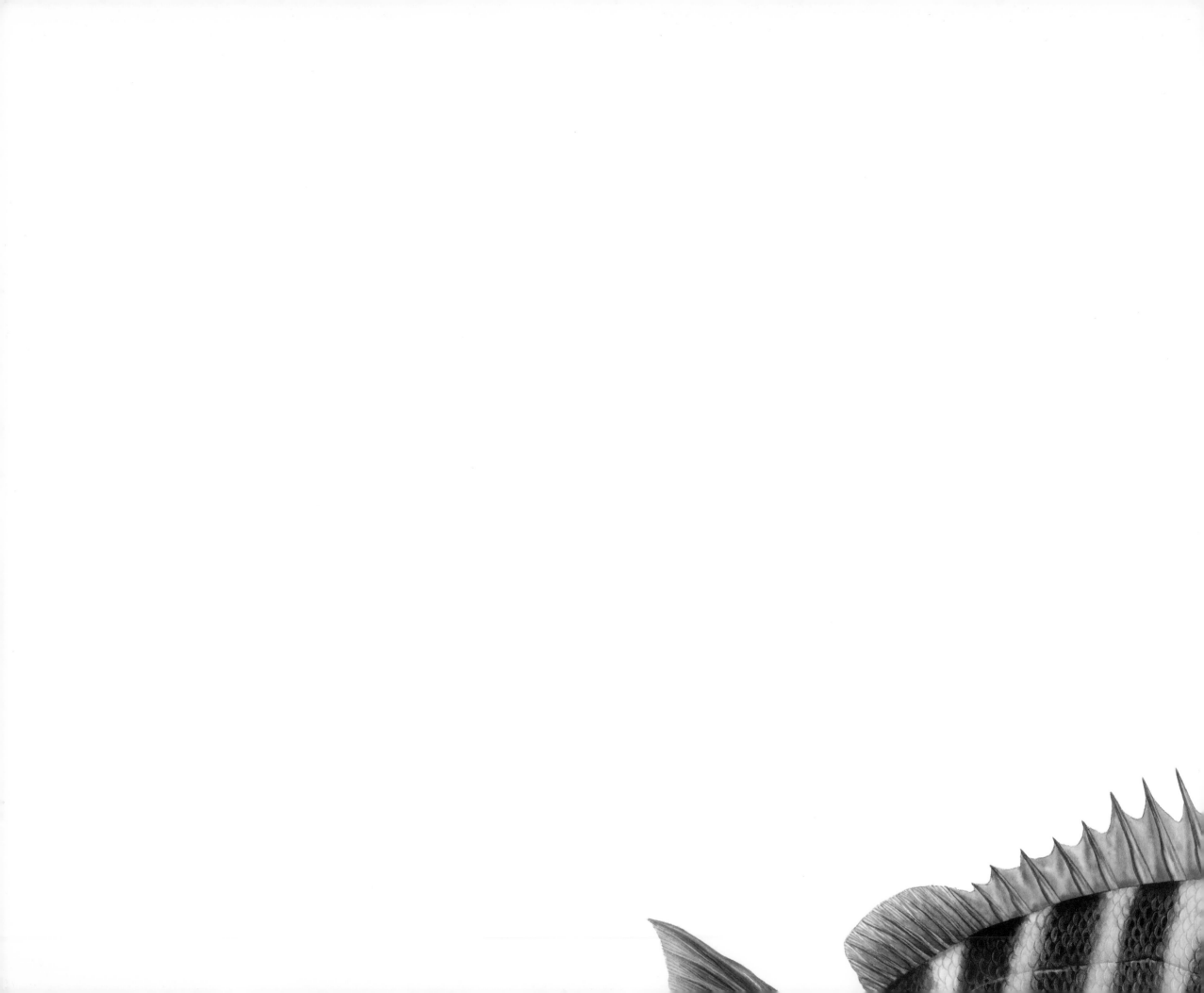